ROSES

ROSES

ROSES IN THE GARDEN
STORIES OF TREASURED COLLECTIONS
by
NGOC MINH NGO

R⫟G

RIZZOLI NEW YORK

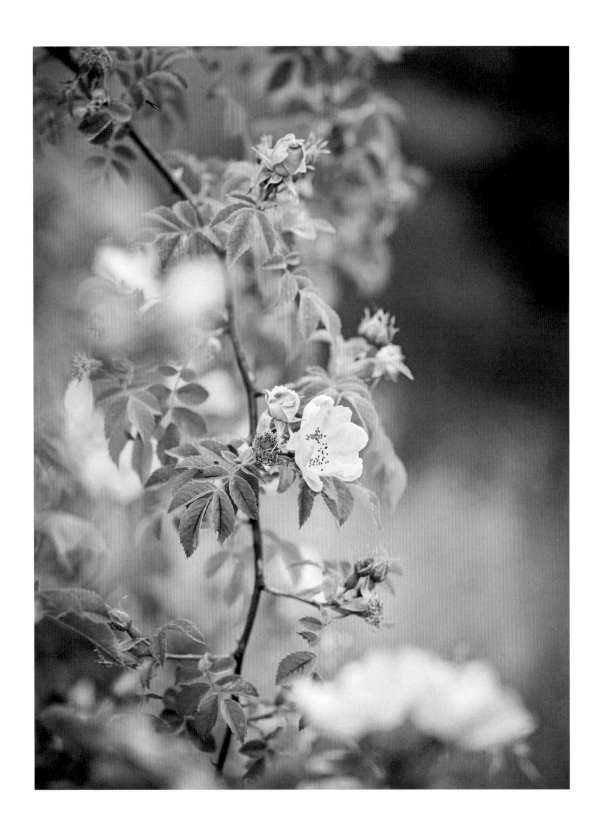

Inspired by my father, dedicated to my sisters:
Trang, Phuong, Anh, Hieu

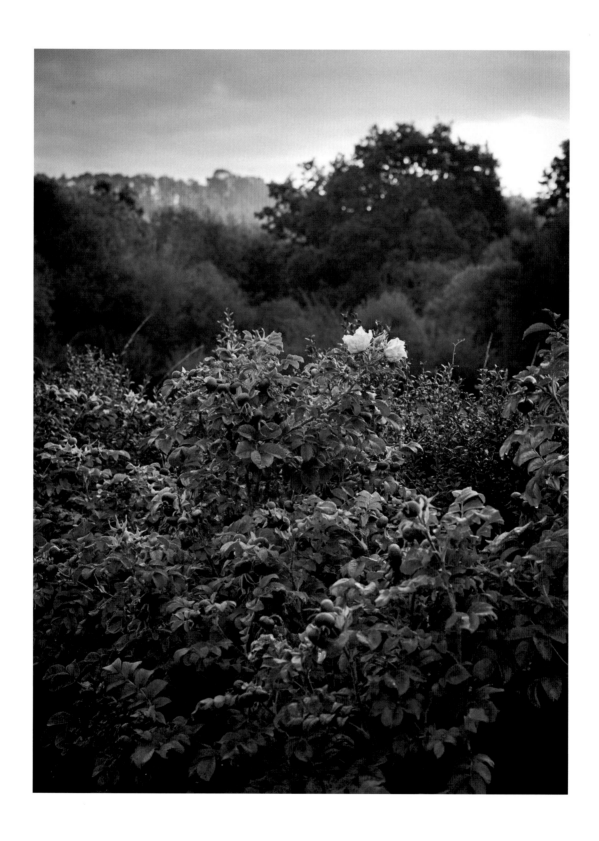

Rosa 'Gravin Michel d'Ursel'

Rosa 'Wife of Bath'

Roses in the Garden

"...with roses the whole place
is shadowed"

Sappho
translated by Anne Carson

I grew up in South Vietnam, just below the Tropic of Cancer. The rose of my childhood—haughty in its beauty, scornful of our climate—was prized far above our tropical flowers but did not deign to grow in our garden. It was a flower to be had only on very special occasions, bought from the market by my mother. These long-stemmed red roses were grown not far away, in the central highland city of Đà Lạt, the only place in the country where roses flourished. Images of rose-strewn gardens loomed large in our romantic vision of Đà Lạt. When my father planted his first garden in America in the late 1970s, he made a bed for roses in a sunny corner. The selection of roses available at the local garden centers consisted mostly of the modern hybrid teas and floribundas in a bewildering range of colors—every shade of pink, coral, yellow, red—that would make a rose connoisseur in Đà Lạt weep with envy. Roses in various shades of orange featured heavily among the All-America Rose Selections winners during that decade and the next. There was 'Yankee Doodle', whose color is described as "sherbet orange"; 'Prominent' is "hot orange"; 'Sundowner' and 'Bing Crosby', simply "orange"; 'Marina', "coral orange"; and 'Shreveport', "orange blend." My father opted for the more traditional reds, pinks, and yellows. While he planted roses in his garden, I fell in love with the story of the Little Prince and *his* red rose from Antoine de Saint-Exupéry's book.

PREVIOUS
In the summer of 2008, with the help of my friend Sarah Owens, then rosarian at the Brooklyn Botanic Garden, I began a project photographing roses. The long journey that led to this book began with images of roses like these, made in dedication to my father.

"Of all flowers, methinks the rose is best," declares Emilia, the beautiful and kind-hearted Amazon in William Shakespeare and John Fletcher's play *The Two Noble Kinsmen*. In cultivation for millennia, with over thirty thousand cultivars in existence and a deluge of new ones introduced each year, it seems that my father was not alone in his love of roses. Many gardeners and flower lovers in different times and cultures have fallen under their spell. In Pahlavi (or Middle) Persian the word for rose, *gul*, is also the general term for flowers. "My heart, like a bud of red, red rose / Lies fold within fold, aflame," wrote Babur, the first emperor of the Mughal dynasty. He filled his garden with roses and gave his daughters rose names: *Gulbadan*, meaning "body like a rose"; *Gulchera*, "a face like a rose"; *Gulrukh*, "rose-cheeked princess." One could argue whether the rose is best or not, but it is undoubtedly part of the royalty in the flower kingdom. It is often thought that the Greek lyric poet Sappho declared the rose King (or Queen) of Flowers in a poem attributed to her, which Elizabeth Barrett Browning translated as "Song of the Rose." Sappho did indeed sing of roses planted among apple trees in the sanctuary of Aphrodite, but as Jennifer Potter pointed out in her authoritative book on the rose, there is no evidence that she actually wrote the poem Browning translated, the paean to the rose in Achilles Tatius's love story, *Leucippe and Clitophon*. Queen or not, to the ninth-century Benedictine monk-gardener Walafrid Strabo, the rose was "the Flower of Flowers" for its beauty, fragrance, healing properties, and symbolic value. What more could be asked of a flower?

Roses grew wild in the northern hemisphere—from the Tropic of Cancer up to the Arctic Circle—long before men walked on earth. They have since made their way into gardens large and small, real and mythical. Herodotus, writing in the fifth century BCE, tells us of ancient King Midas's garden in the valley below Mount Bermium in Macedonia, where wild roses grew, "wonderful blooms, with sixty petals apiece, and sweeter smelling than any others in the world." A century later Theophrastus, known today as the father of botany, reported efforts by the common Macedonian gardeners to domesticate the wild roses from Mount Pangaeus, thus giving us the first written record of roses being tamed in the West. China, with its floriculture dating back to at least the eleventh century BCE, was most likely the first to bring the wild roses into cultivation in the imperial gardens three thousand years ago. Fossils of rose leaflets discovered in northern China date back to the Miocene period, between 5 and 23 million years ago. The first story about a garden rose comes to us from the time of Emperor Wu Di (156–87

BCE) during the Han dynasty. A patron of poetry and literature—and a poet himself—the emperor compared the beauty of his favorite rose to his concubine's smile during a romantic stroll in the garden. Thereafter, the rose became known as 'Mai Xiao', literally "to buy a smile."

Roses are bearers of history,
keepers of memories.
Vita Sackville-West, who planted more than two hundred
varieties in her garden at Sissinghurst,
loved old garden roses not only for their beauty
but also for their history.

Our long entanglement with the genus *Rosa* has woven a web of tales that muddle fact with fiction but in the end tell us something about ourselves. Such is the story of the rose named after Omar Khayyám, the twelfth-century Persian astronomer, philosopher, mathematician, and reputedly author of the *Rubáiyát*, a collection of verses filled with images of blown rose petals as metaphors:

> Look to the rose that blows about us,
> Laughing, she says, into the world I blow,
> At once the silken tassel of my purse
> Tear, and its treasure on the garden throw...

Nizami of Samarkand, a disciple of the great man, recalled his teacher once prophesied that his grave would be in a place where "every spring the north wind will scatter roses." Some years after Khayyám's death in 1131, Nizami returned to Nishapur to visit his tomb and found "so great a shower of blossoms was poured upon his grave that the grave became hidden beneath the roses." Six centuries later, Edward FitzGerald introduced the *Rubáiyát* to English readers with his translation, including Nizami's story in the preface. The flowery imagery resonated with the Pre-Raphaelites, and by the 1880s Omar Khayyám clubs sprang up all over England. In 1893, one such club planted a rose on FitzGerald's grave in a churchyard in Suffolk—a shrub reputedly grown from seeds collected by William Simpson, an artist for the *Illustrated London News*, from a rose on Omar Khayyám's tomb. It was registered in the following year as *Rosa* 'Omar Khayyam'. It is highly doubtful that the rose bearing Khayyám's name is actually the descendant of the original rose on his tomb, which would have been nearly a thousand years old by the time Simpson came upon it, even if such a rose did exist. Its authenticity notwithstanding, Omar Khayyám's rose remains an eloquent symbol, scattering its petals from medieval Persia to Victorian England, pre-

serving the story of how the words of the great poem were brought across centuries and continents to remind us of the fleeting beauty of summer, youth, and life itself.

In 2008, in a different house, my father spent his last days in a room with a view of another rose bed he had planted. He passed away without seeing the roses bloom one last time.

That summer, with the help of my friend Sarah Owens, then rosarian at the Brooklyn Botanic Garden, I began a project photographing roses.

My days began early with a walk through the rose garden, where Sarah cut for me the most beautiful specimens and regaled me with tales of their horticultural history. The rest of the day I spent in solitude, photographing the roses and mentally having a conversation with my father. Like the ancient druids who chanted floral names in the winter months to lure back the sun, I offered countless rose portraits as incantations to bring my father back to me. Immersed in the world of roses and untethered from the present, I traveled through time with my father, in the company of this beautiful and ancient flower and those who had loved it long before us. A parade of notable men and women throughout history—painters, poets, botanists, scholars, mystics, emperors—as well as the humble gardeners from all corners of the world—the anonymous ones like my father—accompanied me while I peered at the unfolding petals through my camera lens.

Despite having photographed hundreds of roses, I am still astonished by their beauty. No other genus, except perhaps orchids, has greater variety. A bloom might have five to eight petals, like the roses that accompanied the birth of Venus in Botticelli's painting, or it might have up to two hundred petals, the favorites of the seventeenth-century Dutch painters. Its petals might fold into themselves, or they might bend back as they unfold. A rose might be delicate and open, ruffled and dainty, pointed and regal, or simply voluptuous. The colors run through the spectrum from rich yellow to crimson red to the palest pink, with some purple hues thrown in for good measure. The plants range from miniatures to ground covers to shrubs to ramblers to climbers to trees. The genus *Rosa* is highly capricious, with a tendency to sport (mutate) new forms and habits without human intervention. But that hasn't stopped hybridizers from trying to come up with ever new varieties to suit our human vision of the ideal rose. It's an inexhaustible effort. In the words of the poet Rainer Maria Rilke, a rose is a "half-opened book, with so many detailed pages of happiness that we will never read."

At the end of a day spent photographing roses, their perfume—an ineffable combination of sweet, spicy, fruity, myrrh, and citrus scent—lingers on my hands and pervades my dreams. As the Sultan al-Mutawakkil, who reigned in ninth-century Samarra, Iraq, declared, "the rose is the king of all fragrances." Much has been written about this ancient flower—2,500 years ago Confucius counted hundreds of books on the subject in the emperor's library—but the rose continues to seduce, and I can't resist its siren call. From Asia to America, the protean rose comes in various guises, regal in formal beds, humble in vegetable plots, carefree in meadows, riotous on walls and tree branches. This is not a book on how to grow roses—their reputation as difficult is legendary and there are countless books by more qualified authors on the subject. Instead, this book offers me a chance to celebrate the rose's enduring beauty and the place it has claimed in gardens all over the world, in different cultures and climates. Most important of all, it allows me—and the readers too, I hope—to dwell in Sappho's rose-shadowed place for a while, with its fragrance turning the ephemeral into the eternal. R✦G

FOLLOWING
My private rose garden is made up of images of roses encountered in gardens I have photographed, as well as Natasja Sadi's extraordinary sugar roses, all seen against the mural I painted for my daughter's old room.

When not photographing roses or reading about them, I study botanical illustrations of roses. A particular favorite is the Dutch Golden Age painter Pieter Withoos's rendition of the gallica 'Versicolor', seen top center.

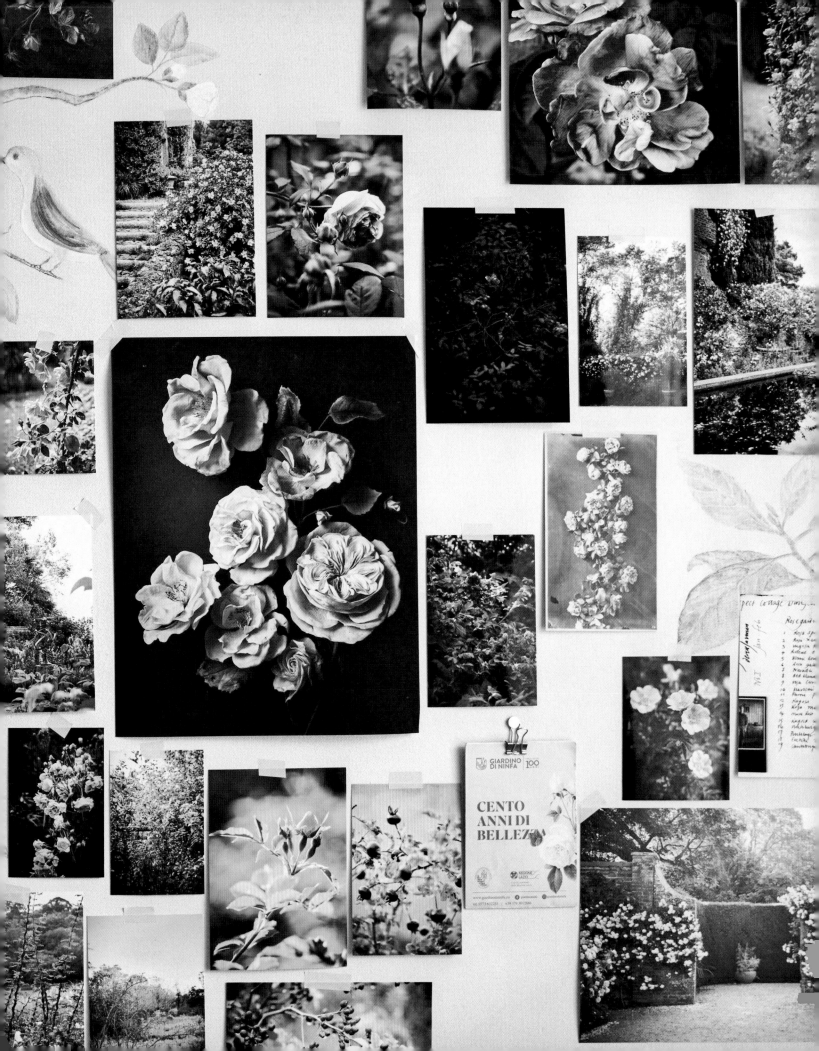

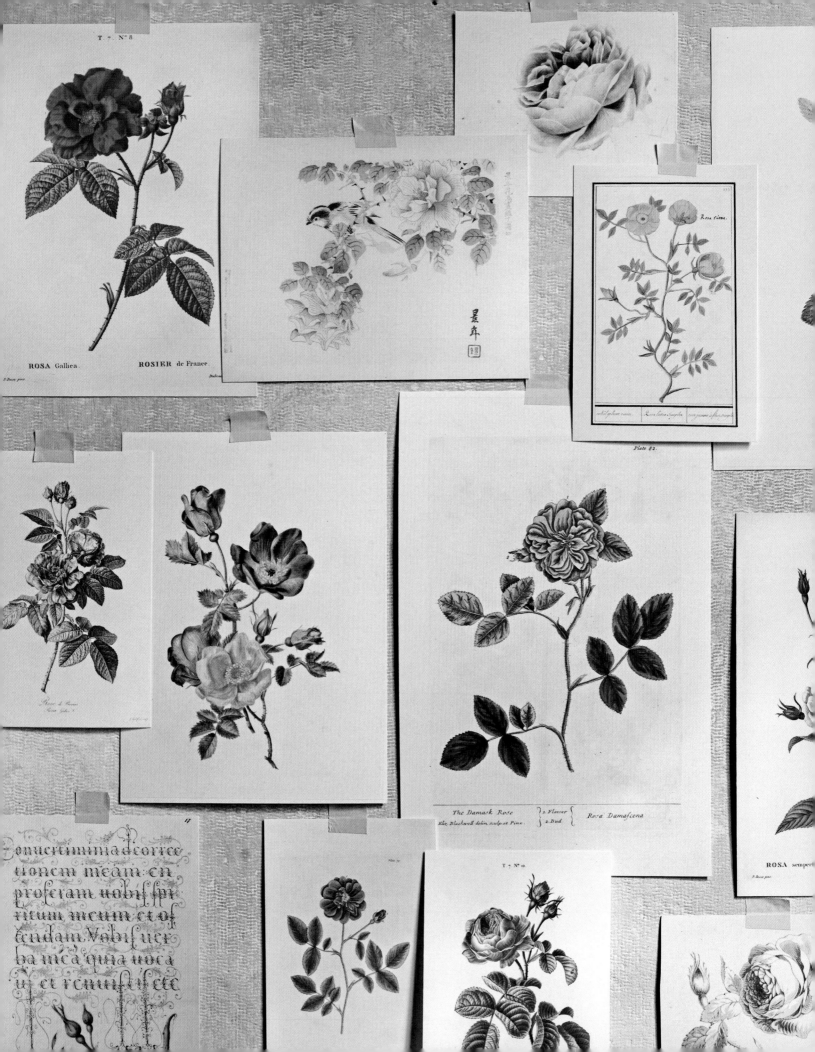

T. 7. N.º 8

ROSA Gallica. ROSIER de France.

Rosa s'ema.

Plate 82.

The Damask Rose { 1. Flower { Rosa Damascena
Eliz. Blackwell delin, sculp. et Pinx. { 2. Bud

ROSA semper

T. 7. N.º 12.

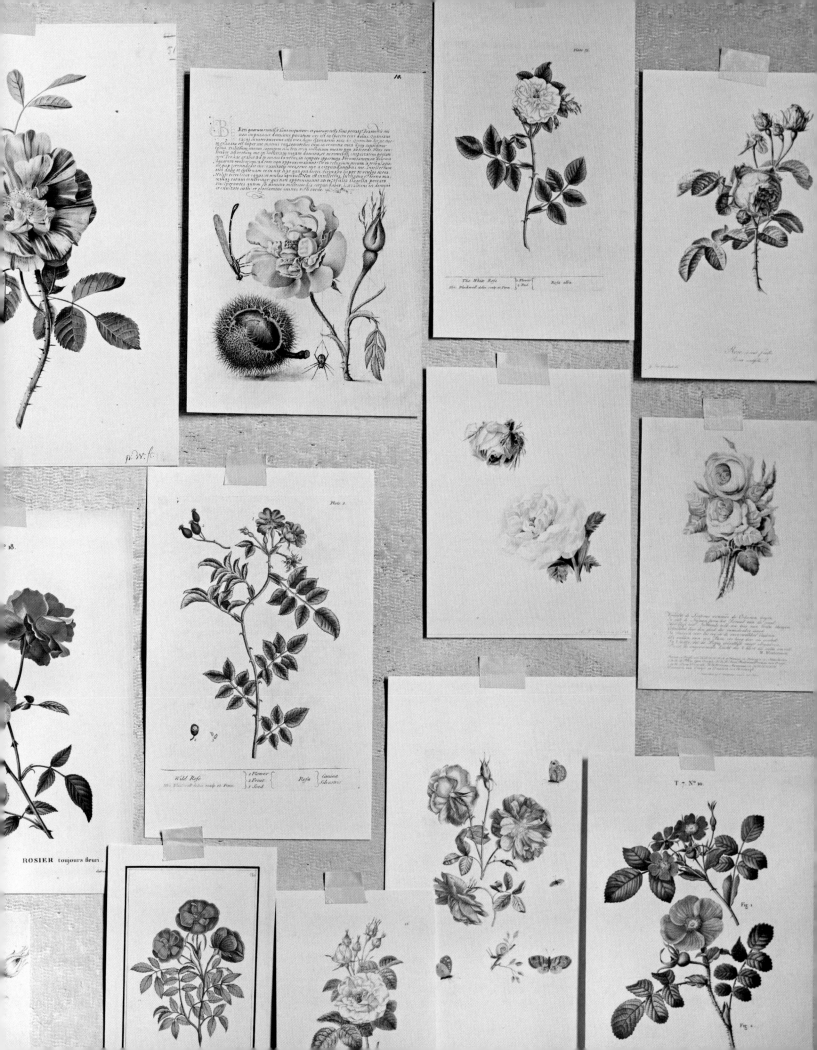

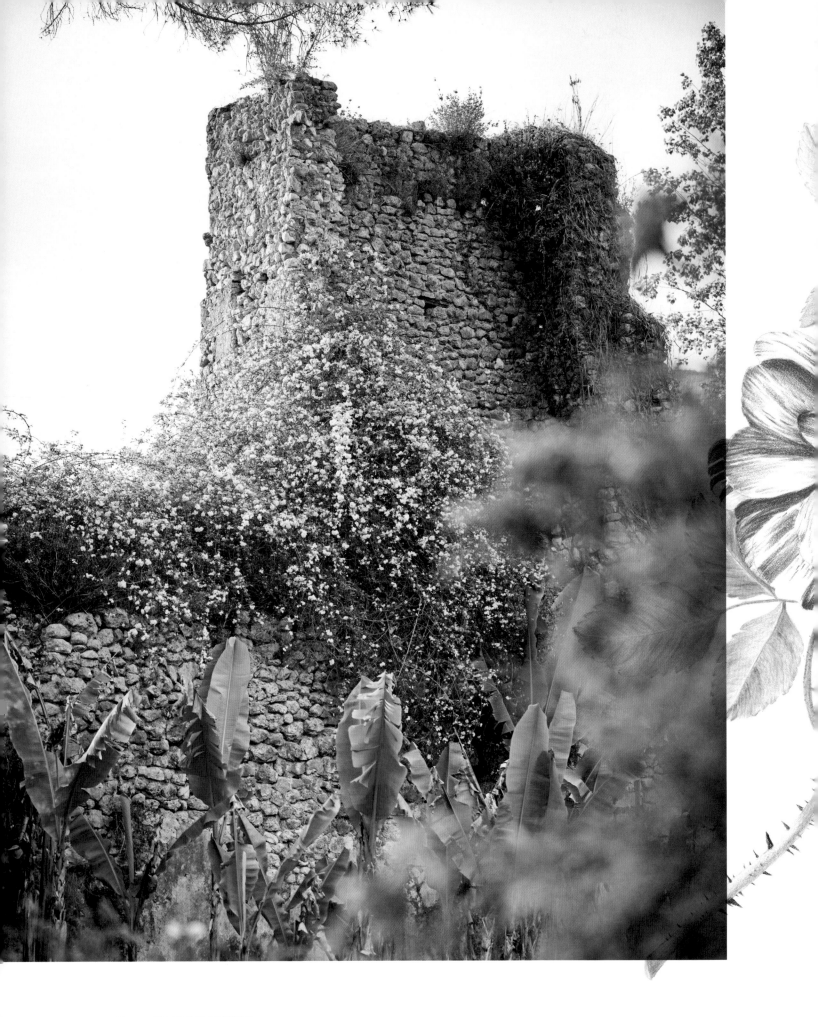

Giardino di Ninfa

As a photographer of gardens, I long dreamt of Ninfa.
Charles Quest-Ritson, an authority on gardens,
roses, history, and Italy—all subjects close to my heart—
proclaimed this oasis just south of Rome
"the most romantic garden in the world."

Created by three generations of the Caetani family, the Giardino di Ninfa, as it's known in Italy, has been designated a Natural Monument, its beauty mythical among garden lovers all over the world. Marella Agnelli—whose intimate knowledge of the garden came from stories and descriptions told by her mother, a friend of Marguerite Caetani—photographed it in the early 1990s for a book. Her images, full of deep shadows and saturated colors, showed a mysterious and dreamlike landscape bounded by towering cypresses, mighty oaks, and majestic pines. Roses hung like curtains from tree branches, smothered stone walls, and grazed the limpid water of a rushing river. Wildflowers carpeted the meadows while cherry blossoms reached for the sky. The ruined medieval towers, castle walls, churches, and battlements hint of bygone splendor, casting an indelible spell over the profusion of flowers and plants. As the writer Iris Origo wrote in a moving portrait of her friend Marguerite, Ninfa is "a garden of haunting and melancholy beauty."

The story of this emerald jewel on the Pontine marshes is one of glories and defeats, fire and destruction, ruin and regeneration. Ninfa's roots dig deep in history, dating back as far as the first century. The foundations of a temple dedicated to the sacred nymphs described by Pliny the Younger now lie at the bottom of the man-made lake. With the collapse of the Roman Empire and the creation of a new route at the foot of the Lepini mountains, Ninfa's settlement grew into a flourishing town in the eighth century. Pope Alexander III, having fled Rome, was crowned in 1159 in the church of Santa Maria Maggiore. Emperor Frederick—or Barbarossa, as he was known— took revenge by sacking the town in 1171. It was quickly rebuilt, with added fortifications. At the end of the thirteenth century, the town, now owned

LEFT
Masses of *Rosa banksiae* 'Lutea' cascade from the remnant of a town wall on the edge of the Piazzale della Gloria.

Illustration, *Rosa gallica* 'Versicolor'.

by Pietro Caetani, held seven churches, 150 houses, and thriving mills for tannery and ironworks. But its fortune was short-lived. Ninfa was decimated in a bloody battle in 1382, set off by years of papal wars and a schism between two branches of the family. The town was burned to the ground, its inhabitants put to the sword. Threats of malaria kept the place abandoned for five centuries, to be enfolded in brambles, ivy, and ferns. Dense thickets populated the forgotten streets. Clematis, bellflowers, and honeysuckle clothed every ghostly wall and tower. In his Italian travelogue, the German medievalist Ferdinand Gregorovius wrote rapturously of the Ninfa that he discovered in 1860: "a fragrant sea of flowers waves above Nympha; every wall is veiled with green, over every ruined house or church the god of spring is waving his purple banner triumphantly."

It was not until the early twentieth century that Ninfa was reborn as a world-famous garden. It took three generations to create it from the "mass of silent ruins," to borrow Gelasio Caetani's words. The trained engineer began the restoration in the early 1900s by devising drainage canals to reclaim the swamps. He also had the tower and the old town hall restored, making the latter into the family's summer home. Along with his mother, the English-born Ada Booth Wilbraham, he uncovered the ruins of the medieval town to form the skeleton of the new garden. Together they planted cypresses, holm oaks, and beeches. Ada added roses in great numbers, including 'Général Schablikine' from cuttings of those she had cultivated at the family estate Fogliano.

With Gelasio's passing, care of the garden passed on to his brother Roffredo and his American wife, Marguerite Chapin, who planted roses lavishly. In one year alone, she ordered 128 roses from England. With the death of her only son, Camillo, Marguerite devoted herself to the garden and her literary journal *Botteghe Oscure*. Ninfa after World War II became a place of consolation, a haven from the outside world, not just for the Caetanis but also for the artists and writers nurtured by Marguerite. Dylan Thomas first published some of his best poems on the pages of *Botteghe Oscure*. Giorgio Bassani, who edited the journal during its twelve years of existence, wrote much of his classic novel *The Garden of the Finzi-Continis* at Ninfa, drawn to the magic of the place. So were the writer Alberto Moravia and the filmmaker Pier Paolo Pasolini, as well as Truman Capote and Tennessee Williams.

The evolution of the garden continued with Marguerite's daughter, Lelia, the last Caetani. She added new plants and refined the garden with

a painter's eye while preserving the ruins that define the place. Lelia and her husband Hubert Howard fought to restrain the industrial and commercial development around Ninfa. In 1954 they bought up a quarry that was being mined nearby, and in an early example of ecological rehabilitation, planted native arbutus, brooms, wild olives, myrtles, lentisks, and hawthorns in the area that had been visibly damaged by the extraction. Without an heir, the Howards set up the Roffredo Caetani Foundation to safeguard the future of the garden. Lauro Marchetti, entrusted by the couple, has faithfully shepherded Ninfa into the twenty-first century, keeping its spirit alive with thoughtful new plantings.

"Ninfa [is] where Flora holds her court, where the only inhabitants are the roses and the lilies and all the thousands of flowers that grow so abundantly in the deserted streets," wrote the English travel writer Augustus Hare in 1874. He could be describing Ninfa 150 years later during the month of May. The magnolias, ornamental cherries, and crab apples are at the end of their blooming. The Judas trees are dressed in fresh mauve-pink blossoms. Marguerite Caetani's beloved dogwoods—they reminded her of her New England childhood—fill the air here and there with their white or pink flowers. Pendulous clusters of wisterias tumble from the wooden bridge and the Roman stone bridge, their reflection on the river making them seem twice as prodigious. Yellow flag irises form an undulating carpet that melds into the giant gunnera leaves along the water. But all these flowers and plants merely set the stage for the roses, which hold the garden in their command, having free rein over the trees, the ruins, and the river.

Far from being cosseted primly in formal beds,
the roses at Ninfa—in over 250 varieties—
clamber on stone walls, tease the surface of water,
tangle in the trees, and sprawl along the riverbanks,
their blowsy blooms running riot.

Dainty yellow banksiae roses flutter in the late afternoon sun like hundreds of finches roosting along the remnants of the old town walls. *Rosa* 'La Follette', the hybrid gigantea introduced at Ninfa by Lelia Howard, leaps over the wall to hang its pink blooms on the trees, unstoppable in its quest to spread its cheer. An impressive specimen of *R.* 'Alberic Barbier' stands alone at one end of the lavender path, a giant monument to itself, smothered in creamy white flowers. Elsewhere, deep crimson blooms of *R.* 'Agrippina', the climbing sport of *R.* 'Cramoisi Supérieur', festoon the empty wall of the gothic palace built by Pietro Caetani in 1308. In the

background, the tinkle of waterfalls harmonizes with melodies of birdsong, a reminder that over a hundred species of birds have been recorded here.

The chronicle of Ninfa is written in its earthy landscape. Tales of papal glories and ruthless destruction lie buried among the flowers. Millennia of human existence are reduced to mere ruins while nature endures. The seasons change but every spring the roses return, bringing with them memories of the women who loved them and made this garden. Like all the best gardens, Ninfa stirs the imagination. Every view is transportive, an inspiration for painters and poets alike. One could imagine the pre-Raphaelite painter John Everett Millais's Ophelia floating above the reeds in the clear and fast-flowing river. The poet Kathleen Raine captured the redolent landscape in "Ninfa Revisted":

> To walk beside such crystal streams
> As water Dante's Paradise
> And irrigate Bocaccio 's shades,
> Spenser's and Milton's bower of bliss,
> Anemone and violets
> Of Circe's or of Shelley's isles.

It's also easy to picture Marguerite Caetani hosting picnics for her coterie of writers, artists, scholars, and diplomats on these grounds, just as Iris Origo described half a century ago: "the guests would bring their children, too, to picnic in the grass, while their elders lunched out under the trees...and there was a great deal of talk and laughter, while further down the stream, where there was peace and silence, an absorbed fisherman was casting for trout." Even the trout at Ninfa is special. The macrostigma—found nowhere else in Europe and far from its home in North Africa—is thought to have been brought here by Hannibal in antiquity.

Gregorovius's "green kingdom of spirits" is what remains of seven hundred years of the Caetani's family history at Ninfa. The garden's haunting beauty—its spirit perhaps protected by the nymphs of Ninfa's ancient origins—owes much to the tumultuous history of the place, the picturesque landscape, and its botanical treasures, not least among which are the heavenly roses. "My daughters and I are very earthy gardeners," Marguerite once wrote to a friend. The garden they made is a terrestrial dance of water, trees, and blossoms among the shadowy ruins. Poised between past and present, chaos and harmony, Ninfa has the air of Sleeping Beauty, a secret garden that zealously guards its memories of a distant past, to be discovered by those seduced by its romantic story and the glory of the roses. R+C

RIGHT
Ada Caetani planted *R.* 'Général Schablikine', a tea rose bred in France by Gilbert Nabonnand in 1878, with cuttings from the family estate Fogliano. Today it is a signature rose at Ninfa, blooming almost continuously all season long.

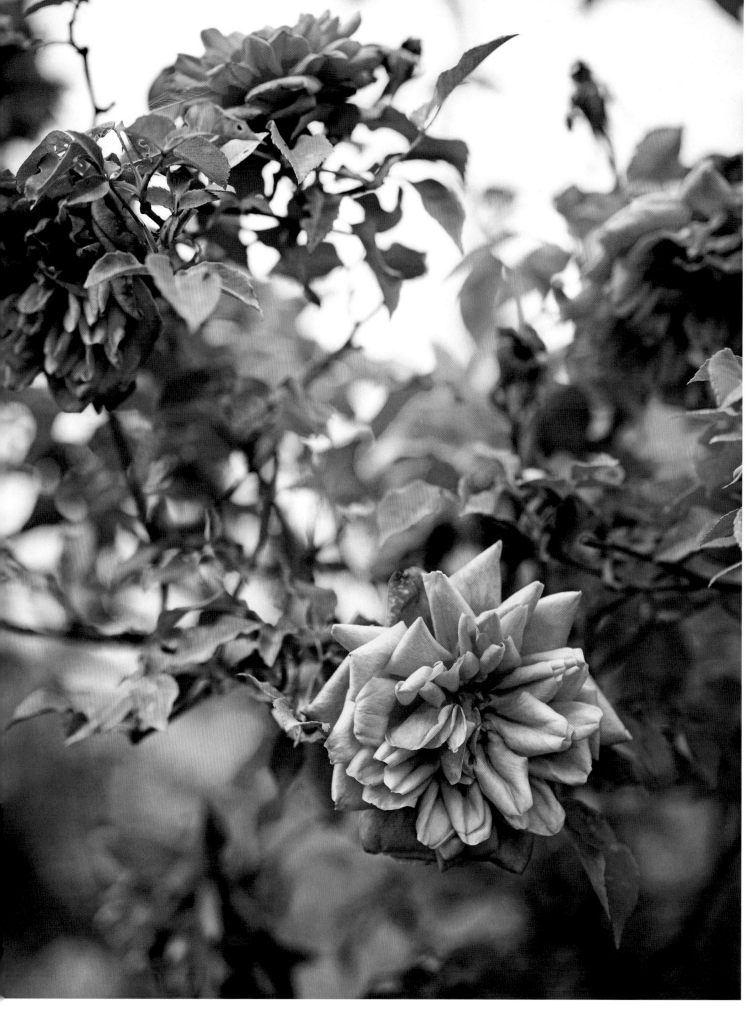

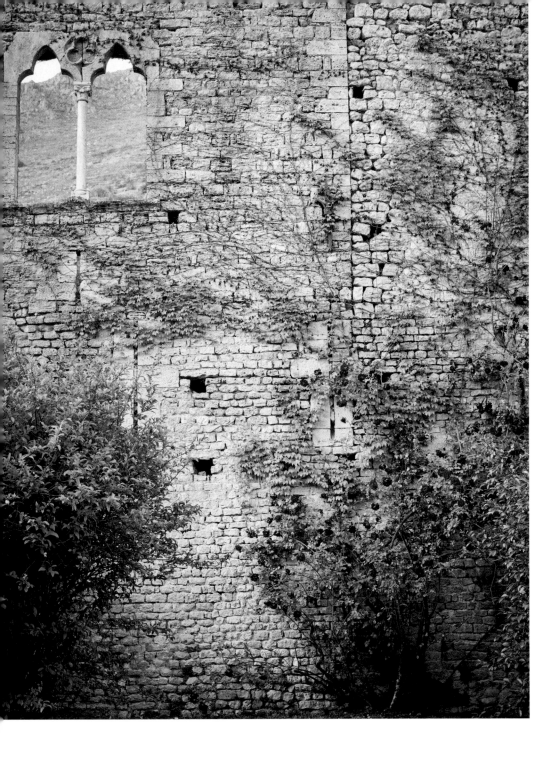

LEFT
Climbing against the wall of the gothic palace built by Pietro Caetani is *R.* 'Agrippina', a climbing China rose bred by the French nurseryman Monsieur Couturier fils in 1885 and introduced in Australia as climbing 'Cramoisi Supérieur', which remains its registered name.

RIGHT
The delicate blooms of 'Mutabilis' change colors as it ages, from pale apricot to coppery crimson. Along with 'Général Schablikine', it is almost always in bloom at Ninfa.

FOLLOWING
In the Piazzale della Gloria, 'Général Schablikine' roses take center stage while on the left the silvery pink flowers of a climbing 'Madame Caroline Testout' bloom alongside the citrus trees. The blooms of yellow Lady Banks roses flutter in the background.

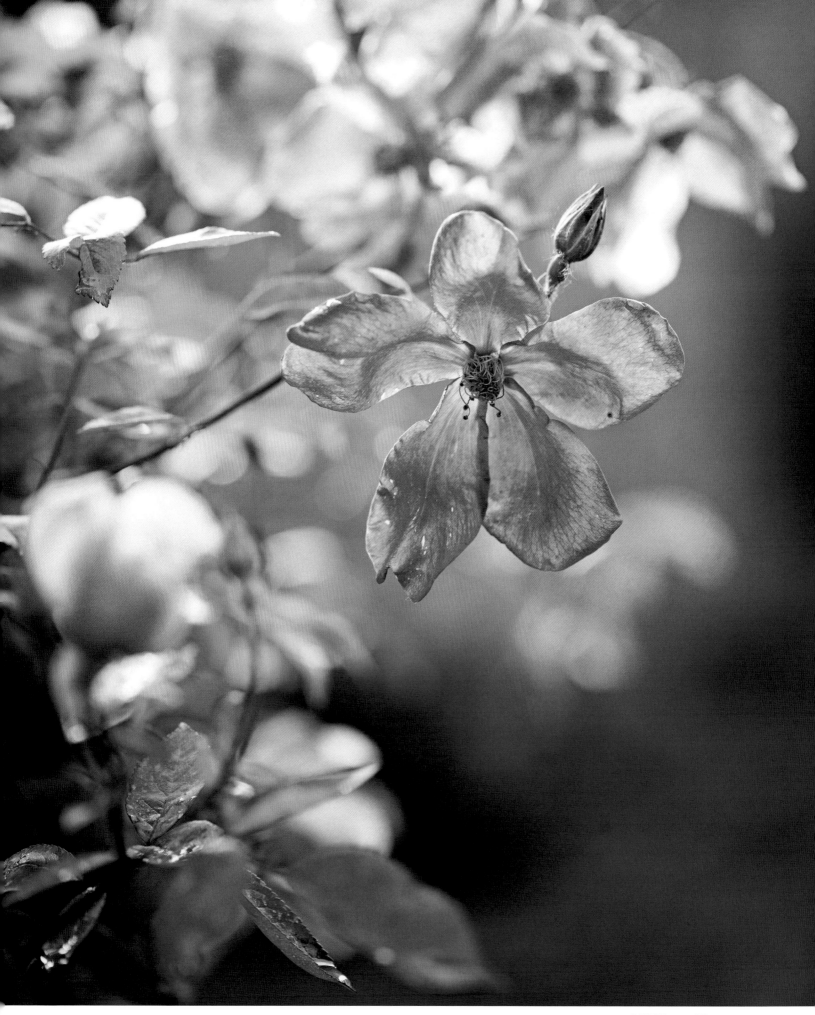

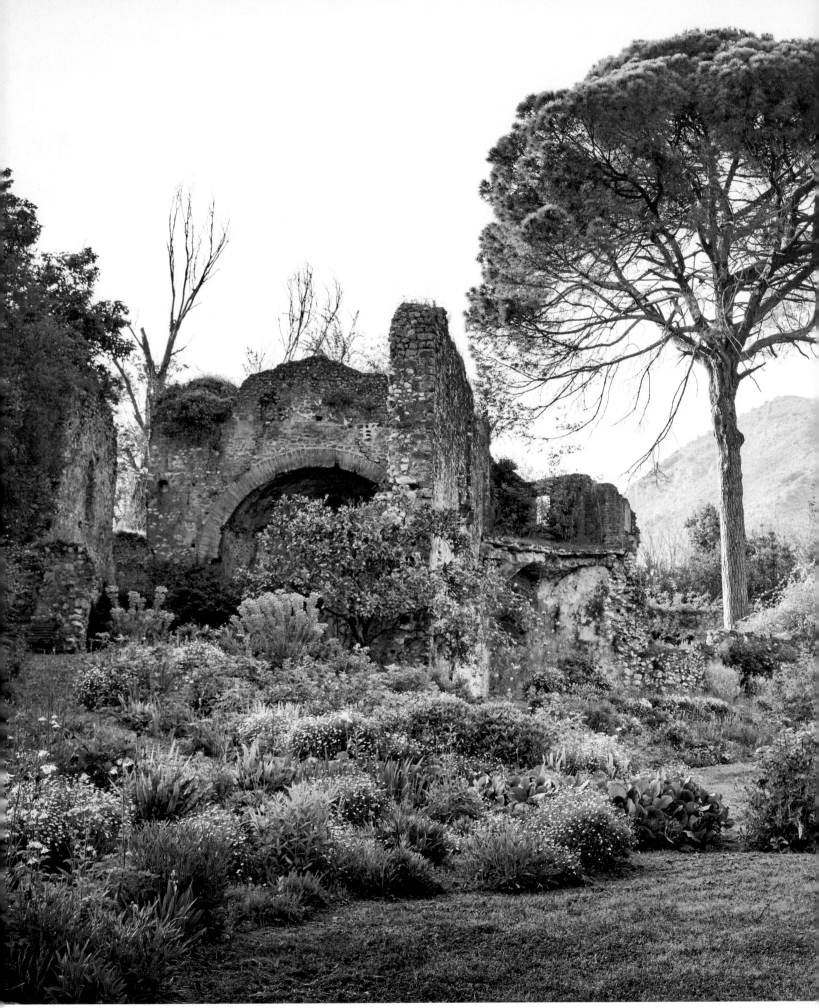

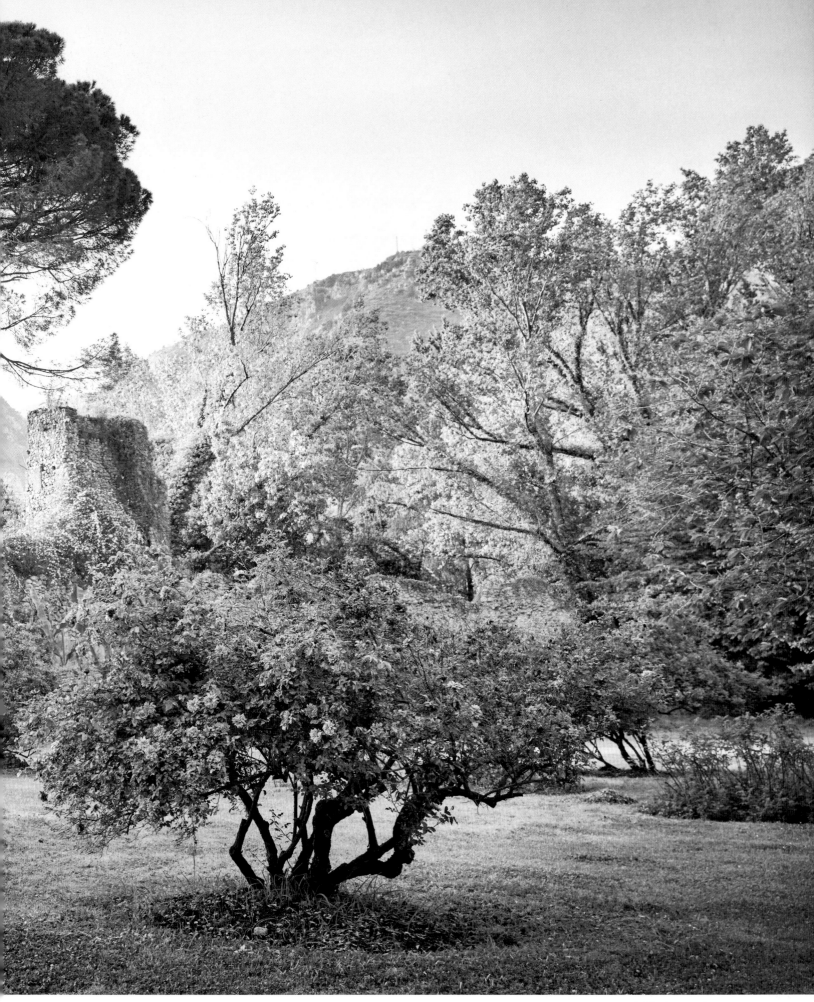

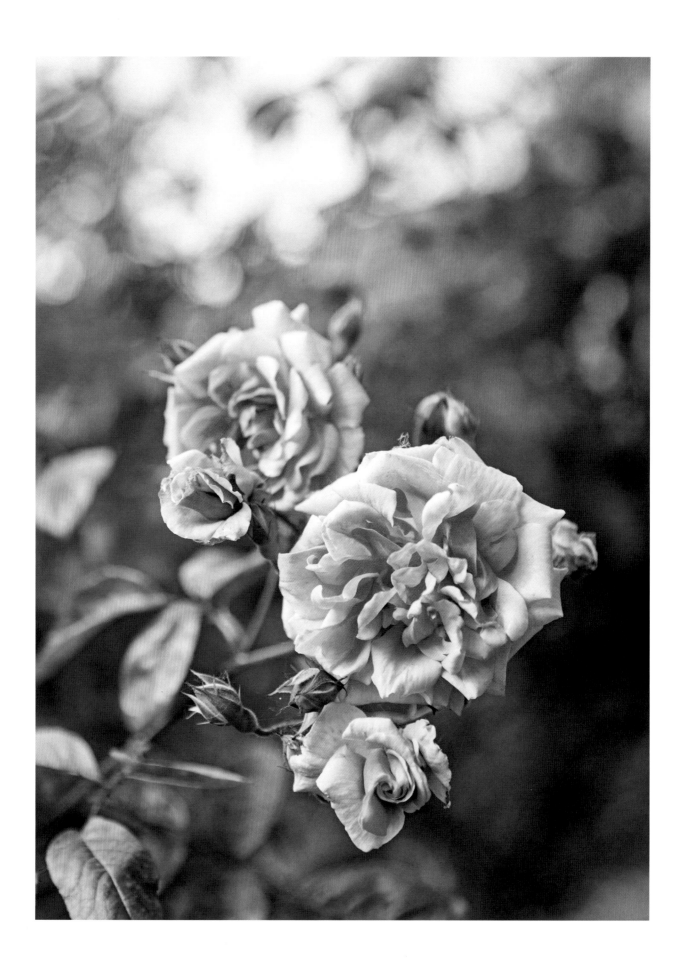

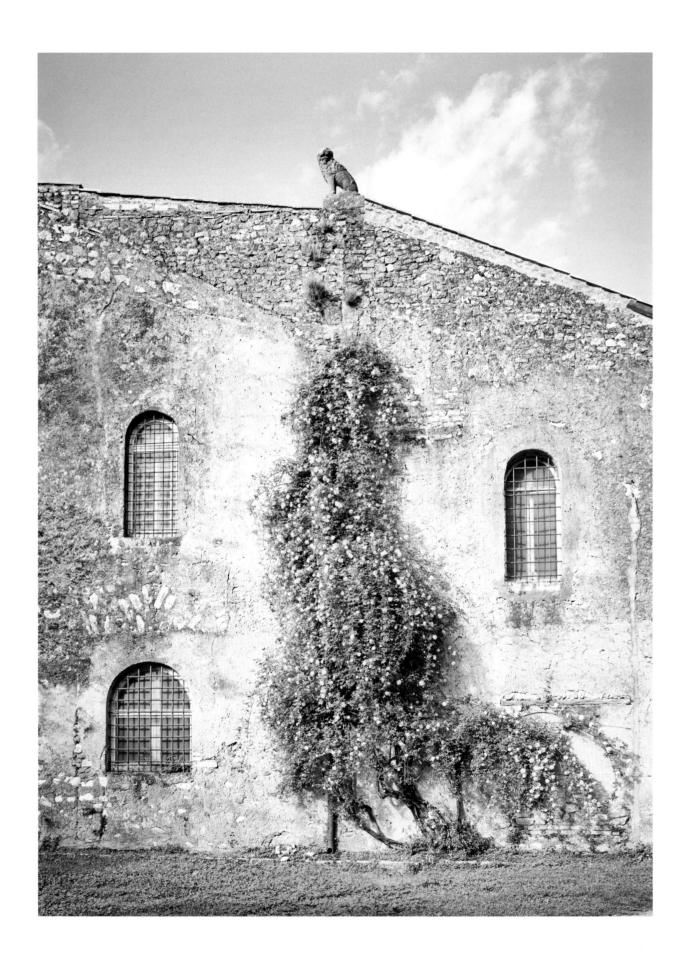

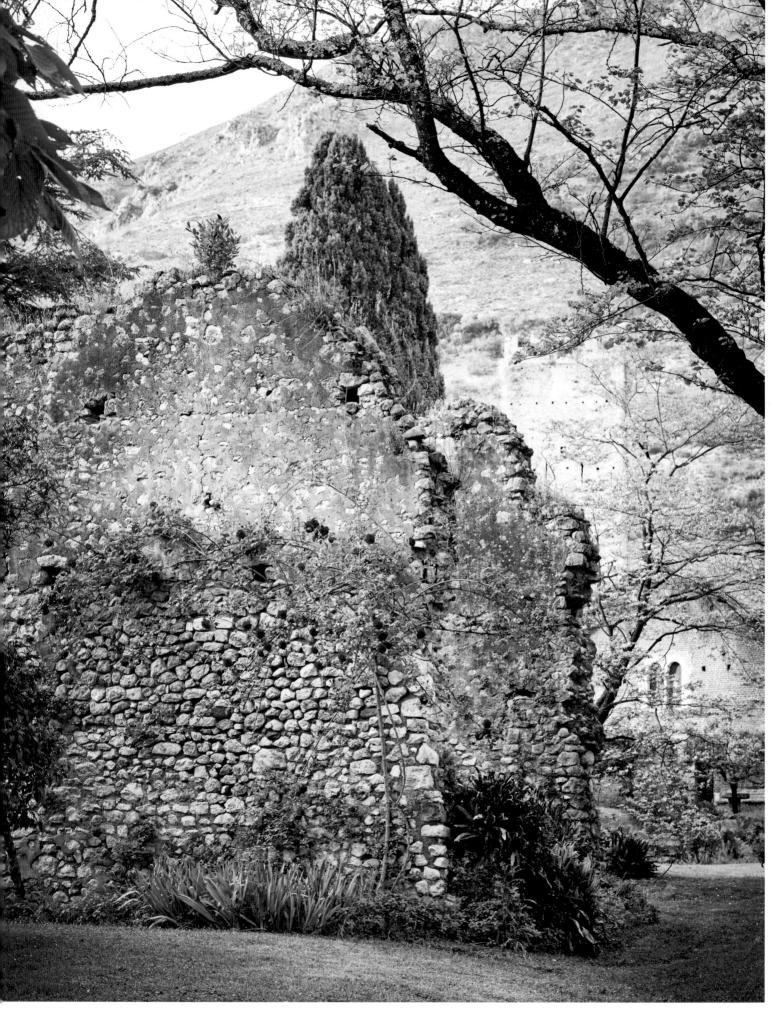

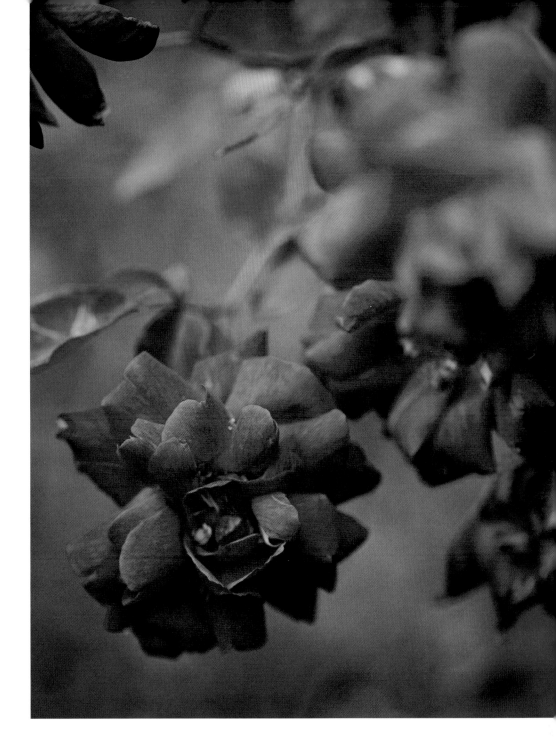

PREVIOUS LEFT
'Coupe d'Hébé', a bourbon rose with
fragrant pink blooms, was introduced in
France in 1840 by Jean Laffay, a gardener
who went on to create what he called
Hybrides Remontant, known today as
Hybrid Perpetuals.

PREVIOUS RIGHT
R. banksiae 'Banksiae', a double white
form of the Banksian rose, was first sent
to England by William Kerr, who had
come upon it in a garden near Canton.
It was then introduced by Jean-François
Boursault ten years later as 'Rosier de
Banks à fleurs blanche'.

LEFT
'Paul's Scarlet Climber' is one of the many
red roses at Ninfa. Graham Stuart Thomas
considered its crimson flowers "splendid"
in color but "unsophisticated" in shape.

RIGHT
The crimson buds of 'Fellemberg' open to
deep magenta flowers that fade to a lighter
pink as they age. Dating from before 1835
with unknown parentage, it is included
in Thomas's book with the Noisette and
tea roses.

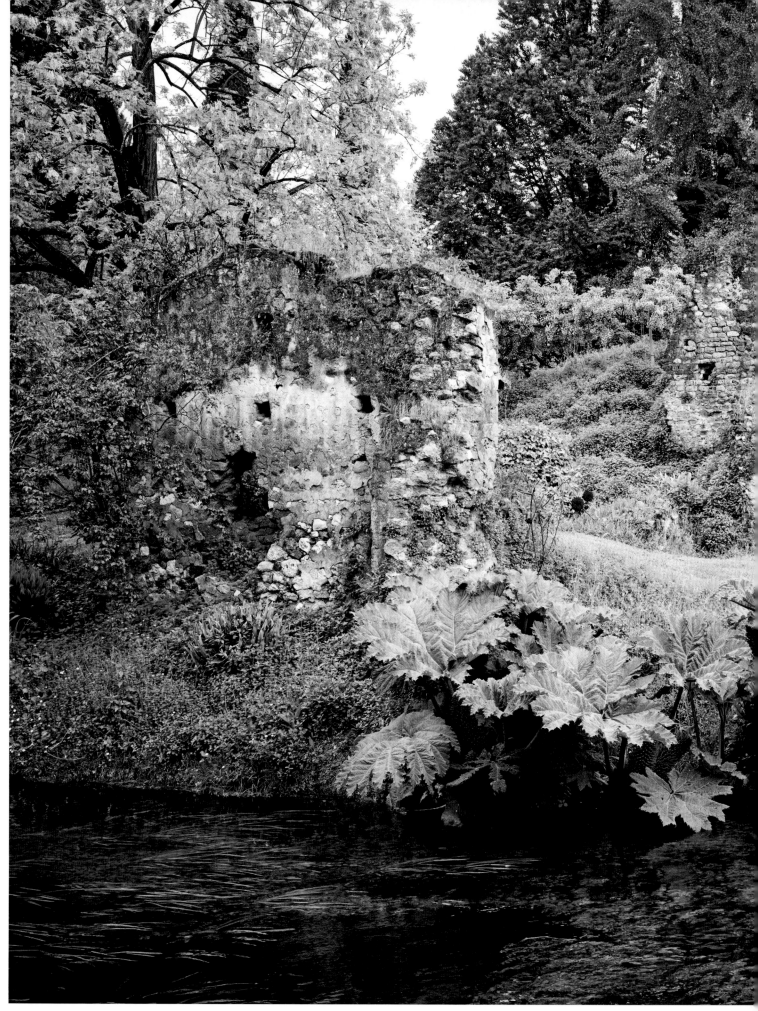

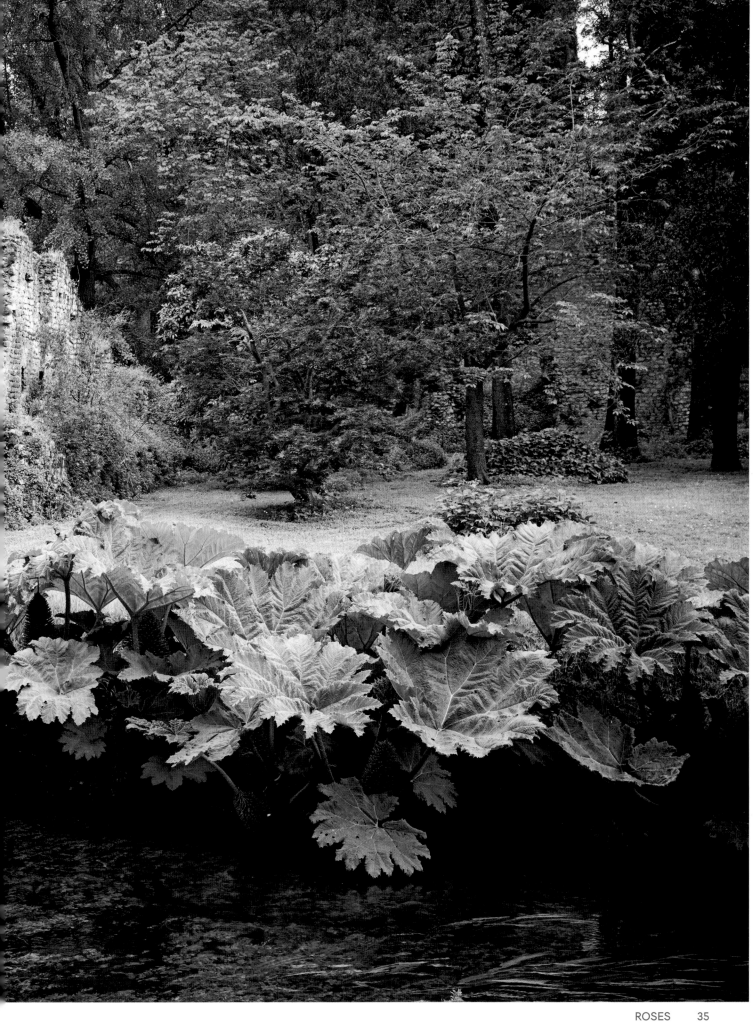

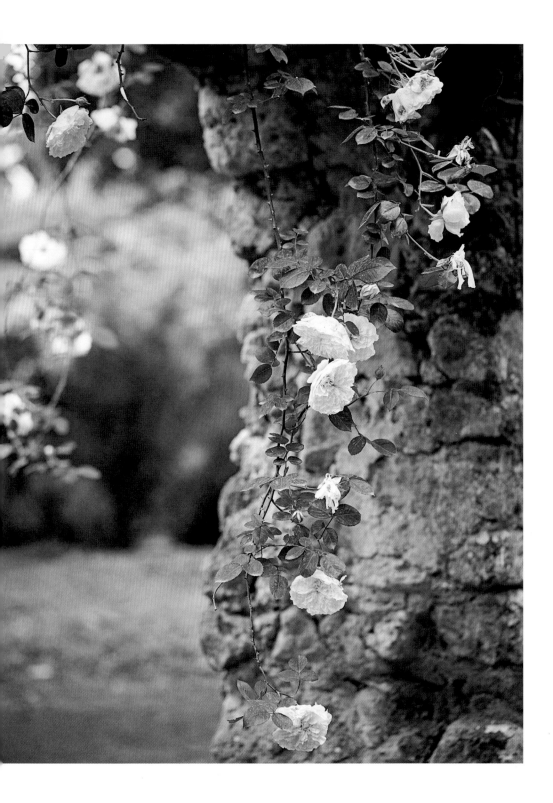

PREVIOUS
One could imagine the pre-Raphaelite painter John Everett Millais's Ophelia floating above the reeds in the clear and fast-moving river at Ninfa.

LEFT
Climbing 'Sombreuil' sends its creamy white flowers down an archway. Often confused with the tea rose 'Mademoiselle de Sombreuil', this modern climber was introduced around 1940. It is of unknown parentage, but most experts agree that it bears traits of hybrid wichurana.

RIGHT
'La Follette', a vigorous hybrid gigantea dating from circa 1900, flowers freely from the top of the wall to the branches of nearby trees.

FOLLOWING
Ninfa today remains as the German medievalist Ferdinand Gregorovius described it in 1860: "every wall is veiled with green." The crimson blooms of 'Parkdirektor Riggers' and pale violet wisterias lend additional colors.

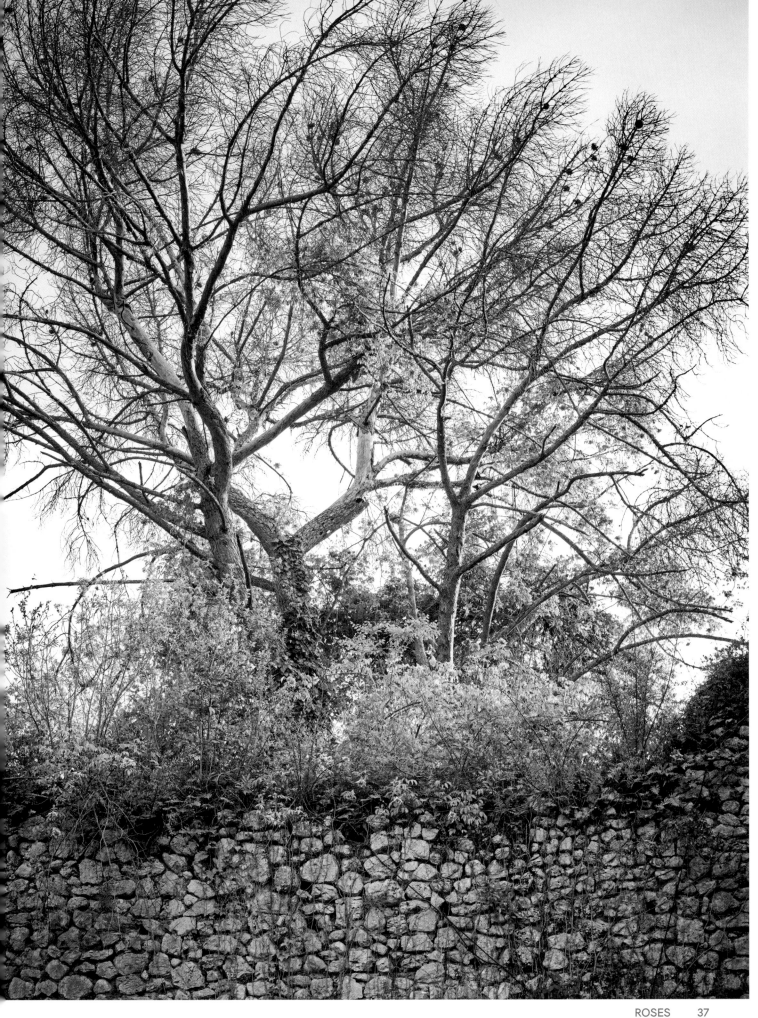

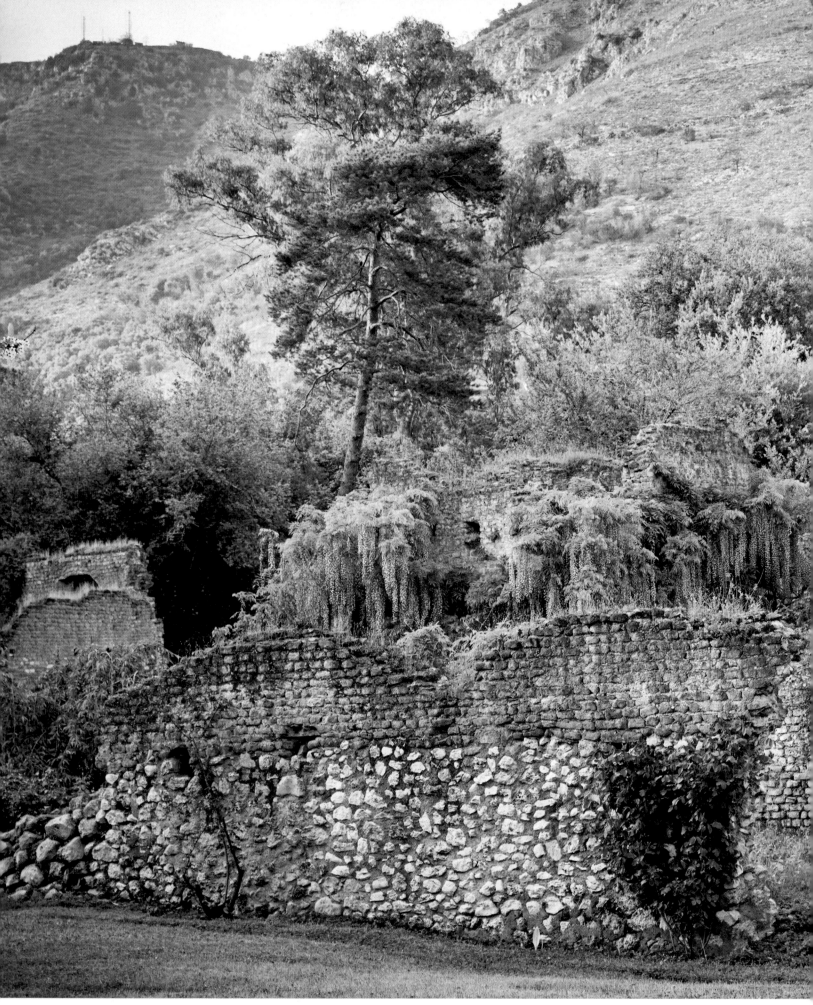

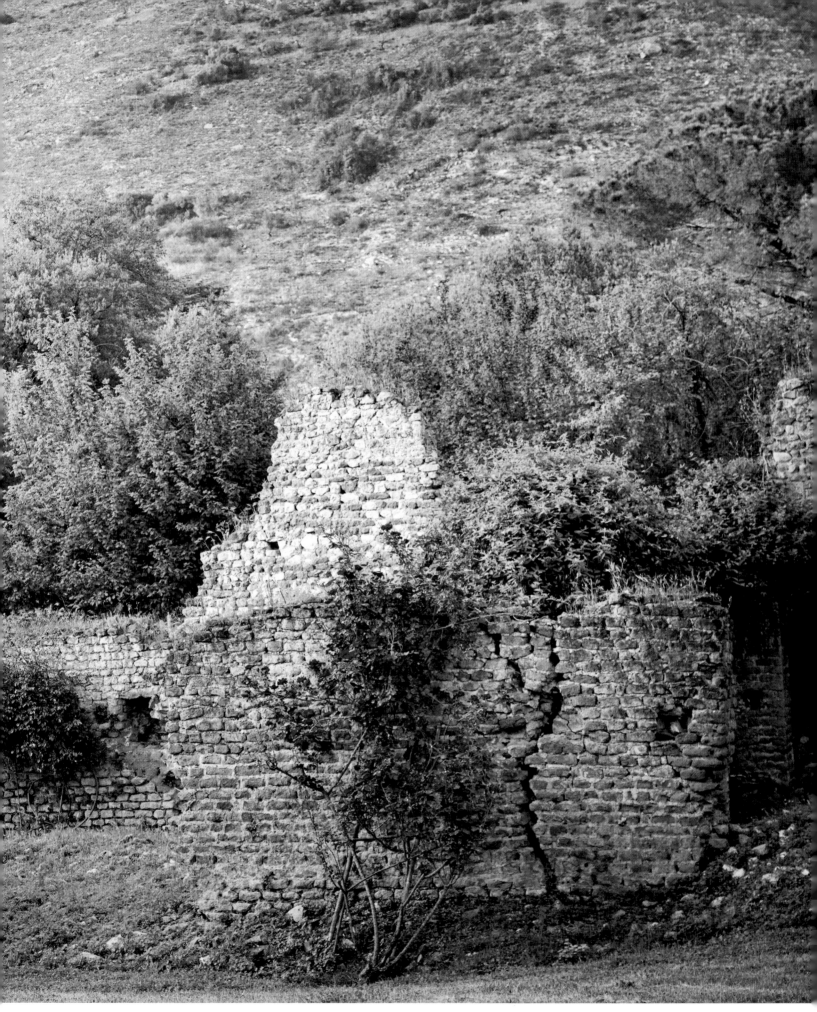

LEFT
As noted by Graham Stuart Thomas,
the deep crimson of 'Cramoisi Supérieur'
bears a trace of 'Slater's Crimson China'.
A China rose introduced in France in 1832,
'Cramoisi Supérieur' is another signature
rose at Ninfa and one of the most beautiful
red roses grown in the garden.

RIGHT
'Claire Jacquier' is a Noisette rose with
clusters of small double light yellow
blooms that fade to cream. Although its
parentage is unknown, it is thought that
the rose is a cross between a tea rose and
a hybrid multiflora.

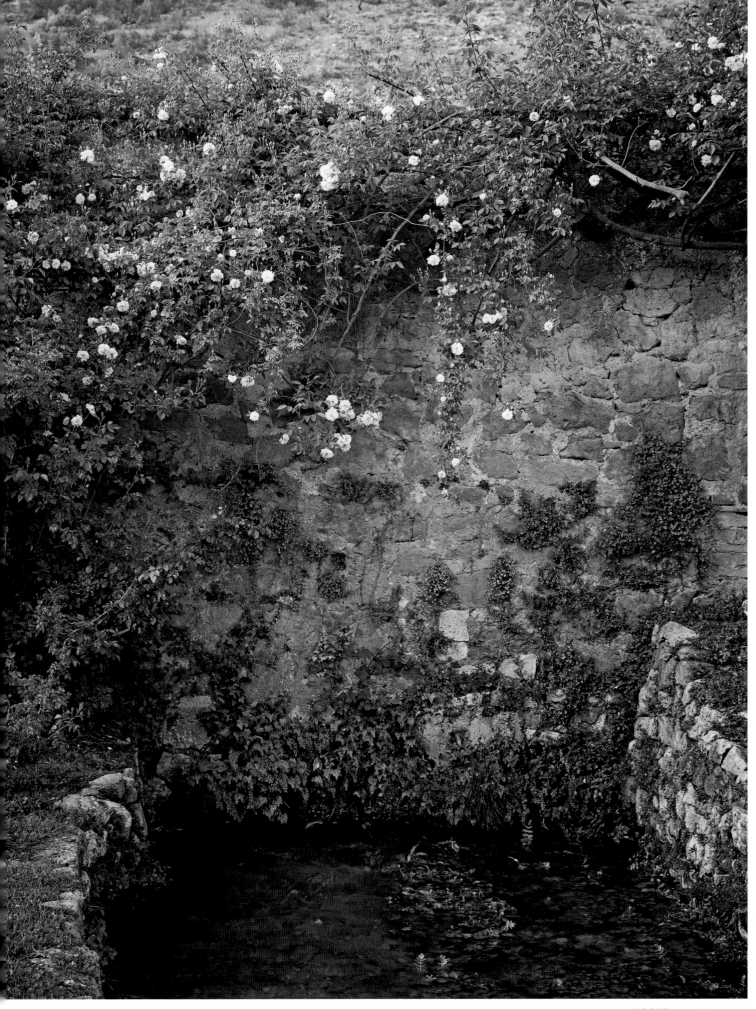

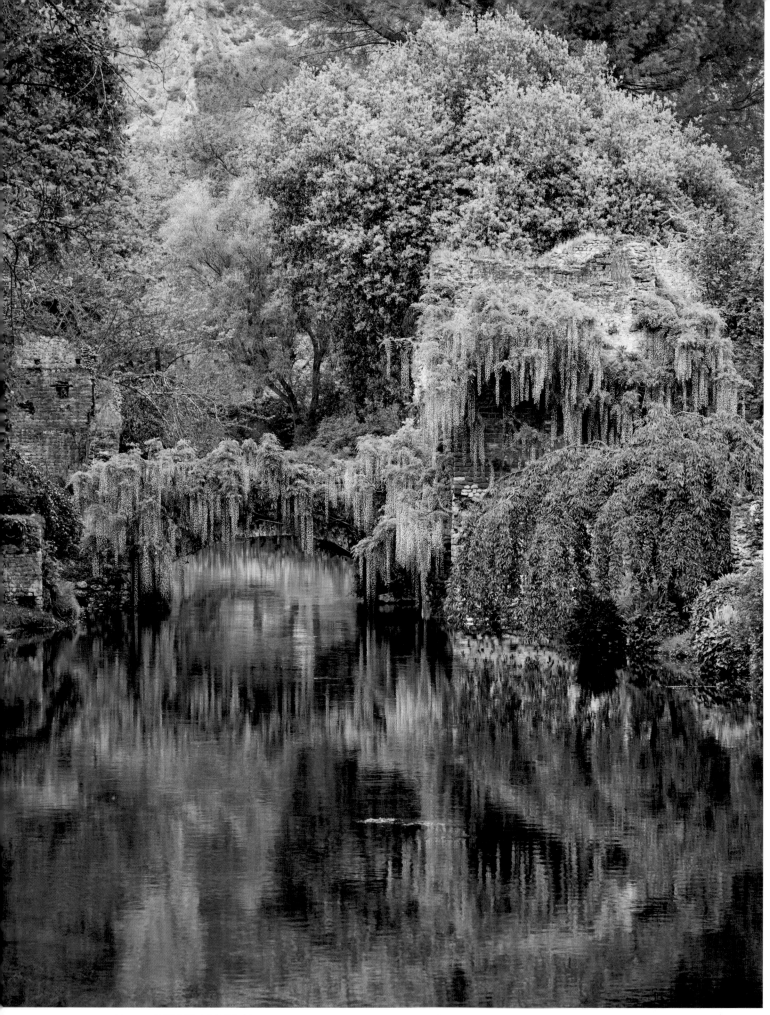

LEFT
At Ninfa, every view is transportive, especially that of the iconic Roman bridge draped in wisteria, where nature and history conspire to make it the most romantic garden in the world.

RIGHT
Blooming against the stone wall is a lone yellow bloom of 'Easlea's Golden Rambler', an English-bred hybrid wichurana introduced in 1932.

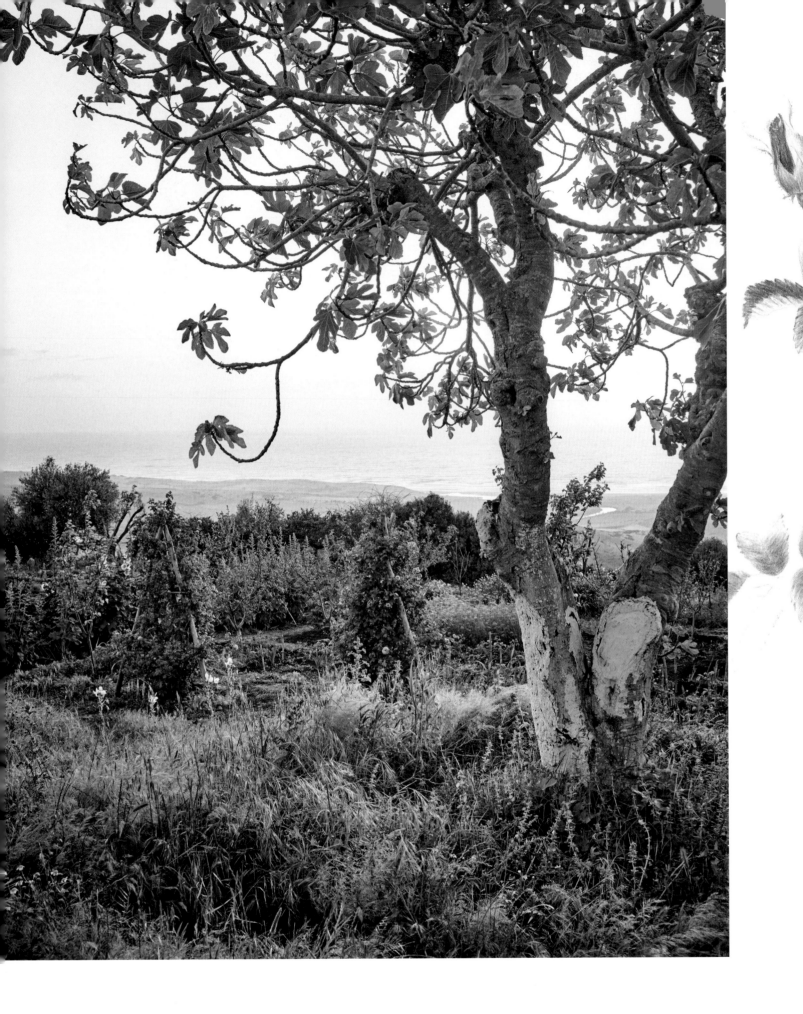

Rohuna

Of all the gardens in the world, Rohuna is closest to my heart. I first set foot in this extraordinary place in May of 2015. My friend Deborah Needleman had introduced me to Umberto Pasti when I told her that I was looking to document people with a passion for flowers.

The two of us came to stay at Umberto's house in Tangier so I could photograph him for my book, *In Bloom*. One afternoon Umberto proposed "a short holiday in the countryside covered in wildflowers," to which we both heartily agreed. The next day Umberto drove us in his battered Range Rover to Rohuna for lunch. About an hour outside of the city, we got off the highway and began to make our way up the hill on an unpaved, dusty, and bumpy road that cut through a patchwork of cultivated fields. We passed no other car, only the occasional donkey carrying a local man or woman at a leisurely pace. At the top of the hill, after several tortuous turns, we arrived at our destination. Behind the corrugated metal gates, the garden unfolded like pages of a book. Narrow paths lined with rosemary led to a series of terraces and garden rooms—some lush and green with luxuriant shade, others sunny and blazing with colors. A plant lover with a collector's mania, Umberto has filled his garden with a treasure trove of plants from all corners of the world that can tolerate the raging heat here, as well as his beloved wildflowers of northern Morocco. While waiting for lunch to be set up, Umberto and I sat under the shade of a fig tree on the edge of a hill, the murmuring sea in the distance below us.

Since that idyllic afternoon I have returned to Rohuna numerous times, and each time the place reveals itself to me as something new. As Umberto

LEFT
View of the Gharsa Baqqali, where damask and centifolia roses bloom in the potager, with the murmuring sea in the distance below.

Illustration, *Rosa × centifolia*.

wrote so evocatively in his novel *Perduto in Paradiso*, Rohuna "is a village of five hundred souls and about fifty houses on the Atlantic coast of old Spanish Morocco, two days' walk from Tangier, between Asilah and Larache. Stone houses plastered with mud and limewashed, with zinc roofs like those of shanty towns, overlooking gardens bordered by barriers of prickly pears. ...[The landscape] is sapped by the climate (torrential rains in winter and baking heat in summer).... All around, rocks, only rocks, among which grow dwarf palms, rock roses, thistles and lentisks, plants even goats find indigestible. There are few trees in this desolate world: a few figs, a few pomegranates, small clusters of carob and olive trees planted at a time of more abundant rainfall and hence one of a certain optimism."

With its hundred-year-old fig and olive trees,
the cows and donkeys,
the combination of the wild and the tamed,
the place is at once earthy and majestic,
always changing with every season, yet timeless.

Umberto's garden, which he named Rohuna, is "a Jebala arcadia" whose lifeline flows to and from the village. Some of the gardeners who now tend the garden are the sons and nephews of gardeners who built the garden thirty years ago. Generations of local children have played, learned, and grown up in the shelter of this verdant oasis. Much of the land is dedicated to Umberto's passion for saving the native wildflowers. Each year thousands more irises, narcissi, gladioli, crocuses, scillas, and other flowering bulbs rescued from construction sites find a refuge on this hillside.

The area around the fig tree where Umberto and I sat during my first visit is called Gharsa Baqqali. What he describes as "a reddish and flaxen landscape that looks like the scene of the creation of the world" is reserved for the orchard—figs, peaches, apricots, and almonds—and a generous potager. Here among the fruit trees, damask hybrid roses and their descendant, *Rosa × centifolia*, mingle with lilies, mint, potatoes, and onions, just as they do in every garden around this Moroccan countryside. These roses, though anonymous and unsung, bear an ancient lineage. "The damask roses in Morocco date back a long time, arriving with the Arab conquerors in the ninth century," explained Umberto one early evening when the sky turned a blushing pink to match the roses. Yet these damask hybrids are rarely found at nurseries, where the selections generally favor modern hybrid teas. Instead, they are sold at the souk, by women who treasure them for their beauty and fragrance.

Nearer to the house, roses from all over the world take up residence in the lush and flowery garden rooms that make up what Umberto calls the Garden of Consolation. Here China roses are grown for the pretty foliage as much as their delicate simple flowers. 'Mutabilis' and 'Bengal Crimson' are in bloom almost all year round. Next to some stone steps just outside the house, the luscious bourbon rose 'Madame Isaac Péreire' fastens its flowers on a rustic wood-and-cane arbor, greeting every visitor with its heady perfume. Another prized beauty is 'Rose de Rescht', a rose with a peripatetic history. Researchers still debate whether this rose originated in Iran or France. One theory has it that it was brought from France to Rescht in 1807 during the French-Persian alliance. It is also believed that the same rose was introduced in England in 1880, only to be forgotten until it was rediscovered after World War II by an English garden writer and plant collector in the Iranian provincial capital whose name it now bears. Umberto's 'Rose de Rescht' came from a cutting given by David Herbert, the second son of the Earl of Pembroke, who lived for nearly fifty years in Tangier.

Umberto learned long ago that he likes roses that meld into trees. In the garden terrace named after its gardener, Chinoui, a climbing 'Mermaid' stretches its limbs from the olive tree to the fig tree across the path, forming its own pergola from which to hang its large floppy flowers. Growing roses in trees requires patience. "When you first plant a rose at the foot of a tree, it takes some time to climb the tree," explains Umberto. "Sometimes it can disappear into the tree for years. But when it has conquered the tree, it is marvelous. The rose takes on an extraordinary volume and an air of romance."

When he was young, Umberto dreamt of making gardens filled with sage, rosemary, lilies, damask roses, and *Rosa gallica* 'Officinalis'—not unlike a medieval garden. Yet his passion for plants makes it impossible to keep to such a limited palette. Rohuna, needless to say, is by no means a medieval garden.

It is a many-splendored thing.

A rural garden that feeds body and soul.

A gathering place for friends and plant lovers, young and old, near and far.

A storybook of tales real and imagined.

A haven for Umberto's beloved "Phoenician flowers, Roman flowers, Idrisid flowers, Almoravid flowers, Jebala flowers...." Though he might have diverged far from the ideal medieval gardens of his youth, Umberto has never

lost his appreciation of roses. In his opinion, "roses are a bit like exotic spices. They are never beautiful alone." At Rohuna, they keep company with African irises, geraniums, nasturtiums, daisies, marigolds, wild garlics, lavender—flowers as humble as the grass. As new plants are introduced into the garden—mostly drought-tolerant species to cope with the changing climate—the roses remain constant, as timeless as these hills. Every year I look forward to walking these rose-scented paths with Umberto while he tells me enchanting stories of the flora of northern Morocco. R✝G

RIGHT
The long canes of 'La Follette' descend from the pergola bearing loose pink flowers with darker, coppery tones on the reverse.

FOLLOWING
Sunlight pierces through the mist to illuminate the roses blooming among the fruit trees in the Gharsa Baqqali. These damask and centifolia roses are grown in nearly every country garden in Morocco.

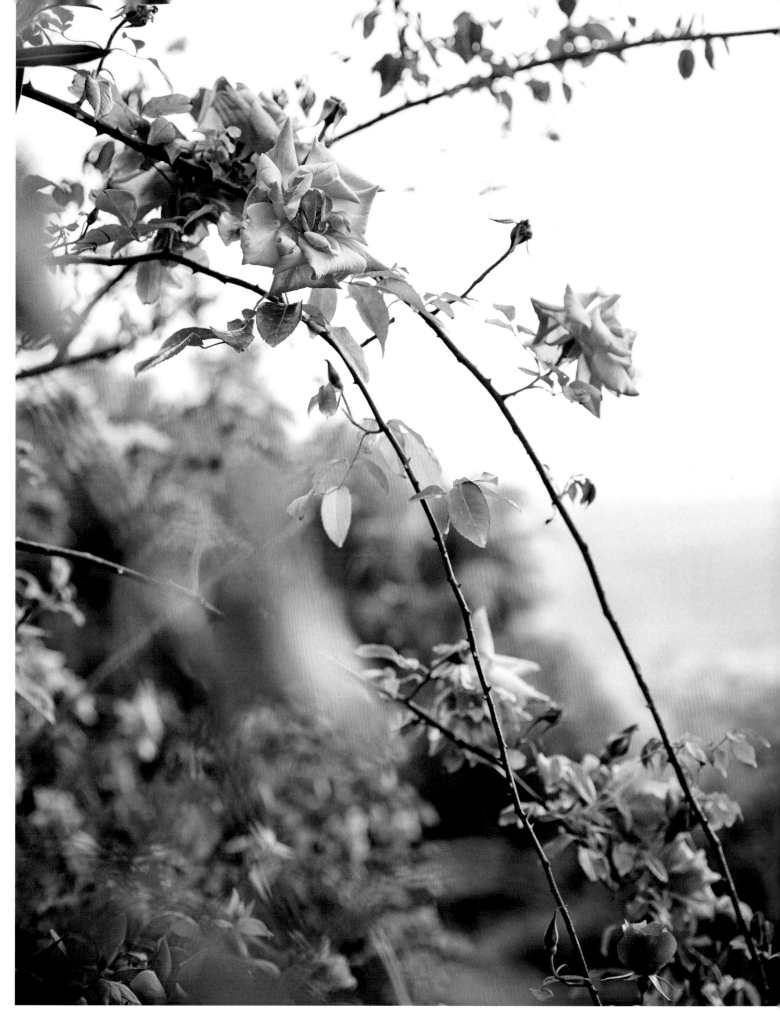

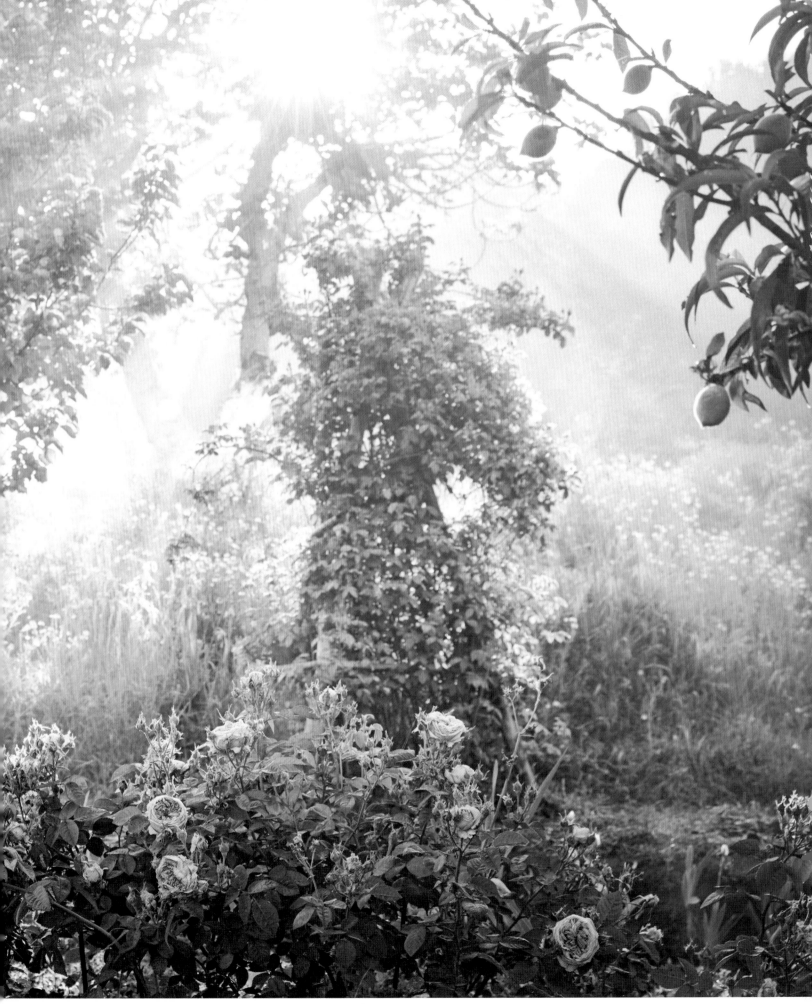

LEFT
The bourbon rose 'Madame Isaac Péreire' stops visitors in their paths with its heady perfume.

RIGHT
A newly planted rose in the potager is an unnamed red variety Umberto found in the market. It adds a jolt of crimson to contrast with the pink blossoms of the fruit trees.

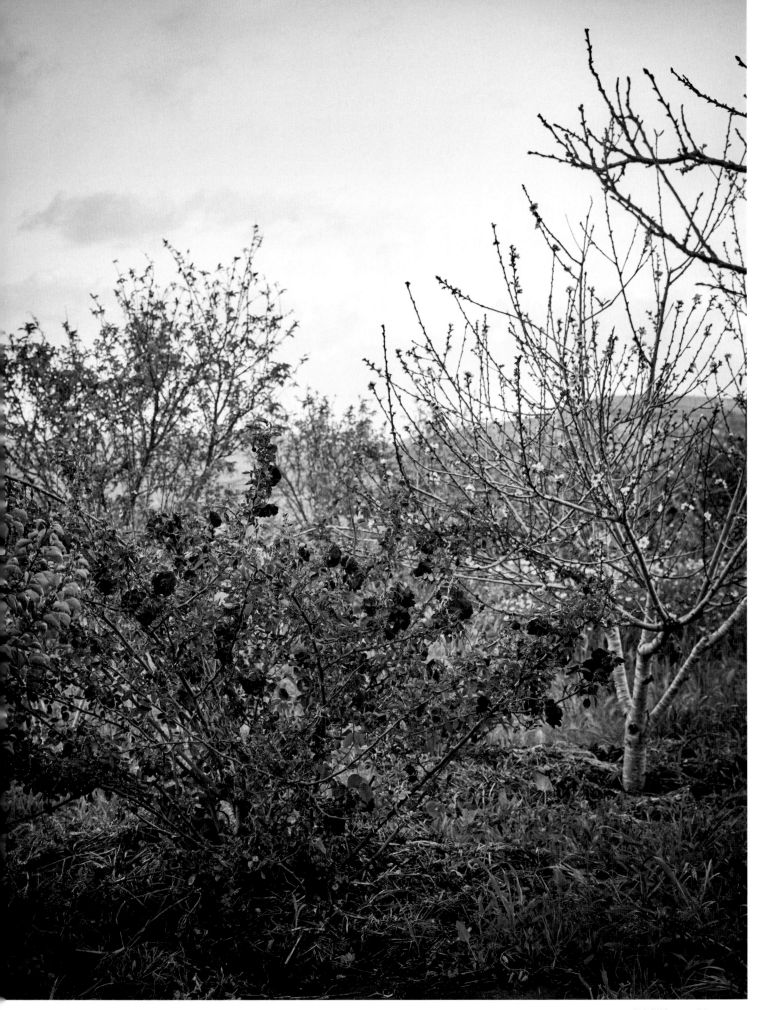

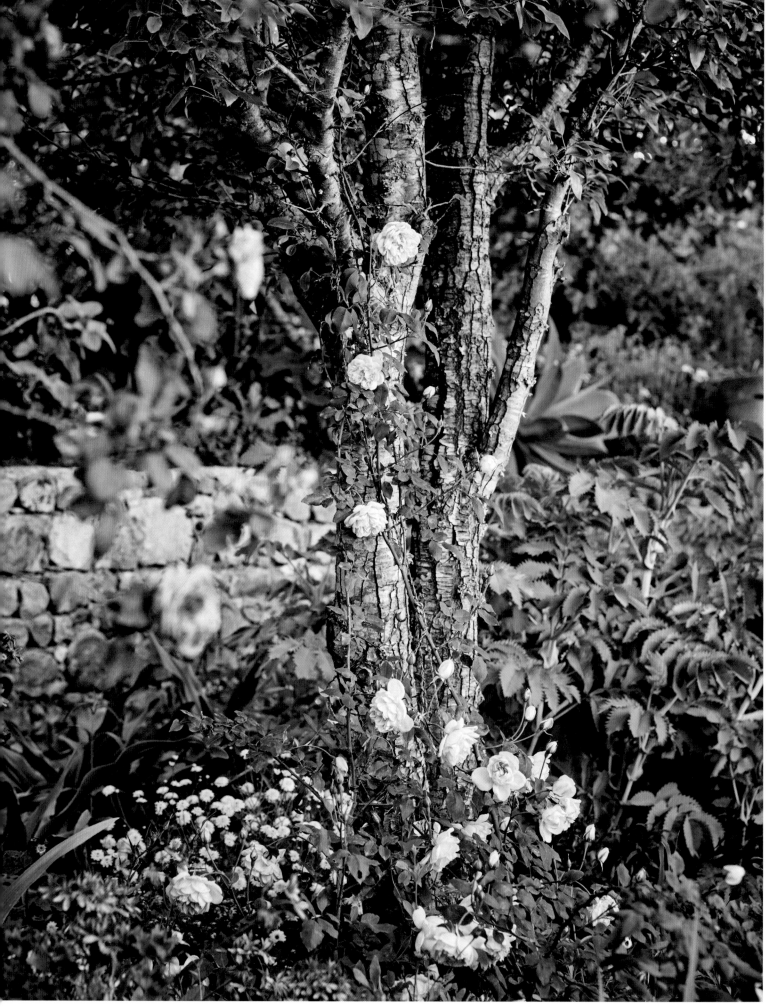

LEFT AND RIGHT
Umberto likes roses that grow freely,
whether it's climbing up trees or on the
rustic *tuteurs*, where he often combines
two different roses.

FOLLOWING
It did not take long for the vigorous
'Mermaid' to climb up an olive tree and
stretch its limbs over to the fig tree,
forming its own pergola from which to
hang its creamy yellow flowers.

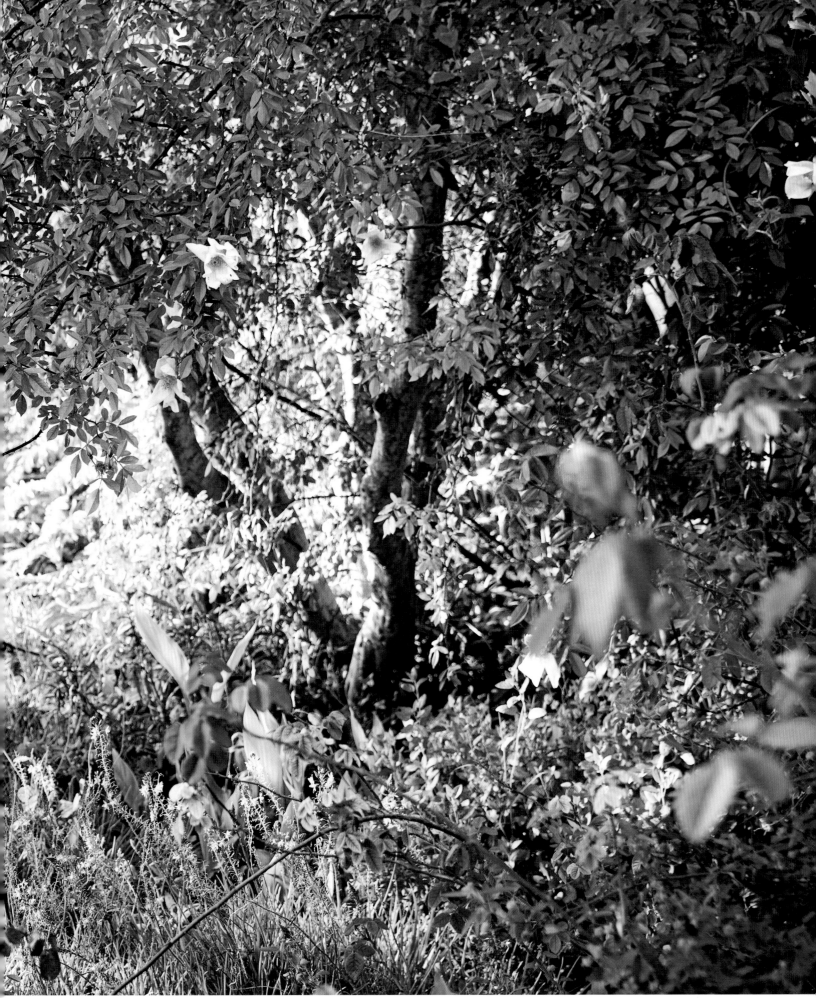

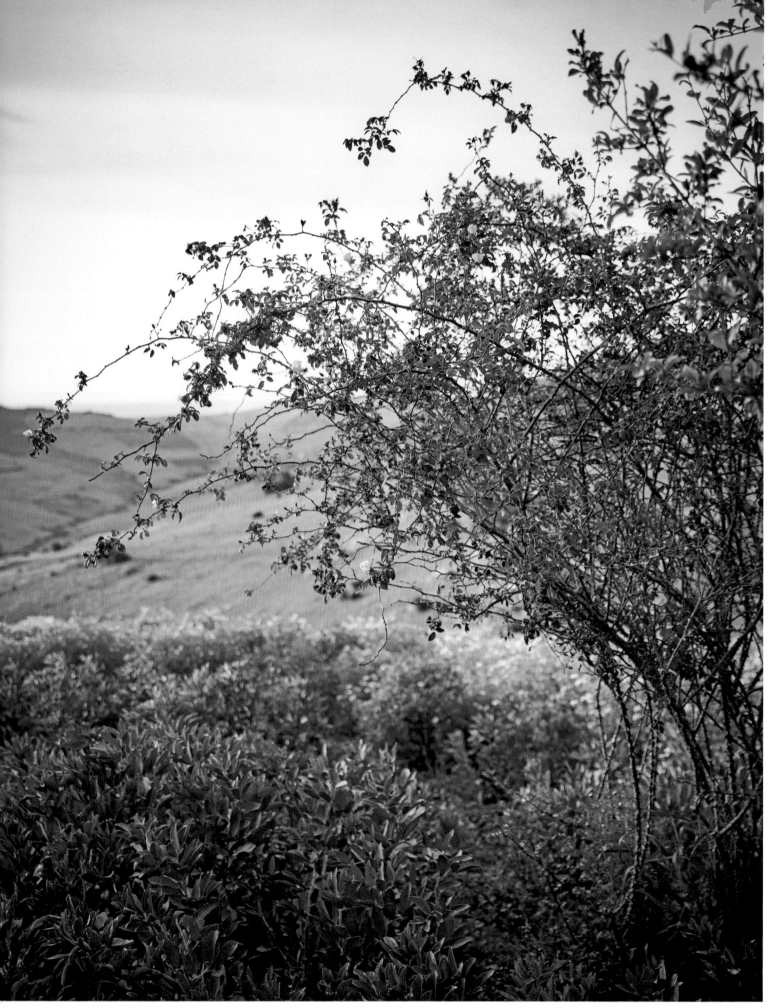

LEFT
R. sicula, native of the Mediterranean region, including northern Morocco, is densely armed with prickles (thorns) but bears sweet little single flowers in clear pink. Though not a favorite in gardens, it looks at home in the Gharsa Baqqali among the fava beans.

RIGHT
The long and elegant buds of 'Mermaid' open into saucer-sized pale yellow flowers with soft white at the edge.

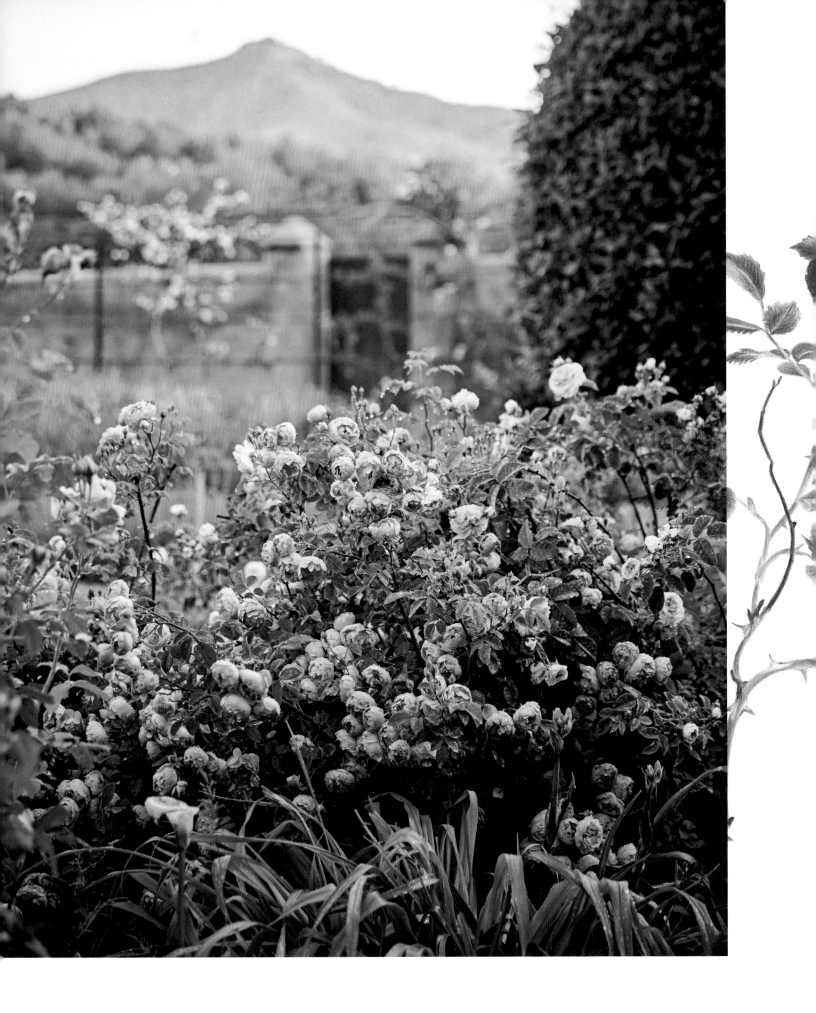

Hortus Conclusus

To reach the Sa Bassa Blanca Museum
on the northeast coast of Mallorca,
you have to drive down a long dirt road through a protected forest.
The nearly two-mile drive in the natural preserve
of Coll Baix is a fitting prelude to
the experience of the museum, which brings together
a perfect balance of nature, art, and architecture.

This hidden gem is the creation of Ben Jakober and Yannick Vu, the most charming and well-traveled husband-and-wife artist team you'll ever meet. Ben and Yannick's eclectic collection of art—assembled over fifty years—and their own works transform the forty acres of an old farm into a paean to the importance of art and beauty in our lives. At the heart of the museum is a rose garden inspired by the medieval *hortus conclusus* where herbs, flowers, and plants were cultivated not only for food and medicine but also for their symbolic values.

The Hortus Conclusus at Sa Bassa Blanca is the work of Yannick, a painter who grew up in the South of France, daughter of a French pianist and a Vietnamese artist. As a child, she spent some years in Vence, a hill town on the French Riviera where roses were grown to supply the perfumers in Grasse and the flower markets in Nice and Paris. The intoxicating scent of damask roses that reached her bedroom window during the blooming season has stayed with her through the years, fueling her lifelong passion for the queen of flowers. In 1978, after years of travel around the globe, she and Ben, a Viennese-born sculptor, discovered this old farm carved out between the mountains and the sea. It had served as a military base during the Spanish Civil War, and the old captain was a gardener who planted white irises outside his living quarters facing the bay of Alcúdia. To build their new home, Ben and Yannick turned to the Egyptian architect Hassan Fathy, who produced a Hispano-Moorish design with traditional domes and spacious terraces. Lush gardens and a large fountain fill a central

LEFT
Clusters of the 'Raubritter', a modern shrub rose from the German breeder Wilhelm J. H. Kordes II, light up the end of the central border in the Hortus Conclusus.

Illustration, *Rosa rugosa* × *R. carolina*.

courtyard. A fifteenth-century Mudejar coffered ceiling from the Spanish town Tarazona graces the couple's bedroom. The garden outside the building was then an orange orchard on a slope whose soil eroded with each heavy rainfall. Recalling the teachings of the Japanese farmer and philosopher Masanobu Fukuoka, whose book *The One-Straw Revolution* she had read in the 1970s, Yannick stopped ploughing the fields on the estate and allowed the native grass to grow below the orange trees. Soon the soil was stabilized, plants thrived, insects returned in droves every spring, and the garden slowly evolved into its current form within the walled enclosure. The struggling orange trees were eventually replaced with laurel trees, clipped into rounded domes.

When Ben and Yannick's nineteen-year-old daughter Maima died tragically in March 1992, the garden took on a different dimension. It became for Yannick "an immense prayer." The stone walls were raised to reinforce the enclosure. The garden was christened Hortus Conclusus, after the walled gardens of medieval Europe whose nomenclature came from King Solomon's "Song of Songs" (4:12):

> *Hortus conclusus soror mea, sponsa,*
> *Hortus conclusus, fons signatus.*
> A garden enclosed is my sister, my spouse,
> A garden enclosed, a fountain sealed up.

The *hortus conclusus* depicted in medieval and Renaissance art was a representation of the Virgin Mary, an enclosed space infused with metaphorical meaning. The white lily represented the virgin's purity, the violet her humility, and the rose, her love, glory, and sorrow.

Inspired by those painted gardens and with the help of friends, Yannick planted roses in Maima's memory. Jinty Money-Coutts introduced her to old roses. Peter Beales's book *Classic Roses*, a gift from Jinty, became an indispensable guide. Jinty's husband, Hugo, author of a book about Mediterranean gardens and owner of a nursery in Santa Maria in Mallorca, provided valuable advice on gardening in the warm, sunny, and dry microclimate at Sa Bassa Blanca. Andy Garnett, a friend of Ben's since their days in military service together, offered *Rosa* 'Pleine de Grâce' to commemorate Maima.

From her friends, Yannick developed a preference for old roses and the English roses of David Austin. In the last thirty years, the garden has seen many of these beauties come and go. Some perished and had to be replaced. Others were too vigorous and had to be removed. Such was *Rosa*

bracteata, which killed all the roses that stood in its way as it fanned out energetically in all directions. Today, a parade of fragrant—and better behaved—gallica and damask roses makes up a hedge bordering the central path from the entrance. Purple-hued 'Charles de Mills' gives way to blushing 'Celsiana', 'Jacques Cartier', 'Cuisse de Nymphe Émue' ('Great Maiden's Blush'), 'Blush Damask'. On the other side of the path, 'Mrs. Honey Dyson', another gift from Andy Garnett from decades ago, now blankets an old almond tree in May with soft peach-colored blooms. 'Rambling Rector', with its clusters of small white flowers, wraps around the dovecote designed by Hassan Fathy. Clouds of 'Bobbie James' cover one corner of the wall. A long pergola, built at the far end of the garden to replace a row of cypresses destroyed by a storm in 2001, is draped in roses of many shades: pure white 'Purezza', deep red 'Bleu Magenta' and 'Guinée', shell-pink 'New Dawn', and soft mauve 'Purple Skyliner', a diminutive and remontant (repeat blooming) version of the old rambler 'Veilchenblau'. A selection of Yannick's favorite David Austin roses keeps the garden in bloom beyond the month of June. "'Constance Spry' offers her unusual shape and very particular myrrh-like scent, accompanied by 'Cymbeline' with its heavy skirt and strange pink that is almost gray, with a fragrance at once lemony and sugary," she writes.

Along with the roses,
Yannick planted an herb garden
in the Hortus Conclusus,
drawing inspiration from the kitchen garden at Villandry.
Old bricks that had aged to a soft grayish pink
were used to mark out the beds.

They came from a demolished old tower and happened to be stamped with "27," the date of Yannick's birthday. Rosemary, sage, chives, lovage—herbs grown in Europe for centuries—fill the beds alongside the exotic Mexican *papalo* and *epazote,* as well as different varieties of salads, including *puntarelle,* or *cicoria di Catalogna,* a chicory "very appreciated by the Romans," she explains.

In 1993 Ben and Yannick established a foundation and opened their property to the public as a museum two years later. A former reservoir now houses an unusual collection of portraits of children from the sixteenth to early nineteenth centuries. A subterranean gallery offers a dialogue between civilizations and continents—archaic artifacts and African, Eastern, and Central American masks are juxtaposed with a prehistoric fossil and

works by contemporary masters in Western art: Rebecca Horn, Louise Bourgeois, and James Turrell. The house was converted into exhibition spaces where contemporary African art is shown alongside Aboriginal art, as well as the works of Western artists like Brice Marden, Domenico Gnoli, and Henri Michaux.

The Hortus Conclusus at Sa Bassa Blanca, made with love in the face of incalculable loss, remains a work in progress—as all gardens are. A lifetime of memories is sown in this small enclosure, where the roses come in many guises: as testaments of friendships, as prayers for a lost daughter, as emblems of beauty and life itself. In Yannick's words, "growing roses is very special: one dreams the whole year long for those brief moments of grace which transport one into ecstasy at dawn when the first rays of the sun caress the open but still firm corollas, preserving all the freshness of the night, then again at sunset when the air is warm and heavy with scent, when the birds perch on the branches of the almond trees for a last concert, and when the blackbirds with their yellow beaks hop on the lawn with a preoccupied air, transforming the garden into a Persian miniature." R+G

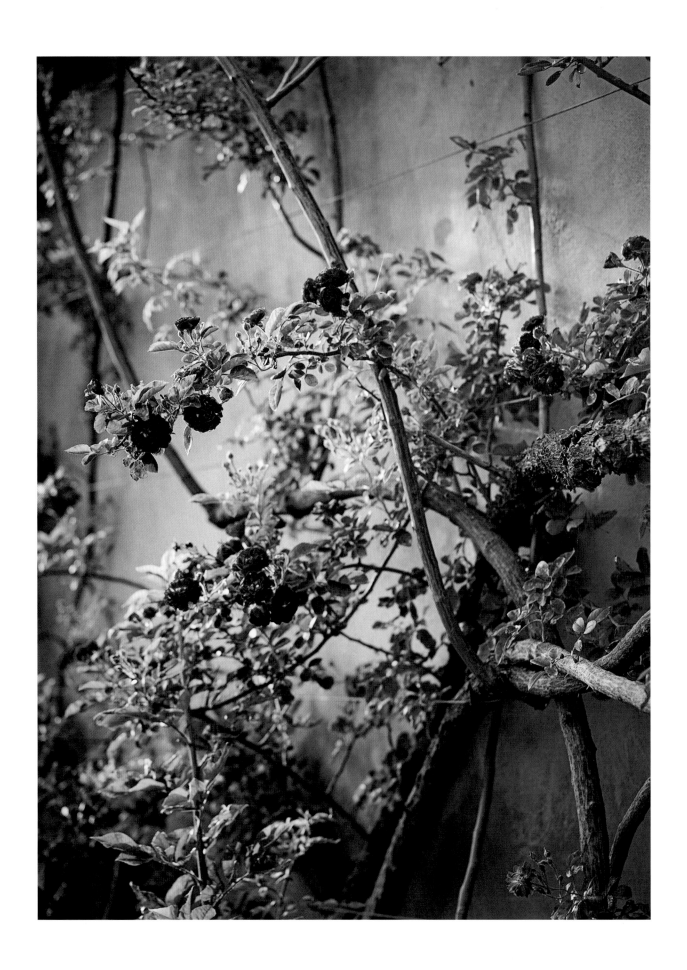

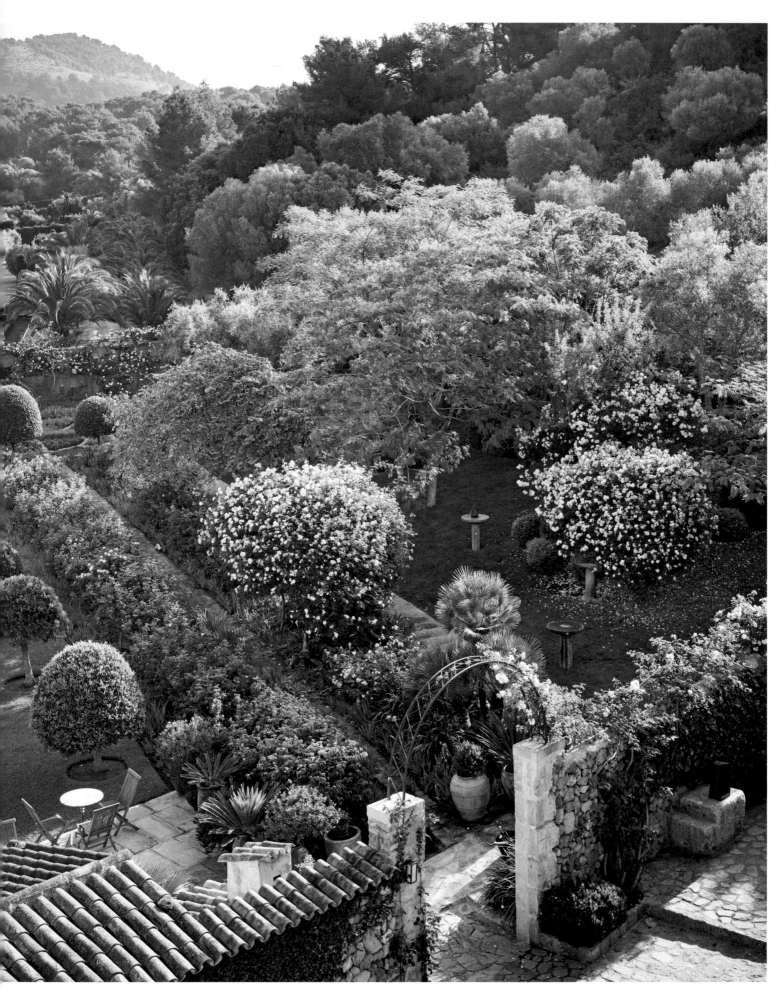

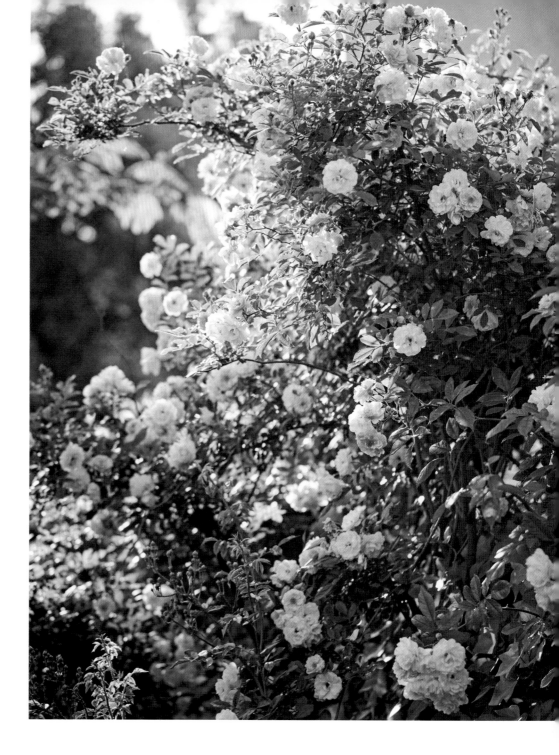

LEFT
From the garden's entrance, gallica and damask roses, as well as more modern varieties, form two long and fragrant borders along the central path.

RIGHT
'Ghislaine de Féligonde' flowers in generous clusters of orange-tinged yellow blooms that age to a very pale yellow on practically thornless canes. This French rambler traces its lineage back to the English bred 'Goldfinch', which in turn descended from 'Hélène', created by the German breeder Peter Lambert in 1897.

FOLLOWING
Inspired by the walled medieval gardens of Europe, the Hortus Conclusus provides a protected environment in which roses thrive as testaments of friendships, as prayers for a lost daughter, as emblems of beauty and life itself.

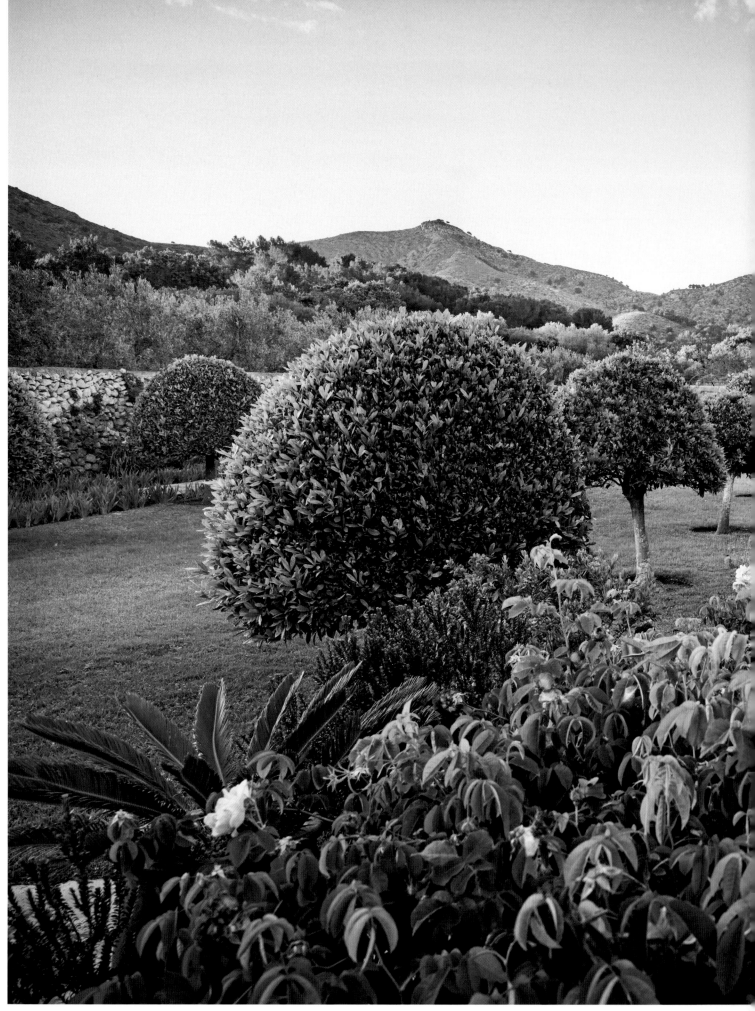

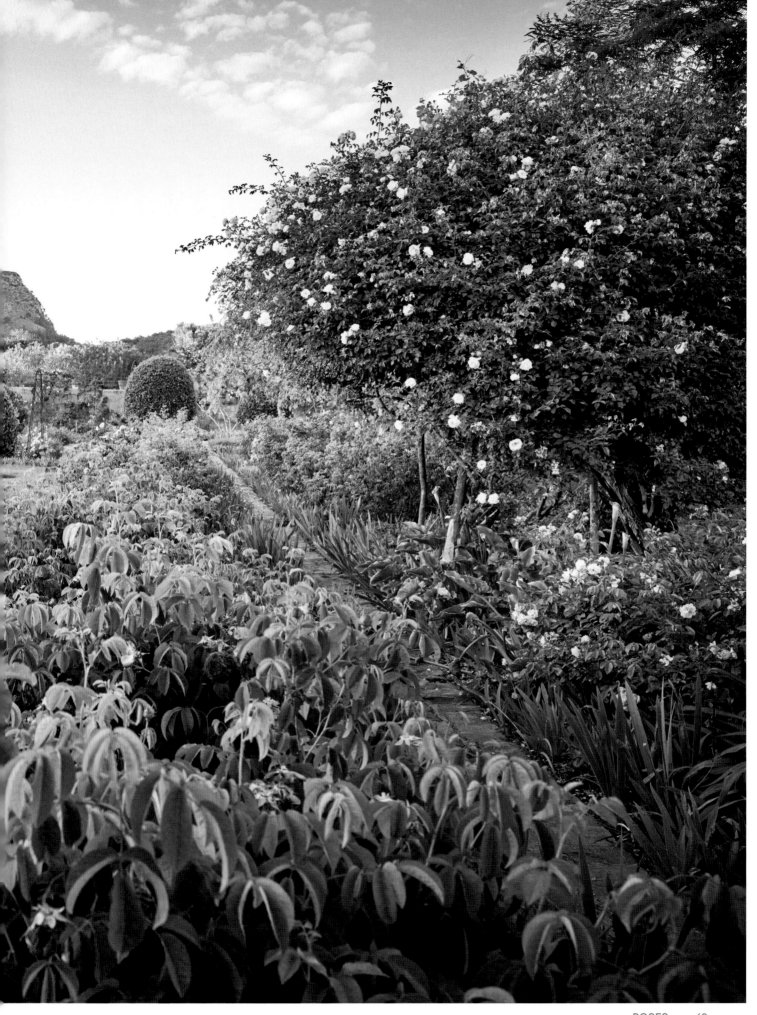

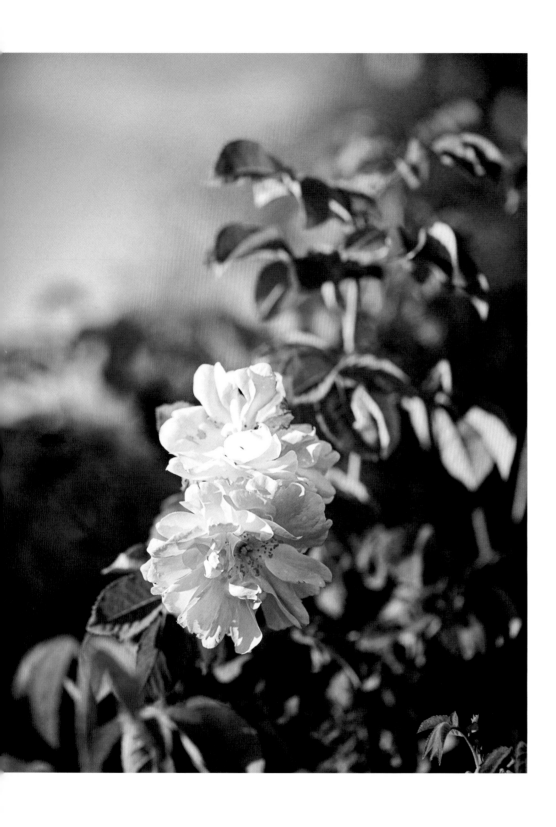

LEFT
From her childhood years in Vence, Yannick remembers the "fields of damask roses that smelled so good from my window." The fragrant damask 'Celsiana' is one of her favorite roses.

RIGHT
'Rambling Rector' wraps itself around the dovecote designed by the Egyptian architect Hassan Fathy.

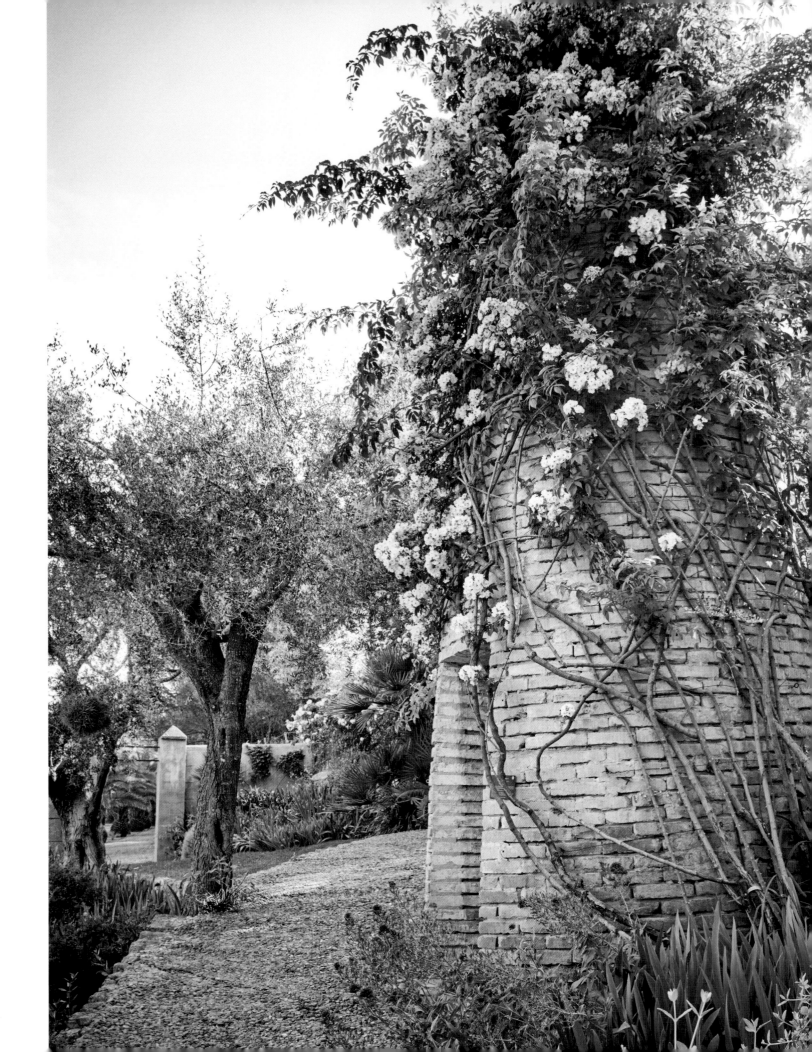

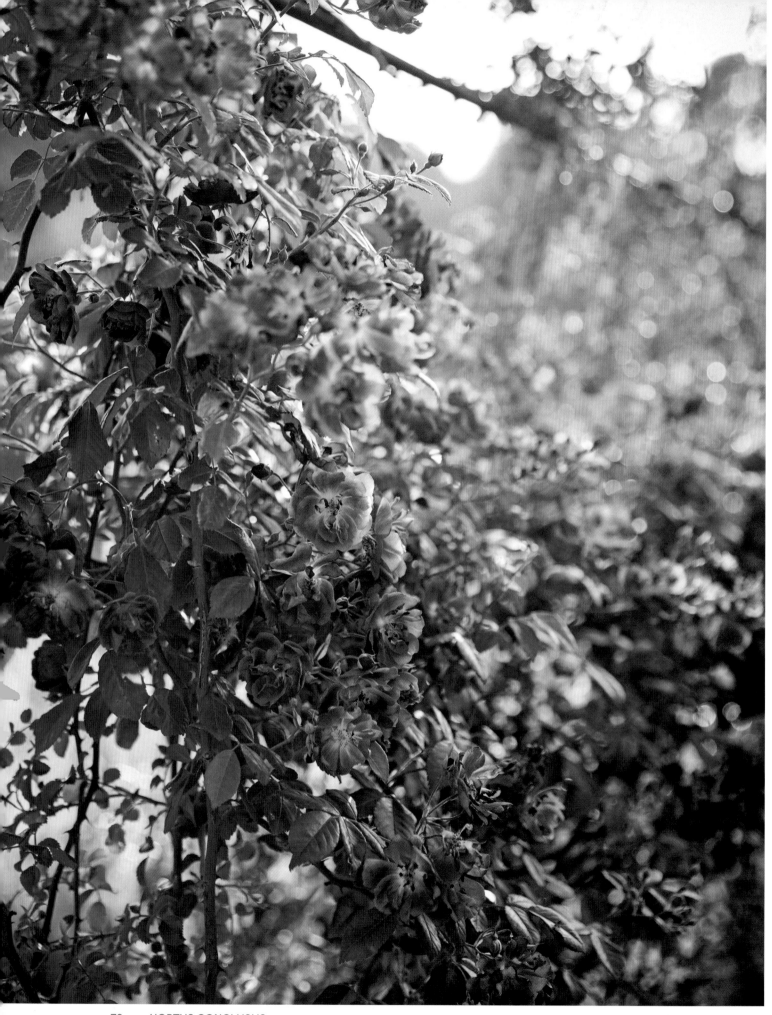

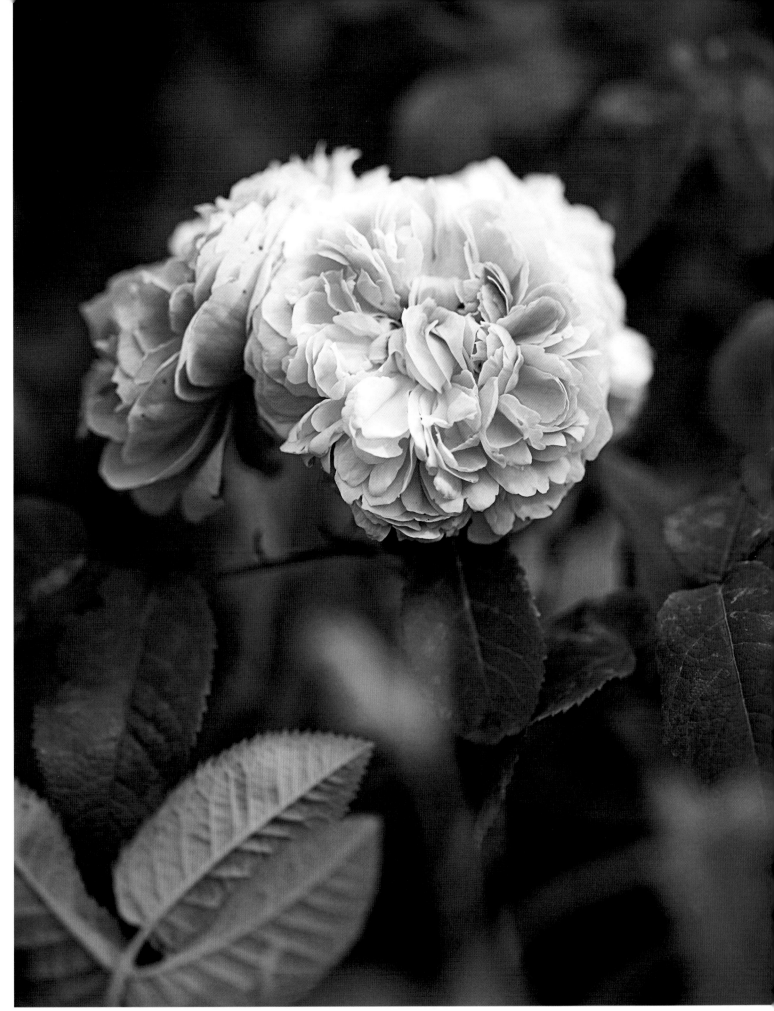

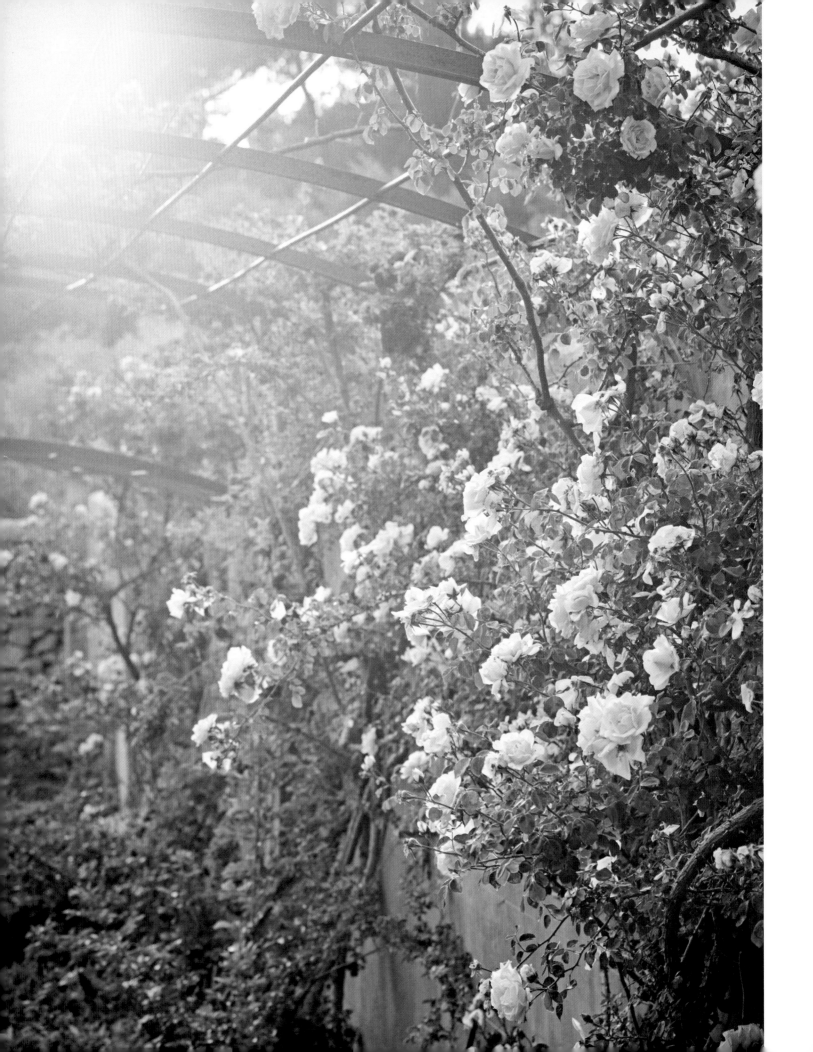

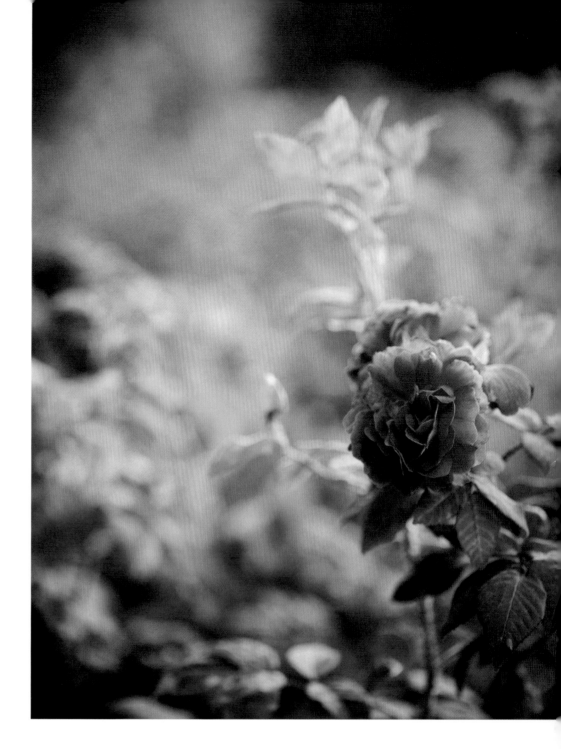

PREVIOUS LEFT
'Purple Skyliner', a remontant twenty-first-century climber, has flowers in a deep shade of purple that fades to mauve and gray, almost identical to the popular but once-blooming 'Veilchenblau', which dates from 1909.

PREVIOUS RIGHT
The once-blooming 'Blush Damask', dating back to 1759, is "unpredictable but so beautiful," says Yannick.

LEFT
'Awakening', thought to be a sport of the celebrated climber 'New Dawn', was discovered by Jan Bölm in the former Czechoslovakia in 1935 and known in Europe as 'Probuzení'.

RIGHT
From her friends, Yannick developed a preference for old roses, classic beauties that have endured for centuries.

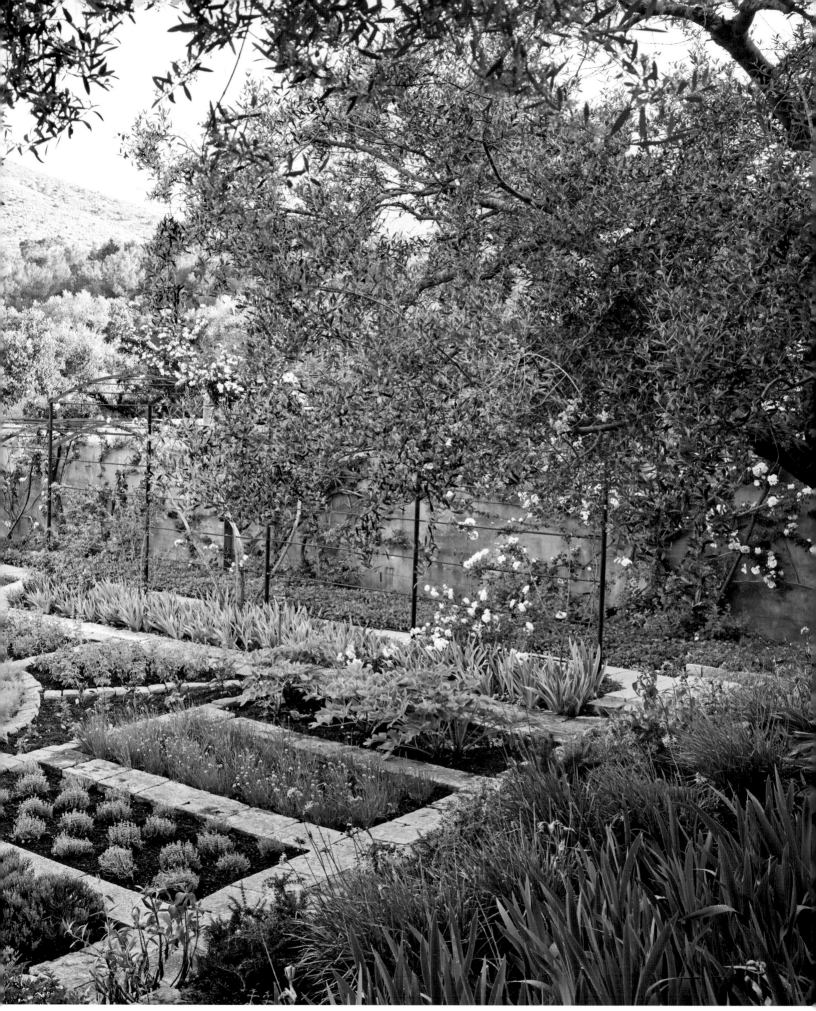

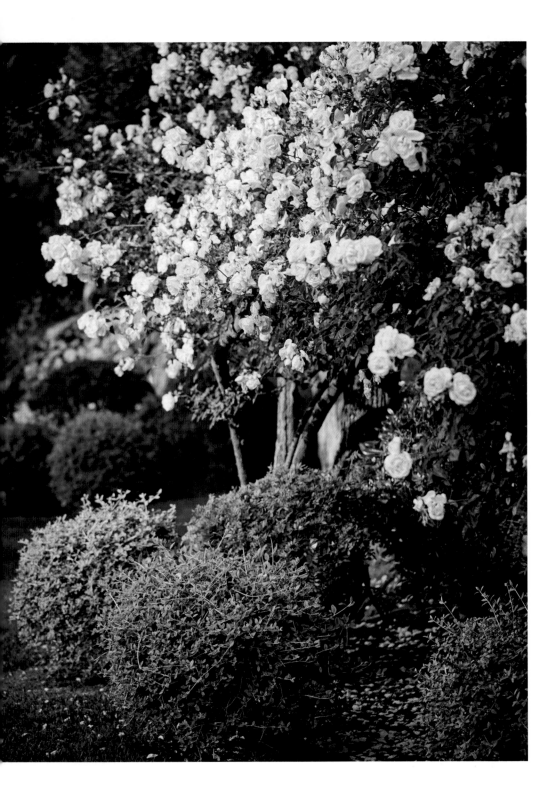

PREVIOUS
Drawing inspiration from the kitchen
garden at Villandry, Yannick also planted
an herb garden in the Hortus Conclusus,
filling it with traditional herbs as well
as exotic species like Mexican *papalo*
and *epazote*.

LEFT
'Mrs. Honey Dyson', a hybrid wichurana
that loves to climb freely on trees, was a
gift from an old friend, Andy Garnett,
who was in the army with Ben when they
were young.

RIGHT
One of the most sumptuous gallicas,
'Charles de Mills' has large, fully double
flowers in a rich crimson purple, with
shades of dark lilac and burgundy.

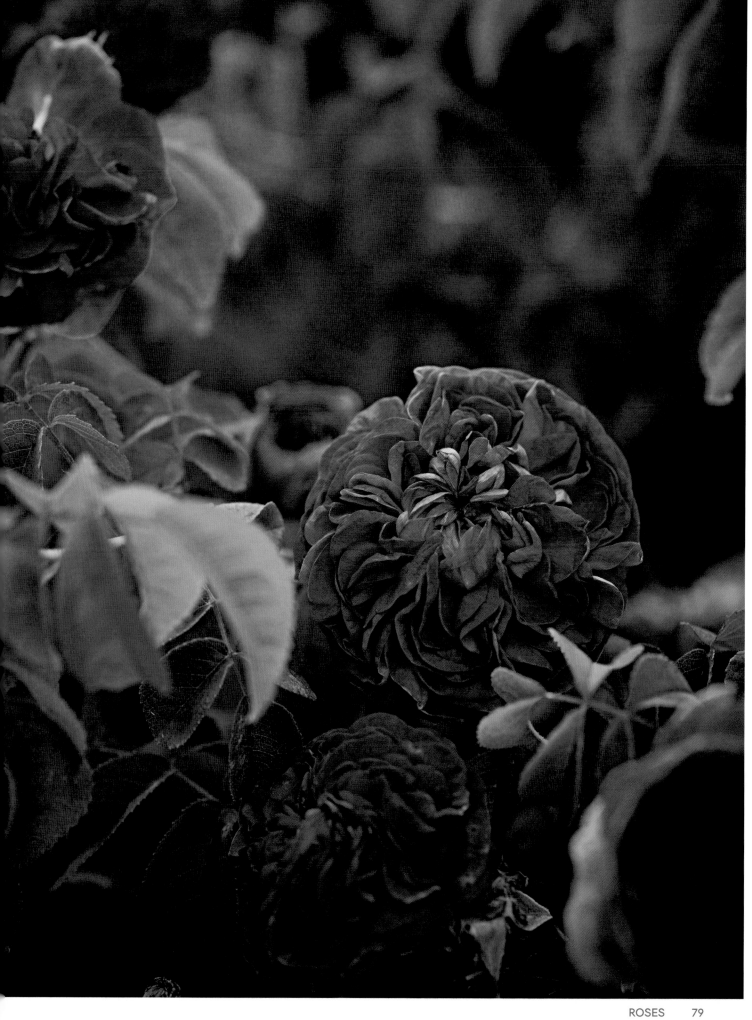

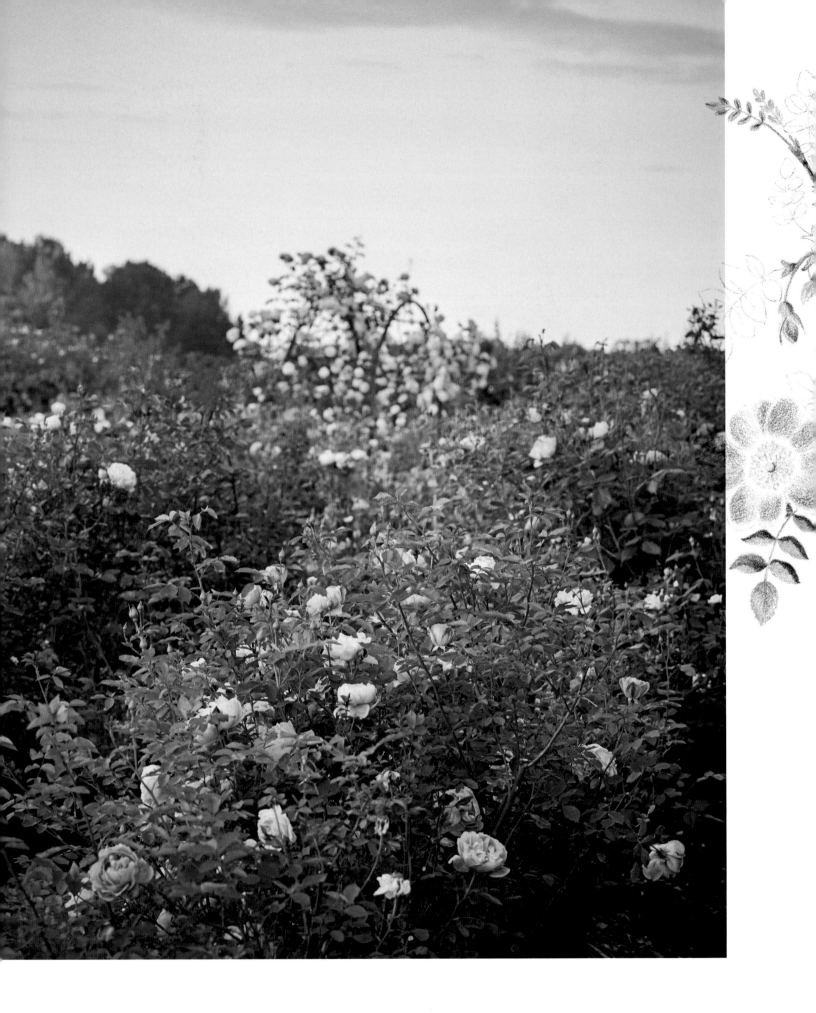

Floret

Since its appearance in the gardens of antiquity,
the rose has been
shape-shifting and multiplying
with the help of bees and humans alike.

Pliny documents twelve varieties of roses in ancient Rome while John Gerard, in his 1597 *Herball*, describes eighteen roses grown in English gardens. Between 1815 and 1827, the number of rose cultivars in the Western world surged from 250 to an astonishing 1,059, surpassing 8,000 a century later. Today, even with tens of thousands of cultivars in existence globally, breeders still persist in crossing and back-crossing different hybrids and species to attain new arrays of forms, hues, scents, and shapes. Changing tastes and trends consign once-beloved varieties into the folds of oblivion, their beauty and stories lost to time.

Gallicas, the most ancient roses in the West, have borne witness to the rise and fall of empires and cultures for millennia. Cherished in Greek and Roman gardens, these blooms fell out of favor with the fall of Rome, shunned for their association with the decadent empire. Resurrected in medieval monastic gardens for their medicinal virtues, gallicas flourished during the Renaissance, adorning illuminated manuscripts and European gardens. In nineteenth-century France, amidst the Napoleonic Wars blockade, French rose breeders like Jacques-Louis Descemet and Jean-Pierre Vibert propelled gallicas to the pinnacle of their popularity, raising hundreds of exquisite varieties. Yet, the introduction of repeat-blooming hybrid perpetuals, and eventually hybrid teas, relegated gallicas once more into obscurity. Today a mere dozen of Descemet's gallicas remain, a trace of their history embodied in the sumptuous 'Impératice Joséphine'.

At Floret, the celebrated flower farm nestled in the Pacific Northwest, Erin Benzakein has embarked on a mission to safeguard Europe's heritage roses, ensuring that these legends of the past continue to grace gardens of the future. In her quest, Erin joins the esteemed ranks of rose preservationists, notably Graham Stuart Thomas, whose book—*The Graham Stuart Thomas Rose Book*—remains the bible for all gardeners interested in the genus *Rosa*. Thomas began his rose preservation mission at the onset of World War II with the acquisition of two big commercial collections of

LEFT
In the cutting garden, roses are planted in long color-coded rows. Seen in the foreground is 'Lady of Shalott', one of the many David Austin roses that Erin grows for arrangements.

Illustration, *Rosa spinosissima*.

species and old roses. In 1972, having amassed three hundred varieties, he found a permanent home for his roses at Mottisfont Abbey, making its walled garden a mecca for those seeking the timeless beauty of these historic blooms.

Erin's inspiration lies closer to home. The first rose expert she met was Anne Belovich, then the owner of the largest collection of rambling roses in North America and author of five books on the subject. Erin's first visit to Anne's garden was an enchanting experience. Spilling from arbors at every turn were arching canes of roses that she had only read about in books. Back at home, she began a modest collection by planting a few dozen heirloom roses against the fence and some ramblers and climbers to enshroud her flower studio in roses once a year.

Twenty years later, the acquisition of an adjacent parcel of land gave Erin the opportunity to realize her dream of a rose garden. With a blank slate before her, she scoured the country for specialty nurseries, collecting nearly 1,000 plants representing more than 250 varieties. On a tour of England for design inspiration, Erin met Becky Crowley, a cut flower grower at Chatsworth House with a background in garden design. Together, they turned the farm from an empty stretch of land into a place teeming with life, planting over a mile of hedgerows, hundreds of trees, perennials, an abundance of peonies—another passion of Erin's—and a rose garden.

The roses at Floret are organized into four main groups, two of which are featured in the cutting garden. In long color-coded rows are varieties destined for the vase, including repeat bloomers like 'Distant Drums', a shrub rose of a tan-mauve blend that is highly popular with American florists, and numerous David Austin varieties, from the soft pink 'Eglantyne' to the golden-apricot-tinted 'Tea Clipper'. Punctuating the rows and arching over the central pathways are metal towers and arbors designed by Becky, covered in ramblers and climbers. The hybrid wichurana 'Léontine Gervais' has proven especially vigorous, practically swallowing Becky's archways in just three years with its salmon-pink flowers and glossy green foliage. It's a rose "that makes you feel like you're the best gardener on earth even when you're not," says Erin. Long canes of 'Alchymist' bearing flowers in shades of yellow, apricot, and pink cascade from the top of a tower like sprays from a fountain.

Species and old roses, primarily once-blooming and hardy varieties, are scattered throughout the orchard, hedgerows, and along the farm's thoroughfare. By mixing roses with mock orange, ninebark, snowberry, myrica,

Indian plum, ocean spray, and other shrubs along the hedgerows, Becky and Erin created a rich habitat for wildlife on the farm. In summer, pollinators feast on the nectar and pollen from the flowers, and in autumn and winter, songbirds feed on the berries and seeds. The plants were carefully selected for their practical use as well as beauty, ninebark and roses being favorites in arrangements. A rose that Erin imported from Germany nearly two decades ago for its hips now makes its presence throughout the hedgerows. Named 'Starberry' and originally bred by an Italian grower, this beauty bears an abundance of clusters of pale pink flowers with a long vase life. *Rosa × dupontii,* added by Becky to spill over the yew hedges in the vegetable garden and along the hedgerows, has now become Erin's favorite. An early bloomer with an unrivaled display, it has beautiful pointy buds that unfold to reveal golden coronets of stamens and creamy white petals tinged on the reverse side with a hint of pink. Though the rose is not without thorns, Erin insists that it's very easy to pick and work with in arrangements. Along the edges of the farm, the hedgerows become less ornamental, with species roses like *R. glauca, R. nutkana*, and *R. gymnocarpa* teaming up with native plants of the Pacific Northwest, including swamp crabapples, Western spirea, willow, and dogwood.

Nearer to the house, a formal rose garden was created for a more personal collection, selected for fragrance and delicate blooms. 'Constance Spry', whose scent reminds Erin of her early days of motherhood, is grown here in a large bed with 'James Galway' and the perfumed damask 'Celsiana', another beloved rose.

In 2022, two decades after her initial visit, Erin returned to Anne's garden, this time accompanied by her team and Becky. With Anne in her late nineties and unable to keep up the care of her garden, the place, though still magical, had fallen into disarray. Roses overwhelmed every structure while brambles choked the ground. Collected over three decades, Anne's beloved roses seemed on the brink of being lost forever. Determined to preserve these treasures for posterity, the Floret team returned the next morning, gathering over a thousand cuttings to propagate at the farm, ensuring that Anne's legacy would live for generations to come.

While the tender cuttings from Anne's garden were rooting in the greenhouse over the winter, Erin continued hunting for rare and heirloom roses. In her research, she came across the Friends of Vintage Roses, whose mission is to preserve a collection of historic roses created by Gregg Lowery and Phillip Robinson over some thirty years. Some were found by rose

rustlers in the 1970s and '80s in old cemeteries and roadsides. Others came as gifts from a small network of international growers of old roses. As Gregg Lowery explains to Erin, "Beauty cannot be owned, but it can be shared. We don't preserve for the sake of the roses, but for the people."

For Erin, to witness Gregg surrounded by his roses in full glory was a revelation. "Stories spill out of him," she recalls. "He can just close his eyes and tell you everything about the roses. Their history. What makes them special." To keep these stories alive, the Friends of Vintage Roses foundation enlists "curators" to adopt part of the collection to safeguard for the future. Erin made the commitment to adopt the Old European roses—albas, centifolias, damasks, eglantines, gallicas, hybrid bourbons, hybrid chinas, hybrid musks, mosses, and spinosissimas. An area on the farm has been set aside and prepared for a rose library. Anne Belovich's ramblers and Gregg Lowery's old roses will be planted in rows, organized by color and clearly labeled to safeguard their identification in the future.

The rose collection at Floret now numbers 750 varieties, with over two thousand plants. The fertile soil and temperate climate of the Skagit Valley make an ideal environment for the roses although the tea varieties do need protection in the colder months. With roses in neat rows in the cutting garden and woven naturalistically into the hedgerows, Floret maintains a fine balance between a working farm and a garden, a combination of wild and cultivated, a reflection of Erin's love for English gardens. The whirring sounds of hummingbirds are never far from the abundance of flowers. Spotted towhees belt their trills from their perch atop the hedgerows. Goldfinches alight on the rose shrubs to survey the ground while swallows smear the sky.

Few flowers have ignited our human imagination as much as the rose. Homer's rosy-fingered dawn. Dante's white rose of Paradise. Shakespeare's eglantine. Yeats's Rose of Battle. T.S. Eliot's the fire and the rose. The symbol of both Aphrodite and the Virgin Mary. Old roses, as Vita Sackville-West writes, are "rich as a fig open, soft as a ripened peach, freckled as an apricot, coral as a pomegranate, bloomy as a bunch of grapes...." They are reservoirs of both natural wonder and cultural legacy, with beauty and history enfolded in their petals. Erin, who has spent her career cultivating beauty and sharing it generously, sees her role as a conduit for the roses, ensuring their places in future gardens. "Roses move through time and change hands," she says. "Gregg and Anne have passed them to me, and I'll have to pass them on to future gardeners." R&G

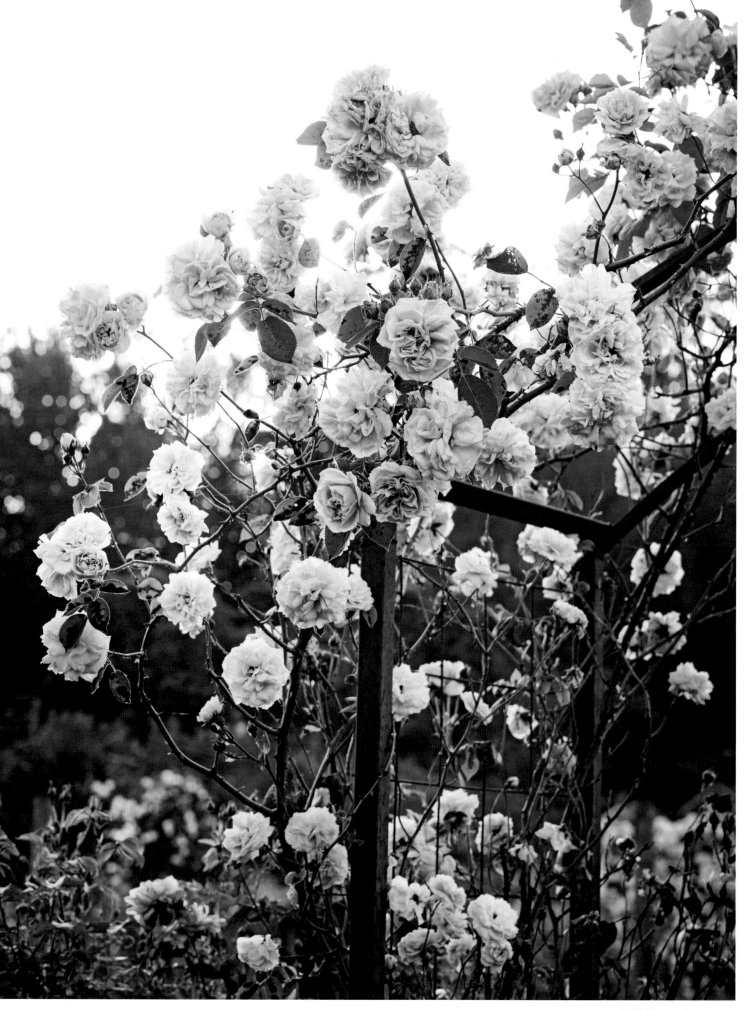

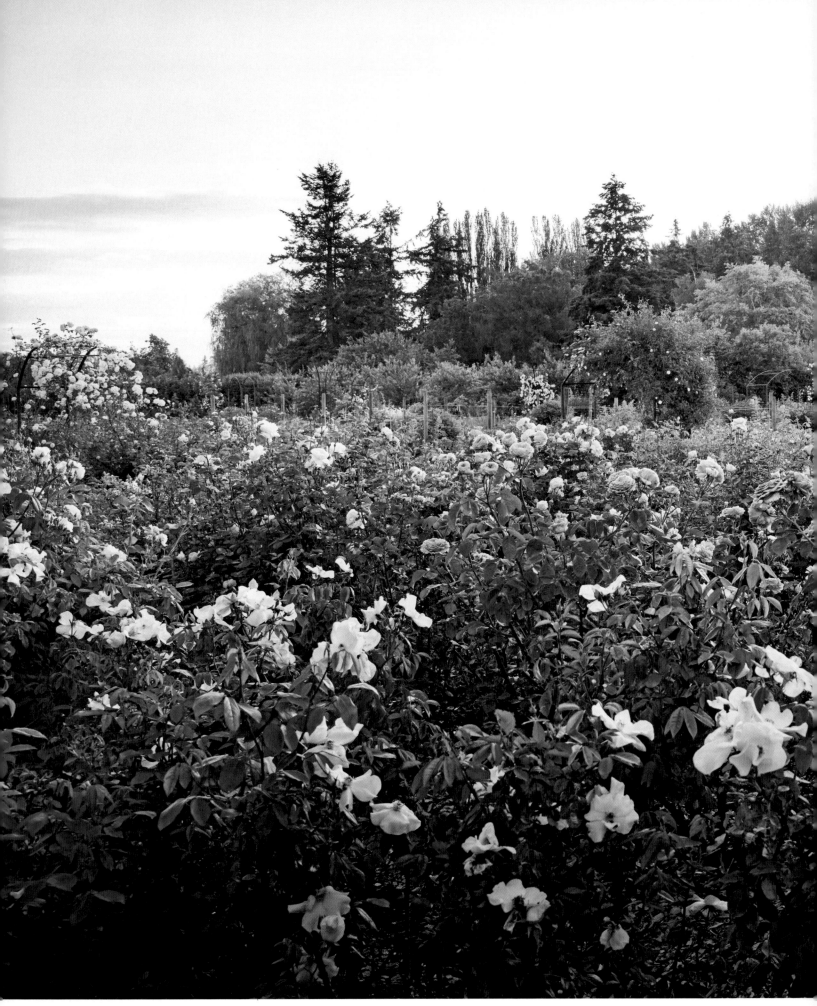

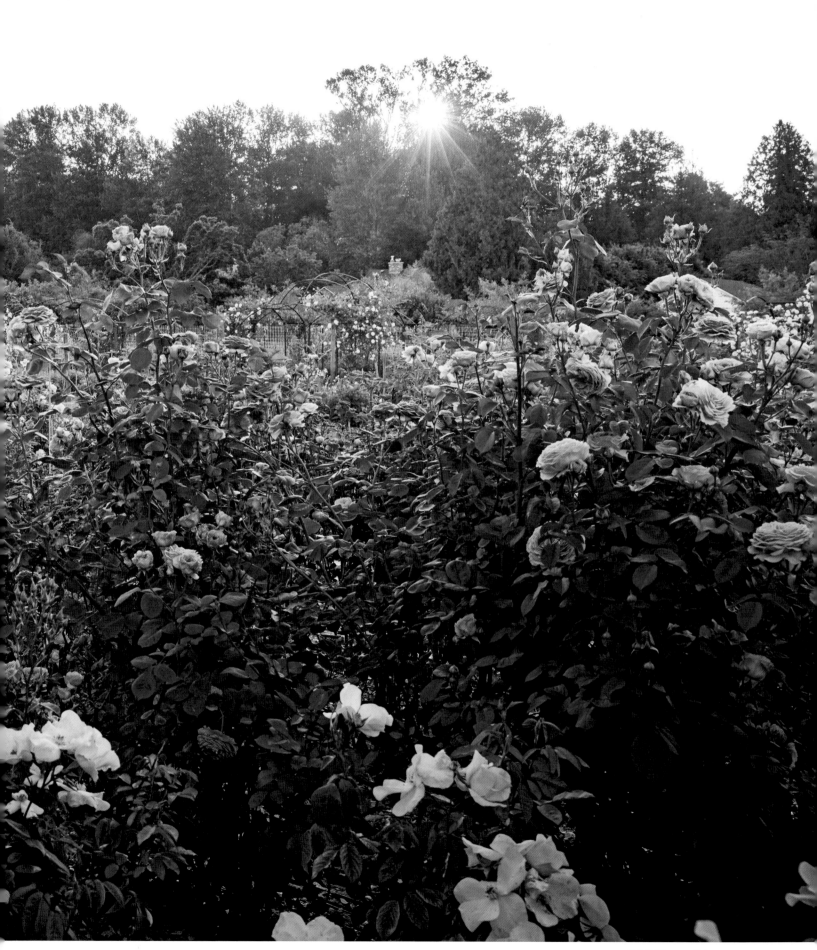

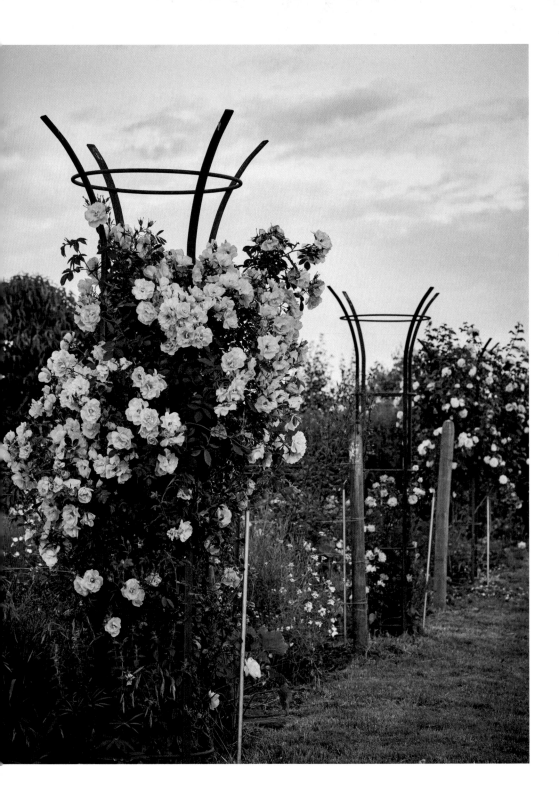

LEFT
Becky Crowley designed the towers and arches in the cutting garden for climbers and ramblers, including 'Above and Beyond', a very hardy new variety introduced in 2015.

RIGHT
Another beautiful climber from Reimer Kordes, introduced in 1956, 'Alchymist' has fully double yellow flowers in shades of orange, apricot, and pink.

FOLLOWING LEFT
Dr. Griffith Buck, under the auspices of Iowa State University, developed hardy roses that would withstand the bitter cold Midwest winters. One of his famed creations is 'Distant Drums', prized by florists for its unique blend of tan, mauve, and pink hues.

FOLLOWING RIGHT
An American goldfinch alights on a shrub of 'James Galway' in the cutting garden.

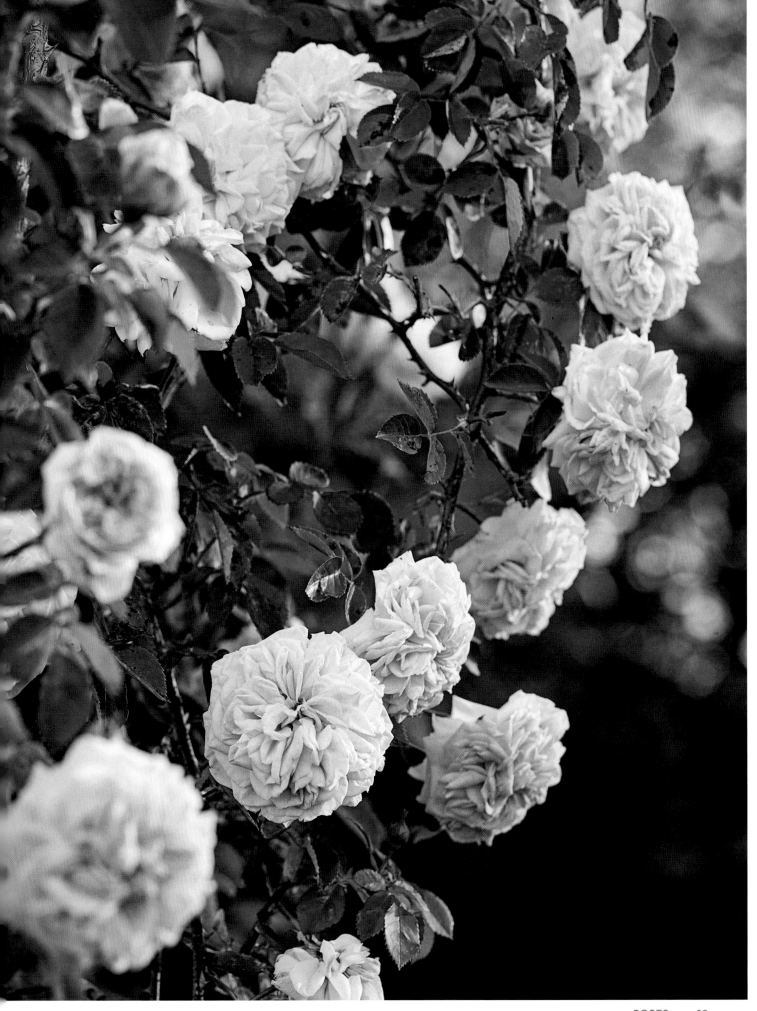

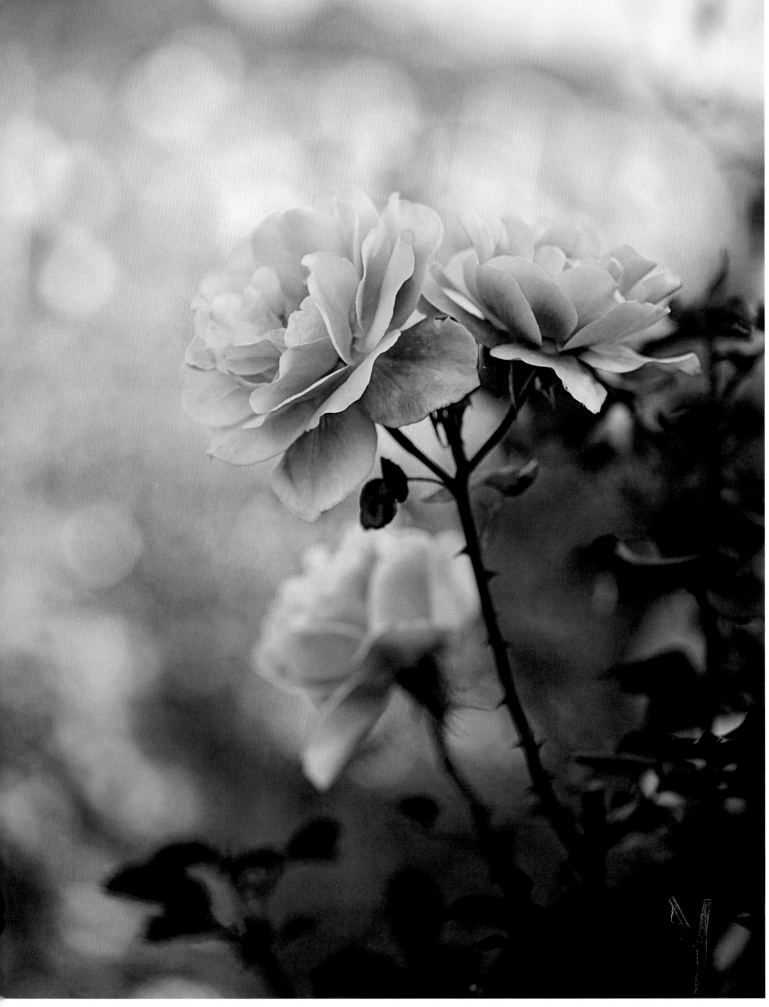

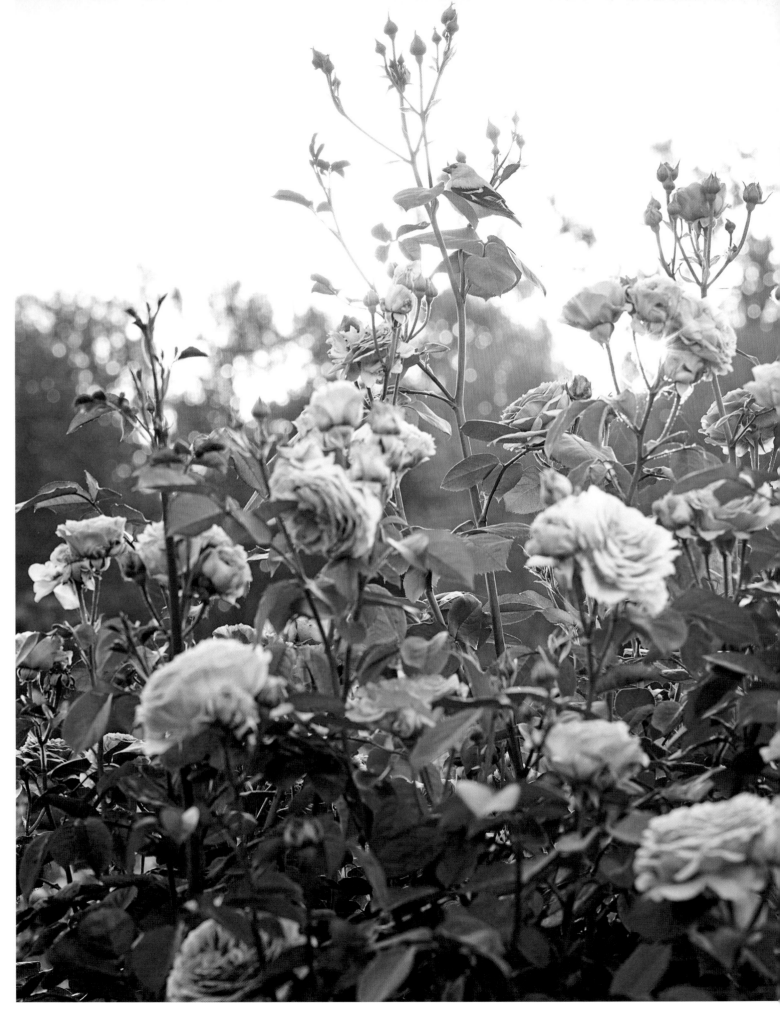

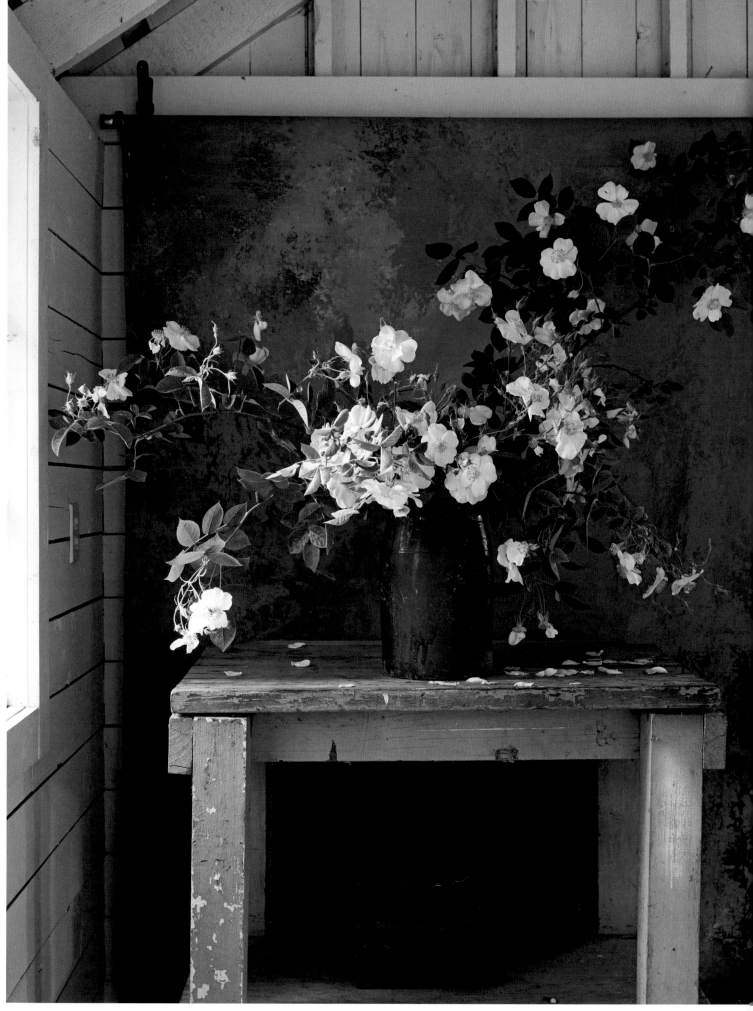

LEFT
If forced to choose only one rose, Erin would opt for *R. × dupontii*. She recommends cutting long arching canes to display *en masse* in order to replicate the plant's full beauty in the vase.

RIGHT
Erin's favorite David Austin rose is 'Tea Clipper', with "giant warm golden-apricot-colored flowers [that] have a bright citrusy scent and change colors as they age."

FOLLOWING
Becky designed the row of metal arches in collaboration with local husband-and-wife artists, Michelle and Jay Barshaw.

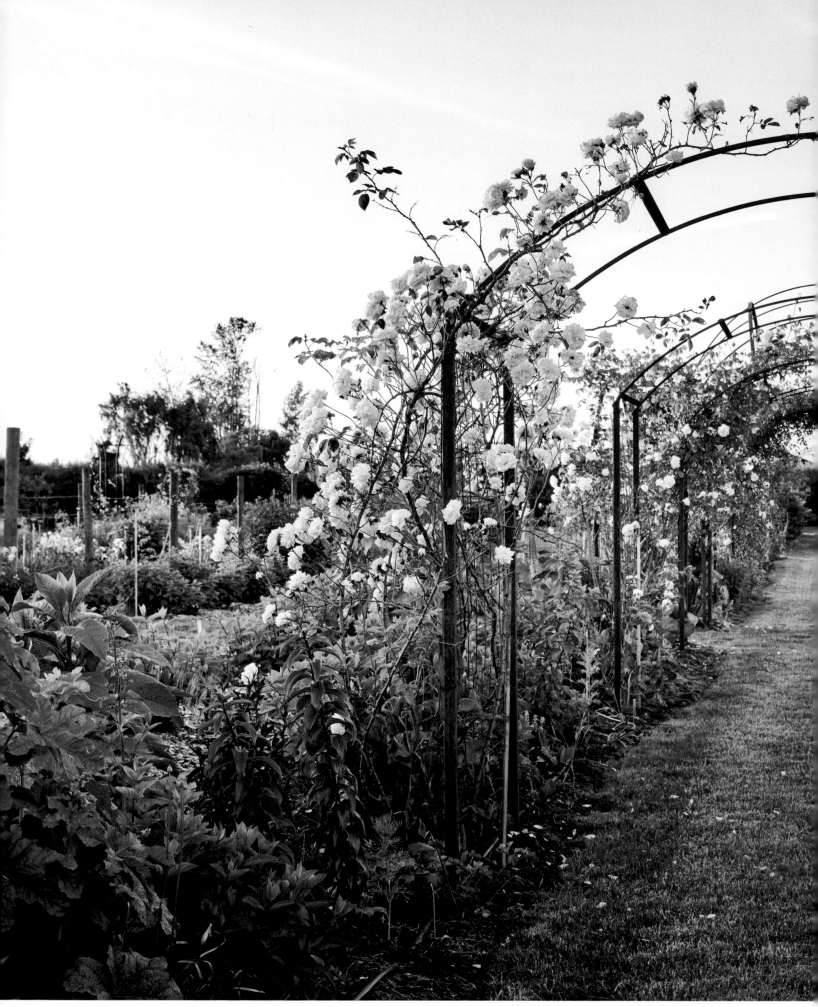

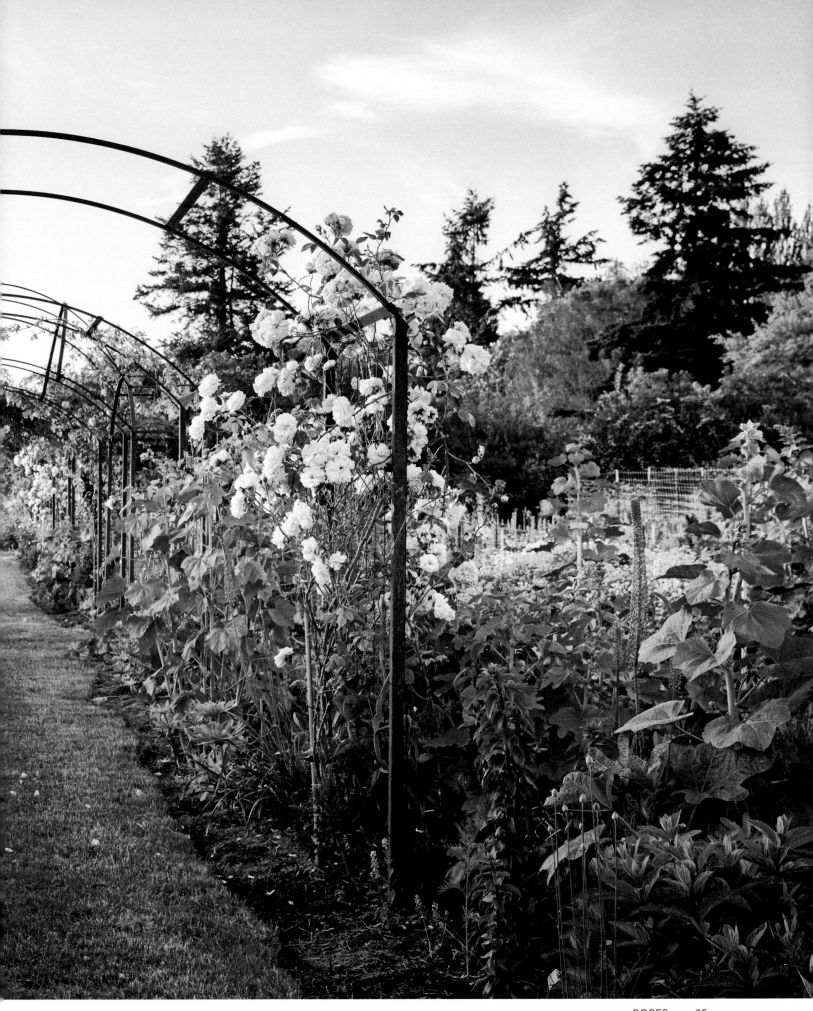

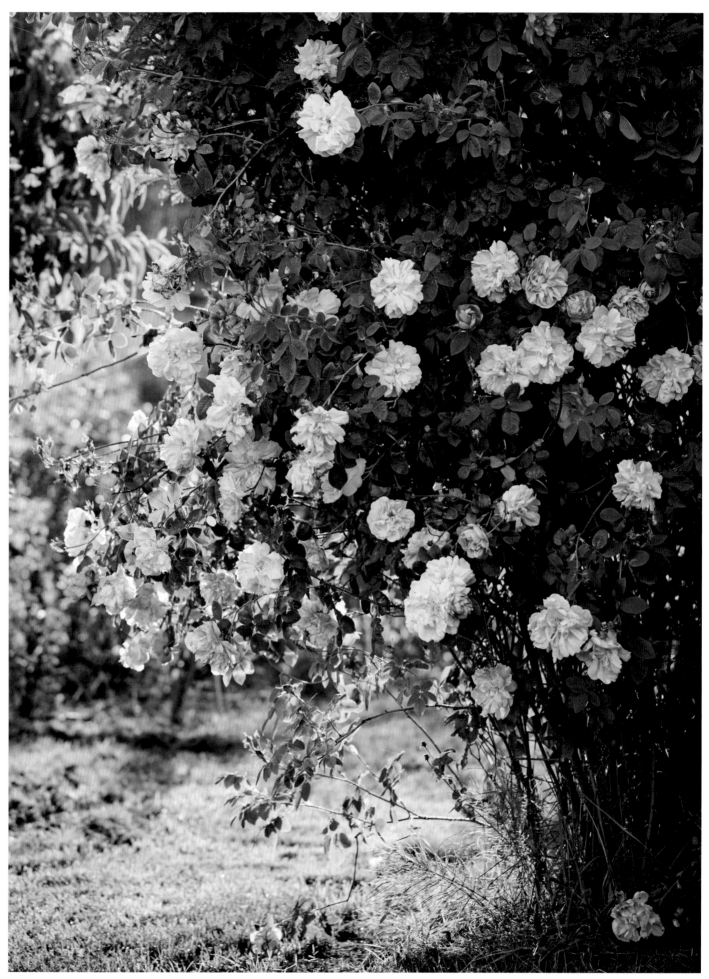

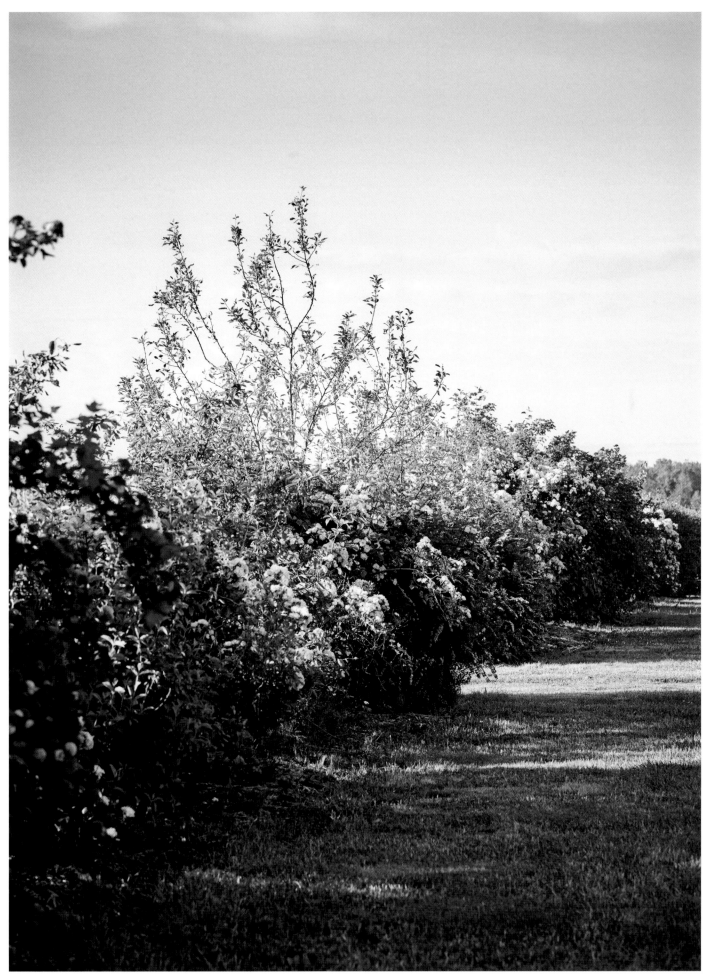

PREVIOUS LEFT
The damask 'Celsiana' is one of many roses planted in the hedgerows around the farm, adding beauty and fragrance to practicality.

PREVIOUS RIGHT
Erin wanted the hedgerows—with their mix of roses, crabapples, ninebark, mock orange, currant, common snowball viburnum, and highbush cranberry—to be "a beautiful tangle of life."

LEFT
'Darlow's Enigma', seen here at the entrance to the rose garden, is a hybrid musk that can grow ten feet tall and just as wide, with nearly constant blooms.

RIGHT
An English rose dating from 1997, 'Marinette' has pointed buds that unfold with flouncy petals into large semi-double pink flowers.

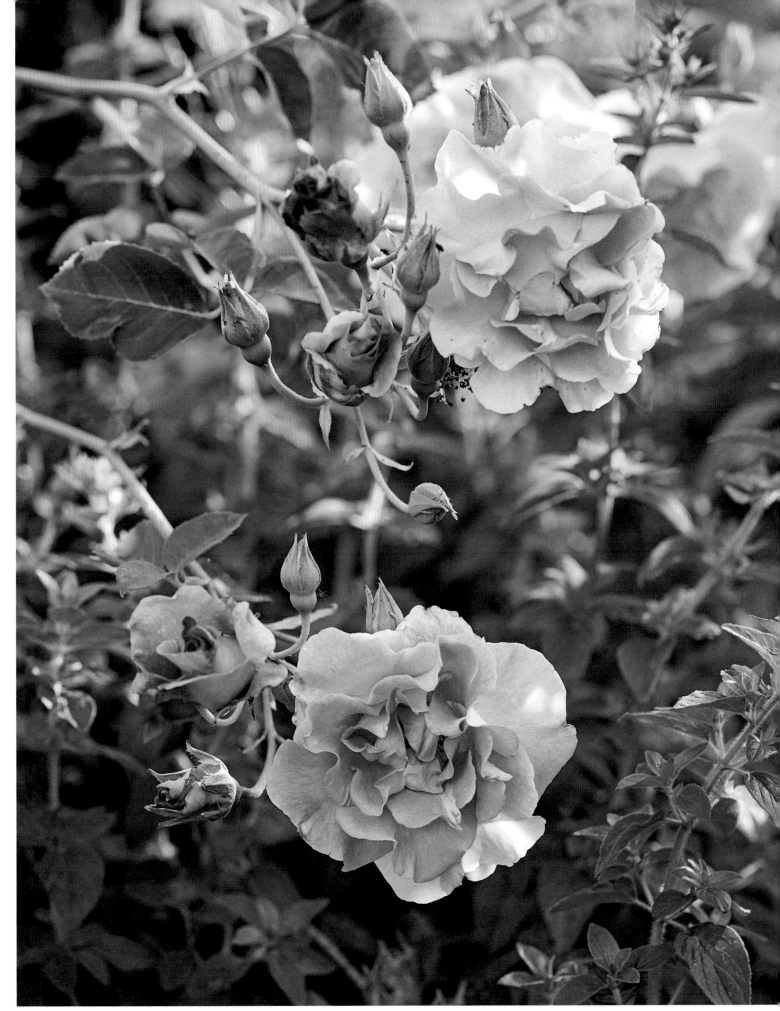

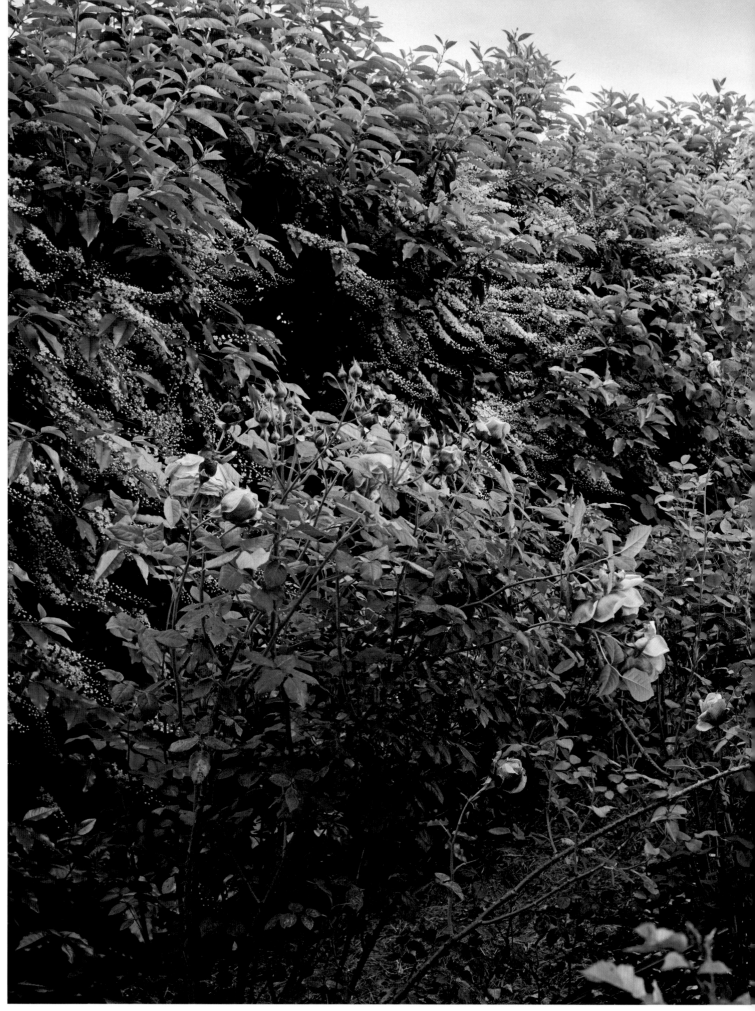

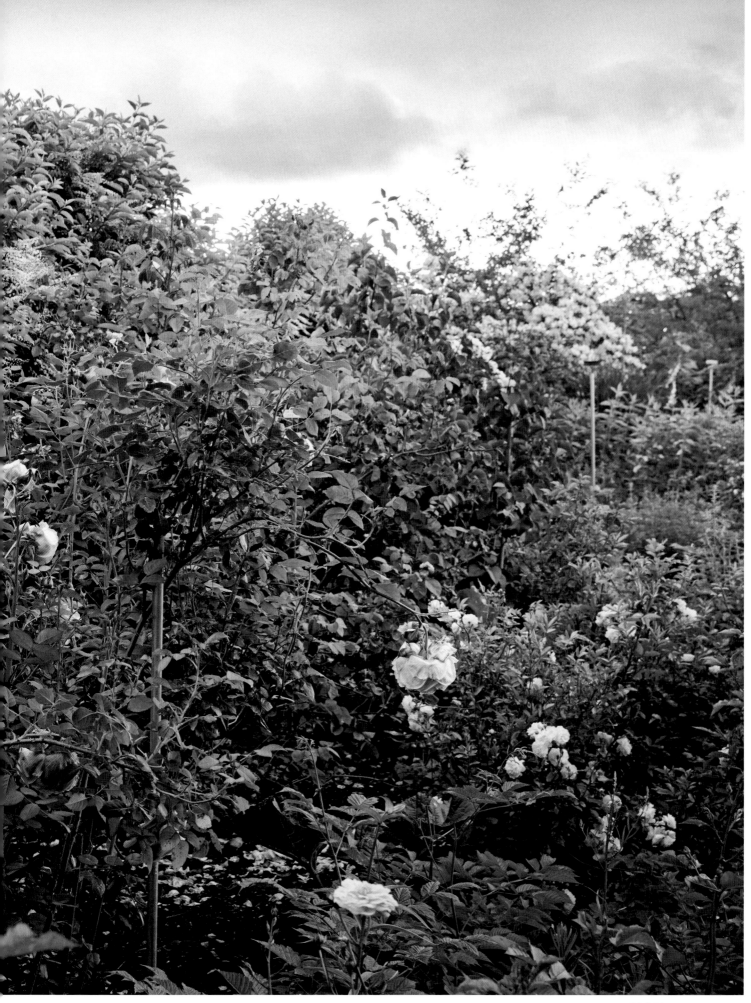

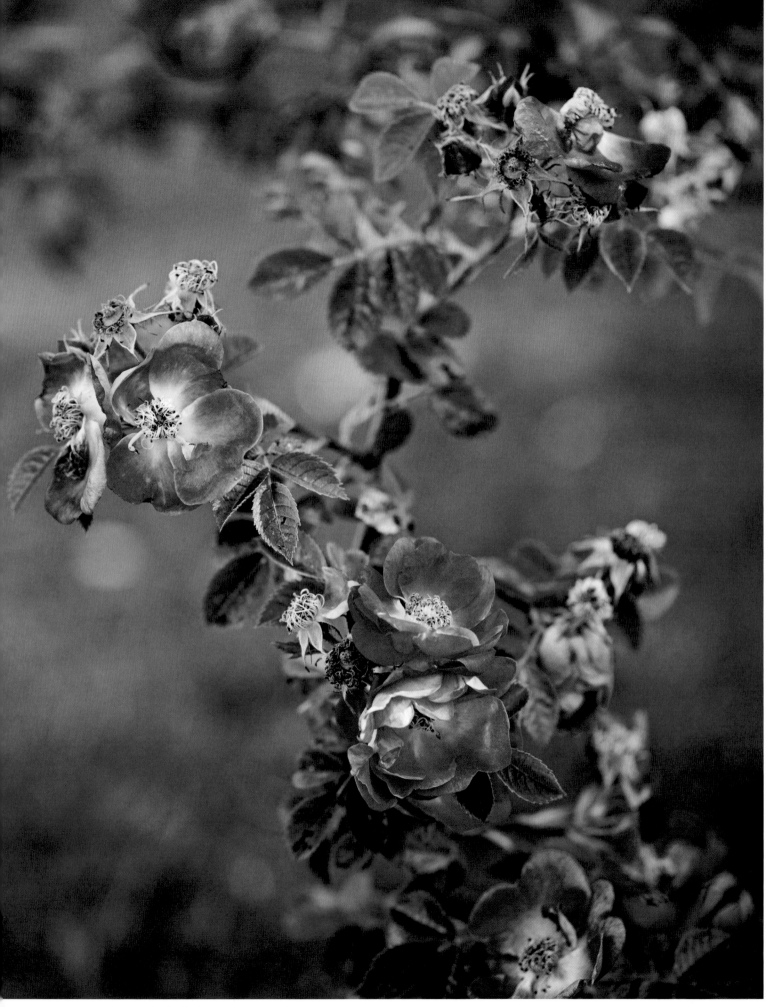

PREVIOUS
A hedge of *Prunus laurocerasus* 'Schipkaensis' encloses the rose garden, where some of Erin's favorite roses are planted, including 'Celsiana', 'Constance Spry', and 'Spirit of Freedom', seen on the left.

LEFT
'Magnifica' is among a large selection of roses from Gregg Lowery's Vintage Gardens that Erin is preserving. Part of what Lowery calls the Eglantine class, it is one of many hybrids of *Rosa eglanteria* (or *R. rubiginosa*), Shakespeare's sweet briar.

RIGHT
Erin's preservation plan includes a rose library of old roses, to be planted in rows arranged by color, as she often does when evaluating cut flowers.

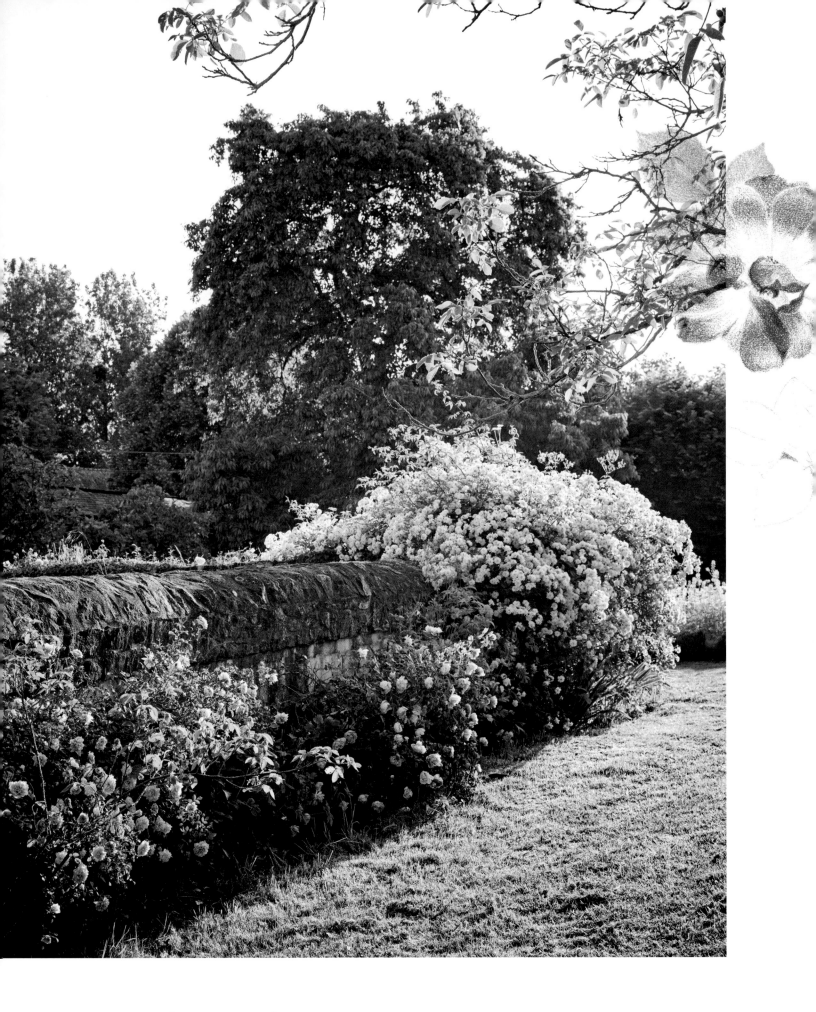

Château de la Rongère

Calling themselves the Land Gardeners,
Bridget Elworthy and Henrietta Courtauld burst
on the gardening world in 2012 with cutting gardens of
wildly romantic designs and floral arrangements
of pure poetry—
loose, languid, and luscious.

To discerning London florists looking beyond the limited range and dull uniformity of industrially grown flowers, they supplied dahlias the size of dinner plates, tulips worthy of Dutch Golden Age paintings, cosmos as delicate as butterflies, and of course, the quintessential English roses, all grown organically at Bridget's family home, the fifteenth-century Wardington Manor in Oxfordshire. Tireless in their signature blue smock uniform or elegant in matching tweeds, the Land Gardeners traveled the globe, breathing life back into historic and walled gardens in England, France, Italy, and Bridget's native country, New Zealand. But their passion runs deeper, and their mission is at once down-to-earth and lofty. Their motto: "Healing our soils, healing our plants, healing our planet."

Both former lawyers who met at their children's nursery school, Bridget and Henrietta share a passion for plants and soil health. Their inspiration may run the gamut from Constance Spry to the 1940s glamour embodied by Rita Hayworth, but they count among their mentors Lady Eve Balfour, author of *The Living Soil*, the founding text of organic agriculture in England. As Henrietta and Bridget wrote in their lavishly illustrated and informative book *The Land Gardeners: Cut Flowers*, "we wanted to grow, to learn, we wanted to spend our time in gardens humming with life, and we wanted to laugh." Paying homage to the army of women who toiled on England's farms during the two World Wars—the Land Girls of Britain—they took on the name the Land Gardeners and created gardens that are beautiful, productive, and full of joy. After more than a decade of research into soil

LEFT
In the cutting garden, the low wall is festooned in 'Paul's Himalayan Musk Rambler'. In the foreground are 'Albertine', a popular rambler, and 'Alfred de Damas', a repeat-blooming moss rose originating in 1855 that is often confused with 'Mousseline', another moss rose introduced by Moreau-Robert in 1881.

Illustration, *Rosa* 'Erfurt'.

biology with the world's top experts and trials with farmers from the UK, Sweden, Switzerland, Belgium, Chile, and Mozambique, the pair introduced their Climate Compost inoculum in 2023. Made on Althorp Estate, Climate Compost is a mix of carbon and nitrogen (from animal manure, straw, fresh greens, grass clippings, weeds, and clay), carefully monitored for the right level of moisture, air, and temperature during the decomposition process. The result is a microbially rich compost that boosts soil health, producing nutrient dense crops and healthy plants while sequestering carbon, helping to fight climate change.

Having sold Wardington Manor in 2021, Bridget now trains her focus on her garden at Château de la Rongère in the picturesque Pays de la Loire. A pair of the rambler 'Wedding Day' stands guard at the gate, flanking the entrance with cascades of perfumed white flowers and butter yellow buds. Beyond the geometric parterres is a wild garden anchored by yew and magnolia trees whose blooming branches are destined for a few lucky florists in Paris. In spring, a constellation of camassias, crocuses, narcissi, and fritillaries light up the ground. Come summer, species roses rise like fountains above eupatorium, salvia, oxeye daisies, and tall meadow grass.

"It's a dance with nature," says Bridget, describing her approach to gardening— a dance accompanied by light, colors, scent, birdsong, insect hum.

On the edge of the meadow, arching canes of *Rosa × alba* 'Maxima' tumble through the billowing grass, bearing creamy white blooms that were once a secret symbol of the Jacobite Rebellion. Down the path, the backlit pink flowers of *R. rubiginosa* glow like jewels scattered on a sea of green. On an elevated narrow stretch overlooking this untamed paradise is Louis' Garden, made for Bridget's nephew who died in 2000. In this intimate space, *R.* 'Gertrude Jekyll' holds court, blooming generously through the season, fat rosette-shaped bright pink blooms fading gently with time. Its old rose perfume, redolent with notes of musk and myrrh, fills the air.

Just a few steps away from this rose-scented bower lies the productive heart of La Rongère, the Walled Garden. Neat rows of cut flowers are laid out among fruiting trees. Tulips, narcissi, fritillaries, and hyacinths usher in the flowering year. Then come apple blossoms when spring is in full tilt. Peonies, irises, and roses arrive with the warmer days of summer. Dahlias, cosmos, and the apple trees weighted with fruit bask in fall's golden light. Hellebores and the pale blossoms of winter-flowering cherry brighten the year's end. Through all the seasons, herbs, annuals, perennials, and vegetables fill out

the garden and make their way into arrangements. As in all of Bridget and Henrietta's gardens, biodiversity is key, and nature is allowed to weave its way through this walled garden. Green manures like mustard fill the beds when needed to increase the soil's fertility. Light and airy plants—such as *Valeriana officinalis* or *Verbena bonariensis*—are encouraged to self-seed. So are patches of nettles, a food source for caterpillars, which in turn will bring butterflies.

Fans of the Land Gardeners on Instagram swoon over pictures of their ravishing roses. At Château de la Rongère, the top choices are English shrub roses—'Royal Jubilee', 'Sharifa Asma', and 'Jude the Obscure' are some favorites—and various hybrid teas, like 'Aphrodite' (known in France as 'Laurette Fugain'), whose flowers Bridget describes as "scoops of raspberries and cream." Hybrid teas are chosen for their long life in the vase, where they change forms and colors with age, "performing a fun dance with their petals," she adds. Henrietta notes the intensity of colors in many hybrid teas as another asset. Both love picking the David Austin climber 'A Shropshire Lad' and the wichurana hybrid 'Albertine', an old rambler with salmon-red buds that open into copper-pink flowers. Dozens more varieties of species, heritage, and climbing roses have been added since my visit to expand the selections for the pair's famous arrangements.

Pruning in March is a light affair, removing dead and crossing wood and weak growth, as Bridget and Henrietta like to live prune when they are harvesting the roses, cutting long stems to shape and improve air circulation around the plants. Cuttings later in the season are done with shorter stems, and in November, they just prune any long stems to prevent wind-rock in winter. Compost teas—and never chemical products—boost the plants' resistance to fungal diseases, pests, and black spots.

With roses thick on the ground and flowering and fruiting trees humming with life, the garden at Château de la Rongère has all the hallmarks of the Land Gardeners' work:

Beauty. Sustenance. Joy.

But their work does not end here. Their zeal to "heal the soil" is evangelical, and when they are not teaching gardeners how to grow beautiful cut flowers, they are giving lessons on their "compost cake" method (the recipe is available in their book *Soil to Table*) and working with farmers to transition to regenerative land use. Growing flowers is a serious business. As Bridget and Henrietta remind us, "The health of our plants, and ultimately animal and human health, rests on how we nurture the life below ground." R✦G

RIGHT
Bridget and Henriette love hybrid teas and English roses for their long vase life, including the peach-tinted cream 'Lichfield Angel' from David Austin and the salmon-colored 'Duchess of Cornwall' from Tantau Roses in Germany.

FOLLOWING
Rows of roses, along with peonies, del-phiniums, foxgloves, and other perennials are grown in the cutting garden among apple trees.

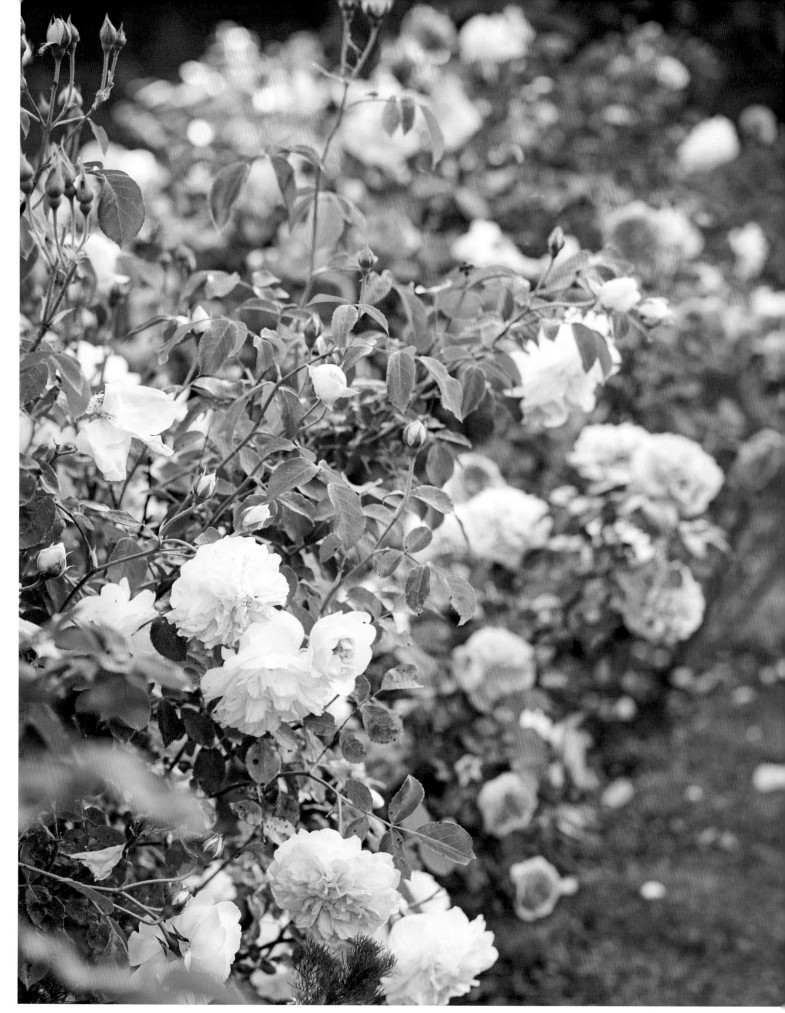

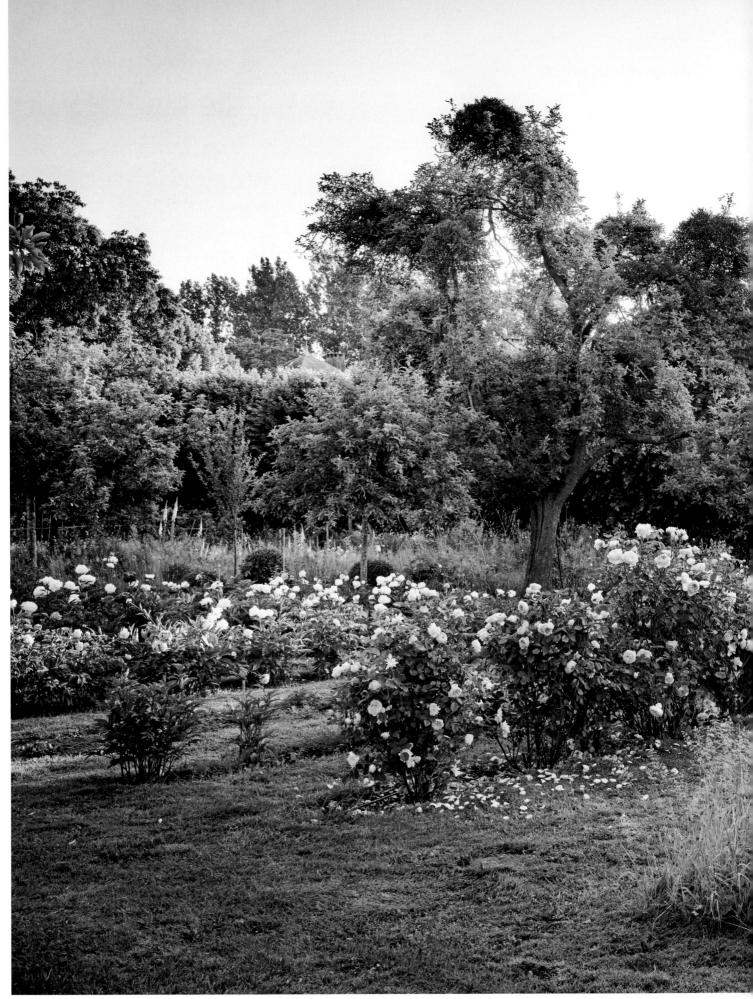

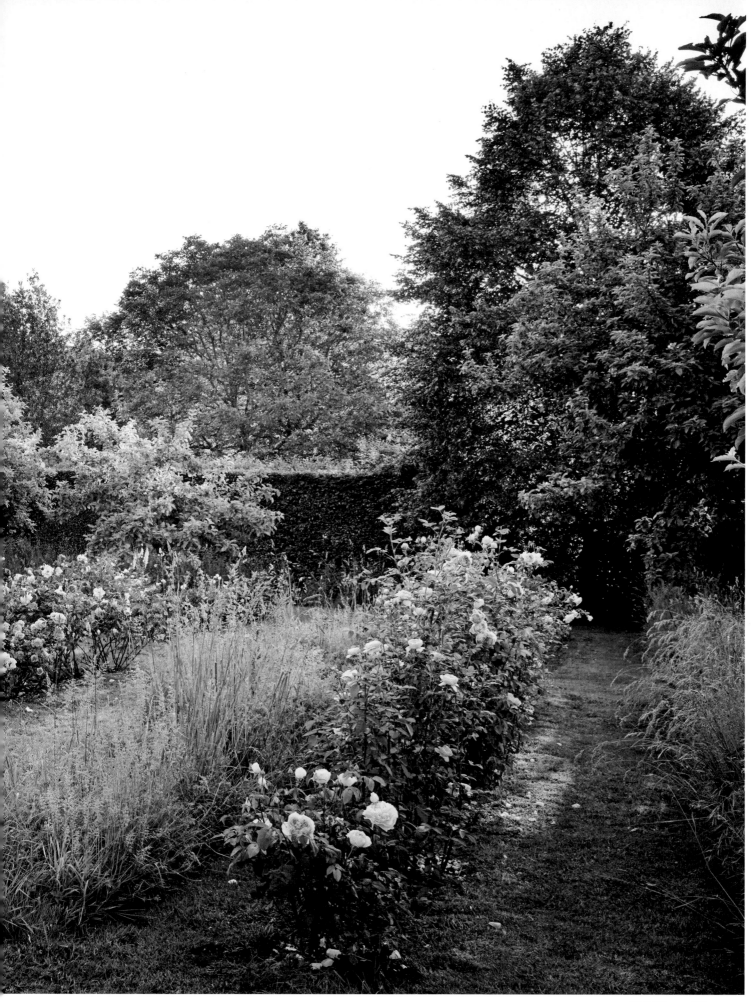

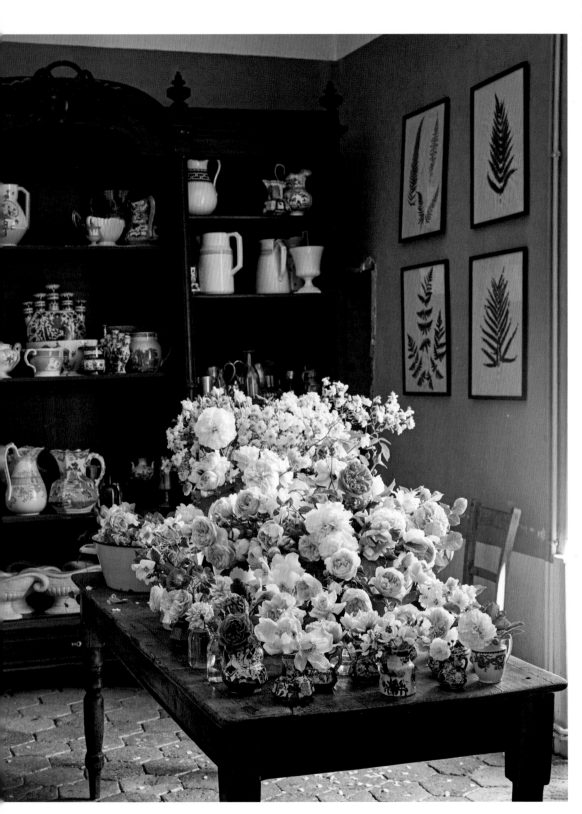

LEFT
Roses are cut, labeled, and observed for longevity, change in colors, and movement.

RIGHT
Out in the meadow, the deep pink blooms of *Rosa rubiginosa* 'Amy Robsart' glow in the afternoon light. The added attractions of this sweet briar hybrid are its fragrant foliage and abundant round, scarlet hips in the autumn.

LEFT
Bridget plants species roses to rise like fountains in the meadows, as the arching canes of 'Alba Maxima' seem to do here.

RIGHT
On the edge of the meadow, against the low wall, is the mysterious *R. × richardii*, first found in 1848 in the Christian province of Tigre in Abyssinia (present-day Ethiopia), in the courtyards of religious sanctuaries. Once named *Rosa sancta*, it was introduced to cultivation in Europe around 1895. It is thought that this natural hybrid of *R. gallica* and *R. phoenicia* was brought from Phoenicia (Syria) to Abyssinia by St. Frumentius in the fourth century CE. It has since acquired many names, including the "Holy Rose" and "St. John's Rose."

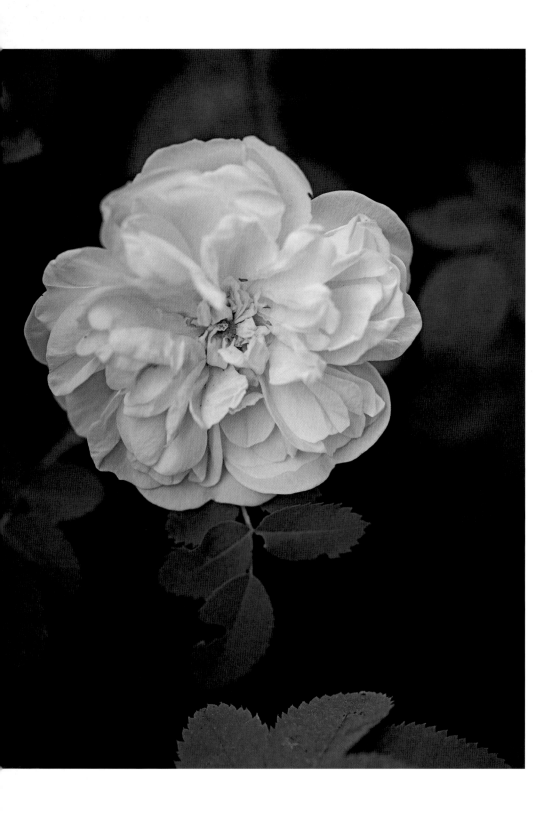

LEFT
The rare 'Hume's Blush Tea-Scented China', thought to be extinct in Europe for many years, was purchased from Trevor White nursery in the UK.

RIGHT
At the center of Louis' Garden—made in memory of Bridget's nephew—is 'Gertrude Jekyll', a David Austin rose named for the celebrated garden designer and author.

FOLLOWING
A pair of 'Wedding Day' ramblers flank the gates of Château de la Rongère, accompanied by 'Roseraie de l'Haÿ' on the left.

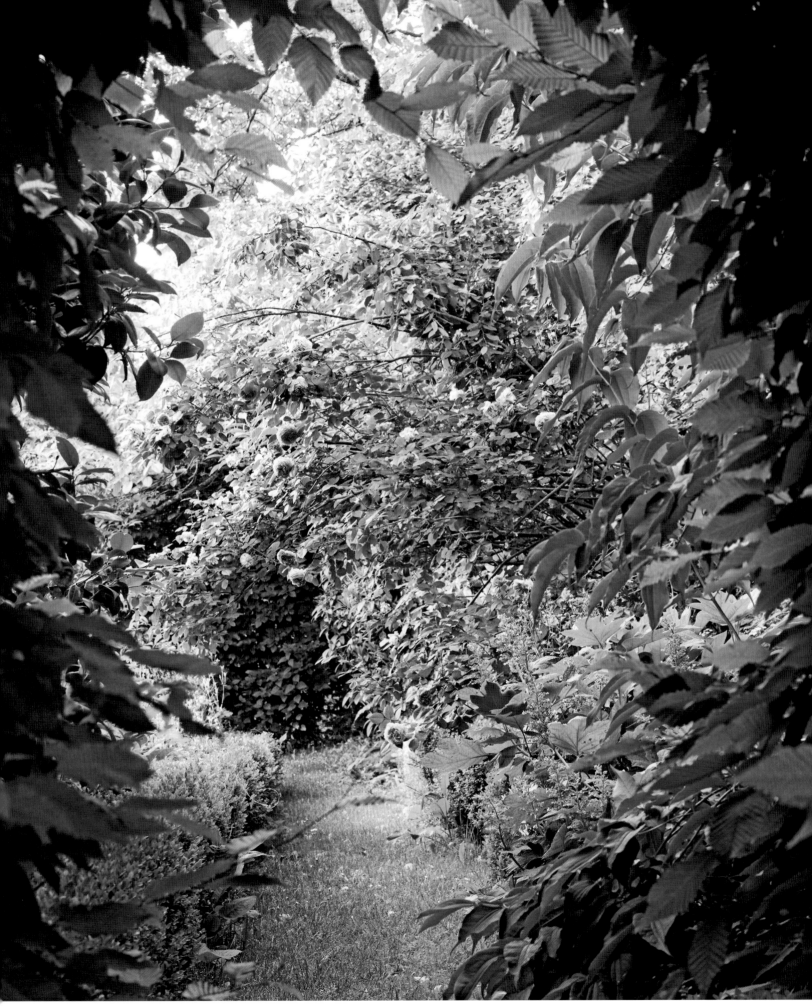

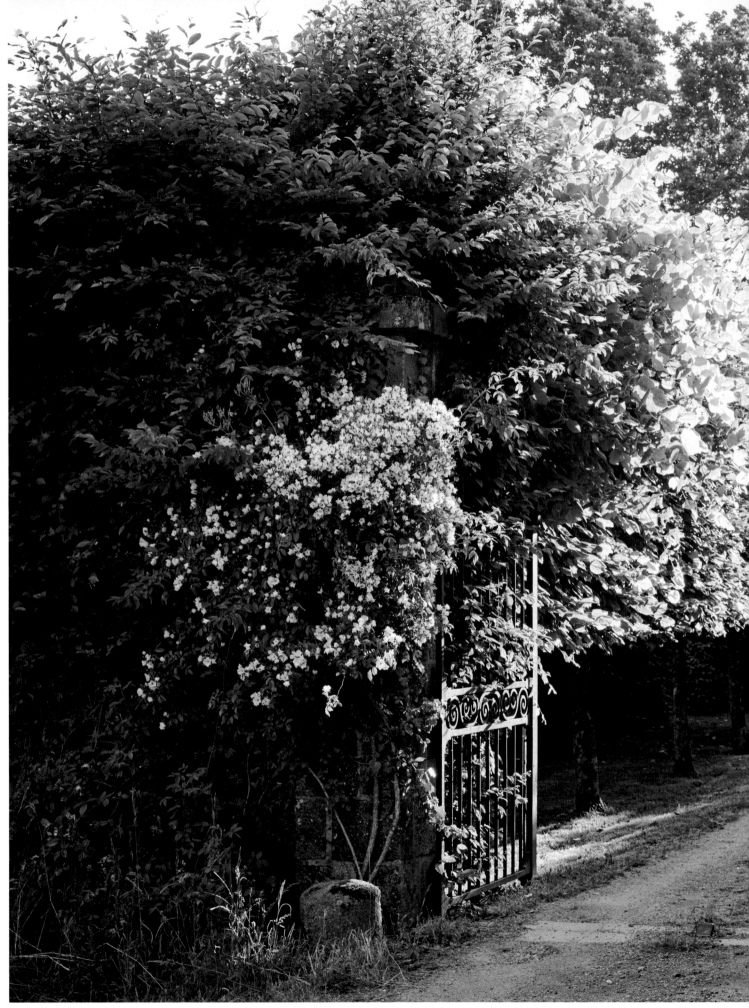

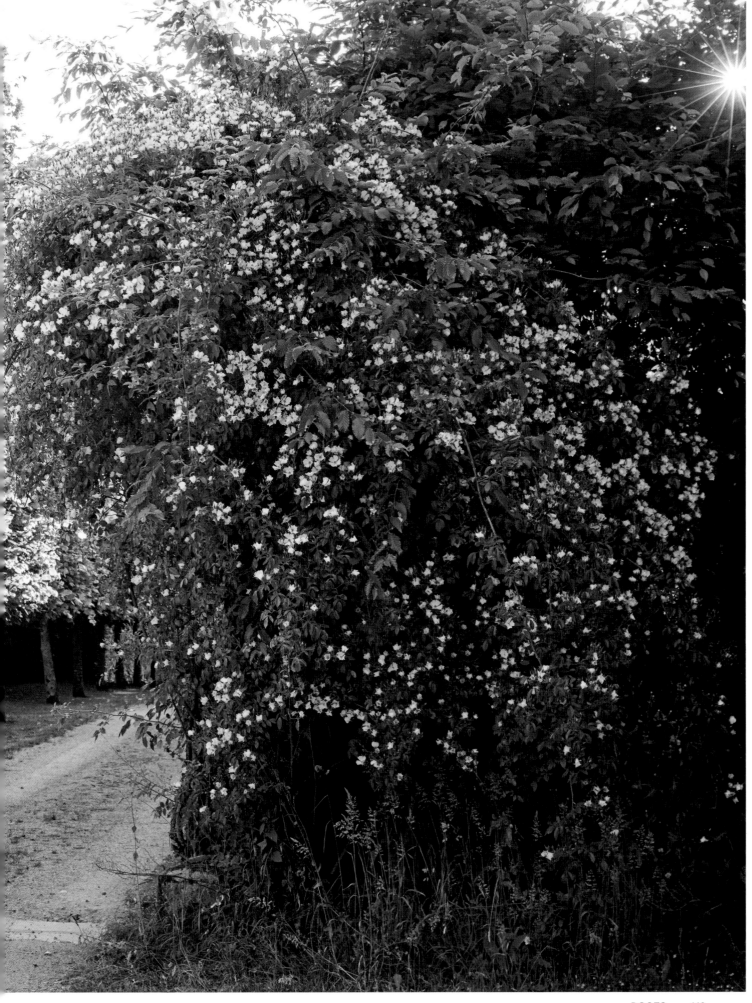

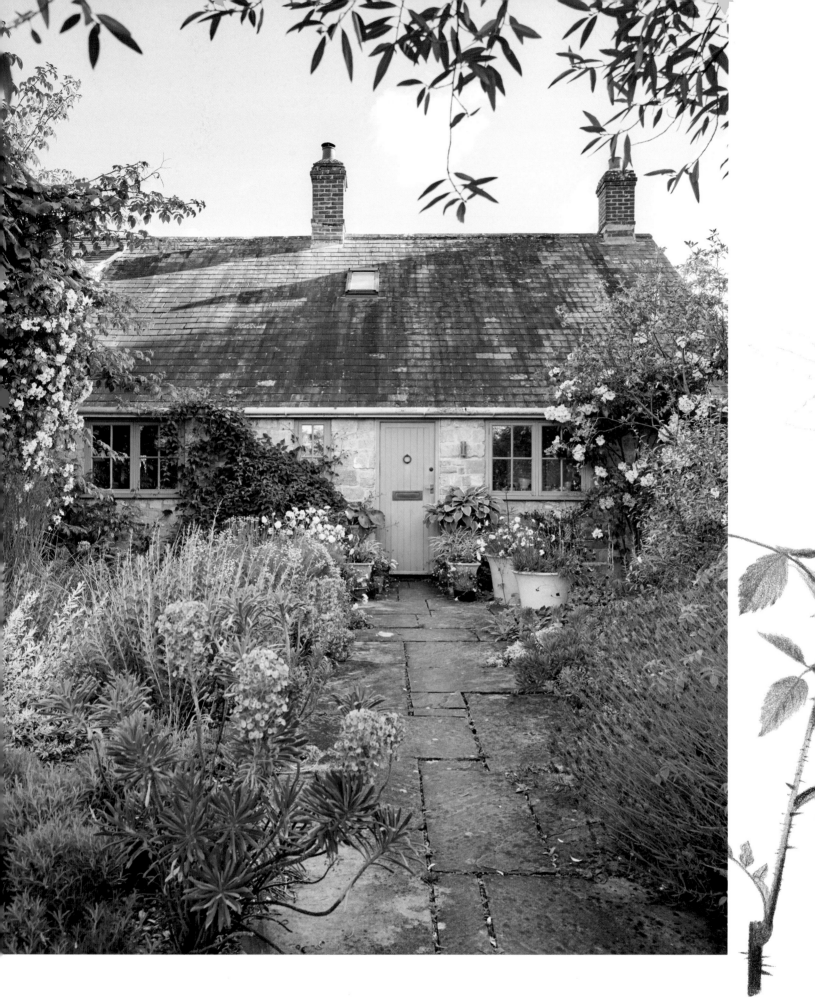

Spilsbury Farm

In his book *Gardens*, Robert Pogue Harrison wrote:
"For millennia and throughout world cultures,
our predecessors conceived of human happiness
in its perfect state as a garden existence."
Nowhere is this truer than at Spilsbury Farm,
the Wiltshire home of garden designer and writer Tania Compton
and her botanist husband Jamie.

In summer you'll find Tania in her dungarees and bikini top among the flowers, which she cuts to arrange *en masse* on her dining table and to fill her dyeing vats for fabrics and threads. The most sensuous moment of the gardening year is when she can press her nose into a bowl full of roses and inhale their scent.

While Jamie grew up as a gardener and spent ten years as head gardener of the Chelsea Physic Garden, Tania found her calling as a garden designer in a life-changing encounter with a meadow along the stony Phoenician tracks of Ibiza where she lived in her early twenties. The plant that caught her eye was anchusa, a Mediterranean native with tiny flowers resembling those of forget-me-nots, but whose color Tania compares to a prized 1980s Guerlain eyeshadow in shades of lapis lazuli flecked with gold. Soon she was beguiled by all the other gems that decorated the meadow, "its garland of cistus and convolvulus, ballota and euphorbia, fennel and rosemary, asphodel and helichrysum," as she describes in her book *The Private Gardens of England*. "In late spring the cultivated meadow's heart burst into pink and red with alliums and poppies, gladioli and corncockles."

LEFT
The front garden at Spilsbury Farm, with plantings as free-spirited as Tania herself.

Illustration, *Rosa pendulina*.

At Spilsbury Farm, the garden that Tania created with "The Botanist," as she affectionately calls Jamie, is as free-spirited as herself. Benign neglect, claims one of the leading voices of the British gardening world, is the secret behind her English arcadia. She never had time to draw up a master plan, so Spilsbury Farm is one long and ever-growing experiment undertaken with exuberance and joy. Sprawling over ten acres of land, the garden radiates from the house and melds into the landscape through a series of flower meadows, an apple orchard, a long hazelnut walk, and an iris-fringed pond. Hornbeams—pruned into tall columns, pear shapes, and large cubes—align with majestic oaks and inject some order into the wildness.

By her own admission, Tania is obsessed with roses—a key ingredient in the making of any part of Spilsbury. In the gravel in front of the house, Tania chose 'Wickwar' and 'Bobbie James' for what she calls "mesmerizing cascades of single white blooms," emphasizing that "single is key as I have little truck with deadheading as I do with pruning." 'Madame Alfred Carrière' and 'Ispahan' are selected for their rampant growth and lack of thorns. A couple of spiny roses, 'Sally Holmes' and *Rosa × odorata* 'Mutabilis', both single-flowered, are grown in the front garden for their "outrageous ability to flower and flower from June to October." 'Queen of Denmark', though ungainly stiff and thorny in her estimation, is given a prominent place in the border because "it has such beautiful flowers from bud to blowse." This once-blooming pink alba rose first flowered in 1816 and is closely related to another of Tania's favorite roses named 'Great Maiden's Blush', or more evocatively in French, 'Cuisse de Nymphe Émue'.

The orchard is edged in staggered rows of single white repeat-blooming rugosas, planted as rooted slips with box seedlings along the middle. As Tania explains, "They grow together and the box creates the enclosure with the roses in bud, in bloom, in hip and in buttery autumn color." In late September the luscious rugosa hips the size of cherry tomatoes are harvested for making jam by her friend, the ceramic artist Kaori Tatebayashi. "Kaori's rugosa jam is the best imaginable addition to vanilla ice cream," attests Tania.

Several springs run through the perennial embellished meadows, whose deep mineral rich soil is fertile grounds for species and old roses. Grouped by color, the rich rubies and dusky purples of 'Tuscany Superb', 'Charles de Mills', 'William Lobb', and 'Rose de Rescht' are woven in one area. The pinks of 'Fantin-Latour', 'Queen of Denmark' and 'Jacques Cartier' congregate in another. The tall meadow grasses hide what Tania humorously calls the

roses' "bad ankles and calves and thighs." Growing roses in the meadows has another upside, as Tania declares: "I can pick them with utter abandon and fill every room with sumptuous bunches and floating bowls to breathe in an atavistic paradise."

Rambling roses—'Félicité Perpétue', 'Rambling Rector'—
climb up trees to great heights, sending down clouds of blooms.
The shaded walkway
under the hawthorn beyond the orchard
turns scarlet in mid-summer with
a carpet of fallen petals from 'Scharlachglut'.

Further away from the house, where the landscape turns more wild, white roses hold court—the famed damask beauty 'Madame Hardy', alba roses 'Alba Maxima' and 'Semi-plena', and R. 'Dupontii', the last having the advantage of being deer proof. Also ignored by the deer is R. californica 'Plena', a species hybrid with lilac-pink semi-double flowers, introduced in 1894. Planted in groups near the gates and well-trodden paths is the eglantine rose, R. rubiginosa, whose "evanescent spicy baked apple scent of its leaves on morning strolls spreads contentment down neural pathways," explains Tania.

In autumn the paths are painted by rose hips in a medley of shapes and colors—the coral flacons of R. moyesii, the spiky yellow chestnutlike balls of R. roxburghii, the orange urn-shaped pods of R. 'Scharlachglut'. The teeny black currantlike hips of R. spinosissima remind Tania of the buttons on her first pair of red leather shoes. Masses of red eglantine hips envelop the hedge along the path to the pond, a banquet for the birds in the winter months.

Tania has an emotional response to roses. As she reflects, "There is something about the combination of their history, scent, beauty, color, form, hips, their variations and verisimilitudes that inspires respect, admiration, and adoration." While she concedes that they do need looking after, "I forgive them all their shortcomings." Her love of roses was sparked decades ago by a Chelsea Flower Show garden by John Scarman, the grower of Roses du Temps Passé nursery. Visits to Mottisfont and Sissinghurst and Ninfa filled her with inspiration. Books on roses by Graham Stuart Thomas, Martyn Rix, and Charles Quest-Ritson gave her a deeper knowledge and insight on their history and cultivation. In Iran, she saw her first rose in the wild, R. persica, with its "vivid cadmium yellow flowers and an aubergine center ringed by bleeding scarlet, vermilion anthers and golden pollen."

The magic of the rose is its scent,
which for Tania can elicit a whole body response,
leading her onto a trail of memories—
childhood afternoons
spent with her grandmother making scrapbooks,
the feel of rosewater splashing on her skin from years long past,
the mountains of rose petals during harvest season
in a small Iranian town she once visited.

Centuries of meaning are enfolded in the rose's perfumed petals. A timeless emblem of beauty from ancient Greece and Rome. A symbol of love from the days of Cleopatra. A heraldic flower of the kings and queens of England. Shakespeare sang of the humble eglantine while Robert Burns compared his love to "a red, red rose." More than any other flower, the rose is a keeper of memories, both personal and collective. It is a portal to other times and places in history. For Tania, "all gardening is Proustian," and she has filled her happy place—the garden—with roses, the madeleine of flowers. R+G

RIGHT
The flower garden at the back of house, with a glimpse of 'Ispahan' blooming in the border.

FOLLOWING
Spilsbury Farm in the month of June is a whirlwind of roses at every turn, including on Tania's dining table, where tall delphiniums join in the merriment.

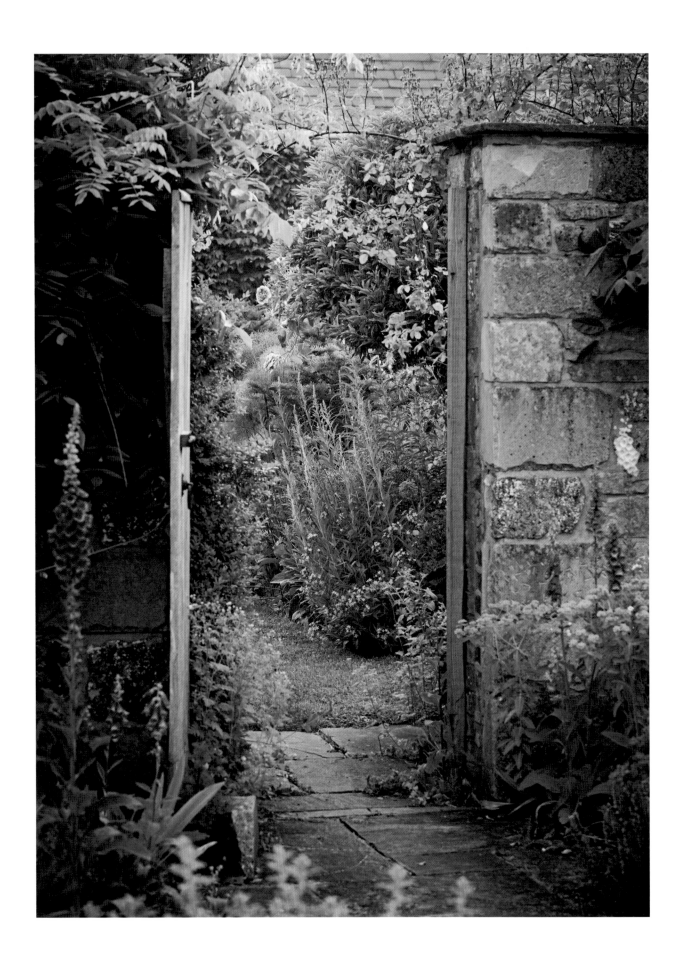

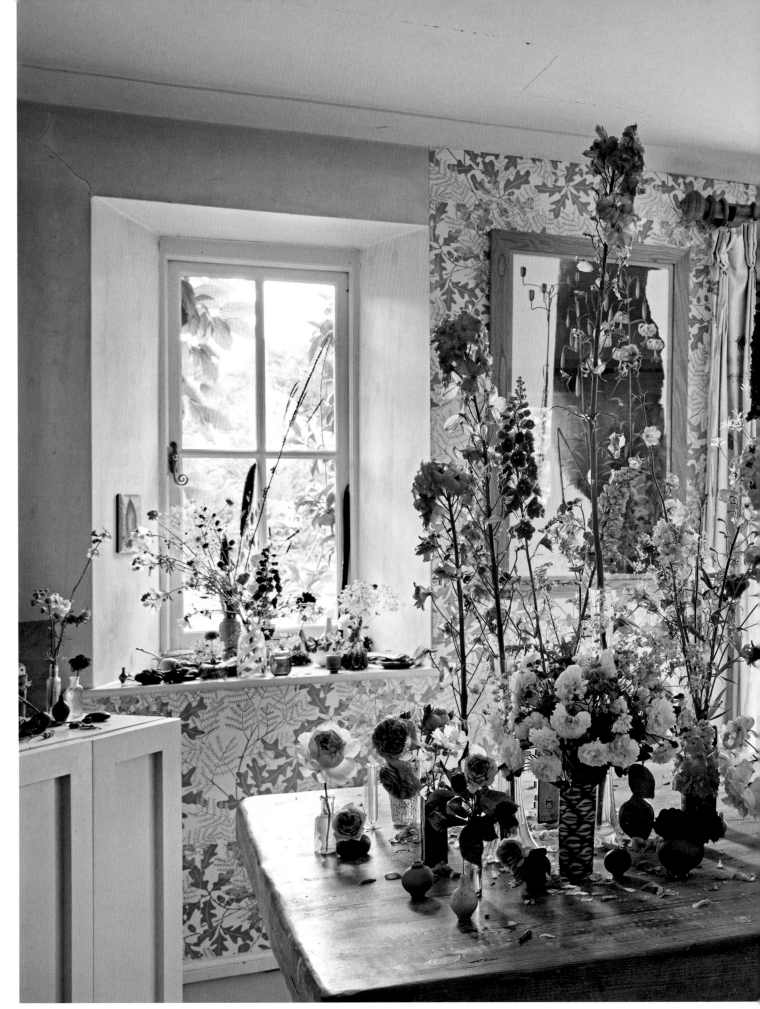

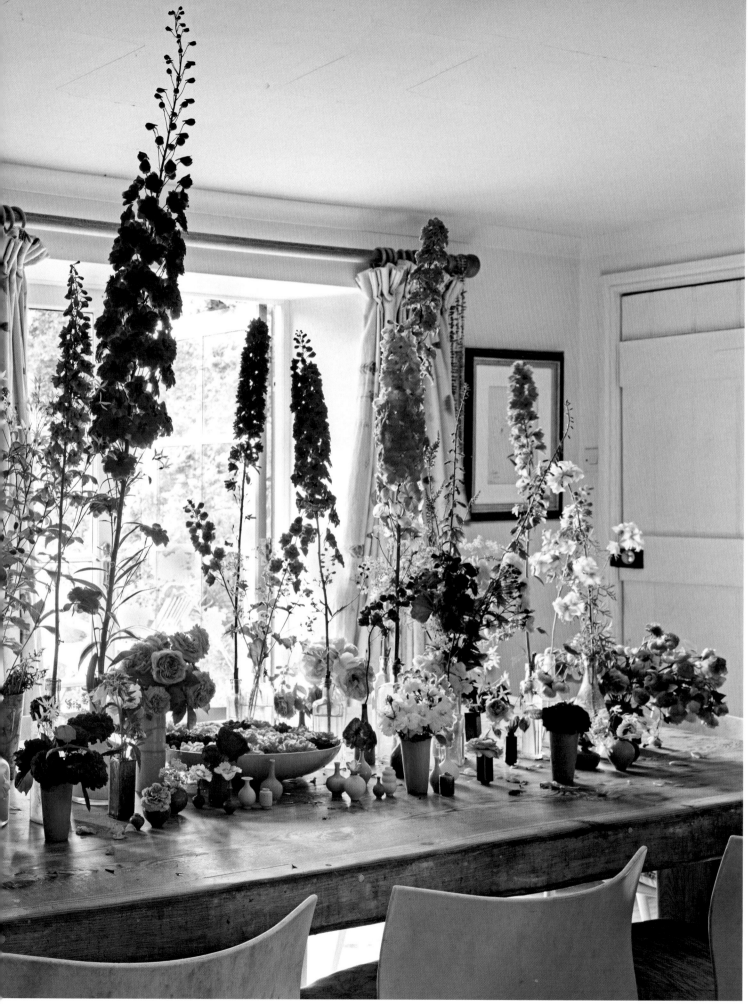

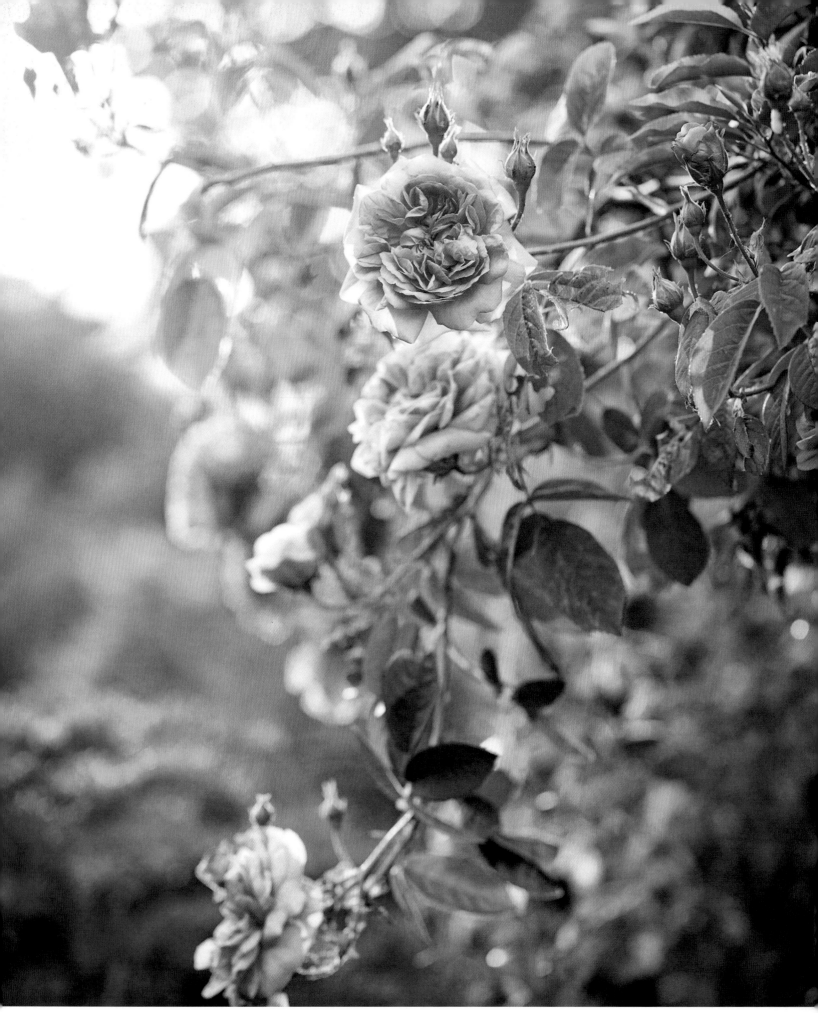

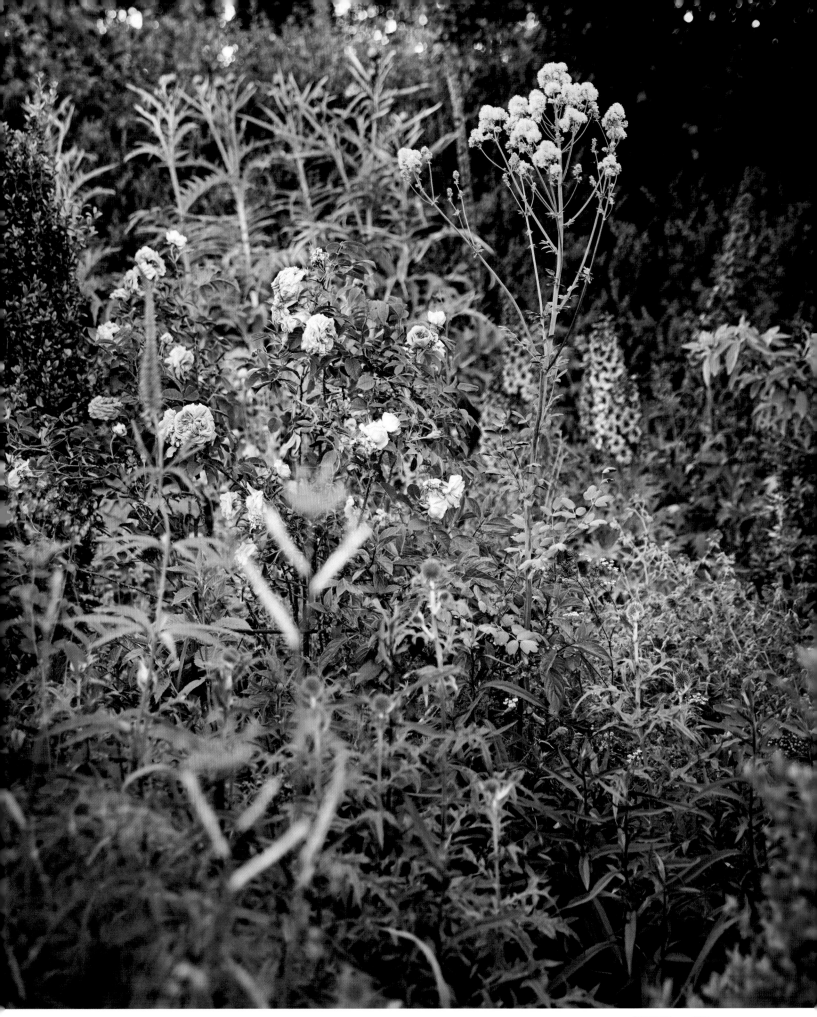

PREVIOUS LEFT
'Ispahan' was planted in the flower border
for its rampant growth and lack of thorns,
as well as its exquisite fragrant blooms.

PREVIOUS RIGHT
Also in the flower border is Tania's favorite
rose, the alba 'Queen of Denmark', whose
perfection of form Graham Stuart Thomas
deemed "almost unequaled."

LEFT
The intensely fragrant moss 'William Lobb',
with its incomparable dusky purple color,
is planted in the meadow along with other
richly colored old roses.

RIGHT
In the tall grass along the path, Tania plant-
ed roses in groups of colors, the dark, richer
tones of 'Charles de Mills' and 'Tuscany
Superb' on the left and the lighter pinks of
'Queen of Denmark' and 'Jacques Cartier'
on the right.

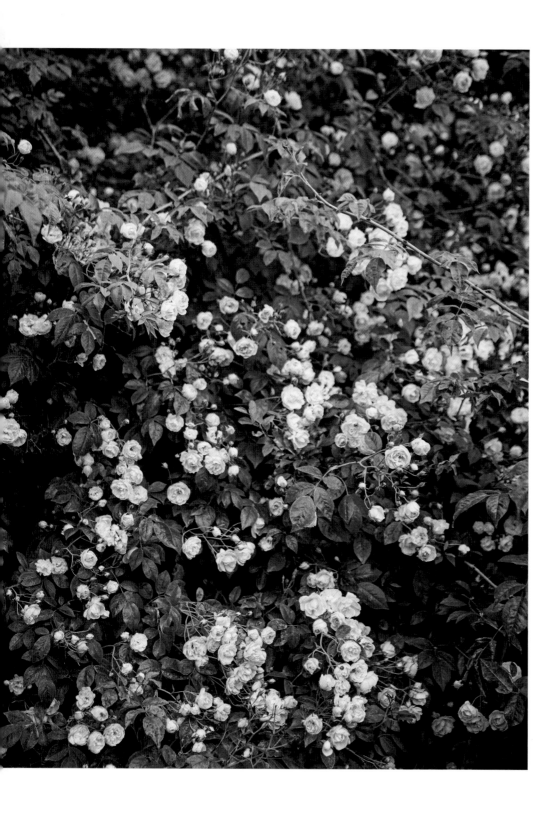

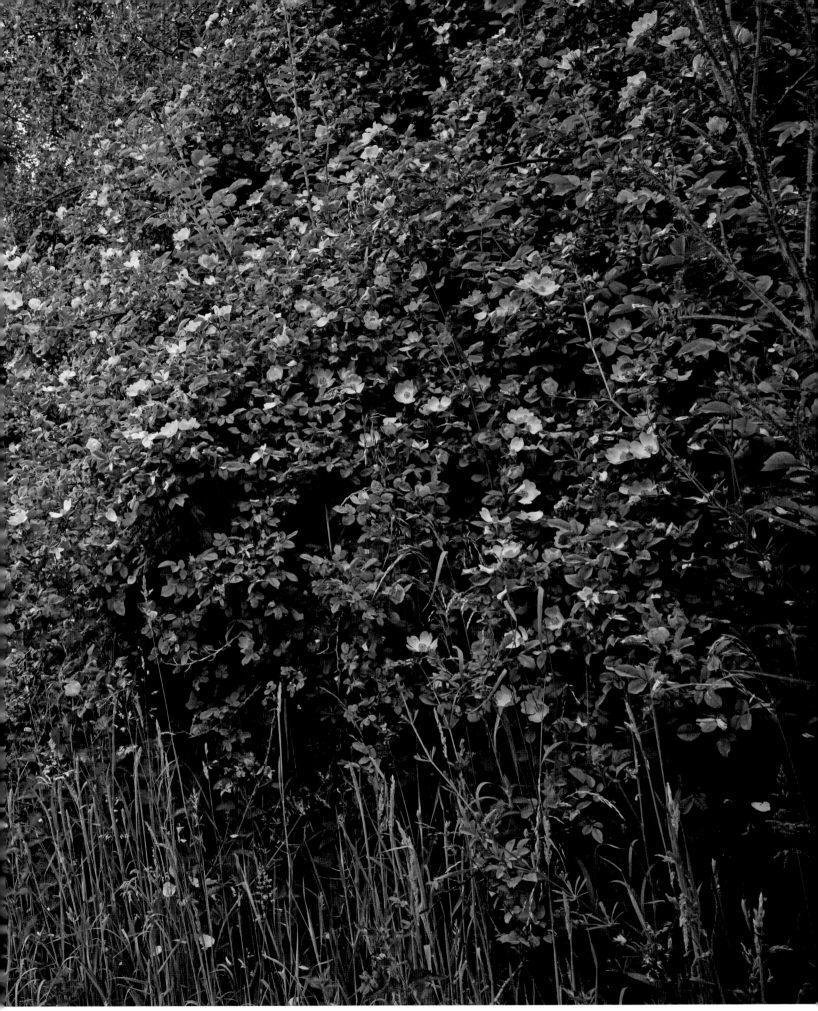

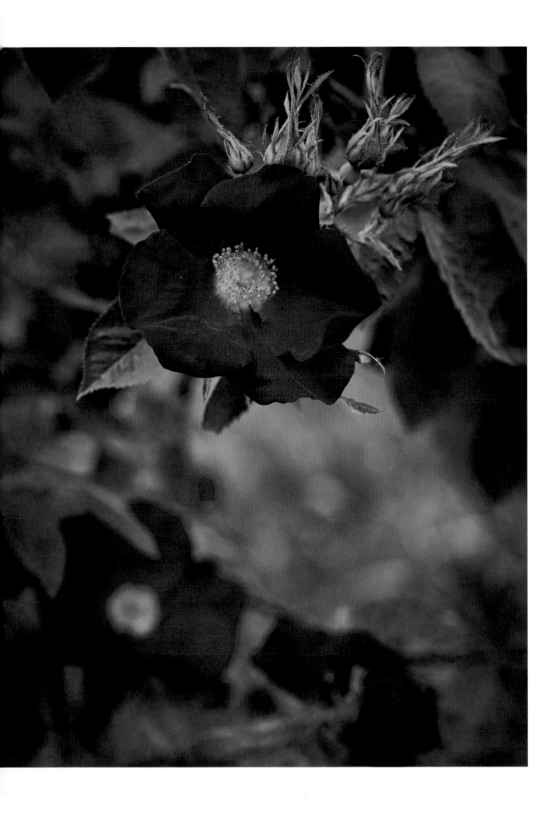

LEFT
Fiery-red blooms of 'Scharlachglut' light
up another path.

RIGHT
With fragrant lilac-pink semi-double
flowers and arching canes armed with
thorns, *R. californica* 'Plena' is a vigorous
rose that deer seem to avoid.

FOLLOWING
Rooted slips of *R. rugosa* 'Alba' were
planted with box seedlings to create
staggered rows of box "with the roses in
bud, in bloom, in hip, and in buttery
autumn color."

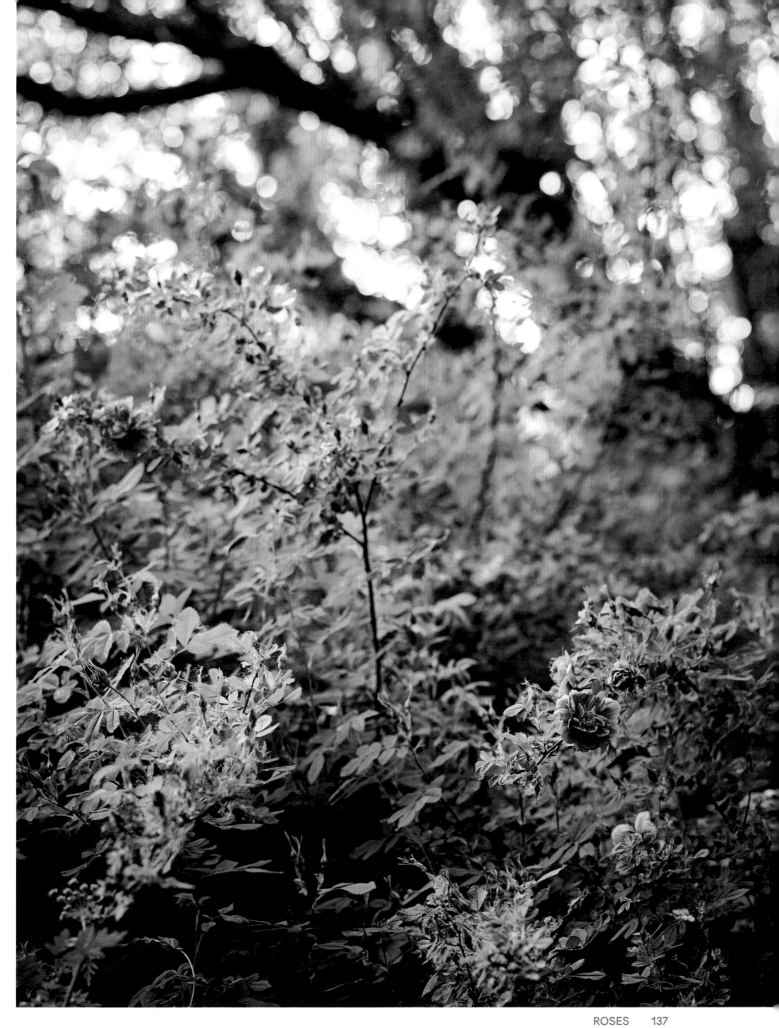

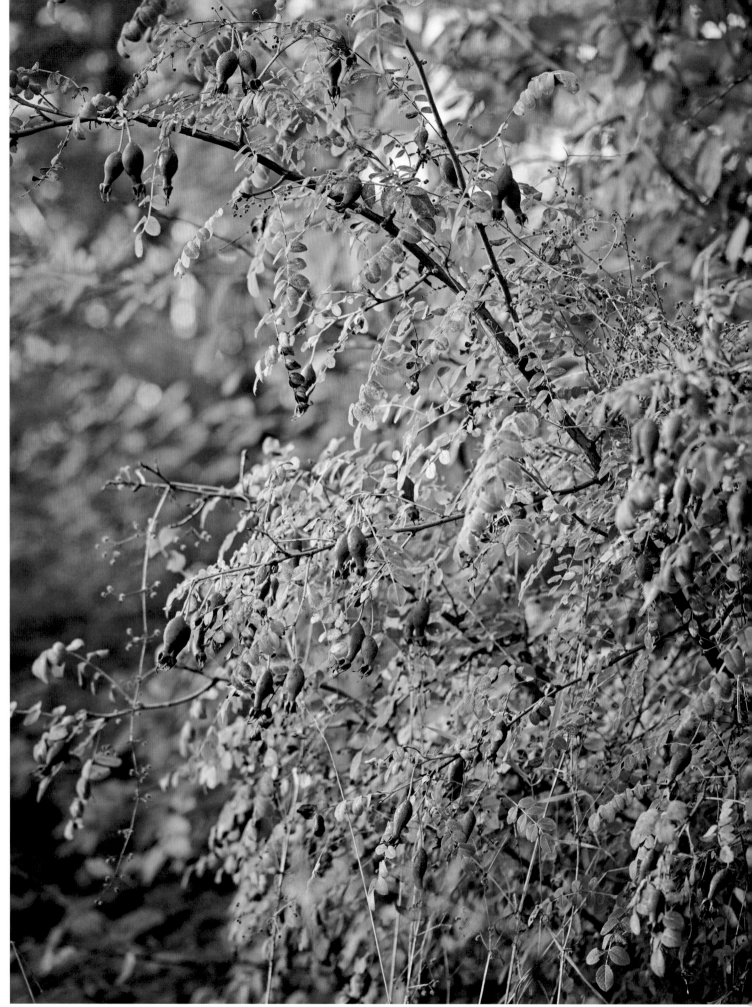

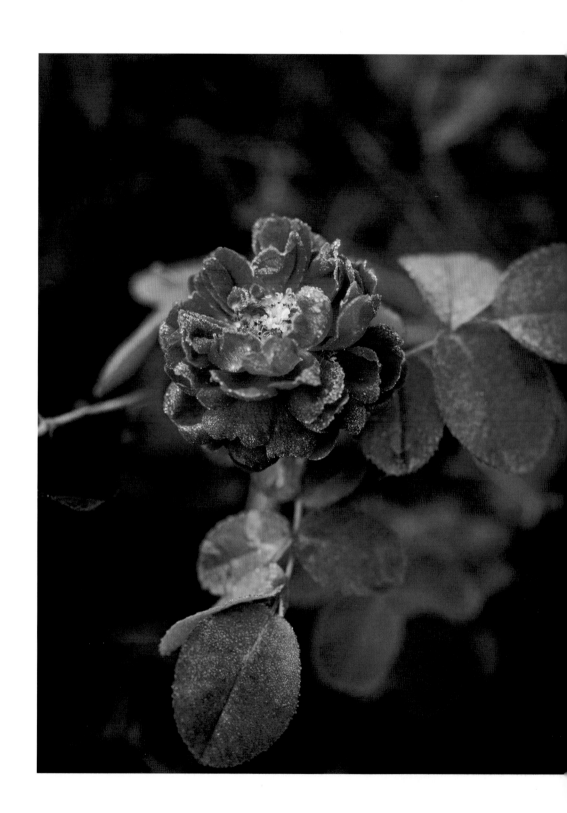

PREVIOUS
The same rows of box are decorated
with rugosa hips in autumn.

LEFT
In his book *Classic Roses*, Peter Beales
declares that it's the flacon-shaped coral
hips of *R. moyesii* that make this rose
so popular.

RIGHT
The last bloom of 'Rose de Rescht' is
dusted with frost.

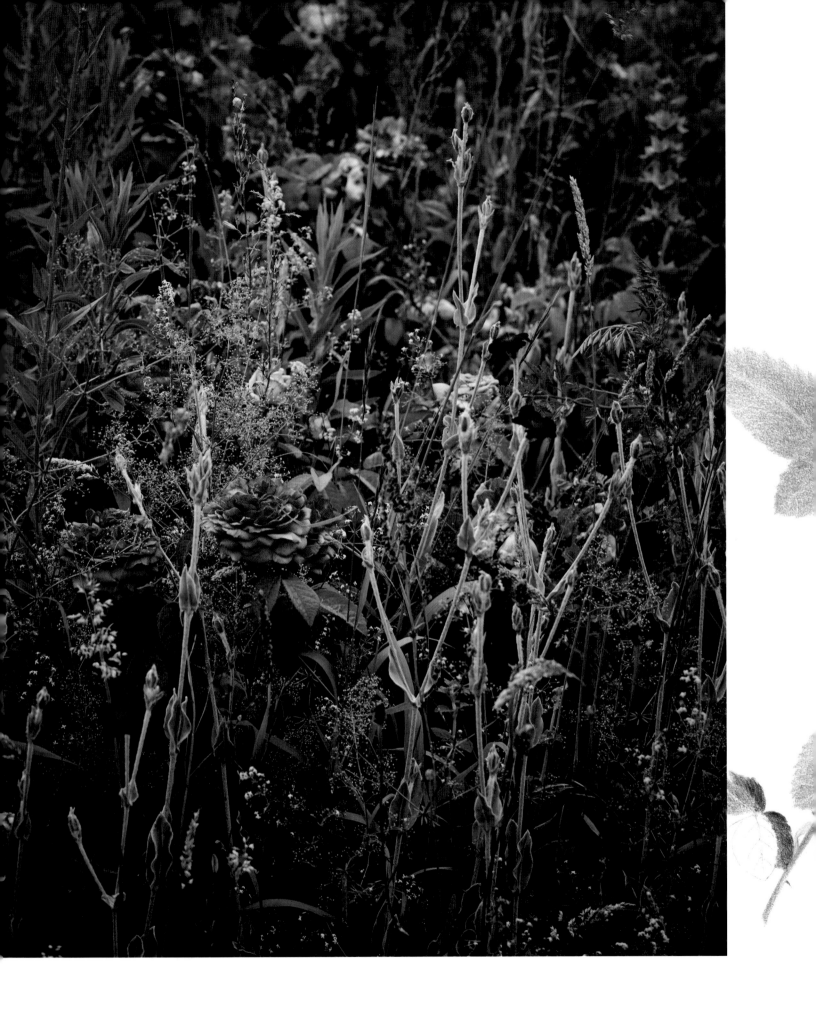

Roseraie de Berty

Hidden in a valley in the Ardèche region of France is
**a rose garden as wild and extraordinary
as the woman who created it,**
Eléonore Cruse, a former actress,
goat and sheep farmer turned rose grower,
and author of several books on her favorite flower, the rose.

The Roseraie de Berty, situated off an unpaved road just outside of the medieval town of Largentière, has been in the making for over forty years. Thousands of visitors have made the pilgrimage to this rose garden, which Eléonore generously opens to the public one month a year, when the roses are in full bloom. From mid-May to mid-June, a riot of roses takes over this enchanted valley, tumbling from long arbors, enveloping trees, erupting from the ground, weaving through the tall grass in the meadow. The roses are not confined in formal beds but allowed to mix freely with cultivated and wild plants alike, blending into the natural landscape between the river Roubreau and a steep slope, among the holm oaks and arbutus that make up the lush vegetation.

Eléonore discovered this secluded spot by chance in 1971. At nineteen, she had embarked on a trip to Africa in her Citroën 2CV, driving across Morocco, Mauritania, then Senegal and Gambia. Upon her return, city life lost all its appeal. Instead, a couple of apprenticeships prepared her for a farming life. A chance encounter led her to Berty, an old farm with a building that dates back at least two centuries. It had been abandoned for nearly twenty-five years, choked in brambles and overrun with invasive plants, the soil impoverished by chemical fertilizers and herbicides. But Eléonore was captivated by the landscape, with the charming river and its magnificent flora and fauna. A line of trees runs along the water's edge, ashes, alders, boxwoods, hollies, willows casting their shadows over a woodland floor filled with columbines, wild anemones, hellebores, primroses, periwinkles, soapwort, and various mosses and ferns, like the royal osmunda. She recalled seeing the diving dipper, the only passerine bird that hunts its prey by diving.

LEFT
In the tall grasses, mauve-colored 'Violacée' and 'Agathe Fatime' tangle with the silver foliage and crimson-pink flowers of rose campion, *Lychnis coronaria*.

Illustration, *Rosa gallica*.

In April, the meadows are carpeted in *Narcissus poeticus*, accompanied by the native orchids *Serapias lingua*. She quickly sold her two *chambres de bonne* in Paris and, at the age of twenty-one, became Berty's happy new owner. Thus began her life as a farmer while raising five children. It has not been a life without difficulties—there was no running water or electricity the first couple of years—but one that she has embraced with passion and creativity. The winters in those early years were spent weaving straw baskets, repairing the straw seats of chairs (which her grandfather had taught her to do), spinning wool (taught by an old neighbor), and dyeing. She wrote to the National Museum of Natural History in Paris, and seeds of rare plants used for dyeing were sent back to her. She grew flowers to sell as bouquets at the market, along with her vegetables, honey, butter, and cheese, so that her stand would sparkle with colors.

In 1984, while perusing the magazine *100 Idées*, she came upon a long article on the recent publication of a book by Charlotte Testu, *Les Roses Anciennes*, published shortly after the author's death. Seduced by the poetic vision of the roses, she ordered the book, which she read as if it were a novel. The historic roses looked nothing like the ones she had known in her grandmother's and father's gardens.

The roses from her childhood were typical of those found in French gardens in the 1960s, shrub roses, remontant, and brightly colored— emblems of postwar modernity, of France's Liberation.

"However," as Eléonore wrote in her book *Les Roses au Naturel*, "they didn't touch me as much as these astonishing roses that I discovered page after page, which spoke to me differently."

Inspired by *Les Roses Anciennes*, she ordered twenty-five varieties of roses, fascinated by their names—'La Virginale' (also known as 'Great Maiden's Blush'), 'Aimable Amie', 'Yolande d'Aragon', 'Zéphirine Drouhin', and many others. When the roses bloomed that first year, she experienced something unexpected. "Caught by a certain romance, I had the strange and fugitive sensation of communicating with my ancestors," she recalled. She could imagine the many rose breeders in the nineteenth century—it was the golden age of rose breeding in France—driven by their passion to create new varieties of the flower loved by Empress Josephine and celebrated by Redouté. Generations of nursery owners have then followed until the day she had the pleasure to touch the same roses more than a century later. "To be a rosarian," concluded Eleonore, "is to reconnect with my culture,

here at Berty, in this forgotten place." She decided to assemble a collection of historic roses, invite visitors to the garden, and develop a nursery of old roses to save them for future generations.

To prepare herself for this new endeavor, she sought the advice of expert rose growers. In 1986, she paid a visit to André Eve at his rose garden in Pithiviers. "He had created a charming universe with soft colors: perennials and clematis mixed with the rose bushes, giving that city enclosure a magical dimension," recalled Eléonore. He generously shared his knowledge of rose culture. The two went on to collaborate on numerous rose conferences and visited many rose gardens in England together.

When she set about looking for a specimen of 'Comte de Chambord', a Portland rose whose perfume Charlotte Testu had so praised in her book, Eléonore's cousin gave her the name of a specialist nursery situated an hour outside of Copenhagen. She immediately wrote to the nursery, but the owner was so busy he took six months to answer, which he did by telephone, in English. He ended the conversation by inviting her to do an apprenticeship at his nursery the following summer. The nursery, Rosenplanteskolen i Løve, had been originally established by Valdemar Petersen in 1930 with an important collection of historic roses. Petersen had been drawn to old roses for their distinctive shape and color, historical origin, and especially fragrance. He had also created a deep yellow hybrid spinosissima, 'Aïcha', which is still in cultivation today. In 1979, the nursery was sold to Torben Thim, an artist and landscape designer. Before taking over Rosenplanteskolen, Thim had studied, among other things, philosophy in Copenhagen, visual arts in Rome, and architecture in Morocco. An accomplished painter, he was introduced to the roses in Løve by the noted mid-century ceramic artist Conny Walther. He has since published numerous books on the history of roses, as well as essays and poems. At Rosenplanteskolen, Eléonore learned to identify the entire collection of more than 1,500 varieties of roses, improved her methods of cultivation, and developed a lifelong friendship with the eccentric Danish rose grower, who named a found gallica rose in her honor, 'Eléonore de Berty'.

Back home, a decision was made to let go of her animals in order to concentrate on the development of her rose nursery. As she wrote in her book, "I had to learn and relearn…horticulture, but also botany, history, architecture, painting, photography, theatre, music, writing…. Ten professions in one offered themselves to me alone as a self-taught person, like a bouquet of roses." Just as she had grown her vegetables organically, she would

do the same with the roses. Care is taken at the planting stage to ensure that the right rose is given the right place. Once established, the plants are not given fertilizer of any kind. The repeat bloomers are deadheaded after the first flush of blooms. Pruning is done in early winter. Growing roses for the nursery allows Eléonore to study their habits and characters throughout the year. Visits to gardens in other parts of Europe—Denmark, Germany, England, Ireland—feed her knowledge of how each of the hundreds of varieties of old roses might behave, but she would never attempt to reproduce certain designs, however much she likes them. The garden at Berty has taken its form slowly over time, enlarged in places every three or four years to make room for new introductions. To connect the garden to the woods, roses were planted at the feet of the holm oaks. Roses of great stature were also strategically placed to blend into the landscape.

Climbing roses grown on tall arbors cascade down in curving silhouettes, echoing the undulations of the trees and hills in the landscape. It's hard to tell where the garden begins and where it ends.

"I want to nestle the garden in the hollow of this valley as if it has always been here," wrote Eléonore in her open letter to the garden's visitors.

In recent years, writing and painting have taken increasingly more of her time when she is not gardening and caring for her collection of more than five hundred roses, attending rose conferences around the world, or judging the international Bagatelle rose competition. I had the fortune of spending three days with Eléonore in her rose garden in the wild, listening to the story of how she gave up her bohemian life in Paris to raise goats in this rural valley and finding her true nature among the roses. We talked long into the night, two strangers brought together by our quest for beauty, whose emblem is "the Flower of Flowers." I left Berty fortified by the gift of friendship; the introduction to so many old roses—but new to me—'Pink Leda', 'Hippolyte', 'Duchesse de Verneuil', 'Jenny Duval', to name a few; and the indelible memories of this magical rose-scented valley. R+G

RIGHT
Clambering up the wall of the centuries-old building is the rambler 'Alexandre Girault', bred in 1907 by René Barbier, whose family-owned nursery introduced hybrid wichuranas to Europe in the 1900s.

FOLLOWING
With roses blooming among tall grasses, hanging from trees, and cascading down arches, it's hard to tell where the garden begins and where it ends.

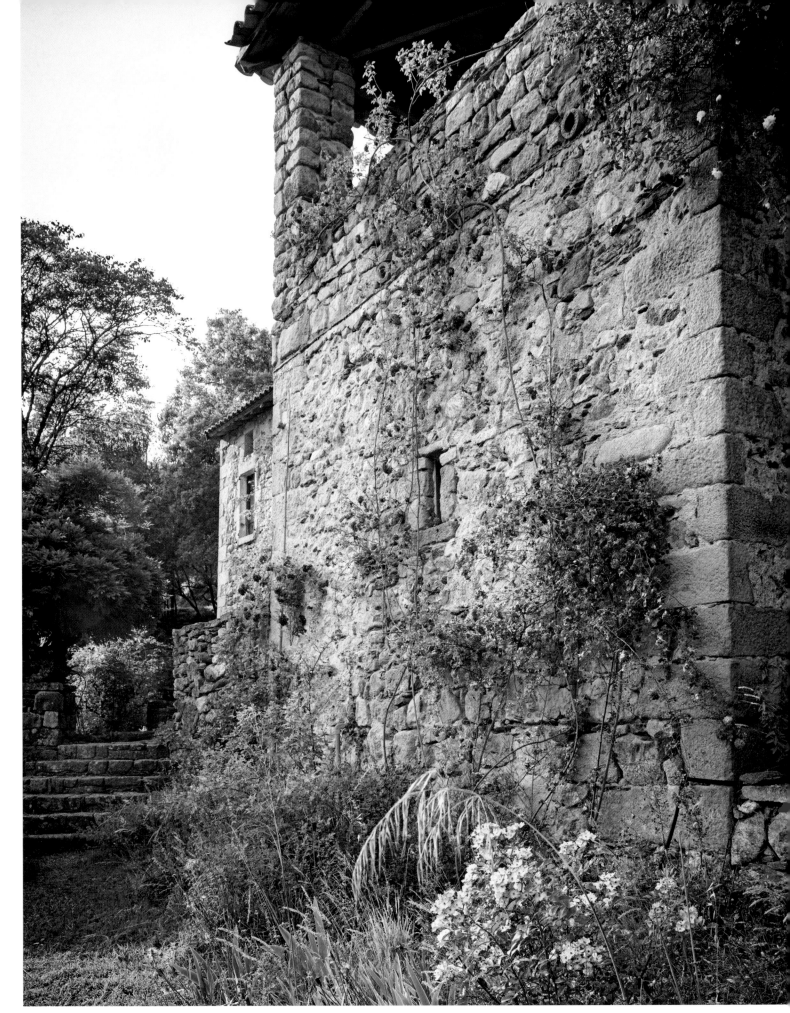

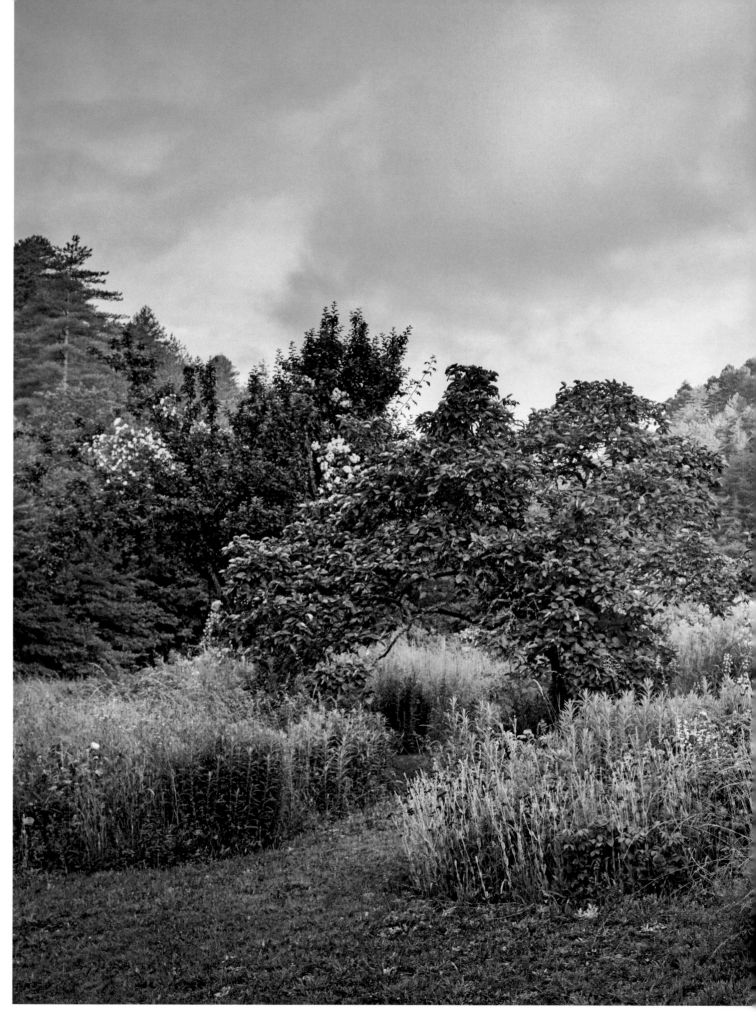

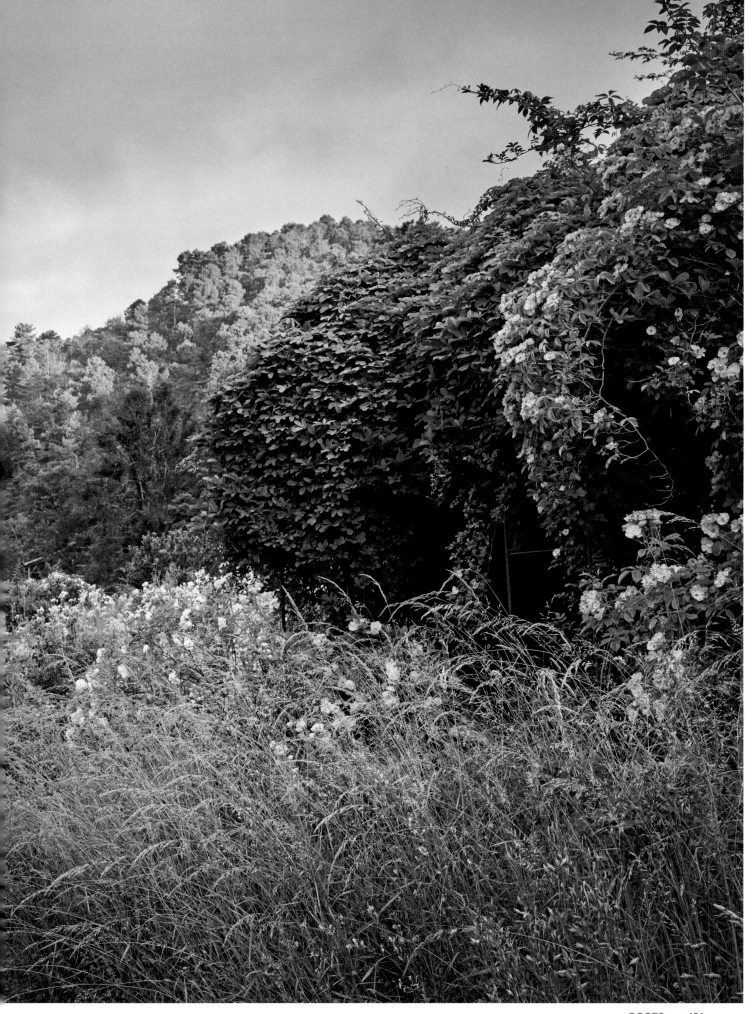

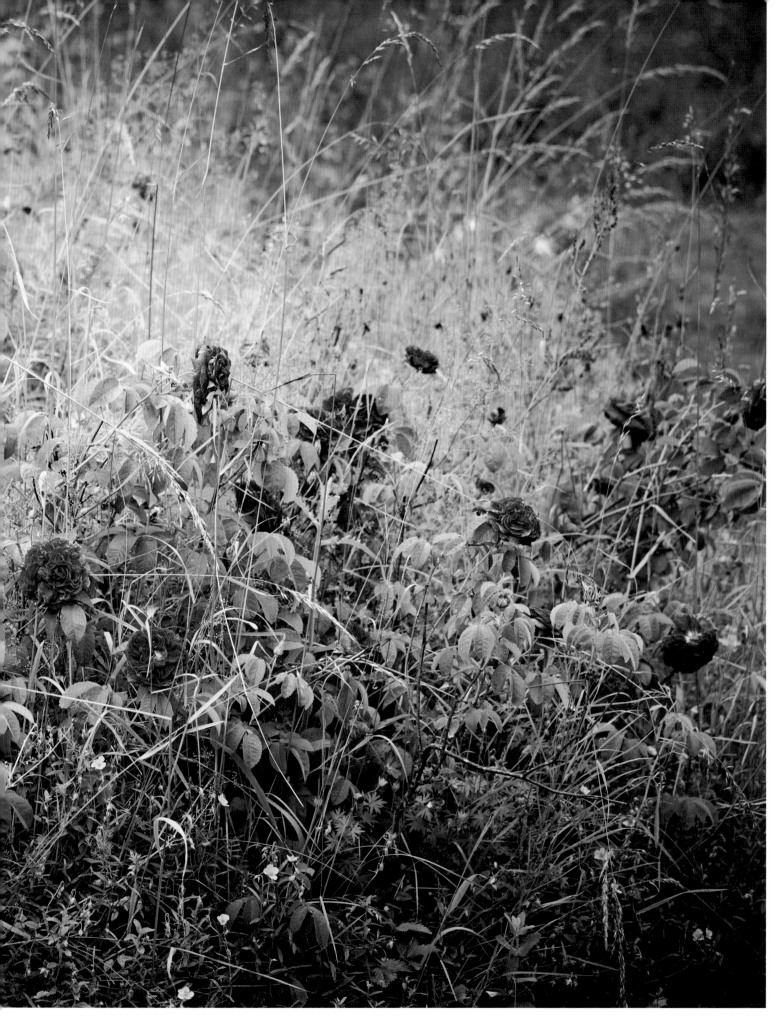

LEFT
'Charles de Mills' is a sumptuous gallica
of uncertain origin, but it is believed
to have originated in the Netherlands
before 1786.

RIGHT
'Jenny Duval', seen here tumbling over
the wooden bridge, is often confused
with another gallica, 'Président de Sèze',
both having two-toned flowers with dark
centers and lighter edges.

FOLLOWING LEFT
Henri Fantin-Latour painted some of the
most opulent roses and according to one
account died after collapsing among the
roses in his garden. This rose, whose origin
is shrouded in mystery, was introduced
by the English nursery T. Hilling & Co.
in 1945 as 'Fantin-Latour'.

FOLLOWING RIGHT
'Albertine' is another best-selling rambler
from the Barbier nursery, with coppery-
pink buds that unfurl into delicately
ruffled petals.

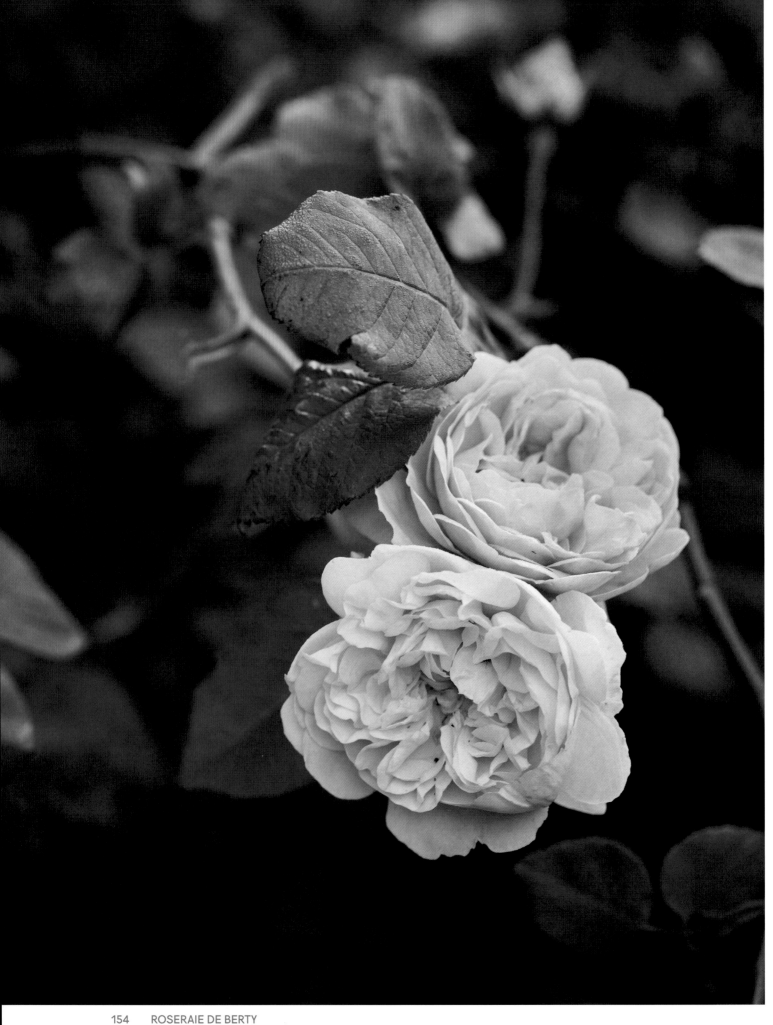

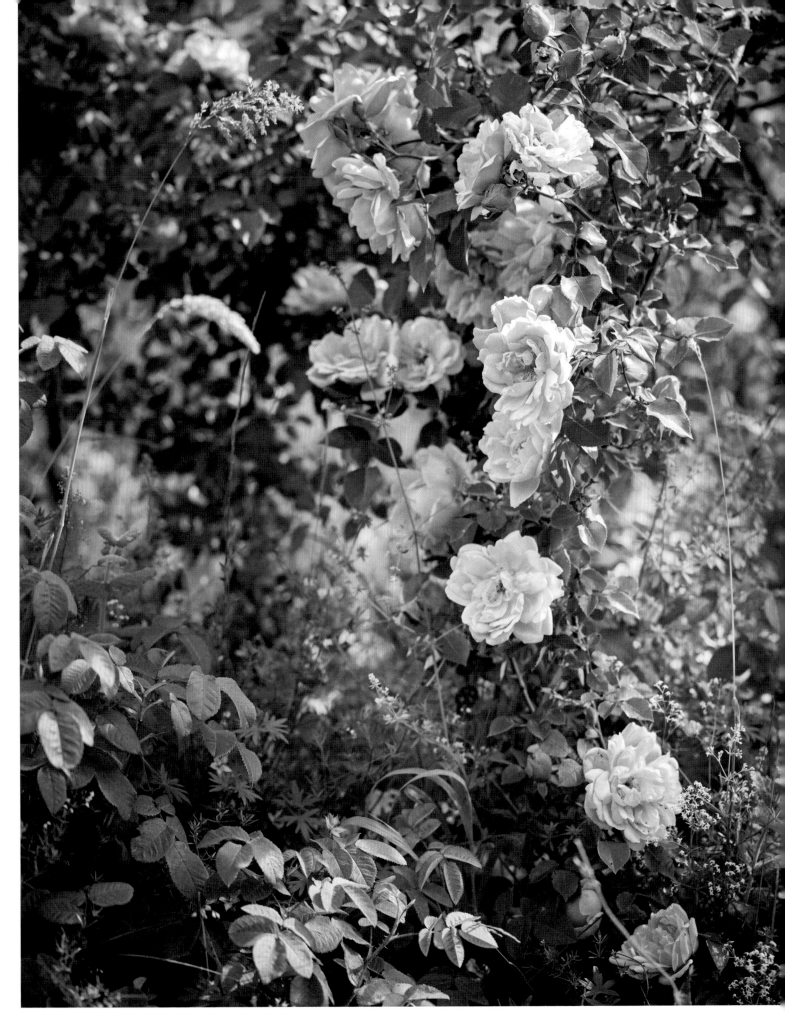

LEFT
The violet hue of the gallica 'Hippolyte' deepens in the meadow at dusk.

RIGHT
Roses grow rampant and merge with the landscape at Berty, strewn in the grass or tumbling down from great heights like an avalanche, wild with abandon.

FOLLOWING
An apple tree is dressed in the dainty white blooms of 'Bobbie James', with the elegant gallica 'Splendens' at its feet.

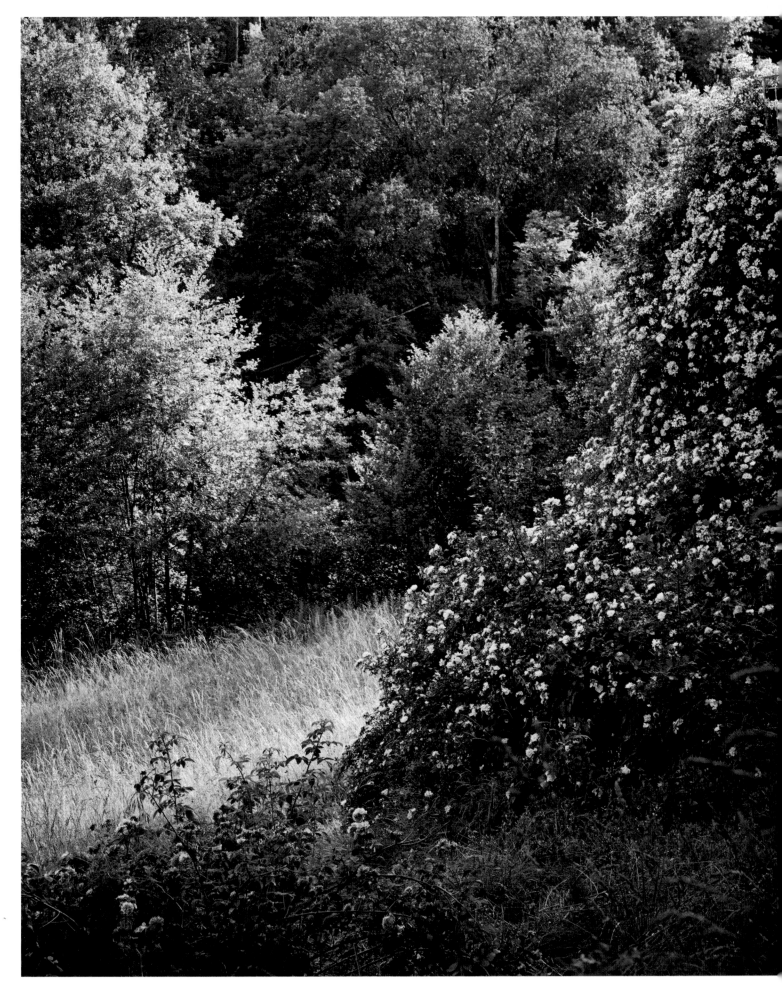

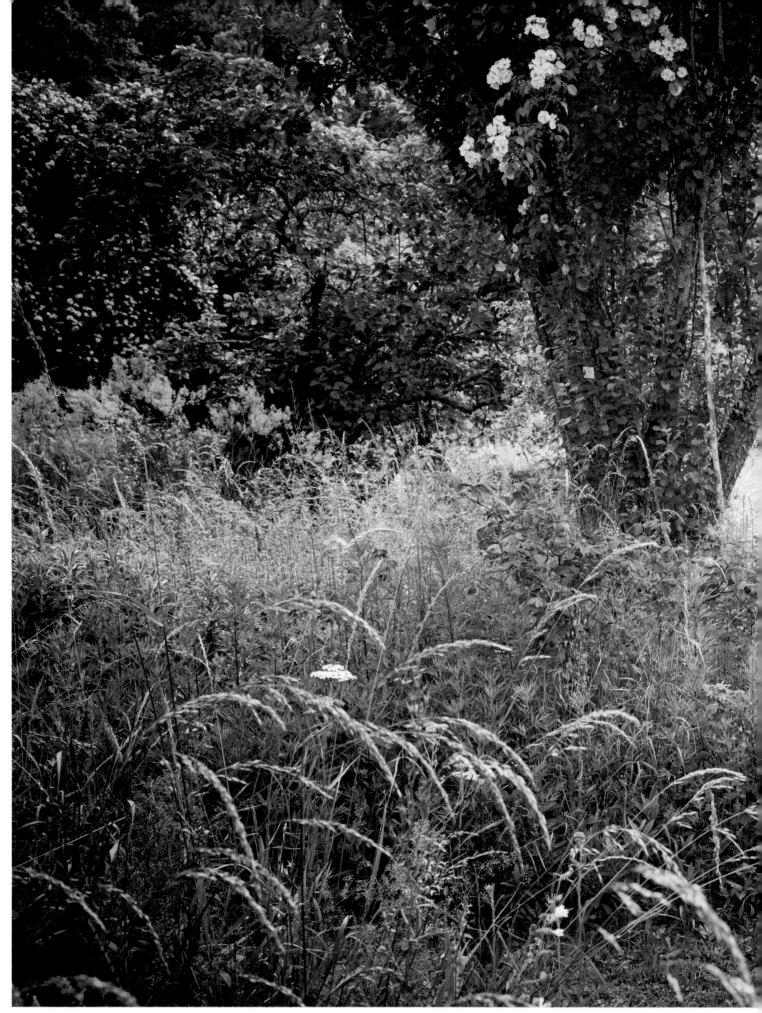

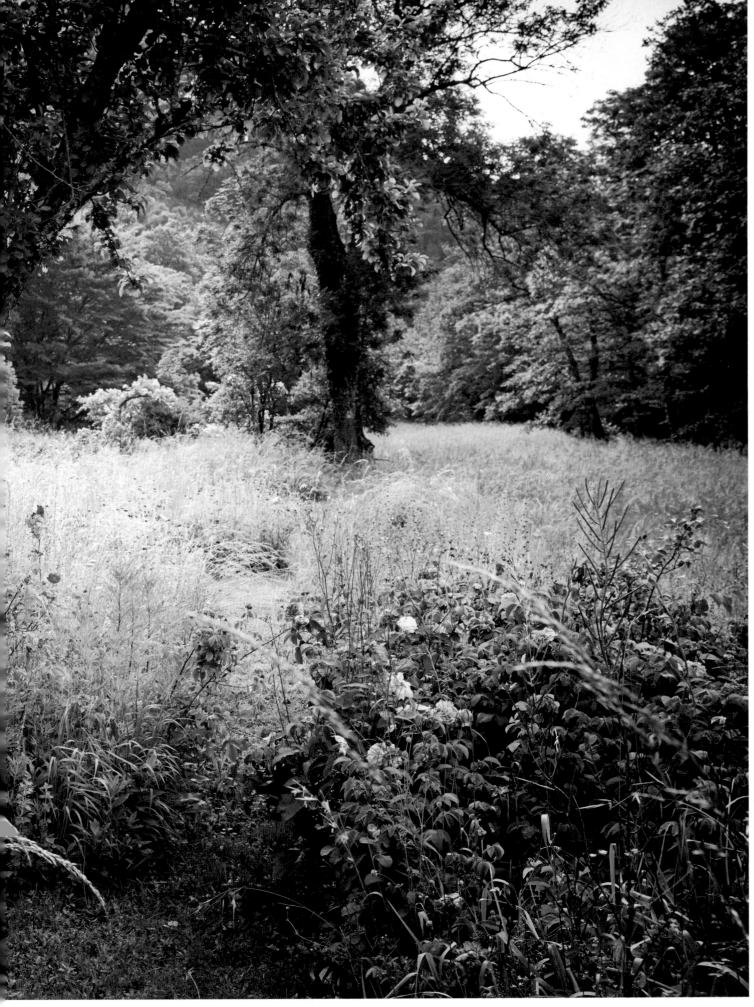

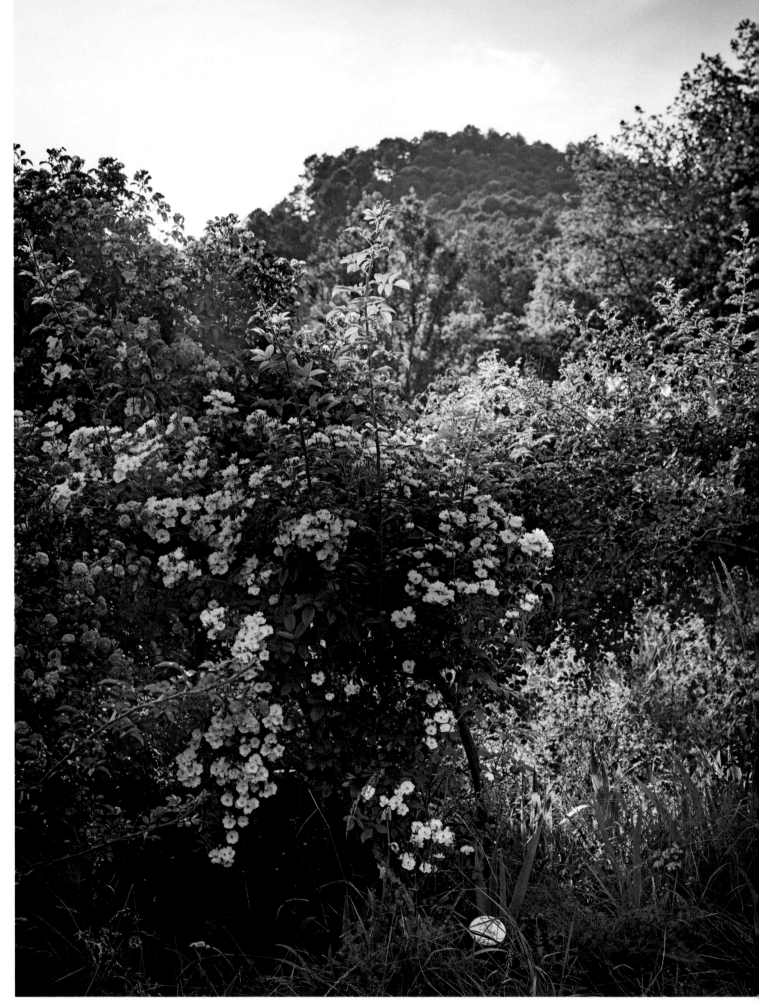

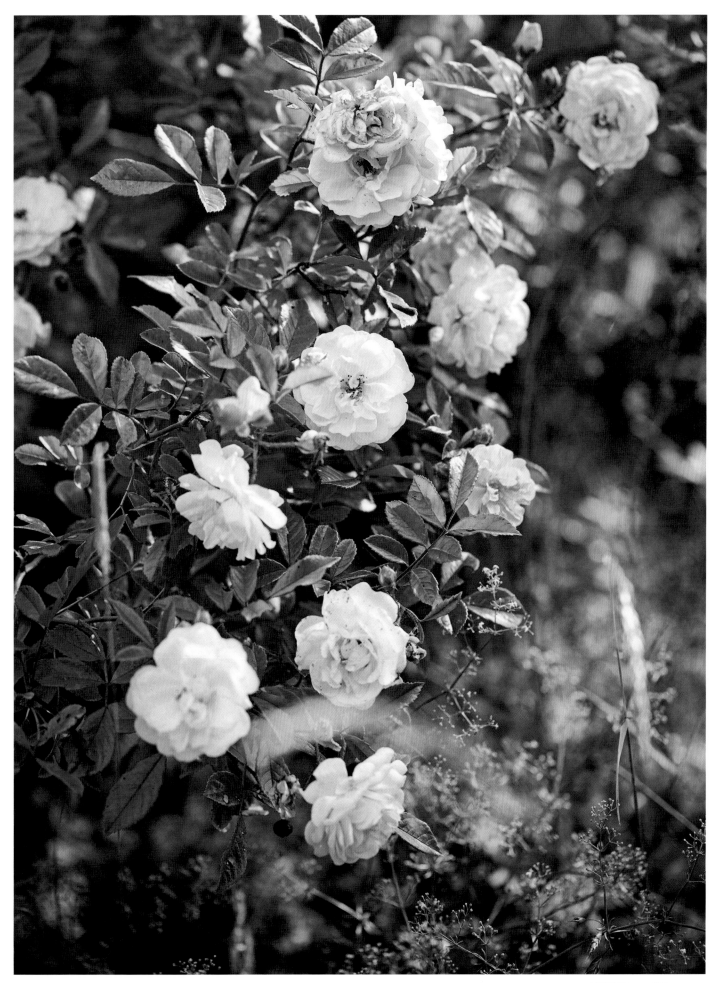

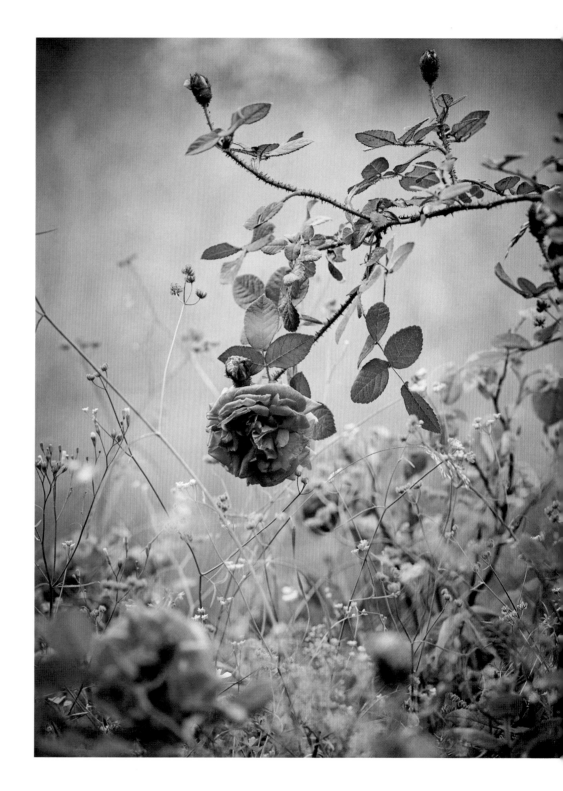

PREVIOUS LEFT
A series of ramblers and climbers are woven together to drape over a long arbor with their colorful blooms.

PREVIOUS RIGHT
'Ghislaine de Féligonde' is a carefree rambler with a long blooming season.

LEFT
The strawberry red blooms of 'Alexandre Girault' glow against the verdant backdrop of the dense woodland that shelters the valley at Berty.

RIGHT
Growing old roses connects Eléonore with the rich heritage of rose culture in France. This elegant moss, 'Duchesse de Verneuil', was bred in 1856 by Pierre-Hubert Potemer, one of the many French rose growers in the nineteenth century who contributed to the extraordinary expansion of the singular genus *Rosa*.

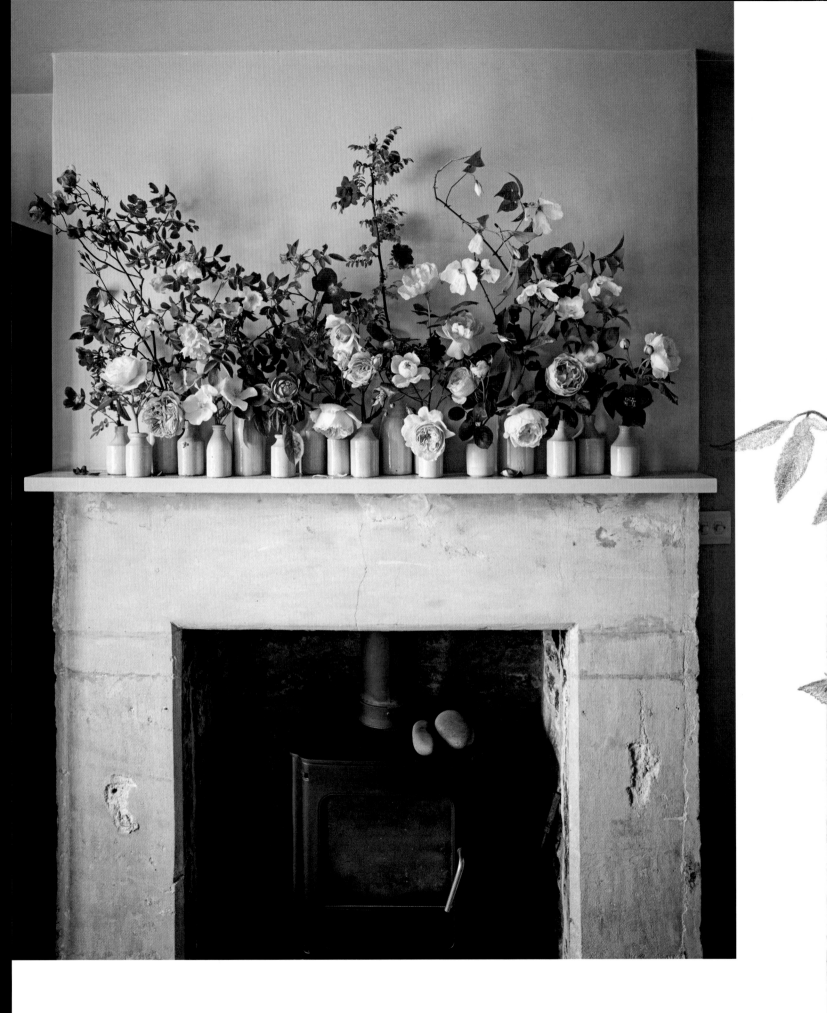

Hillside

Dan Pearson is a British landscape designer
whose work spans the globe,
from the 593-acre Tokachi Millennium Forest in Japan
to countless projects in his home country,
as well as Italy and the United States.
A gardener since the tender age of five,
he designs gardens that are
**borne out of an understanding of
the natural landscape and a deep knowledge of plants.**

Since 2010, Dan and his partner Huw Morgan have made their home at Hillside, a former smallholding perched atop a narrow valley, surrounded by a patchwork of steep sloping fields, all under a boundless sky. Gardening in a landscape so rich in natural beauty has nudged his practice to an ever more attentive, nuanced, and gentle approach. As he articulated in an interview with the Australian garden writer Georgina Reid: "I'm interested in using plants in a way that feels so right that you almost don't notice them." Hillside, he adds, "provided us with a canvas to do something that connected very deeply with nature. I wanted to feel like a smaller part on the land."

The slopes of the valley at Hillside were once market gardens before being given over to grazing for cattle. A neighbor remembers them being covered with vegetables in rows from when she was a child. An old orchard still stands in one of the fields. Dan and Huw spent the first five years at Hillside getting to know the landscape intimately, tramping the fields to observe the different ecologies in every wild corner, charting the seasons with the movement of the sun, the flowering and fruiting trees. They tended the land with a light hand, letting the vegetation grow back along the ditch where the farmer had once cut back the hedge, seeding some of the fields to turn them back to meadows, and planting trees, including what Dan

LEFT
To mark the seasons, Huw decorates the mantel with flowers from the garden throughout the year. In June, he fills the vases with a bounty of roses.

Illustration, *Rosa laevigata*.

describes as a "blossom copse on the top field where some ancient terraces crease the hillside." On the banks behind the house, he put in crabapples with flowering bulbs at their feet.

Today the cultivated gardens at Hillside, filled with treasures collected over a lifetime of gardening as well as new plant discoveries, take up only one acre of the total twenty acres of the land. A half-acre perennial garden, brimming with textures and colors, is as rich and intricate as a medieval tapestry. A kitchen garden is carved out in front of the barns, anchored by a pair of troughs. Narrow beds at the western end of the garden are planted with soft fruits to provide wind protection. Larger beds are reserved for herbs and vegetables while espaliered pears are grown against the cinder block retaining wall. The area above the wall in front of the barn is the cutting garden, where a selection of David Austin roses is grown as trials. After consulting with the rosarian Michael Marriott, Dan drew up a list of twenty-four varieties—selected for disease resistance, scent, color, and good foliage. Through the years, many have succumbed to black spots in the damp climate while others have proven more resistant. 'The Lark Ascending' is the most vigorous, growing a good six feet in a season, with a near constant flush of semi-double apricot blooms. 'Mary Delany' is a standout with its graceful habit and shell pink flowers. 'Lady Emma Hamilton', bearing golden orange flowers and tinted dark plum buds, is another strong-growing plant, with a strong zesty scent to boost. 'Jubilee Celebration', heady with an old rose perfume, has opulent coral pink roses that fade into shades of salmon, yellow, and orange. Growing these roses as cut flowers enables Dan and Huw to study their habits both in the garden and in the vase. Ultimately, Dan would like to refine the selection to just a few, keeping only the true favorites that have revealed themselves slowly over the years, like the deep red and strongly scented 'Munstead Wood'.

The sumptuous David Austin roses might be unsurpassed in a vase, but it's the more restrained species and single roses that truly claim Huw and Dan's hearts.

No other rose can better conjure the essence of the English countryside than the native sweet briar or eglantine, *Rosa rubiginosa*, prized for its delicious apple-scented foliage. Dan wove sweet briar into a long hedge bordering a path behind the house to catch its fragrance. Eglantine seedlings were also planted widely in the fields, near the gates and the stiles along the hedges to cast their perfume on the pair's walks over the land. While deer

love most roses, they avoid the scented foliage of *R. rubiginosa,* making it an invaluable asset in the garden as much as in the wild. Close in resemblance to the sweet briar is the common dog rose, *R. canina.* At Hillside, it is grown in the sunny spots higher up the slopes and along the banks behind the house. In the old orchard, it scrambles up an ancient apple tree, throwing its dainty pink flowers over the lumbering branches like confetti for two weeks in June. The third English native rose, the field rose, *R. arvensis,* is more earthbound, stretching its long limbs in the shadier areas along the hedgerows. Other species roses are planned for the future, including *R. sweginzowii,* a wild species from central to southern China introduced to the United Kingdom in 1902, and *R. setipoda,* often described as one of the most handsome Chinese roses, with dark red flagon-shaped hips.

Two decades ago, when he was judging the open gardens of Islington, Dan fell in love with *Rosa × cooperii.* Given a cutting, he grew Cooper's Burmese rose in his London garden, where it monopolized an entire wall. He brought a cutting from the same plant to Hillside and gave it a spot outside the corrugated tin barn.

In June, clouds of large cupped ivory flowers float above a sea of dark glossy foliage, connecting with the whites of the hawthorns and creamy elders in the hedgerows in the fields.

Though doubtless a beauty, Cooper's Burmese can be a beast if left alone. When it threatened to overwhelm the barn after a few years, Dan scaled back the plant by half, a job made painfully arduous by the rose's thorny limbs.

Another treasured rose is a *R. spinosissima* that Dan raised from seeds collected in the sand dunes of Oxwich Bay on the Gower Peninsula, where Huw holidayed each summer as a child with his Welsh parents. More diminutive in habit, this Scotch briar is weighted with inky black hips by midsummer. *R. soulieana,* a robust species rose from the rocky hillsides of western China with luxuriant gray-green foliage and masses of creamy blooms that give way to a profusion of small orange hips in autumn, is a beloved of Huw. On the banks behind the house, the tall limbs of recently planted *R. moyesii* 'Geranium' jostle through the tangle of grasses, daisies, and byzantine gladioli, bearing flowers whose shade of red Vita Sackville-West, writing in her popular garden column, deemed indescribable before positing that "it is the color I imagine Petra to be, if one caught it at just the right moment of sunset." In autumn, the canes display their distinctive

bottle-shaped hips that Sackville-West exhorts her readers to "preserve at all costs." On the slope above the pond, Dan planted *R.* 'Scharlachglut', a hybrid gallica sometimes referred to by its English name 'Scarlet Fire'. Its tall arching stems bear an abundance of large single flowers that turn from bright scarlet to cerise pink as they age.

In Greek mythology,
the red rose had its origin with Aphrodite,
the goddess of love.
In a rush to save her mortal lover Adonis from a wild boar,
Aphrodite brushed against a white rose bush
and cut her ankles on its thorns.

Her blood stained the petals and thus the red rose was born, freighted with the ardor, yearning, and passion of love, giving us William Blake's "crimson joy" and Pablo Neruda's "blaze of the rose-tree." Reflecting on his favorite roses, Huw notes, "As with many plants, it is those that have a particular resonance or emotional context which lodges them in one's memory. Dan and I met in 1991, but it wasn't until Dan took me to Home Farm to meet his client, mentor and friend, Frances McGarry (then Mossman) in the summer of 1992, that I really understood what it was that he did as a gardener and designer. The atmosphere at Home Farm was relaxed and generous. The gardens on the edge of wildness, luxuriant and sensual. I was incredibly moved by the garden and we would visit often, with Frances encouraging me out into the garden on arrival to pick as many flowers as I could for the house. We would cook together in the evenings from a well-thumbed copy of the first *River Cafe Cookbook*. The garden formed a potent backdrop to the beginnings of our now thirty-three-year-long relationship. The roses Dan grew there are still some of our favorites: *Rosa × odorata* 'Mutabilis', *R.* 'Scharlachglut', *R. moyesii* 'Geranium' and the wild roses, of course." The species and single roses, in their simple beauty, tell the story of Huw and Dan's enduring love in gentle whispers, like a secret code written into the landscape at Hillside. ▪

RIGHT
A selection of David Austin roses is grown as trials in the cutting garden.

FOLLOWING
Bordering the path from the house to the barn and cutting garden is a long hedge of *Rosa rubiginosa*, ending with a large shrub of 'Mutabilis' that is nearly always in bloom.

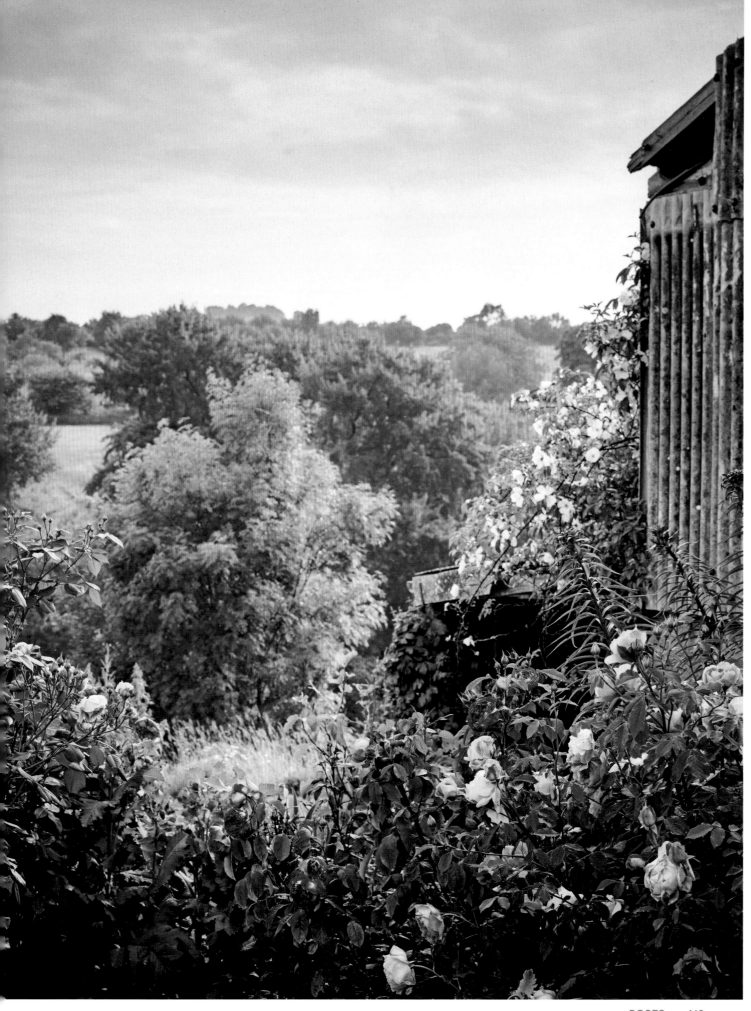

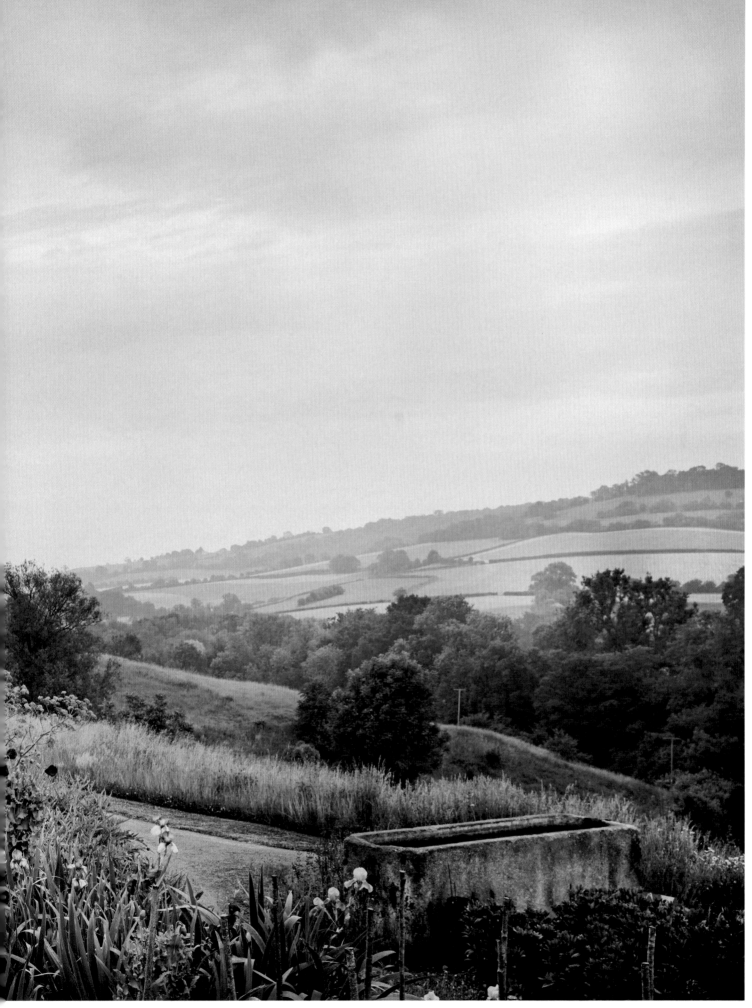

LEFT
LEFT
Arching canes of *R. canina* tumble
over the long grass, mingling with daisies
and orchids.

RIGHT
The cerise-pink *R. pendulina* is one of Dan
and Huw's beloved single-flowered roses.

FOLLOWING
As Dan writes in his book *Natural
Selection*, "single roses will glow in the
June green and hips will take on the
mantle to ease the shift into the winter
monochrome with a last bolt of color."
'Scharlachglut' fires up the meadow in June.

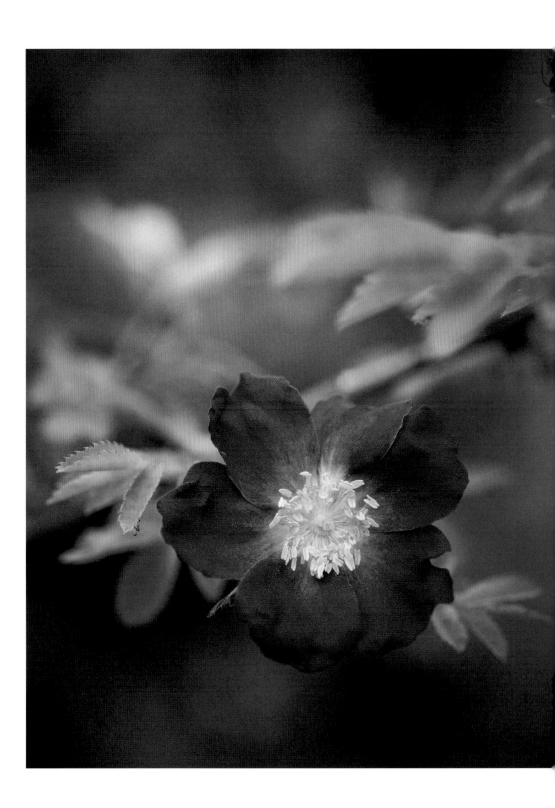

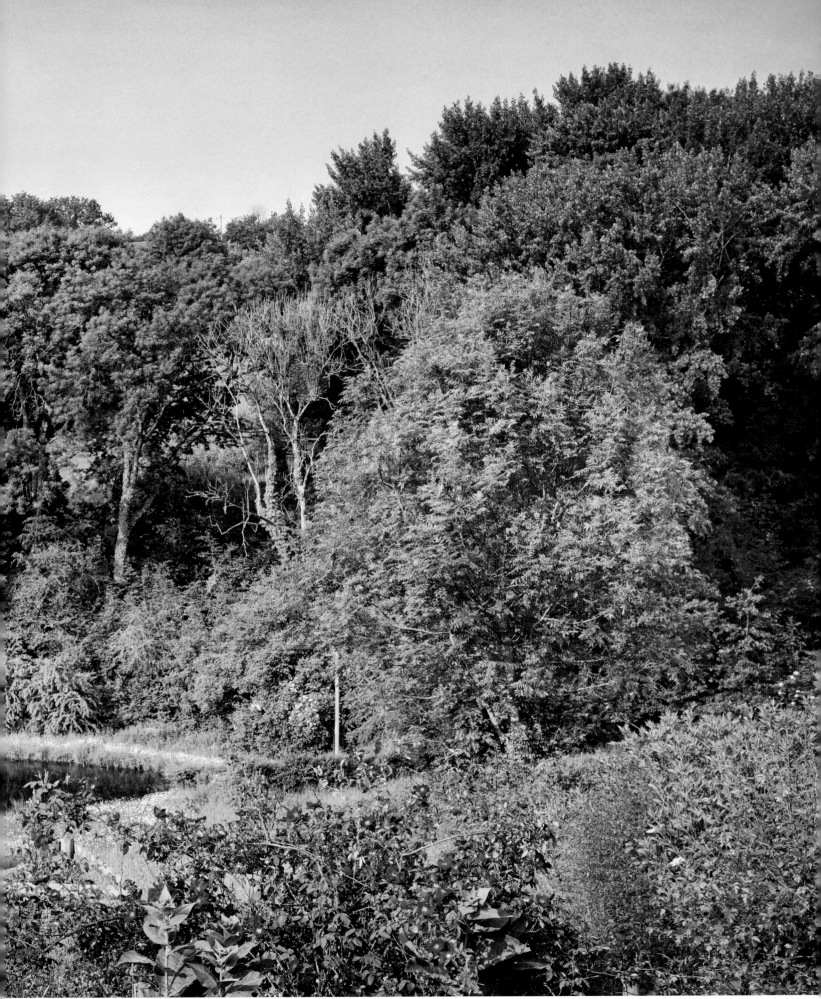

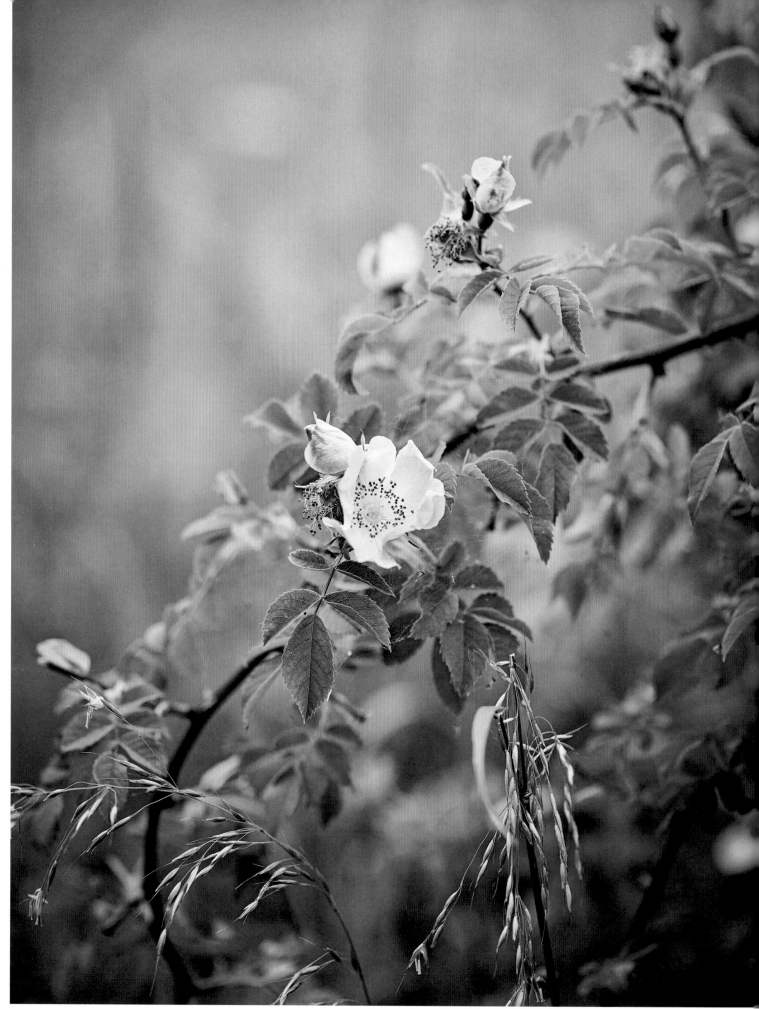

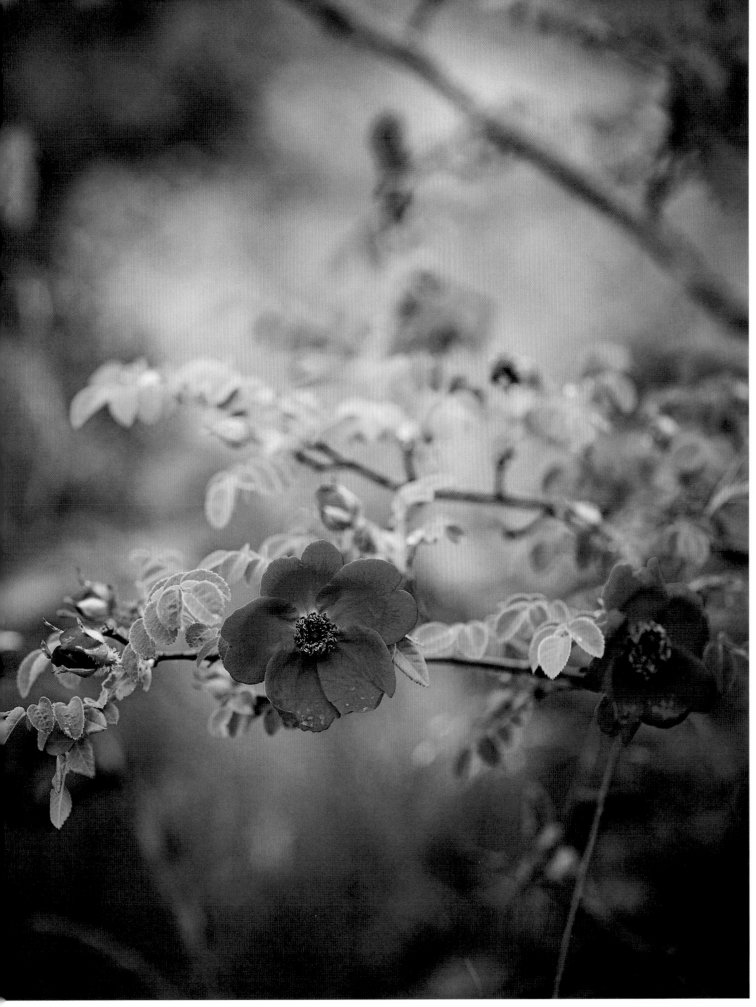

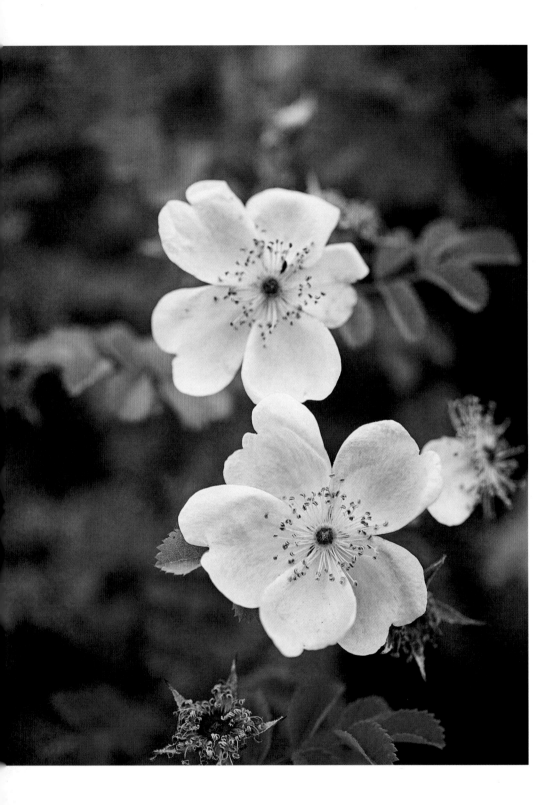

PREVIOUS LEFT
The simple beauty of the dog rose is redolent of pastoral landscape surrounding Hillside.

PREVIOUS RIGHT
For Vita Sackville-West, *R. moyesii* embodies "the delicacy, lyricism, and design of a Chinese drawing." At Hillside, Dan grows the cultivar 'Geranium'.

LEFT
Dan raised this treasured *R. spinosissima* from seeds collected in the sand dunes of Oxwich Bay on the Gower Peninsula, where Huw holidayed every summer as a child.

RIGHT
David Austin roses are grown above the vegetable garden to observe their habits both in the garden and in the vase. *R. × cooperii* has to be tamed on occasions to keep it from overwhelming the corrugated tin barn.

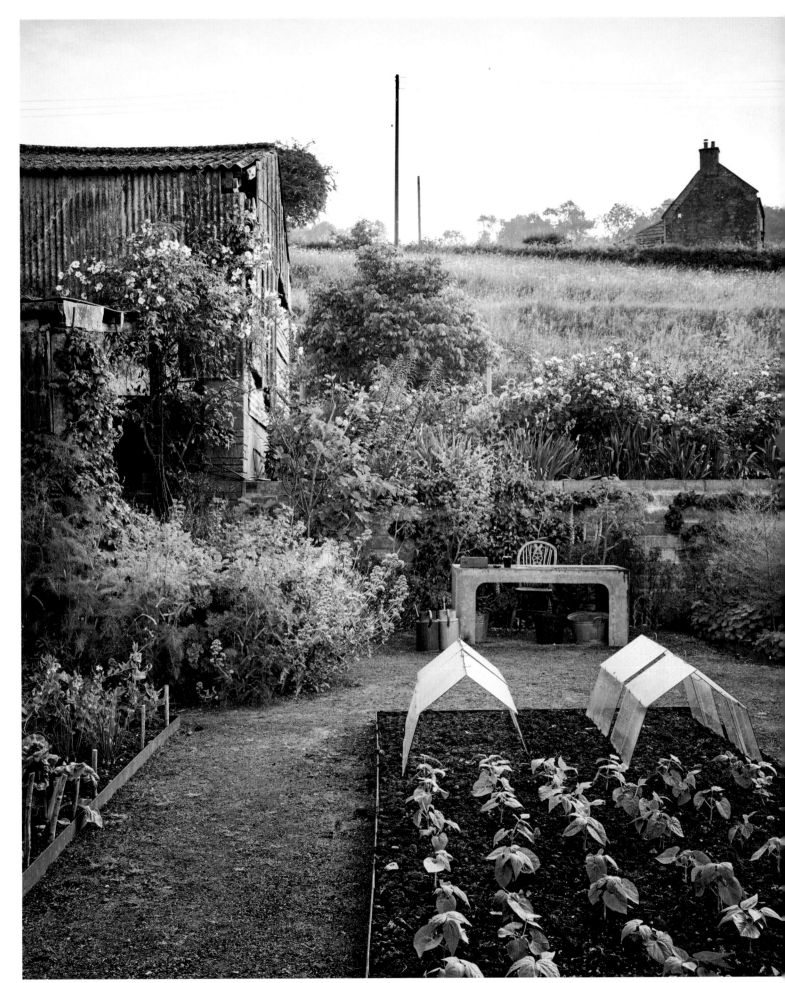

LEFT
Once-flowering roses—like this hybrid spinosissima 'Single Cherry'—may be fleeting, but for Dan, they are worth it "for that feeling of time slowing down."

RIGHT
R. soulieana, with its gray-green foliage and abundant clusters of white blooms, is one of Huw's favorite roses.

FOLLOWING
The unassuming beauty of the species and single roses cherished by Dan and Huw speaks of love—for the land, and for each other.

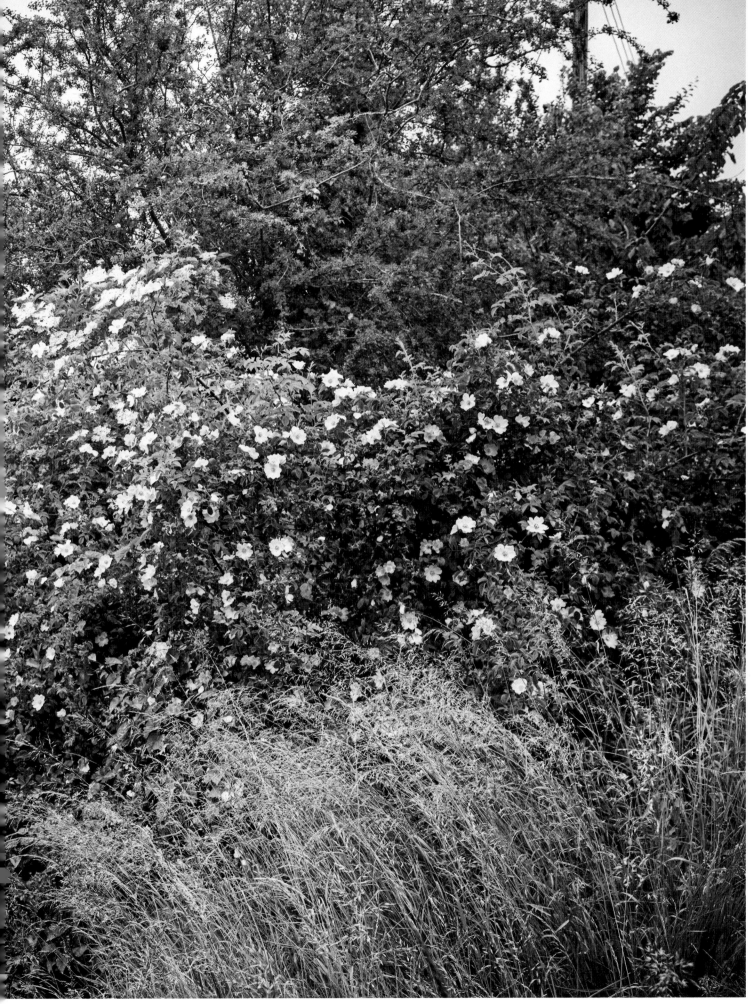

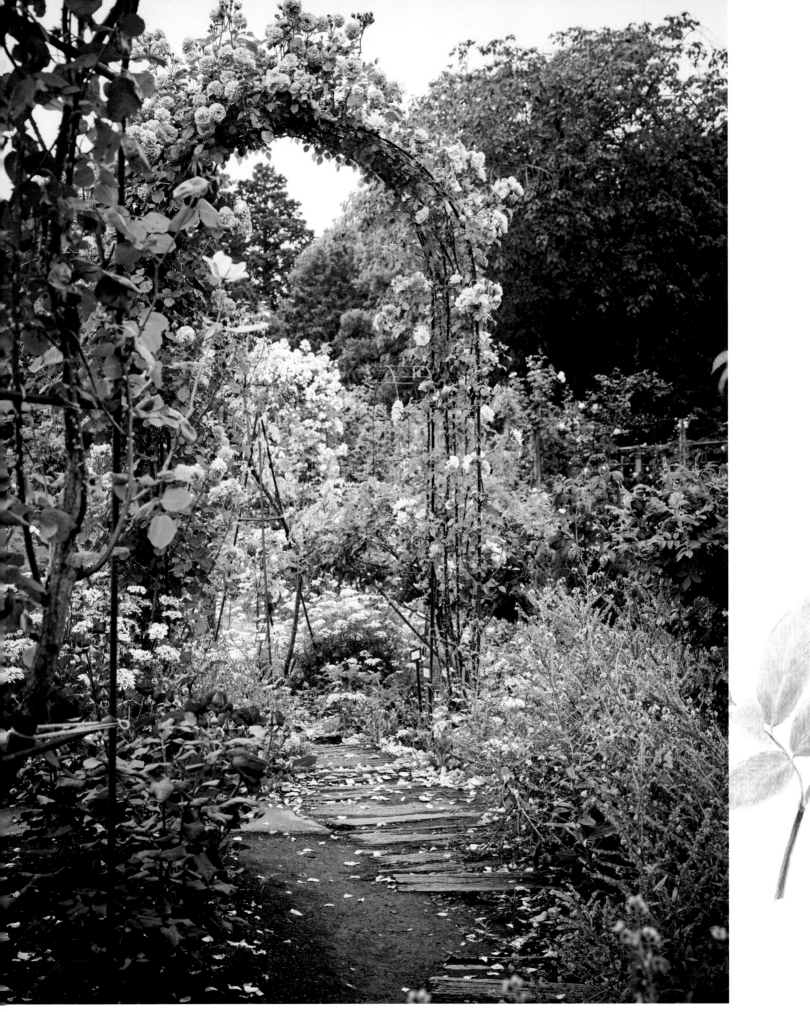

Sakura Kusabue-no-oka

The idea of a garden devoted specifically to roses
—a rosary or rosarium—
arose in the beginning of the nineteenth century in England
and culminated in the creation of Roseraie de l'Haÿ in 1893
by Jules Gravereaux in France.

Just a few miles south of Paris, the garden at its peak featured an astonishing collection of nearly eight thousand species and cultivars. Today, the Europa-Rosarium in Sangerhausen, Germany, claims the title of the largest rose garden, with 8,300 cultivars and species, including nearly all existing varieties of certain classes—polyanthas, hybrid perpetual, Noisette hybrids, and ramblers. In Italy, the Fineschi Garden holds some seven thousand varieties, collected over a lifetime by the surgeon Gianfranco Fineschi, whose legacy is a living museum of the genus *Rosa*. In Japan, the Kusabue-no-oka rose garden in Sakura, in the Chiba Prefecture, holds a relatively modest collection of some 1,250 varieties, but it is no less a testament to the enduring beauty and lure of the rose.

Japan is home to sixteen native rose species, most notably, *Rosa multiflora*, *R. wichurana* (*R. luciae*), and *R. rugosa*. The first two species have since been used in the breeding of many modern climbers and ramblers in the West, such as the popular 'New Dawn'. Many cultivars of *R. rugosa*, including 'Roseraie de l'Haÿ', introduced in 1901, are prized for their perfume and hardiness in European and American gardens. Yet the rose's place in the Japanese garden is relatively recent, and the one person most responsible for popularizing its appeal in the country is Seizo Suzuki. As Dr. Yuki Mikanagi, a rose expert and curator of the Herbarium at Chiba Natural History Museum, explains, "He taught us the pleasure of learning about roses." Mr. Suzuki, who came to be known in Japan as "Mr. Rose," discovered the pleasure of learning about roses at a young age. Inspired by a crimson-red rose in his father's garden—the hybrid China 'Gruss an Teplitz', bred by the Hungarian hybridizer Rudolf Geschwind around 1897—the ten-year-

LEFT
In the fragrance garden, 'Lavender Lassie' and 'Albertine' drape their scented blooms over the pergola.

Illustration, *Rosa* 'Trier'.

old Seizo Suzuki went on to devote his life to the study and cultivation of roses. At the age of twenty-four, he opened his own rose nursery in Tokyo. In 1958 he became the director of Keisei Rose Nursery, where he built a collection of nearly two thousand heritage roses while also breeding over a hundred new varieties. Upon his retirement, Mr. Suzuki asked Katsuhiko Maebara, a young gardener who had inherited the love of roses from his mentor, to take over the collection. With 250 varieties from the rose grower's collection, Katsuhiko created the Rose Culture Institute with a group of rose experts, including Dr. Yuki Mikanagi and Dr. Yoshihiro Ueda, a rose researcher, to preserve and share the beauty of heritage and species roses, and established the Rose Garden Alba in a vegetable field on his parents' land in the city of Sakura, twenty-five miles east of Tokyo. In 2006 the Rose Garden Alba found a new and bigger home on land owned by the city and became the Kusabue-no-oka rose garden. Its new name literally means "grass pipe of the hill." As its director Katsuhiko explains, "In Japan, some people can play various melodies by putting a grass leaf between their lips." Kusabue-no-oka thus evokes a peaceful pastoral scene where such melodies could be heard, a fairly accurate description of the garden.

Set on the edge of a forest, the Kusabue-no-oka rose garden extends over some three acres, divided into sixteen sections that tell the story of the rose's development and pay tribute to its prodigious beauty. Unlike the European traditional rose gardens with formal beds in geometric patterns, the City of Sakura Rose Garden (as it's known around the world) is designed to blend into its bucolic setting. Rustic wooden structures recall bygone days of rural Sakura. Sumptuous and fragrant roses line the winding paths in abundance and spill from simple wooden arbors and tall pillars built by a large group of devoted volunteers who also help maintain the garden all year round. Species roses are given free rein to show their natural habit as they would in the wild, spreading their thorny limbs wide or stretching up to the sky.

The garden begins with a section devoted to Mr. Suzuki and his rose creations, followed by the World Species Rose Garden, which allows Japanese rosarians to study wild species from North America and Europe, like *R. foliolosa*, *R. setigera*, *R. sempervirens*, and others.

The Garden of Rose History charts the evolution
of the flower in cultivation,
a protean progress that has yielded the greatest varieties
of any genus, except perhaps the orchids.

The rose's metamorphosis and itinerant journey around the globe is condensed within this garden, which includes varieties collected from Gregg Lowery's historic roses in California. Here are the gallicas prized for their medicinal properties since medieval times, the perfumed damasks originating from Central Asia, the painterly centifolia from Holland, the mutant moss (so named for the unusual mossy stem and bud), the blowsy bourbon (a chance crossing of a China rose with a damask on what was then called Île de Bourbon in the Indian Ocean), the floriferous Noisette (an 1802 cross between a musk and a China rose that originated from Charleston, South Carolina, and was further developed in France), and finally, the modern hybrid tea.

The Chinese Rose Garden offers another story of the rose. Featured here are roses from Qingyan Garden in Huai'an City, Jiangsu Province, varieties rarely seen in the West, with the exception of 'Old Blush', the China rose from which so many modern roses have descended. Though it had been in cultivation for centuries, it was known for a long time in the West as 'Parsons' Pink China', named after John Parsons, in whose garden it made its debut in Europe in 1793. At Sakura's Chinese Rose Garden this timeless beauty, with petals colored from deep pink to almost white on the same flower, bears its Chinese name, 'Yue Yue Fen' ("monthly pink," in Chinese). Curiously, its Japanese name is Koshin-bara, an indication that this rose blooms not monthly, but every sixty days (Koshin-ko being an event in folklore that occurs every sixty days).

The Japanese Rose Garden features wild species from Japan and their offspring, including the rare rose tree *R. hirtula*, called Sansho-bara in its native country. In the Asian Rose Garden, *R. multiflora* var. *cathayensis* from Sichuan—its clusters of open pink flowers a popular gathering spot for buzzing bees—bloom alongside *R. gigantea* from the Yunnan Province and India. The Redouté Garden celebrates the French painter with seventeen cultivars and five wild roses that were included in his masterpiece *Les Roses*. A collection of yellow roses is gathered in one garden while pink and white ones fill another. The Fragrant Rose Garden showcases the flower's rich perfume, from the classic damask scent of 'Kazanlik', used for centuries in the extraction of essential oils, to the sweet note of the more recent hybrid musk 'Lavender Lassie'. The Single Rose Garden pays homage to the delicate beauty of single-flowered roses like 'Francis E. Lester' and 'Catherine Seyton'. Another exquisite specimen in this garden is 'Yuki's Dream', a China rose found in Sichuan and named for Yuki Mikanagi. Gathered in

one place, these simple yet sublime blooms show off their elegant bearings, each one a regal representative of the queen of flowers. The next garden, reserved for old roses, is encircled in a kaleidoscope of blossoms from tall climbers and ramblers—deep purple 'Veilchenblau', apricot-hued 'Jean Guichard', pristine white 'Bobbie James'.

In his travels around the world to study heritage roses, Katsuhiko met and befriended many rosarians who generously shared cuttings from their collections. The last three gardens at Kusabue-no-oka commemorate these friendships. La Bonne Maison holds a selection of old rose beauties from Odile Masquelier's famed garden in Lyon, France. Rare China roses and hybrid giganteas from Helga Brichet are planted in the Santa Maria Valley Garden, named after the Brichet residence on a gently sloping hill in Perugia, Italy. The Dream of India Garden is dedicated to roses adapted to the hot climate of South Asia, bred from *R. gigantea* and other wild roses by M.S. Viraraghavan—fondly remembered as "Viru"—in India.

With its parade of roses
blooming at the feet of ivy-clad trees,
Kusabue-no-oka rose garden is a humble yet glorious tribute
to the rose and the connections we make through its beauty—
with nature, with history,
and with each other.

Walk among these many-colored roses, their scent filling the air in this tranquil pocket bound by the forest's edge and you will hear the echoes of this ancient flower's journey through the centuries, across continents. The roses gathered here are treasures long cherished and nurtured, having made their way into the hearts of gardeners in different times, places, and cultures. They are stories from the distant past to be told in the future. RFG

RIGHT
A bloom of 'Old Blush', one of the "four stud Chinas"—the ancestors of modern roses—unfolds its elegant petals. It is also known as 'Parsons' Pink China', but in its country of origin, this rose bears the name 'Yue Yue Fen' (monthly pink).

FOLLOWING
In the Garden of Rose History, shrub roses jostle on the ground with salvias, foxgloves, and feverfew while ramblers and climbers spill from wooden pillars and metal arbors.

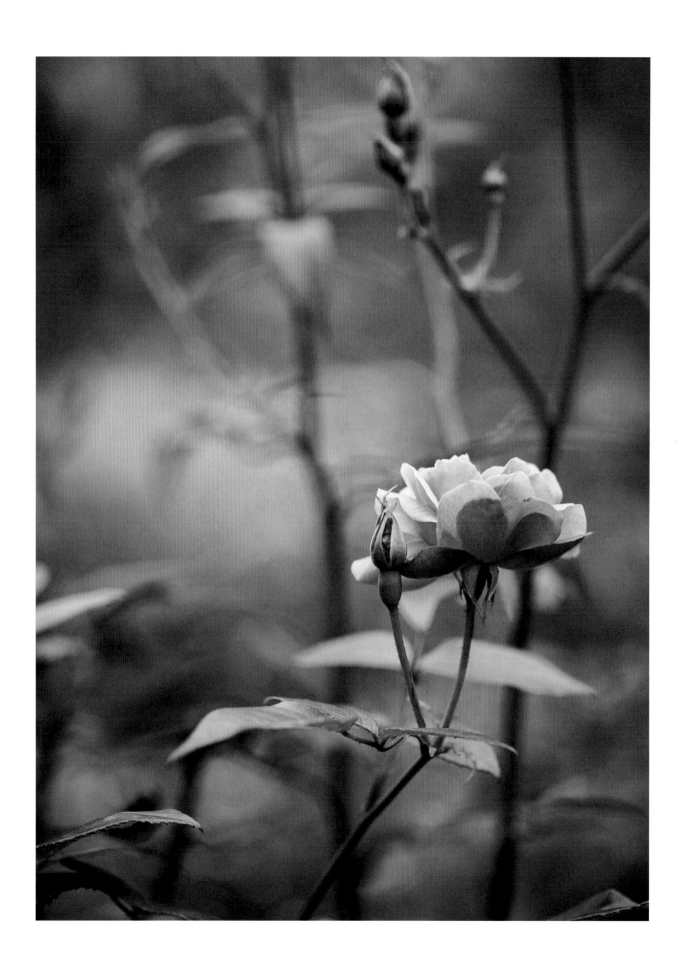

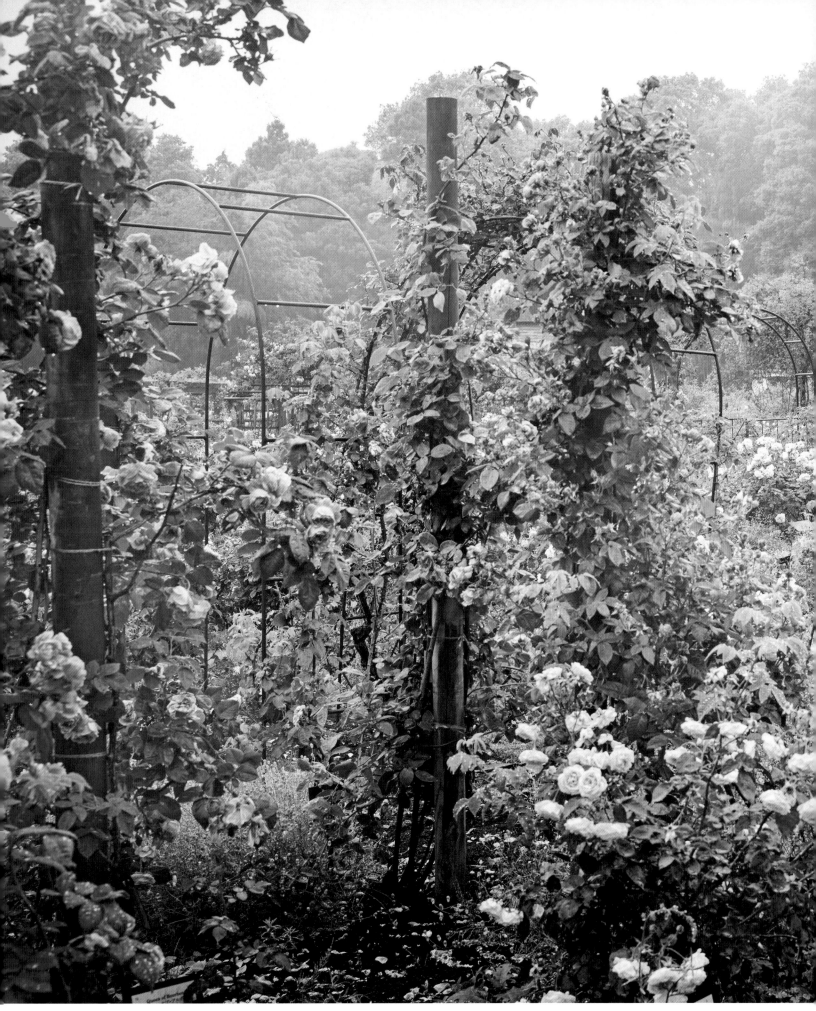

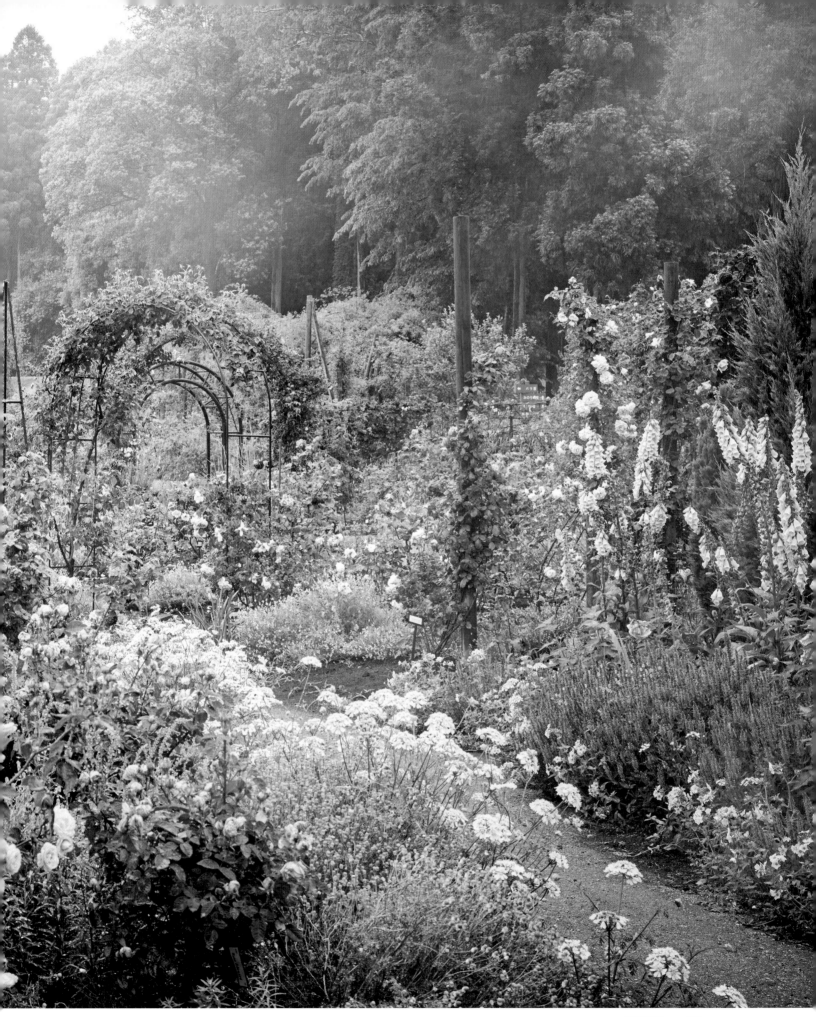

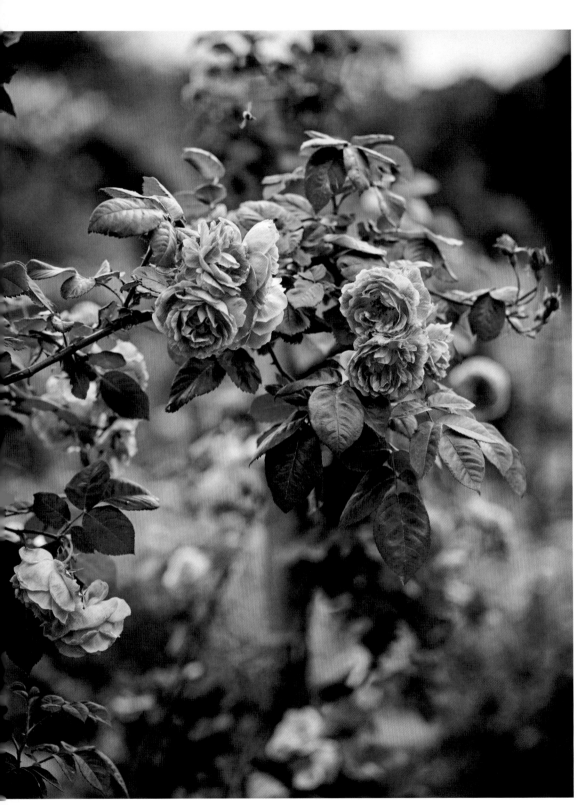

LEFT
Katsuhiko Maebara grows his favorite bourbon rose, the aptly named 'Queen of Bourbons' on a simple pillar to show off its sweetly scented cupped flowers.

RIGHT
One of the gems in the Single Rose Garden is a hybrid rubiginosa named after a character in Sir Walter Scott's novel *The Abbot*, 'Catherine Seyton'.

FOLLOWING LEFT
This handsome moss rose was named 'Maréchal Davoust' in honor of one of the original eighteen Marshals of the Empire named by Napoléon in 1804, whose name is actually Louis-Nicolas Davout.

FOLLOWING RIGHT
'Ann Endt', with its unusual red color with deep magenta undertone, is a found rose named by the rosarian Nancy Steen in New Zealand prior to 1978. Some experts believe that it is the same rose bred by Philippe-André de Vilmorin in the nineteenth century, a cross between *R. rugosa* with the American species *R. foliolosa*.

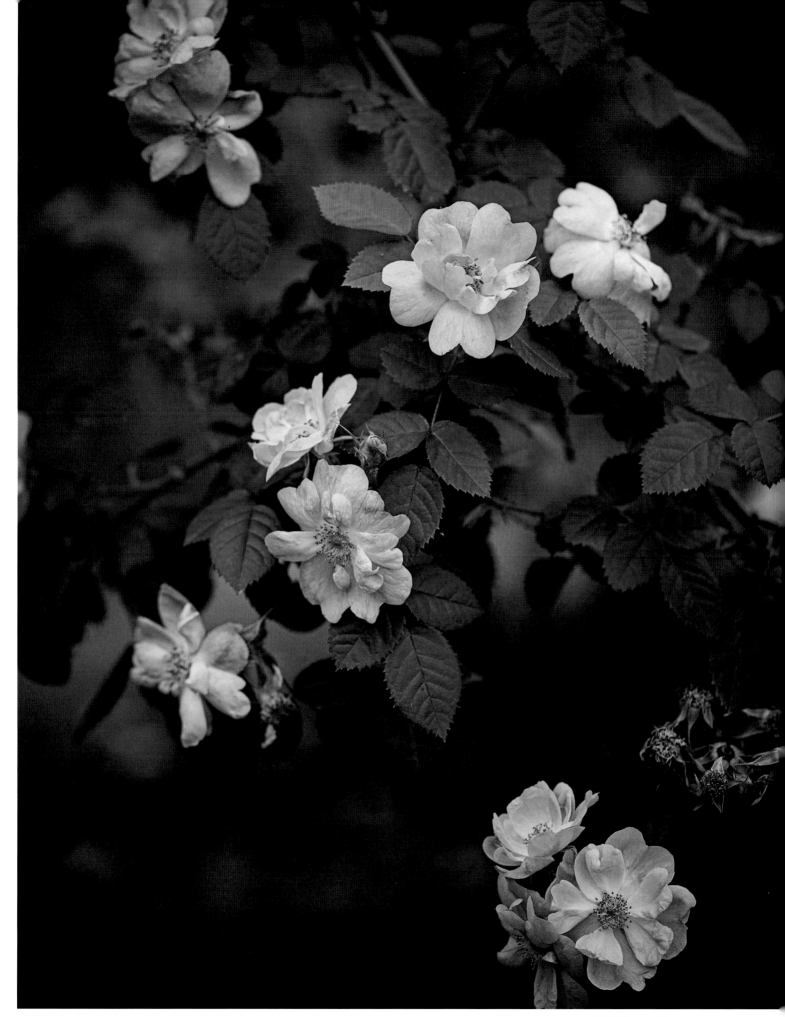

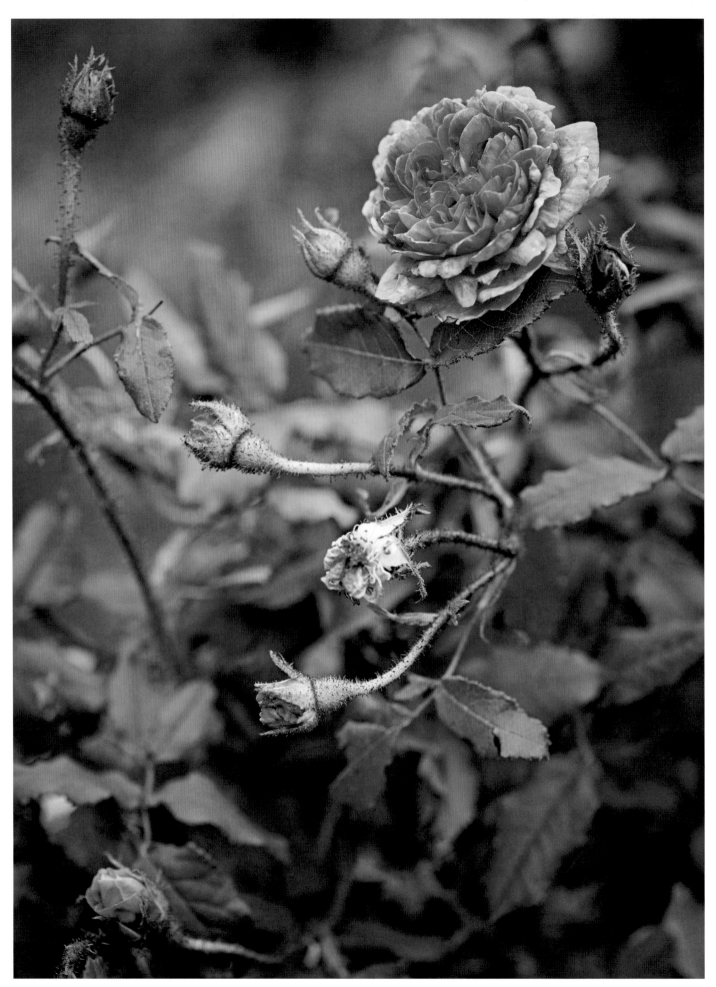

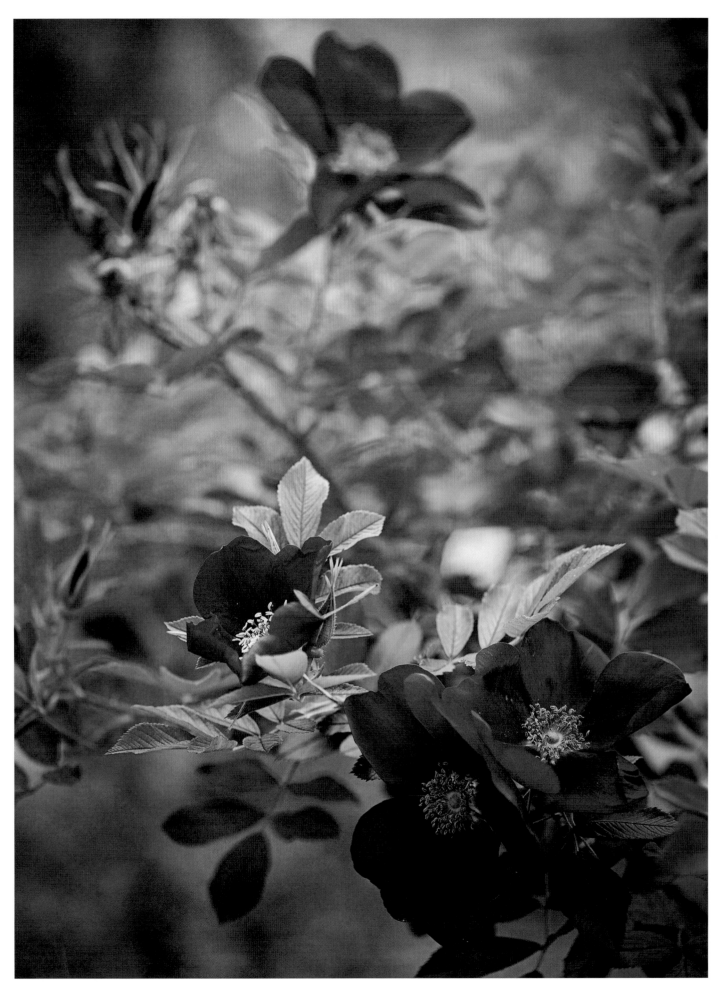

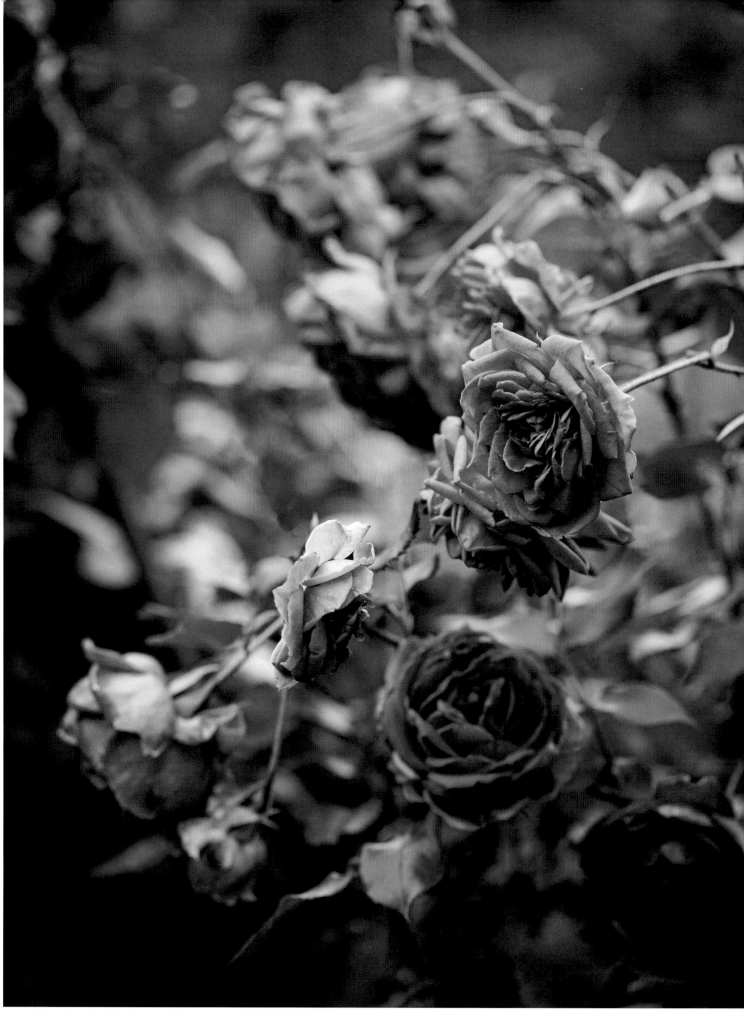

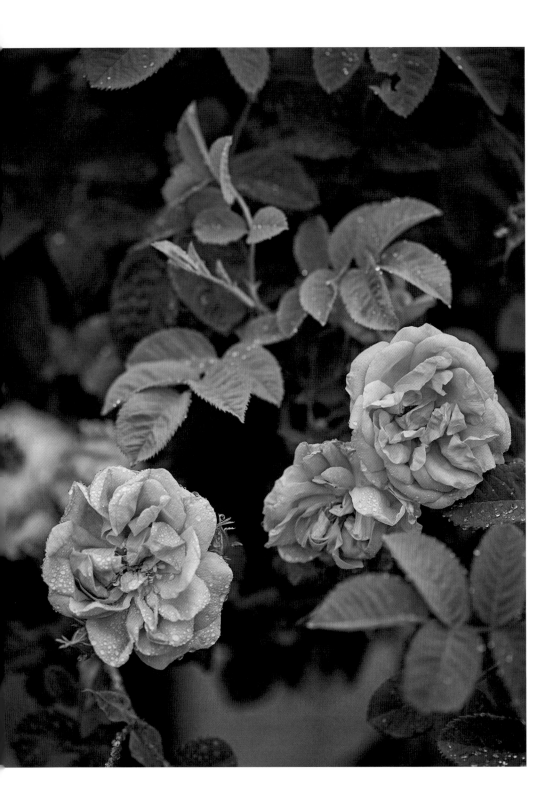

PREVIOUS LEFT
The Indian rose breeder M. S. Viraraghavan, a friend of Katsuhiko's, named this rose 'Belle Sakura' to celebrate the garden's fifteenth anniversary in 2021.

PREVIOUS RIGHT
Japan is home to a number of species roses, including this scented beauty, *R. davurica* var. *alpestris*, which grows mostly in grassland and on forest margins in Hokkaido.

LEFT
The perfumed damask 'Kazanlik' bears the name of the valley in Bulgaria where it has been grown for over three centuries for the production of attar.

RIGHT
'Blush Rambler', a vigorous climber heaping with clusters of cupped flowers and practically devoid of thorns, is often found in old gardens in the UK.

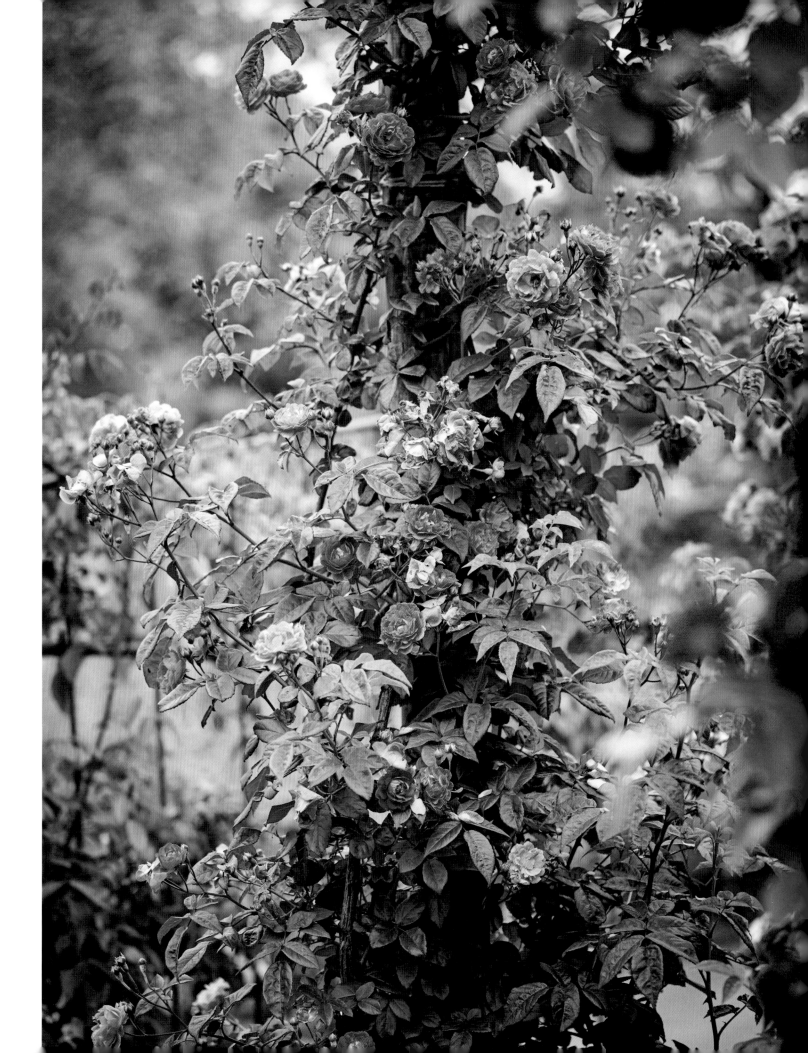

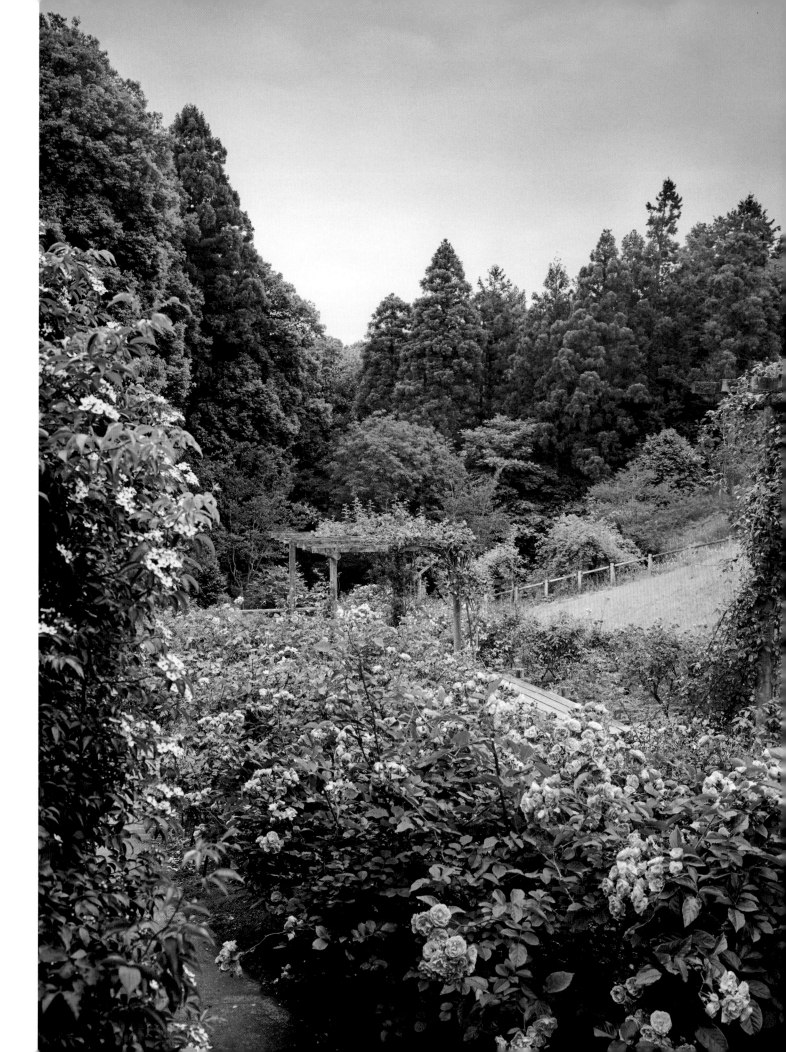

LEFT
Katsuhiko chose a south-facing slope
for the garden dedicated to the collection
of China roses and hybrid giganteas from
Mrs. Helga Brichet's garden in Perugia.

RIGHT
Among the rare China roses in the Santa
Maria Valley Garden is 'Bengali', bred
by Auguste Nonin & Fils in France in 1913,
not to be confused with the floribunda
Kordes rose of the same name.

FOLLOWING LEFT
If Dr. Suzuki had never encountered the
beauty of this red rose, 'Gruss an Teplitz',
Sakura Kusabue-no-oka Rose Garden
might not exist today.

FOLLOWING RIGHT
Among the jewels in the Single Rose
Garden is a rose found by Dr. Yuki
Mikanagi in Sichuan and named in her
honor, 'Yuki's Dream'.

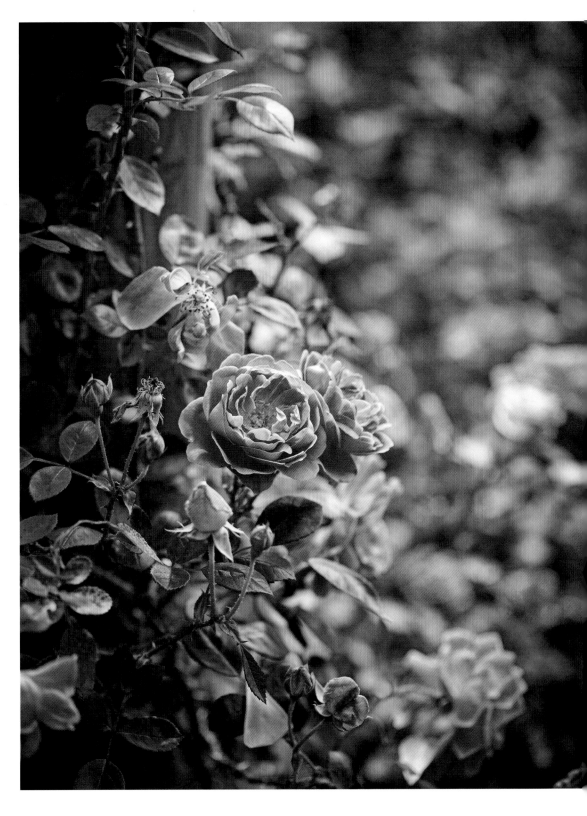

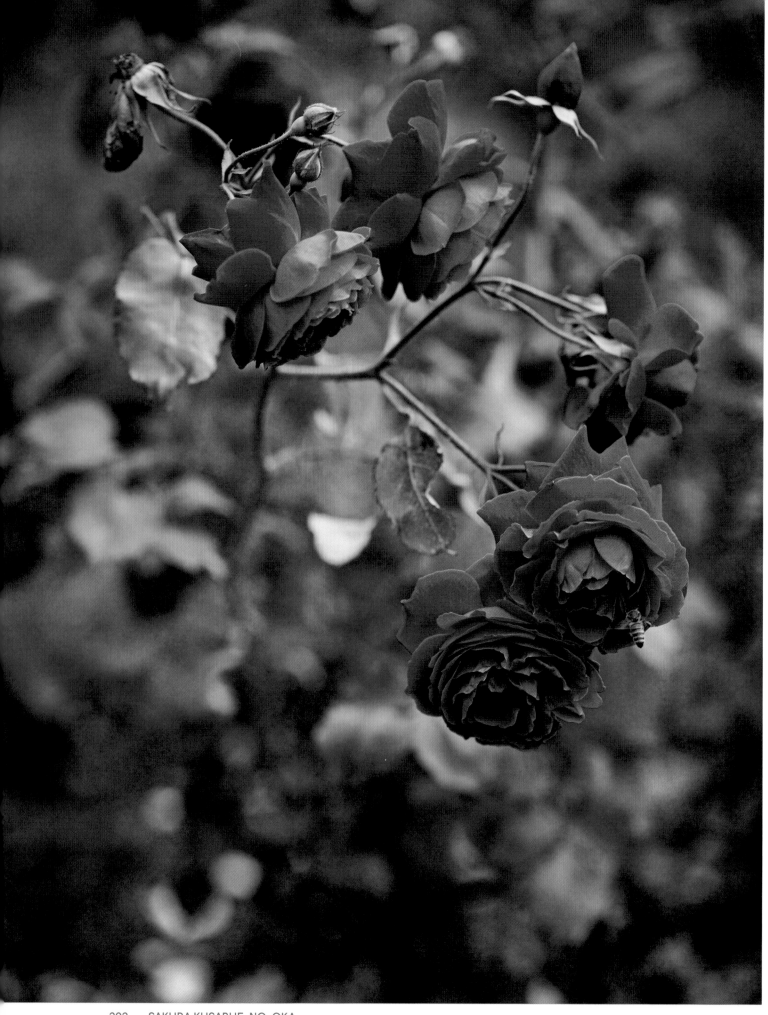

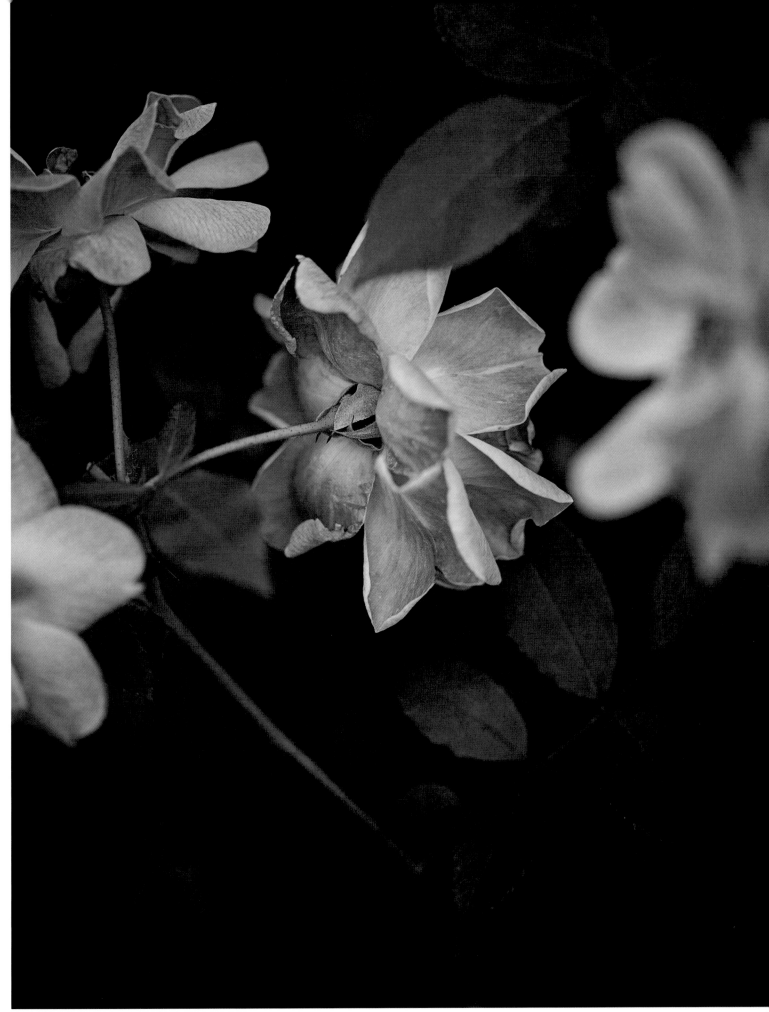

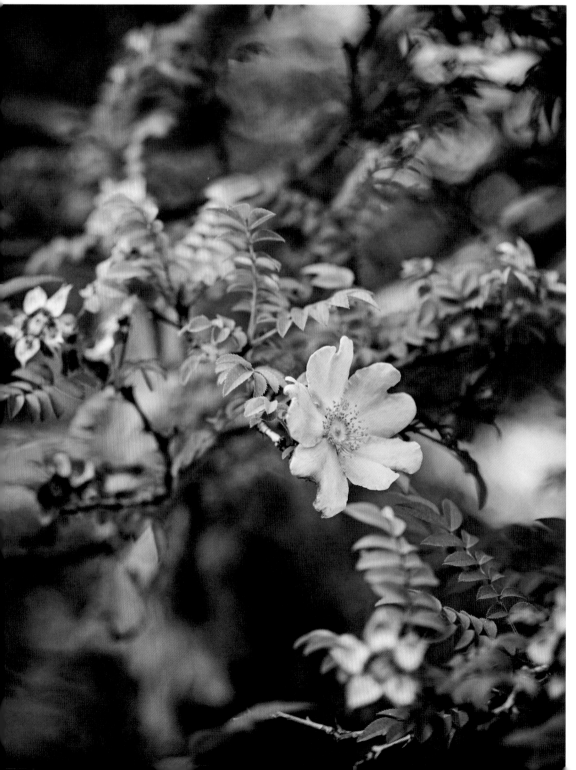

LEFT
R. hirtula is a unique Japanese species rose with a growth habit of a tree. It is found on the mountains in the Fuji-Hakone areas of central Japan, growing between chestnut and beech trees. Its Japanese name is Sansho-bara, which translates as "Japanese pepper rose," indicating the resemblance of its leaves to the Japanese pepper tree.

RIGHT
The Double Chestnut rose (*R. roxburghii* 'Plena') earned its name for its chestnut-like hips. Its blooms, tightly packed swirls of ruffled petals, bring to mind the painted roses of chinoiserie art.

FOLLOWING
'Heavenly Pink' is the name of the rose in the foreground, but it might as well describe the dreamlike sea of roses in the Garden of Rose History.

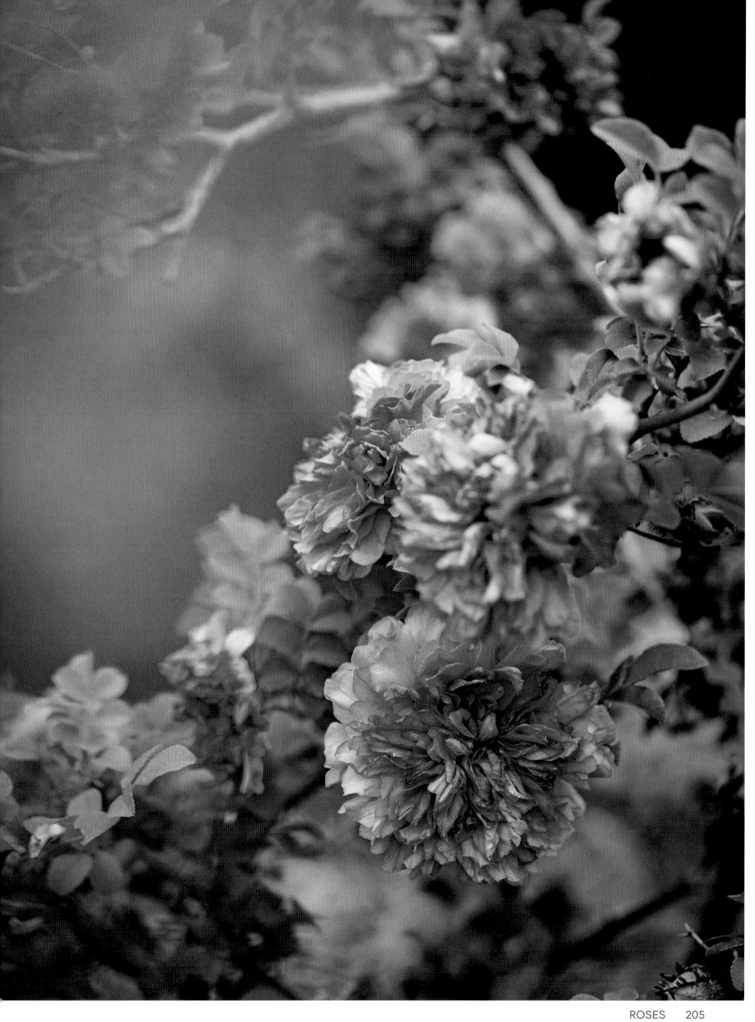

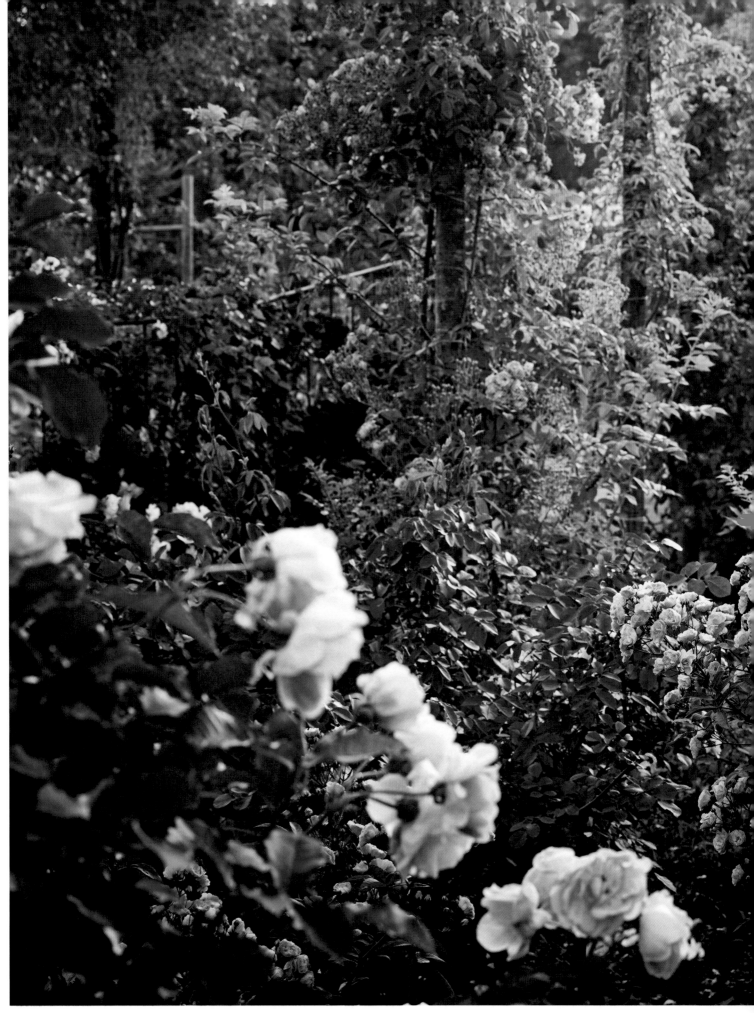

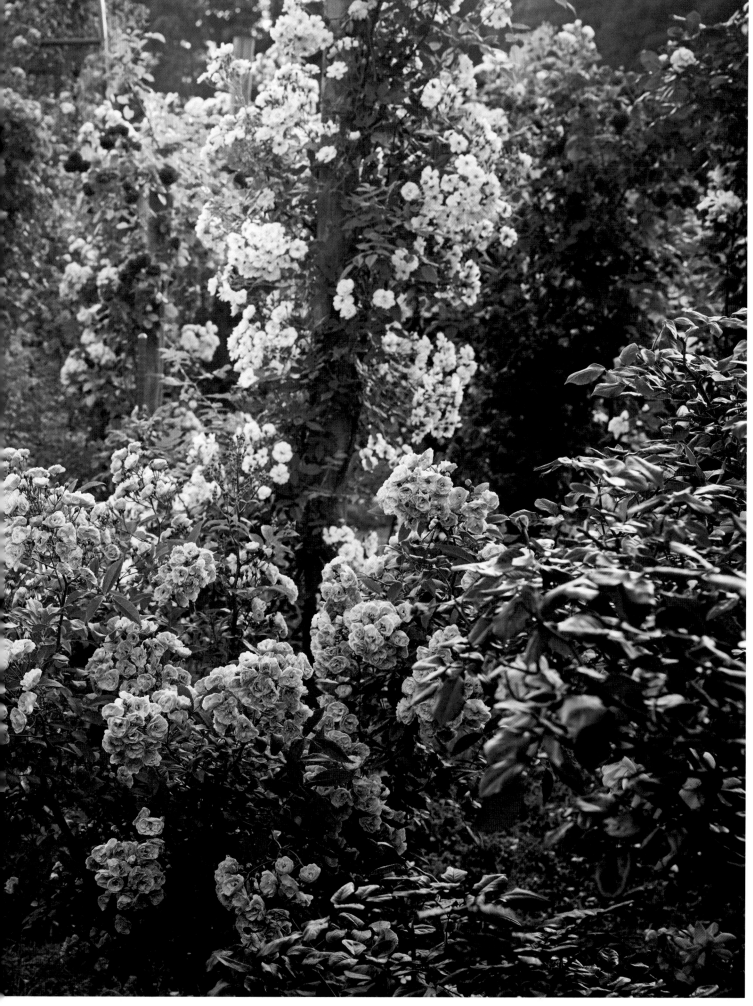

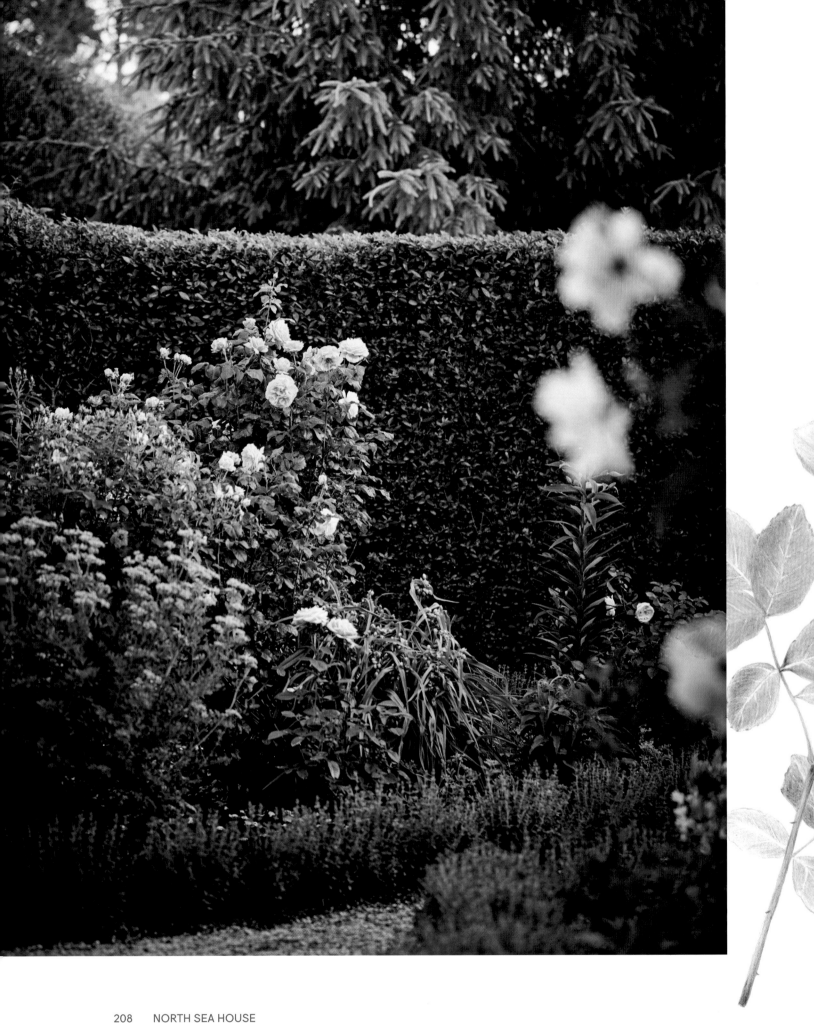

North Sea House

Perry Guillot is known for his sweeping open landscapes
on some of the most notable properties
on the East Coast of America.
His work, strongly architectural and mostly green,
has the beauty and precision of a haiku,
akin to the gardens of Japan
as much as the eighteenth-century English landscapes
from which he draws most of his inspiration.

"My gardens are planted, not built," he often says. His designs—from concept to plant selection—are rooted in the historical and cultural context of the location. For over fifteen years, Perry has made his home in North Sea, a quiet hamlet on the northern shore of Long Island's South Fork, drawn to its rural charm, natural beauty, and rich history in agriculture and fishing. The garden he made for himself there is informed by a fascination with the cosmos since childhood. Using a limited palette of plants and a purity of form—the circle in all its iterations—he keeps the focus on the bucolic vistas of the surrounding pastures and the vast dome of blue sky above. A circular lawn bordered by a low box hedge anchors the point of arrival and departure. Catalpa trees dot the landscape, glorious in their summer bloom. Hidden behind a privet hedge in a corner of this pastoral landscape is a circular rose garden, a tiny jewel box under the generous sweep of the neighbor's century-old catalpa tree.

"I am not the first choice to get hired to do a flower garden," admits Perry, "but my first loves, like those of most landscape architects, are shrubs and flowers," especially roses. The idea for the rose garden at North Sea House began with a gift from the project of a client, a sundial that became the quiet focus of Perry's secret flower garden. Taking a cue from the "scale and imagery of the carving on the sundial," Perry designed an

LEFT
'Moonlight Romantica' blooms behind
the privet hedge of Perry Guillot's secret
rose garden.

Illustration, *Rosa* 'Huntington's Hero'.

Elizabethan-inspired garden, placing it in a sun-drenched spot on the property. Forty feet in diameter, the garden is centered on the view of the house in the distance, enclosed within a ring of privet hedge with an iron gate at the entrance. Just as enclosures once protected the Elizabethan gardens from wild animals—hungry deer were a problem then as now—and prevailing winds, the hedge, which Perry keeps loose on top, protects the roses from the same threats. Three large beds radiate from the sundial, edged by a low teucrium border. Gravel quarried locally on Long Island fills the paths. Feverfew, rue, thalictrum, and euphorbia, with their gray-green foliage, complement the palette of the roses, mostly white and pale pink, with some yellow. Martagon lilies, verbascum, and Star of Bethlehem join the party with their tall flowery stalks.

The first roses to bloom every year at North Sea House are the rugosa hybrids, which Perry recommends for novices interested in growing roses for the first time. "They grow fast, are fragrant and very hardy," he explains. Natives of the colder regions of China, Japan, and Korea, *Rosa rugosa* grows on sand dunes along the coasts. Tolerant of salt sprays and disease resistant, this species was introduced to America in 1845 and has now naturalized all over the New England coast, where it's known by its common name, beach rose. Though many gardeners find rugosa roses too coarse and thorny, Perry insists that there are many fine cultivars of this species. "'Sir Thomas Lipton' has a more traditional grandiflora habit," he points out, his own specimen in evidence. It should also be noted that while more elegant than a typical beach rose, 'Sir Thomas Lipton' works well as a formal hedge in a larger garden. 'Roseraie de l'Haÿ', introduced by the French breeder Charles Cochet-Cochet in 1901, is another rugosa favorite, its magenta purple blooms filling the garden during the month of June with a heady clove perfume. Native species roses feature frequently in Perry's work on wetland buffer and revegetation projects.

At North Sea House,
the flowers of *Rosa virginiana* unfold their delicate petals
with the warmth of the morning sun,
mingling with clusters of the loosely double pink flowers of
'Mary Delany', one of several David Austin roses
in the garden.

A small space in one of the beds is dedicated to the hybrid teas that came from Perry's work on the renovation of the White House Rose Garden. 'John F. Kennedy' blooms alongside 'Pope John Paul II' and 'Queen

Elizabeth', as well as 'Peace', a rose with a fascinating story. In the 1930s French hybridizer Francis Meilland cross-pollinated a seedling with the hybrid tea 'Margaret McGredy' to create an unusual yellow rose with petals edged in pink. He named it 'Madame A. Meilland' in memory of his mother, Claudia. Just before the German occupation in France in 1940, he sent cuttings out to other countries. Four years later, Robert Pyle, the new rose's grower in America, wrote to Meilland that "it will be the greatest rose of the century." 'Madame A. Meilland' was rebaptized as 'Peace' and introduced in this country on April 29, 1945, just days before Germany surrendered and World War II ended in Europe. Delegations to the first meeting of the United Nations in San Francisco were given the rose to encourage thoughts of world peace. Nearly two decades later, Bunny Mellon included the Peace rose in her 1962 planting plan of the rose garden she designed for President Kennedy at the White House. Its 2021 renovation, unveiled in politically charged times, sparked criticism far and wide. With humor now, Perry himself points out, "To many, the initial appearance of the restored parterre and young rose plantings had a strict military precision, as though Napoleon might be coming for lunch." With time, the garden matured into something "extraordinary," he says, with the borders looking like "a prairie" in summer abundance. Most importantly, more roses are now blooming at the White House Rose Garden—with over two hundred shrubs, an improvement to the dozen on-site before the project began.

Meanwhile, at North Sea House, the rose garden in the month of June is a feast for the senses. Behind the privet hedge, masses of roses crowd the beds, their perfume filling the air in this secret garden. Birdcalls punctuate the hum of buzzing bees. Faded petals fall gently on the ground as new flowers open, the cycle of life in ceaseless motion.

These roses
—old and modern, from near and far, fleeting and timeless—
effortlessly carry the weight of symbols,
be it love, beauty, or war.

These fragrant blooms can brighten the darkest days. As President Kennedy wrote in a letter to Bunny Mellon shortly after the Cuban Missile Crisis, referring to the White House Rose Garden, "I need not tell you that your garden has been our brightest spot in the somber surroundings of the last few days." R&G

RIGHT
Perhaps the most famous creation of
the French rose grower Francis Meilland
is the Peace rose. Though it was first
baptized 'Madame A. Meilland' in honor
of the breeder's mother, the rose's destiny,
and thus its name, was fatefully changed
by the events of World War II.

FOLLOWING
In a sunny corner of North Sea House,
a circular privet hedge with an iron gate
encloses Perry's Elizabethan-inspired
garden.

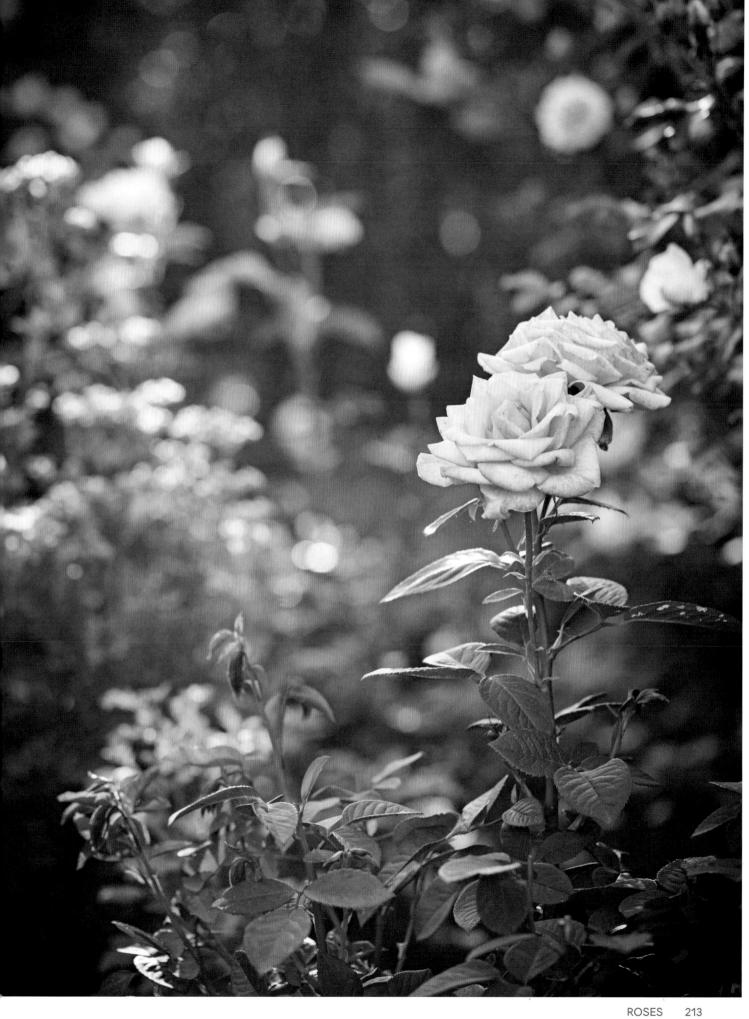

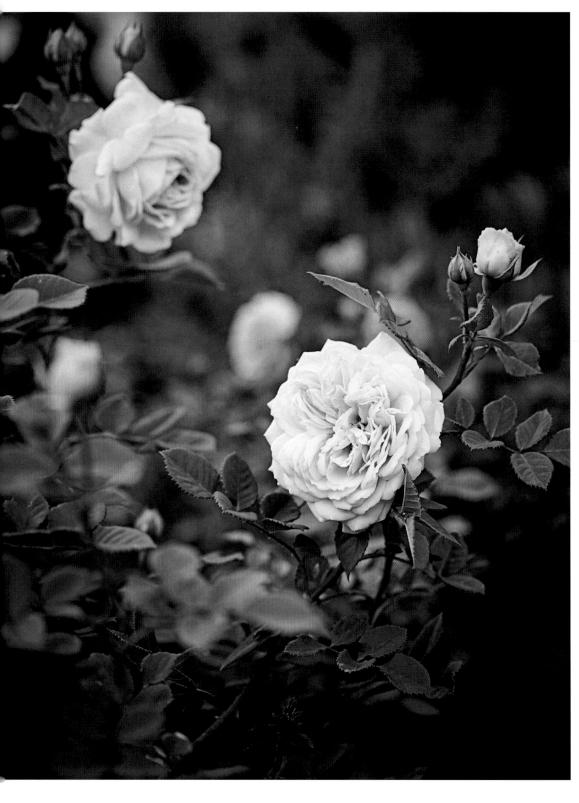

LEFT
A relatively new introduction from David Austin, 'Emily Brontë' was named for the author of *Wuthering Heights* on the bicentenary of her birth, 2018.

RIGHT
Set in three large beds bordered by teucrium, the roses are accompanied by feverfew, rue, thalictrum, and euphorbia, all plants that hew to a strict palette of gray-green and yellow.

FOLLOWING
The idea for the rose garden began with a gift, a sundial that became the quiet focus for the ebullient flurry of roses.

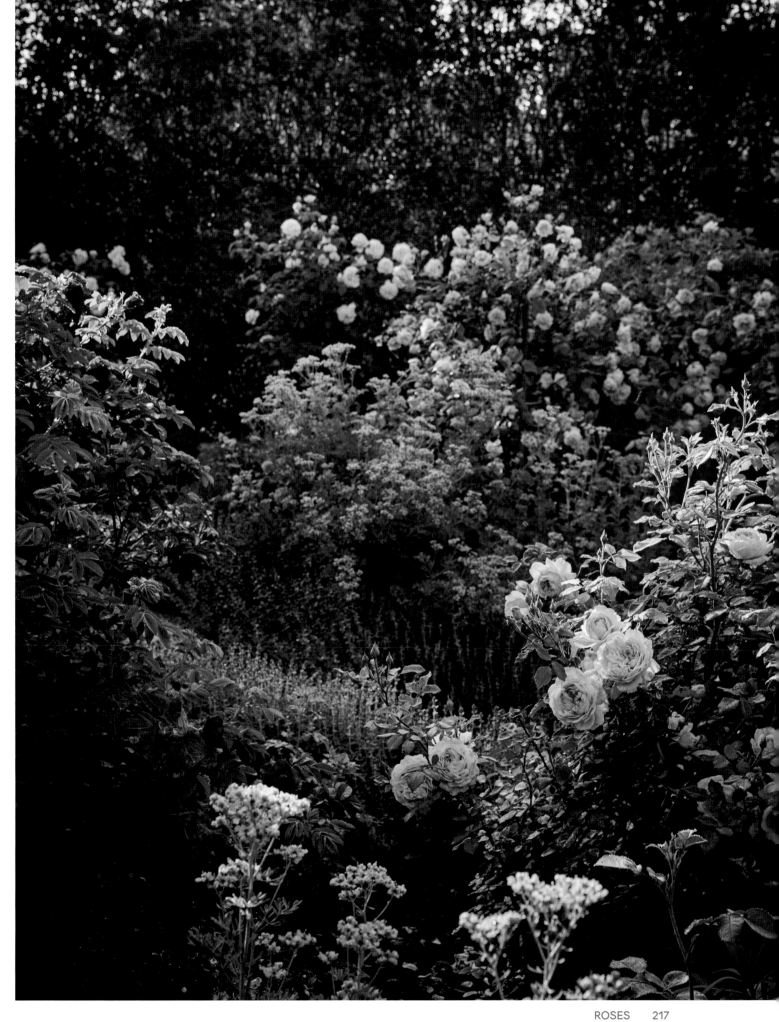

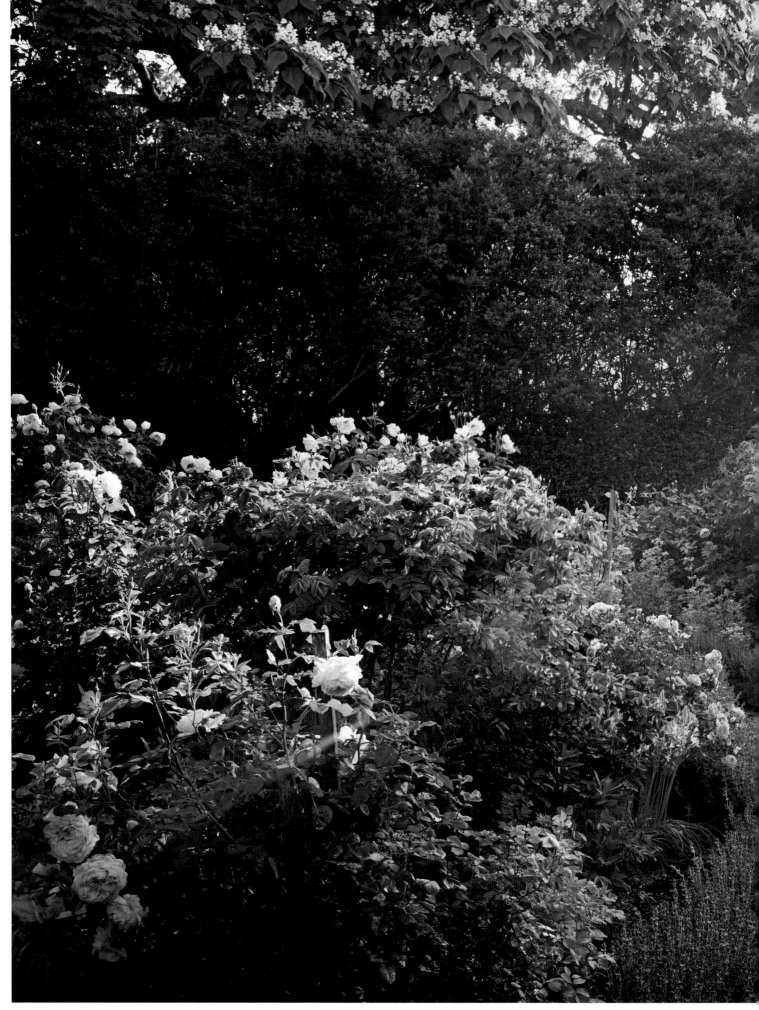

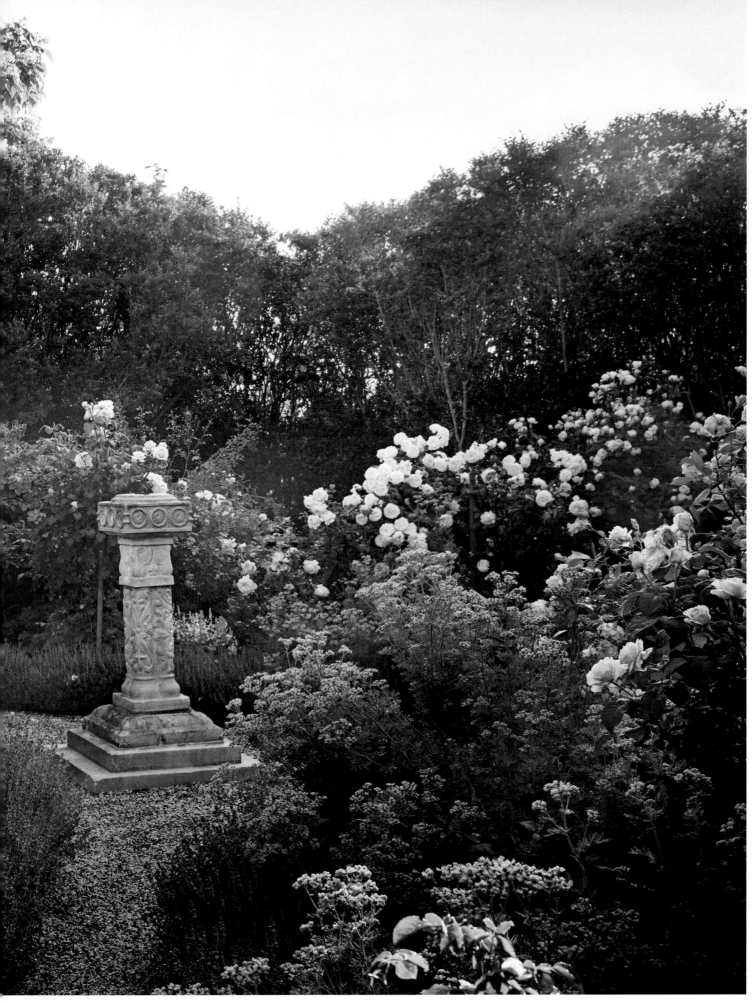

LEFT
For novice rose growers, Perry recommends hybrid rugosas, including 'Roseraie de l'Haÿ', whose origin dates from more than a century ago.

RIGHT
The native species *Rosa virginiana* is often used in Perry's work on wetland buffer and revegetation projects, but its understated beauty also has a place in an ornamental garden.

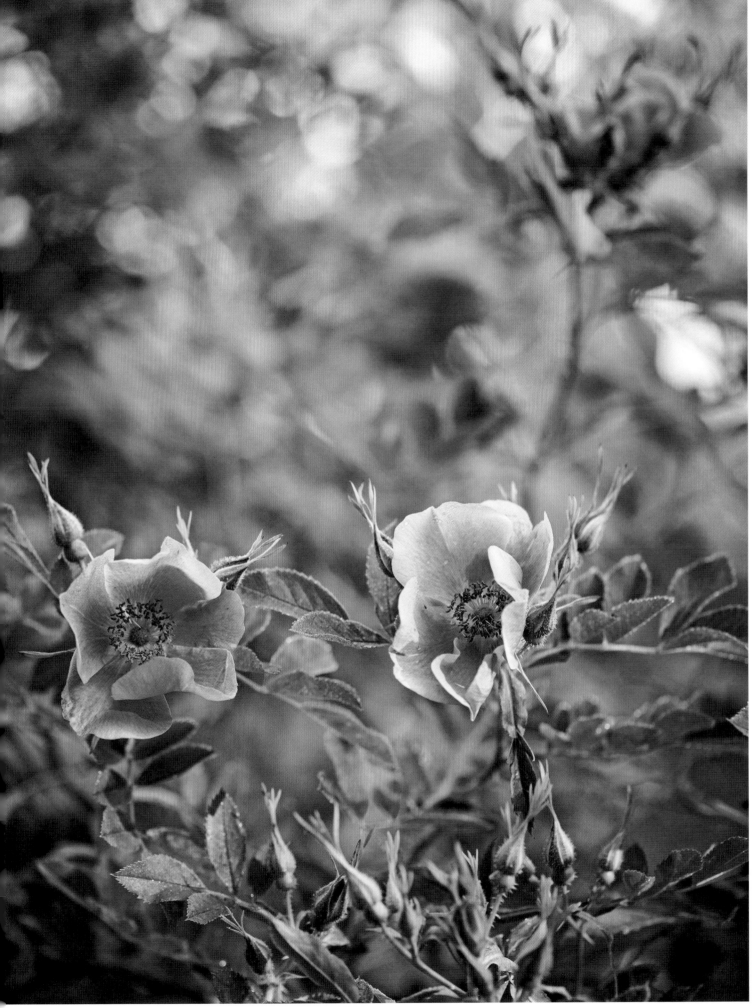

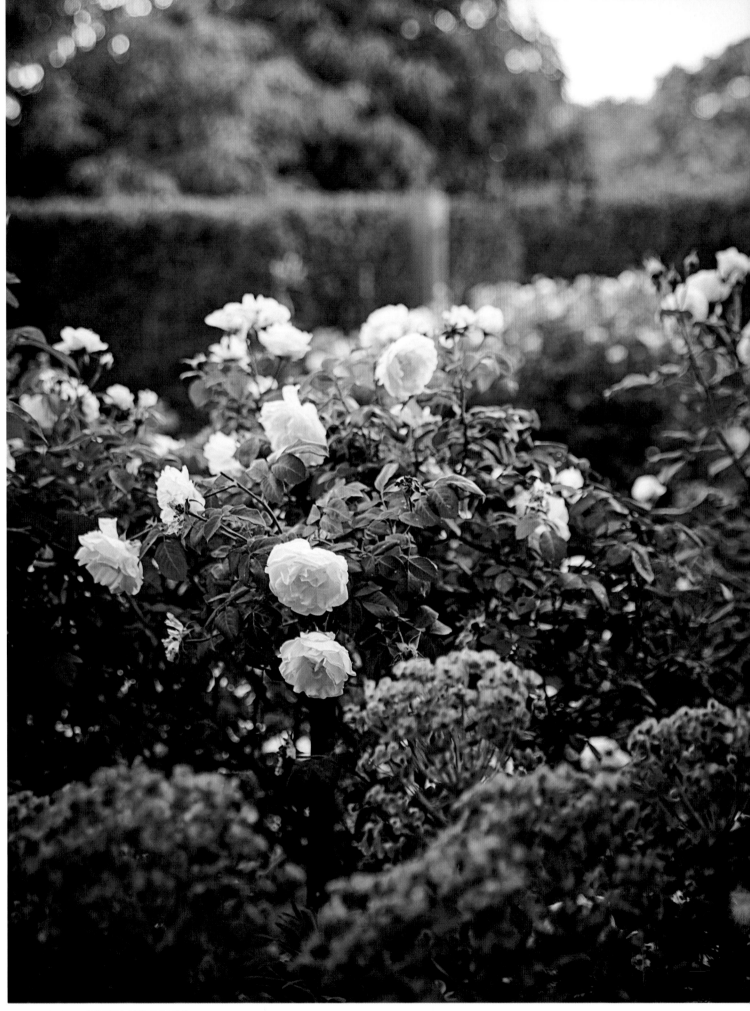

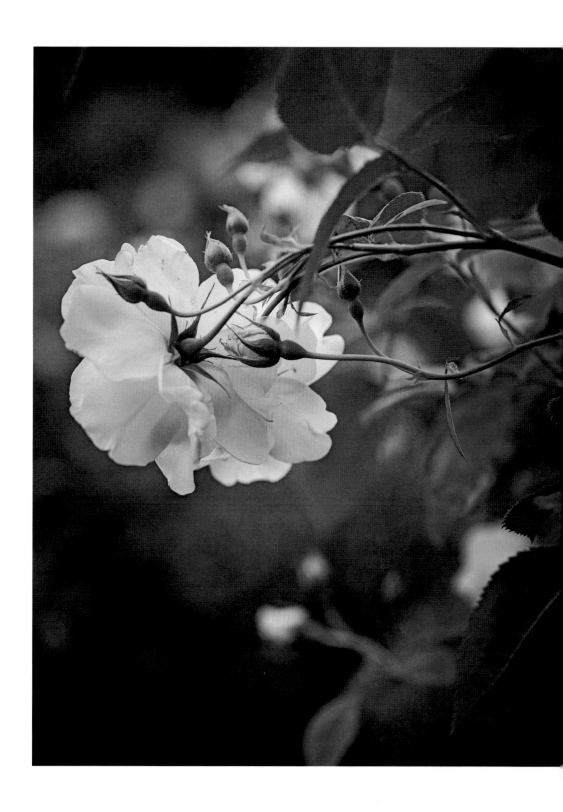

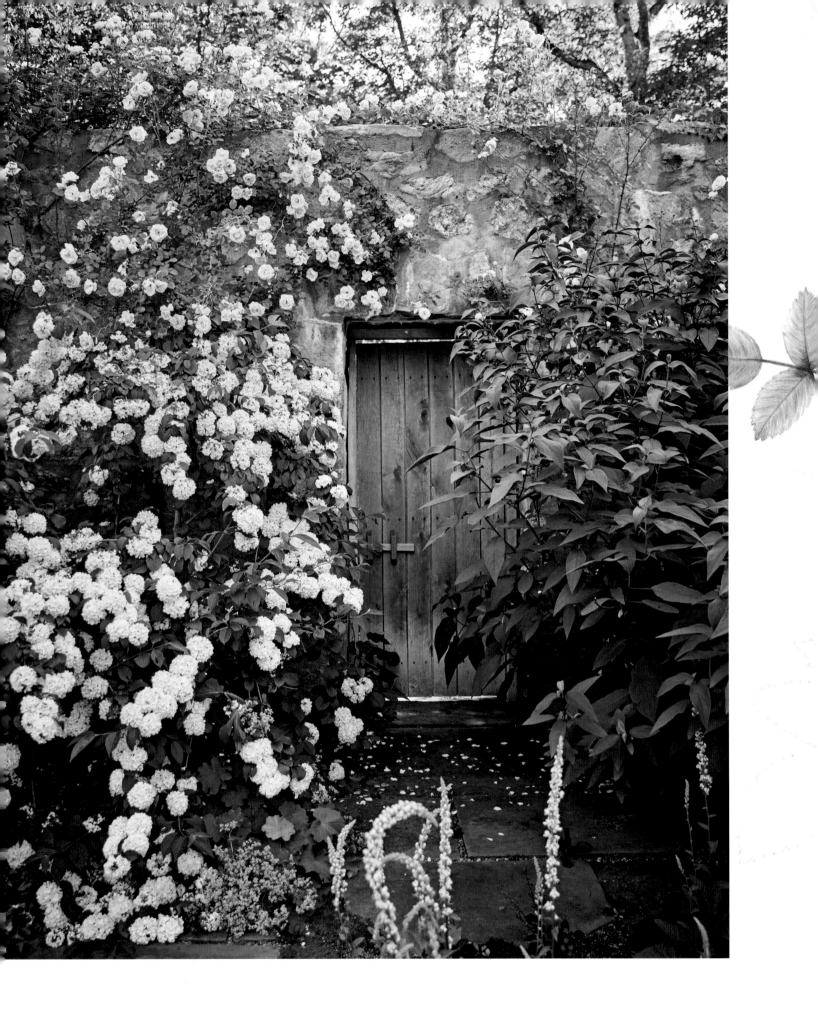

Cat Rock

A garden can be many things.
A refuge. A pleasure ground. A conversation with nature.
A multilayered aesthetic experience.
Colors, forms, textures, scents, movements—and even sounds—
make up a garden's composition.
Time adds another dimension to this living tableau.

Elements of unpredictability—the weather, the very nature of plants eluding our best efforts to tame them—keep a garden constantly evolving, ever changing. The walled garden at Cat Rock, nestled in the Hudson Highlands, is such a work of art, the fruit of an ongoing collaboration between the owners of the property, Jack Bankowsky and Matthew Marks, the landscape designer Lindsey Taylor, and the gardener Tony Bielaczyc. Roses weave their way through this sprawling landscape from the house to the walled garden like splashes of paint on a canvas.

The Hudson Highlands—a series of steep mountains rising above a narrow stretch of the Husdon river—was once populated by thick oak forests dotted with stands of towering tulip trees, American elms, sugar maples, red maples, white ash, black cherry, and black birch. Ancient bedrocks a billion years old form the foundation of a terrain rich in wildlife—even today the area is home to rattlesnakes, bald eagles, least bitterns, and eastern fence lizards. The rugged beauty of the region in the nineteenth century inspired the first artistic movement in America, the Hudson River School. While painters like Thomas Cole and Frederic Edwin Church sought the heroic in this wilderness, well-heeled New Yorkers found the highlands' natural landscape the perfect escape from the burgeoning city just fifty miles downriver. For five generations, Cat Rock was a weekend retreat for the family of railroad mogul Frederick Henry Osborn. Atop this vertiginous hill covered in 120 forested acres of land, the views are unparalleled. To the north, the Hudson River shimmers and bends around Storm King Mountain to make its

LEFT
"The garden is magical, very much like a children's storybook, a secret garden," says Lindsey Taylor of the walled garden she designed at Cat Rock.

Illustration, *Rosa glauca*.

way to the Catskills in the distance, a panorama as majestic today as when the Hudson River School painters found it more than a century ago. Looking south one sees New York City in its grandeur, the Empire State and Chrysler Buildings clearly visible on a cloudless day.

Cat Rock's forested land is under conservation, but its gardens were once designed by Ellen Biddle Shipman, one of America's first woman landscape architects. Her work here had mostly vanished by the time the property passed on to the current owners, who conceived a new overall scheme that pays tribute to Shipman with a formal lawn and garden area at the back of the house. From there, a series of wild and formal landscapes were envisioned for the journey to the walled garden and beyond: "Passing through a small gate at the end of the lawn, the formal area descends into a wild meadow dotted with ancient native mountain laurels; then, descending further still in the direction of the distant Hudson River view, one moves gradually back to more order, first through the orchard—restored to retain its romantic feel—and finally ending with order again, in the formal walled garden. On the other side of a door in the back wall of the garden is a coda of sorts in the form of a naturalistic woodland garden that leads to a network of woodland trails winding through the larger property."

"The idea of a walled garden was, from the start, both practical and aesthetic," explain the owners. "On a practical level, we wanted to create pockets within the larger Cat Rock garden where the hum from distant traffic would be reduced. On an aesthetic level, we were inspired by many sites we had visited touring gardens of Europe, particularly the walled garden at Rousham and the Lutyens–Jekyll collaboration at Bois des Moutiers in Varengeville-sur-Mer, Normandy." With images from their favorite moments at various locations, the owners approached Lindsey Taylor, a local garden designer who began her career as a garden editor for Martha Stewart's magazine. For Lindsey, the brief was to create a relatively formal garden quite far from the house as a destination to draw people down to the lower area of the property. "In the early days, the idea of the secret garden kept coming to me," she recalls. Separating the garden from the orchard above was a crumbling suggestion of a retaining wall, which she raised much higher to add drama and a greater sense of enclosure while achieving the desired level grade in the garden below. Rockface makes up the fourth wall, keeping the distinctive topography of the area as part of the garden. Century-old boxwoods languishing elsewhere on the property were relocated to hug the walls, mark the entrance, and soften the formal

terrace. Ideas evolved in a fluid dialogue between clients and designer as elements of the garden slowly emerged. First the edible and cutting garden. Then a gravel garden and stone terrace with planting pockets. Two large square beds for herbaceous perennials connect the two areas.

Roses ramble all along the journey from the house through the orchard to the walled garden.

"We have a special interest in the wild side of roses, the species roses and the rugosas," says Jack Bankowsky. The rugosas are especially prized for their hardiness in the cold climate of the Hudson Highlands, as well as for their fragrance. 'Snow Pavement', a hybrid rugosa in the palest shade of lavender, blooms on the edge of a precipice, framing the scenic view of the Hudson River below. 'Thérèse Bugnet', grown in clusters, lines the path to the walled garden. Species roses—*Rosa spinosissima, R. moyesii, R. arkansana*— are scattered among the tall grass and ferns in the meadows and orchard. Another favorite is 'City of York', a climber with generous white flowers and rich golden stamens, grown on the white oak fence of the edible and cutting garden. Great affection is also reserved for 'Constance Spry', "both for her blooms and namesake, the inspired London florist, who was at the height of her powers at about the time Cat Rock must have been coming into its own."

The palette for the roses in the walled garden is mostly white, with a slight flush of pink. The only exception is 'Veilchenblau', a once-blooming hardy rambler grown over a rustic tripod in one of the large perennial beds. Its generous clusters of magenta-purple flowers, fading to a grayish lilac, tangle with the nodding lilac-colored blooms of *Clematis viticella* 'Betty Corning'. On the back wall, pale pink 'New Dawn' blooms above *Viburnum plicatum* 'Mary Milton', whose blushing flowers accompany its rose companions. Nearby, the delicate gray-plum foliage of *R. glauca* is contrasted with the bold velvety chartreuse of *Hydrangea aspera* var. *villosa*. The rambler 'Rural England' sends its masses of flowers cascading down from great heights on the rockface, to be joined later by *R. setigera*, a late bloomer planted by the gardener, Tony Bielaczyc. The walled garden in June is a symphony of roses blazing, cherries ripening against the wall, allium seedheads tottering on long stems, meadow rue reaching for the sky, silver lamb's ears jostling with golden lady's mantle, bees buzzing among the flowers. All the elements conspire to keep the garden humming in harmony and looking just wild enough without tipping over into chaos.

The poetic beauty of Cat Rock is tended by Tony's careful hand and artful eye. The vigorous 'New Dawn' and 'Constance Spry', planted next to each other, require some vigilance to stay distinct, with just a gentle overlap. To keep *R. setigera* from taking over the path, Tony layered it into the rock-face with pockets of soil and encouraged it to scramble upward. The tender 'Blush Noisette' is given winter protection. To prune 'Veilchenblau', he has to "take it off the tripod entirely, lay it on the ground and cut it back and then put it back into place." Such effort is worth it for the plum-toned roses, a riff on a scale of rich burgundy colors in the flowers and foliage and fruit of other plants in the garden: *Hydrangea aspera* 'Plum Passion', *Angelica gigas*, *Physocarpus opulifolius* 'Monlo' (Diabolo ninebark), *Geranium phaeum* 'Samobor', *Nicotiana* 'Chocolate Smoke', Italian plum. Vertical plants—*Verbascum chaixii* 'Wedding Candles' and foxgloves—provide strong upright elements to counter all the rosy blowsiness.

Like all works of art, a garden demands a lot of effort. In the walled garden at Cat Rock, architecture, design, horticulture, and poetry coalesce for a multisensory aesthetic journey.

On a clear summer morning I pass the rose-strewn meadow and descend the rocky path scented with the spicy fragrance of 'Thérèse Bugnet'. Bird calls crisscross the air. In the orchard *R. spinosissima* has already started setting their tiny round dark hips. Tall spires of foxgloves carrying their pale yellow tubular flowers sway gently. Rounding a bend in the path, I glimpse the blushing blooms of 'New Dawn' scrambling across the roof of the shed. Pausing at the stone steps to take in the painterly garden that unfolds below, I think of Sappho's words (as translated by Anne Carson): "...with roses the whole place is shadowed." R+G

RIGHT
The oak fence of the vegetable garden is festooned in the creamy white blooms and glossy green foliage of 'City of York'. The landscape of the Hudson Highlands is glimpsed beyond the back wall.

FOLLOWING LEFT
Hardy rugosa 'Snow Pavement' frames the view of the Hudson River with its flowers, which, despite the name, are not snow white, but a tender shade of lavender.

FOLLOWING RIGHT
Rosa arkansana blooms among the yarrows and milkweed in the meadow.

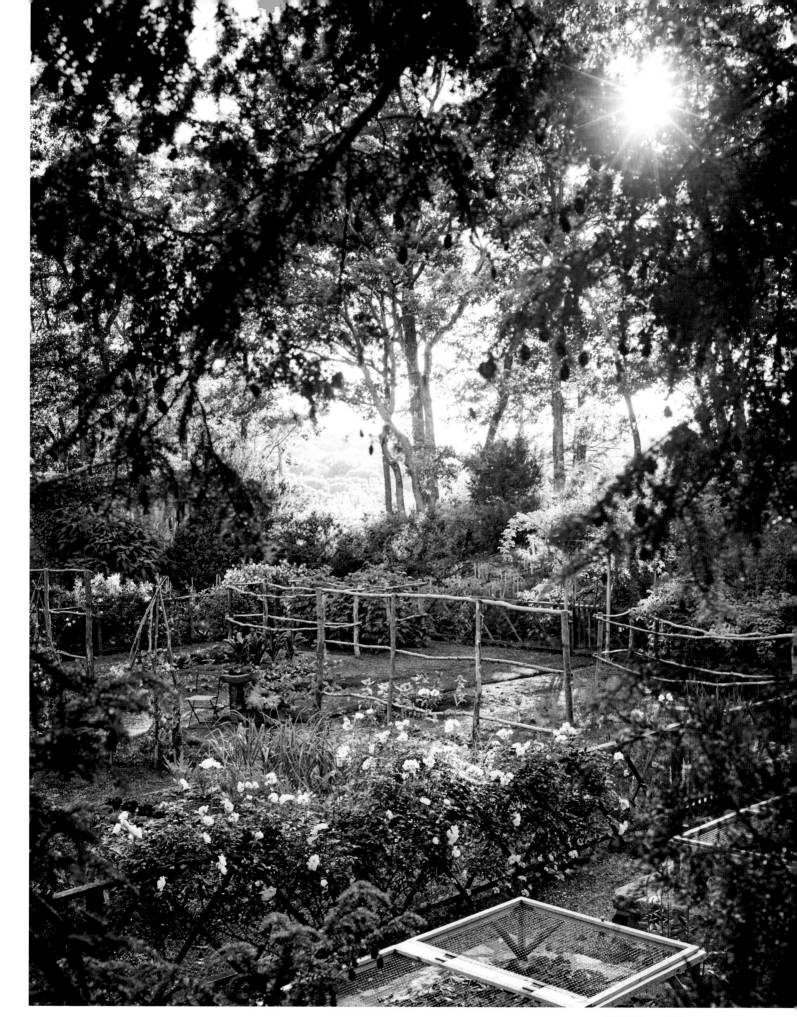

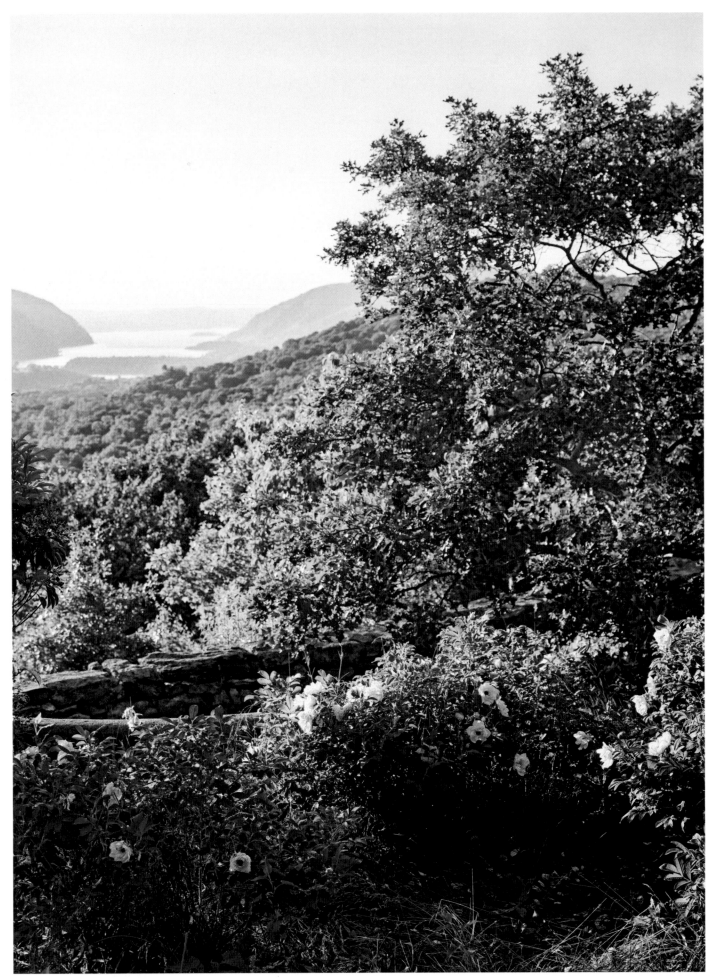

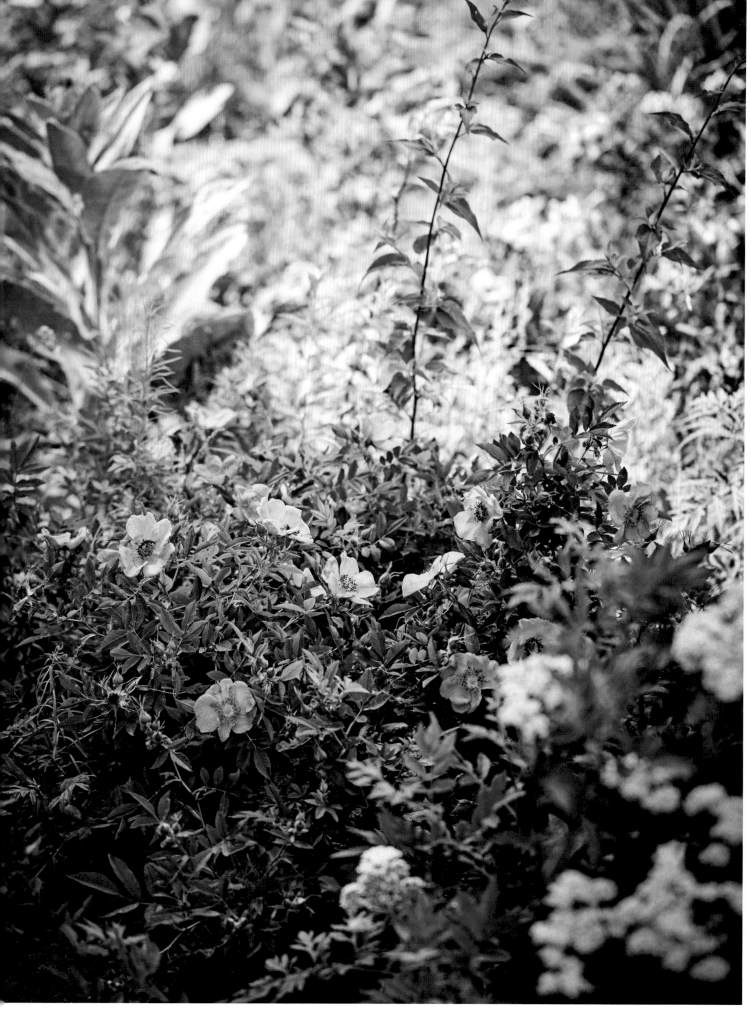

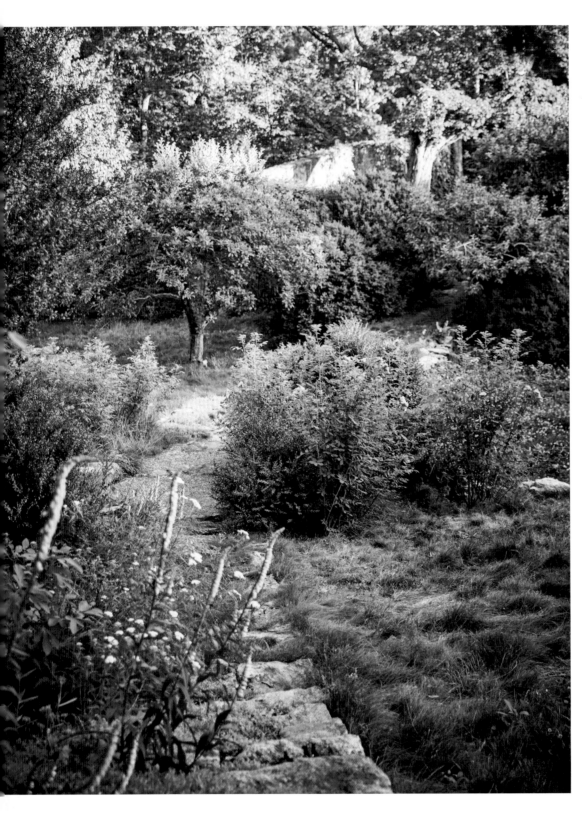

LEFT
Another rugosa hybrid, 'Thérèse Bugnet', lines the path from the orchard to the walled garden.

RIGHT
The reliably proliferous 'New Dawn' scrambles across the roof of the small stone building in the walled garden.

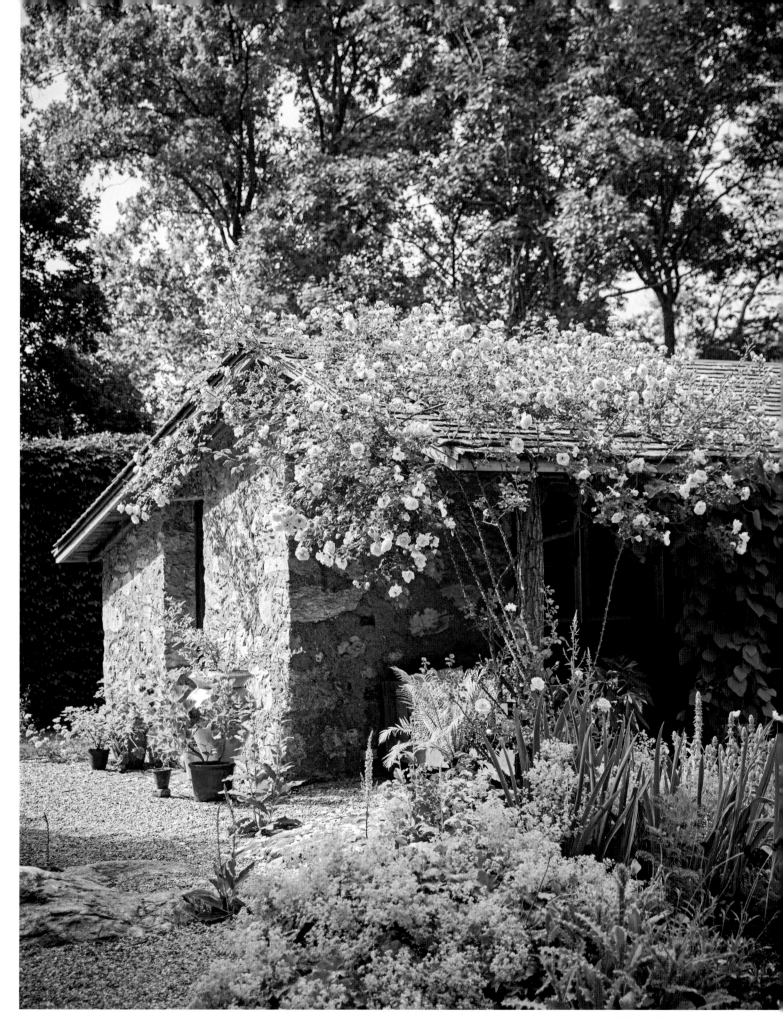

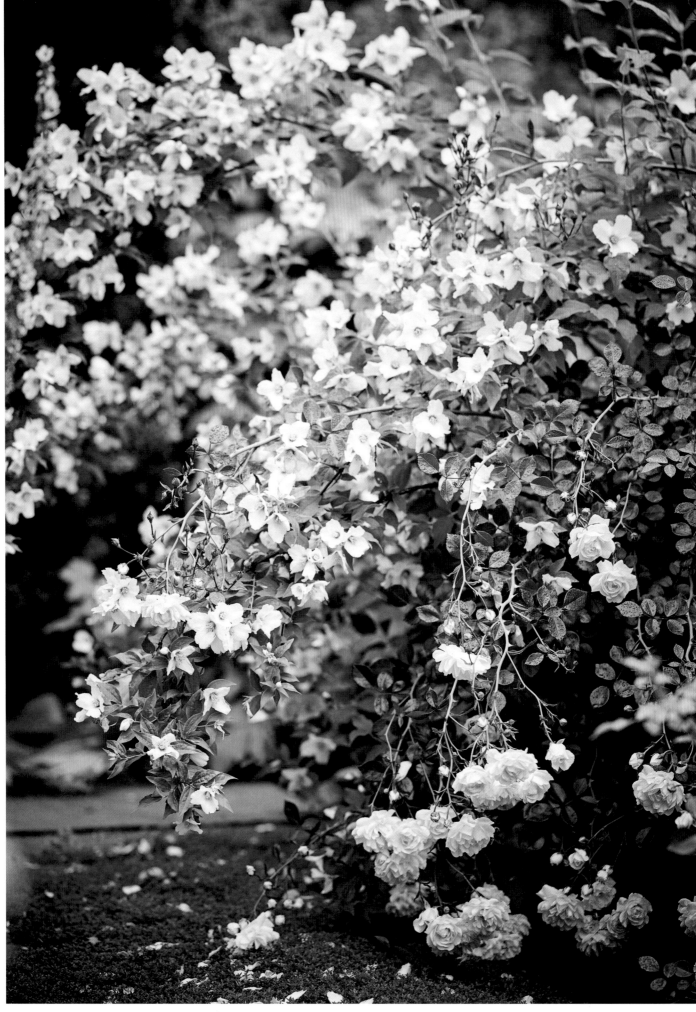

LEFT
Everything is carefully choreographed yet
seemingly untamed, like the coordinated
movement of 'Sea Foam'—its long canes
bending from the weight of the blooms—
and its companion, a mock orange.

RIGHT
In another artful combination, the gray-
plum foliage of *R. glauca* is contrasted
with the velvety chartreuse leaves of
Hydrangea aspera var. *villosa*.

FOLLOWING
Under Tony Bielaczyc's tender care, all
the elements conspire to keep the garden
humming in harmony and looking just wild
enough without tipping over into chaos.

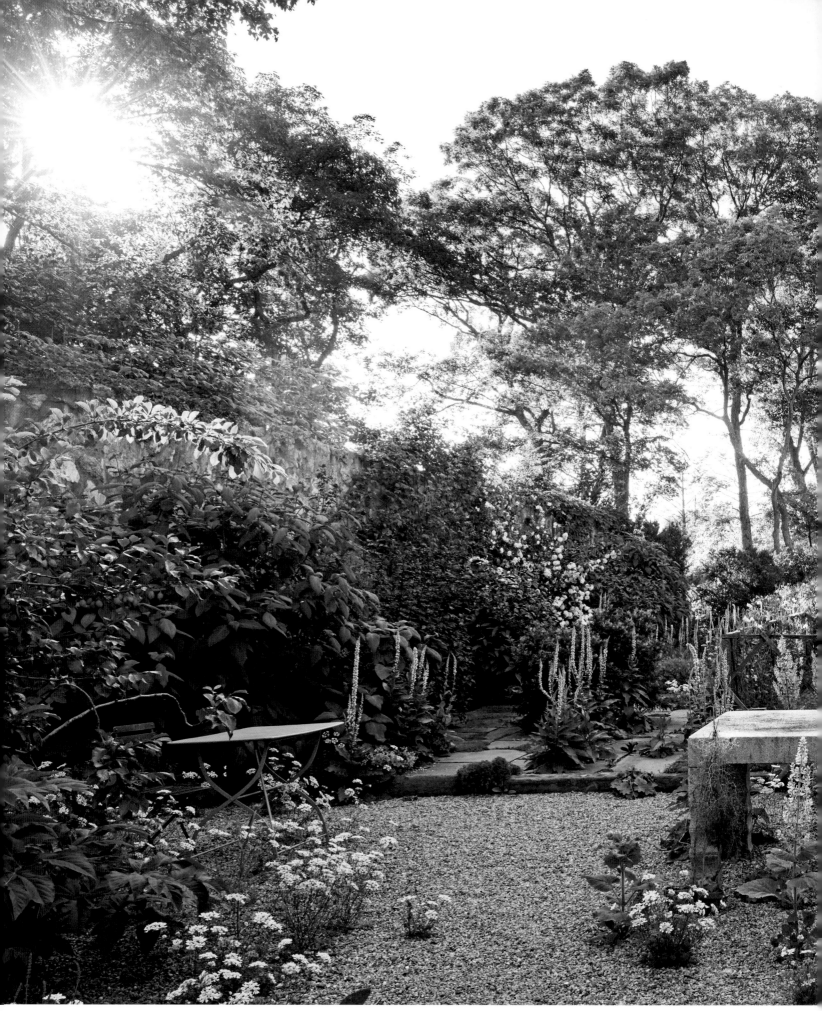

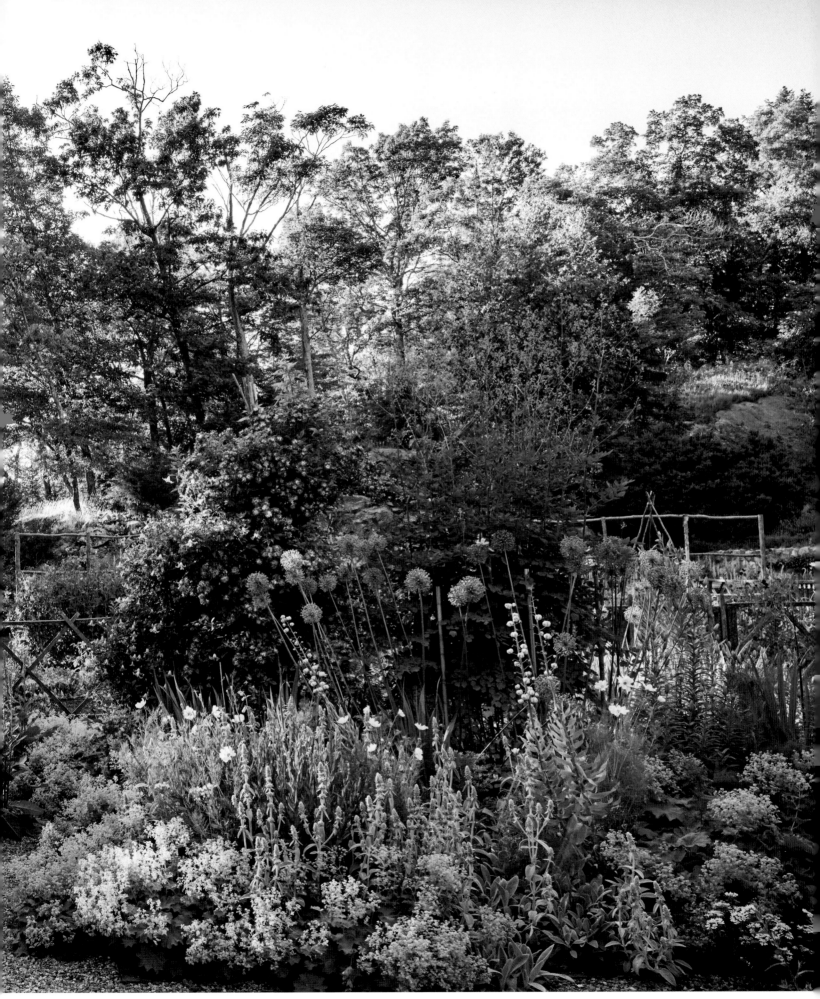

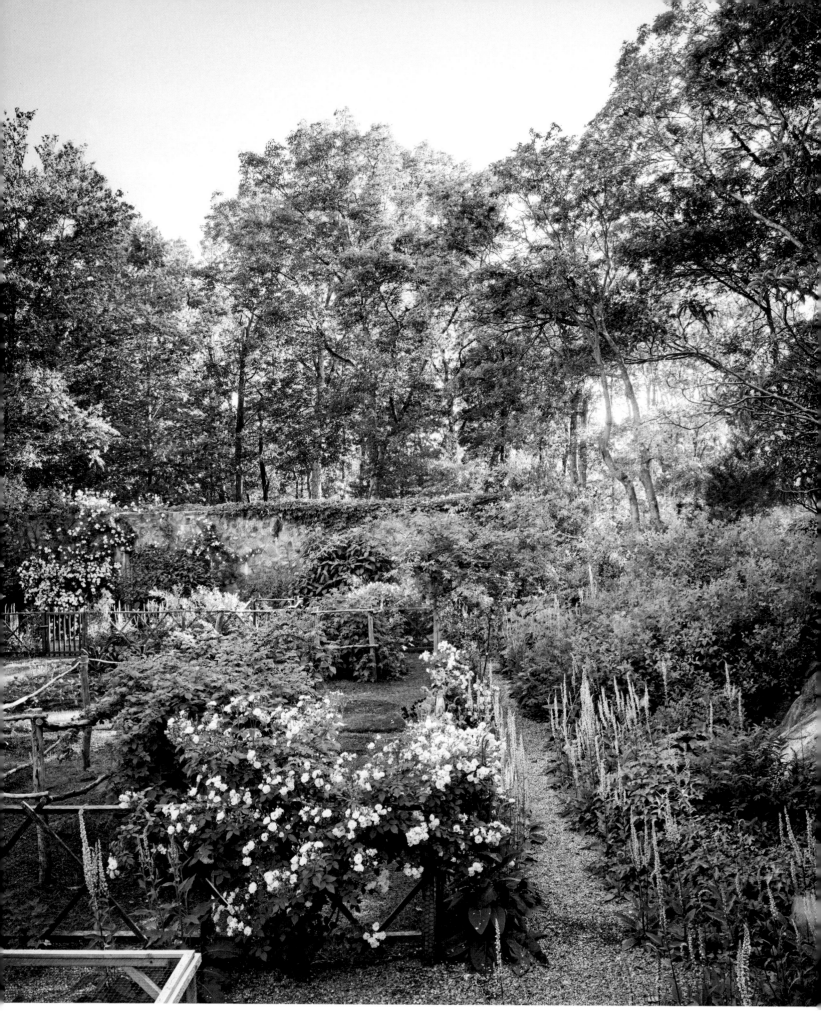

LEFT
Verbascum 'Wedding Candles' provides
strong upright elements to counter all the
rosy blowsiness.

RIGHT
R. spinosissima is grown as much for its
early blooms as for its ink-black hips.

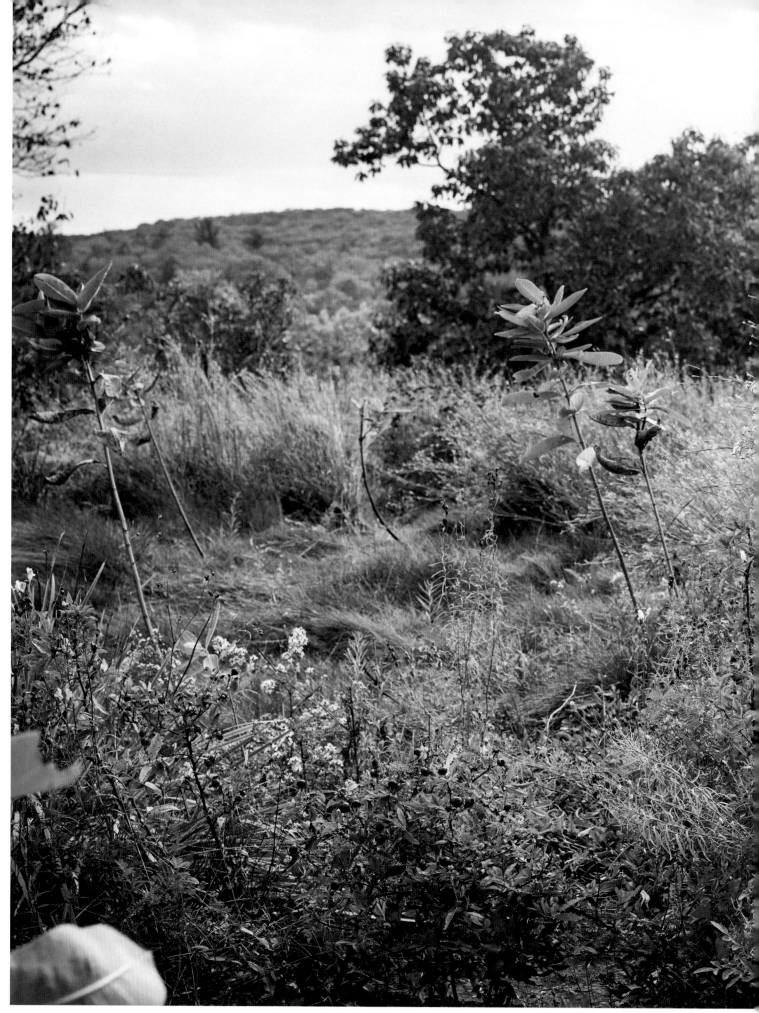

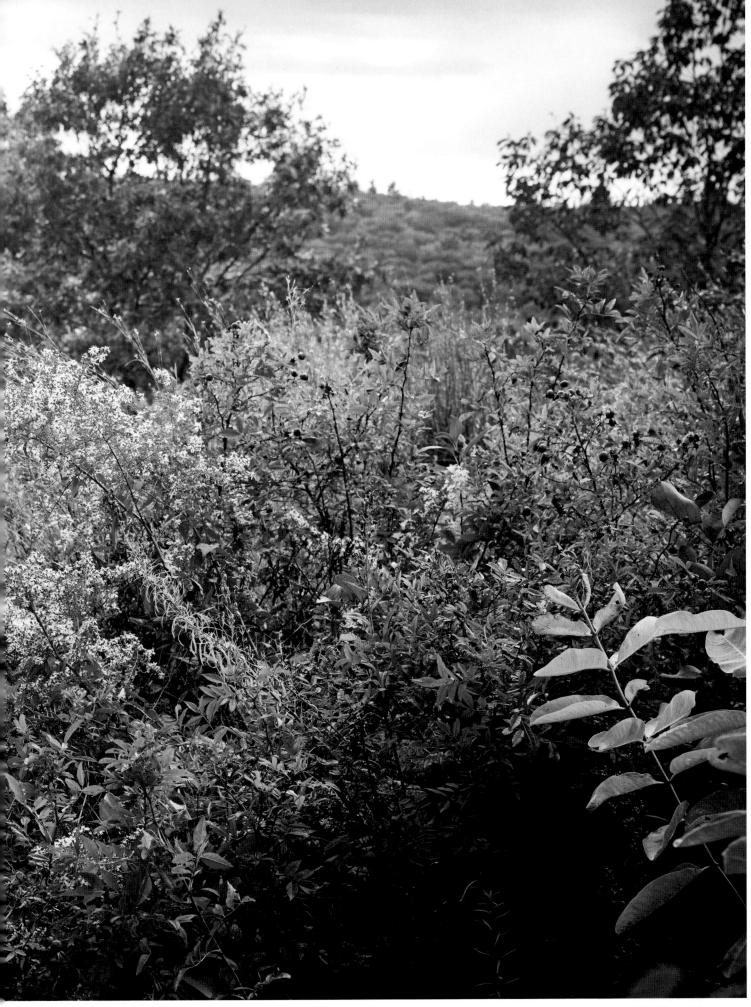

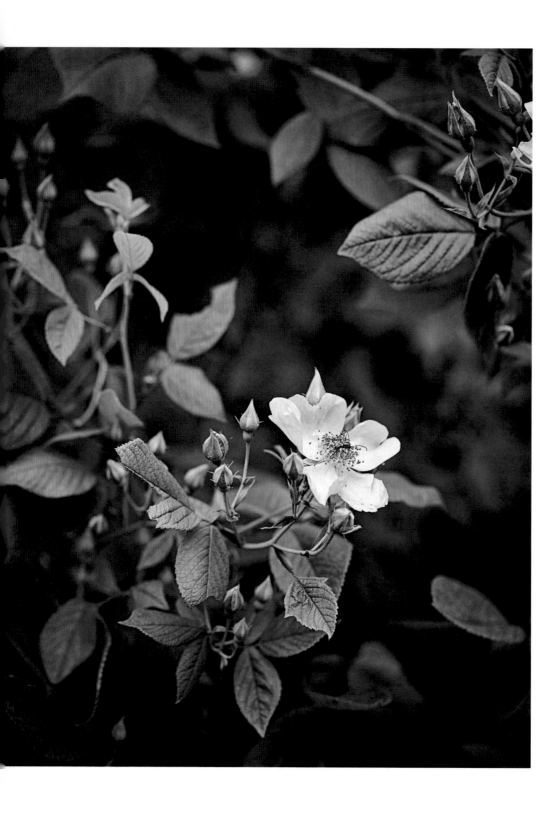

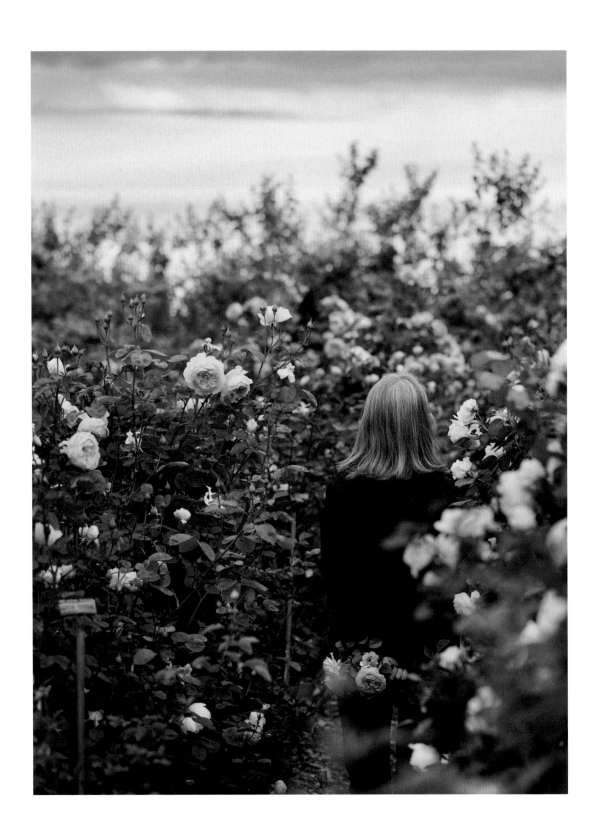

The Roses

There are too many roses to list
all the varieties grown in the gardens
featured in this book.

The City of Sakura Rose Garden alone has nearly 2,000 species. I have assembled instead a selection of roses encountered during my time photographing these places. They range from the humble species like the dog roses at Hillside to the enduring Old Rose beauties to the modern shrubs by David Austin and the Kordes family. Some of these roses are featured in the previous chapters, as noted with page references, and images of many of the other varieties can be found in the following pages.

LEFT
Floret Flower Farm, June 14, 2024.

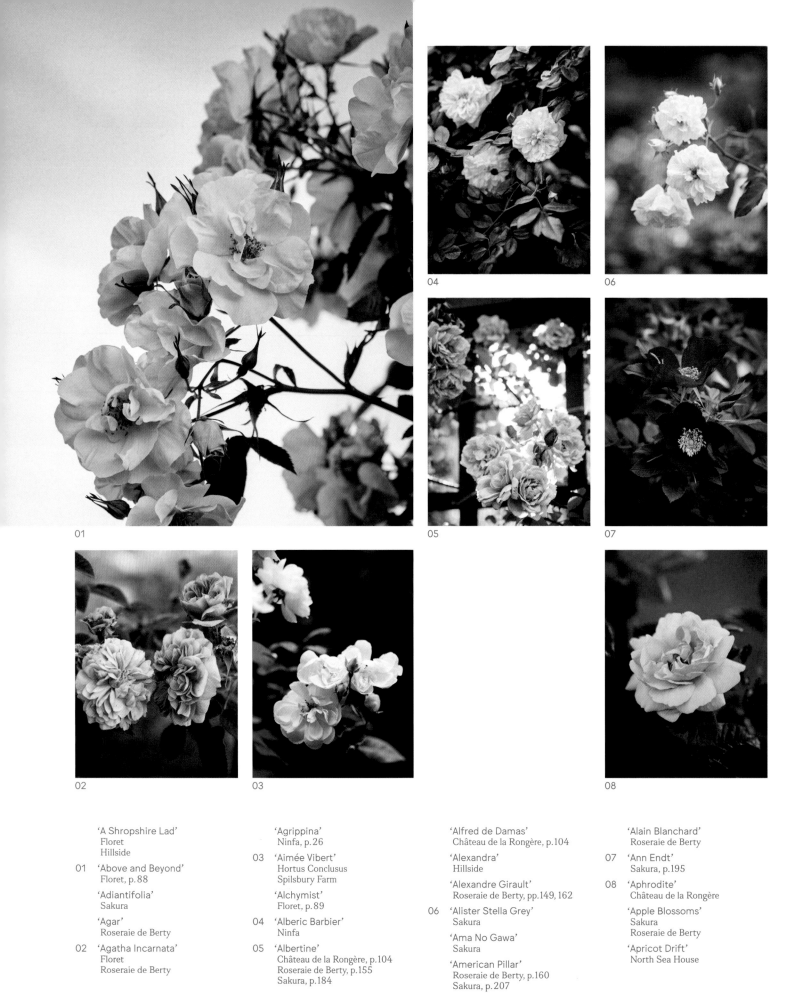

01

02

03

04

06

05

07

08

09

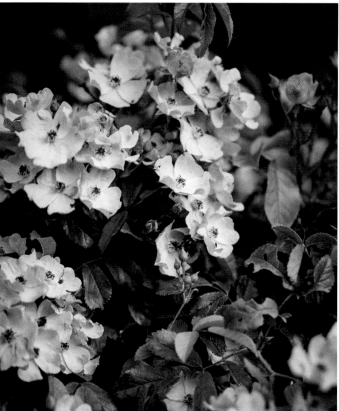

11

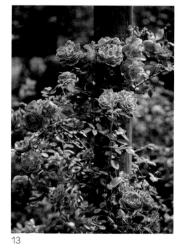

13

10

14

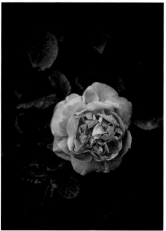

12

'Blush Noisette'
Noisette is a class of old roses that originated in the United States. In 1802, a chance crossing of 'Old Blush' (also known as 'Parsons' Pink China', one of the four stud Chinas) and *Rosa moschata* was found on John Champneys's large plantation garden just southwest of Charleston, South Carolina. Seedlings of the new rose, named 'Champneys' Pink Cluster', were given to his neighbor Philippe Noisette, who came from a distinguished family of horticulturists. The Frenchman had gone to Saint-Domingue in Haiti to escape the French Revolution before settling in Charleston, where he eventually became the head of the South Carolina Medical Society Botanical Gardens. Philippe sent Champneys's seedlings, including 'Blush Noisette', to his brother in France, where they were crossed with tea roses to produce a new class of roses that bears the family name. 'Blush Noisette', introduced in France as 'Noisette Carnée' and painted by Pierre-Joseph Redouté as *Rosa noisettiana*, remains a popular rose in gardens around the world.

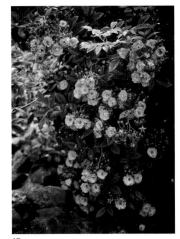

15

'Bobbie James'
The rambler 'Bobbie James' is
a modern rose introduced by
Sunningdale Nursery in the
United Kingdom in 1961. A hybrid
wichurana of unknown parentage,
this once-blooming rambler is
tremendously vigorous, growing
twenty to thirty feet tall. In mid-
spring its canes are smothered in
large clusters of fragrant, semi-
double white flowers with bright
yellow stamens. 'Bobbie James'
was discovered as a seedling by
Graham Stuart Thomas—who was
working for Sunningdale Nursery
at the time—in the garden of his
friend and longtime correspondent
the Honorable Robert James, who
cultivated a garden of roses at St.
Nicholas, in Richmond, Yorkshire.
Thomas noted the rose's "glorious
fragrance" and judged it to be
"a really splendid luxuriant and
prolific plant." 'Bobbie James' will
happily scramble up a tree, cover
a fence, or reach the second story
of a house.

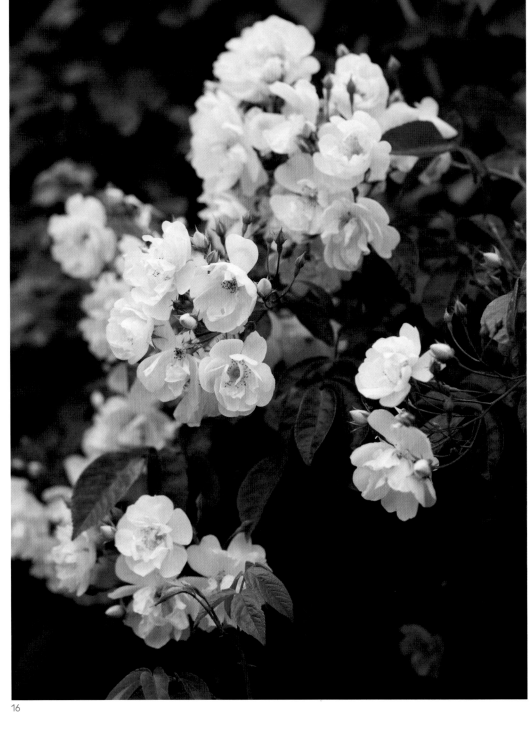

16

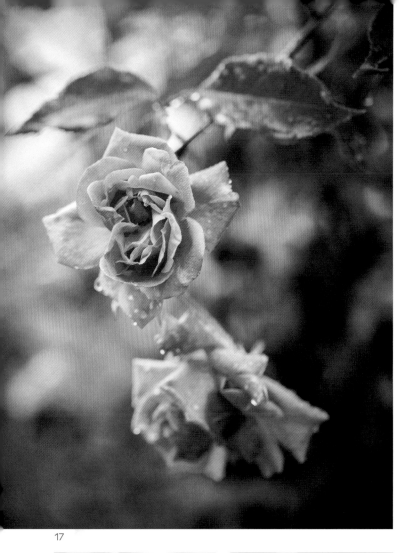

17

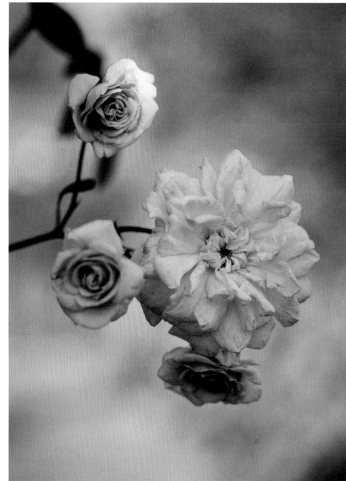

20

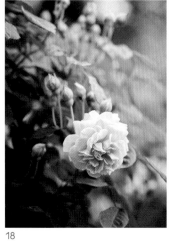

18

19

21

'Celsiana'

Like all damasks, 'Celsiana' offers flowers with an exceptional fragrance. An old rose of unknown origins dating back to before 1750, it was introduced into France from Holland by the Cels family nursery around 1817. It bore the name *Rosa damascena mutabilis* for the mutable colors of its blooms. Clusters of pink buds open into flowers with soft and flouncy petals that fade to blush and nearly white. A shrub in full bloom will feature the various stages of coloration. Growing up to six feet tall with supple canes covered in gray-green foliage, its habit is as graceful as its beautiful flowers. Pierre-Joseph Redouté, along with his co-author of *Les Roses*, Claude-Antoine Thory, renamed it 'Celsiana'; Redouté painted a version of the rose with the unusual genetic mutation called flower proliferation, where buds will form from the center of a flower. Although its cause is not known, proliferation can be triggered by various factors, including a late frost, insect damage, extreme heat, or a virus.

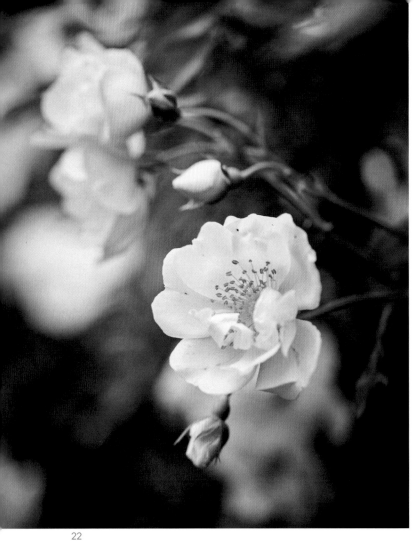

22

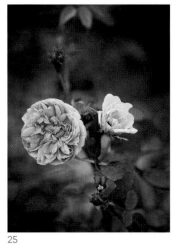

25

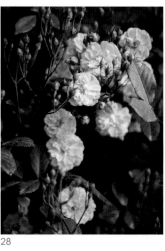

28

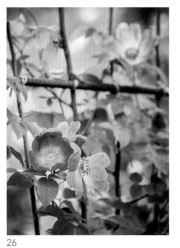

26

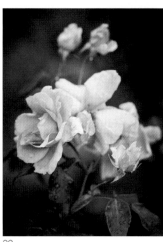

29

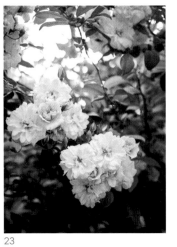

23

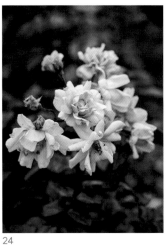

24

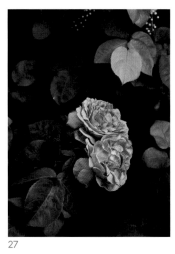

27

'City of York'
'City of York' is a dependable
climber that is hardy, vigorous, and
disease resistant. It was a beloved
rose of Pierre S. Dupont—the
founder of Longwood Gardens in
Pennsylvania—who grew it under
its original German name, 'Direktor
Benschop'. Bred in 1939 by the
hybridizer Mathias Tantau, 'City
of York' is a descendant of the
popular rambler 'Dorothy Perkins',
introduced in 1901 by the American
nursery Jackson & Perkins. 'City
of York' inherited its parent's
hardiness and prolific flowering, but
not its susceptibility to powdery
mildew. Its fragrant cupped flowers
and pale yellow buds come from
another progenitor, the hybrid tea
'Professor Gnau'. In a ten-year trial
of roses at Longwood Gardens,
'City of York' proved to be among
the top performing roses.

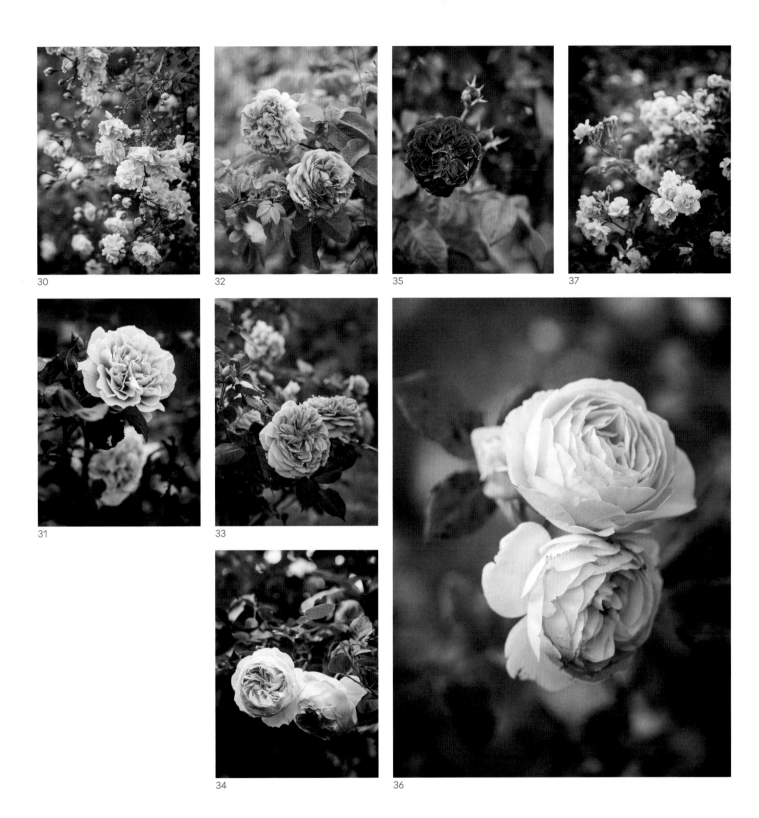

30

32

35

37

31

33

34

36

38

41

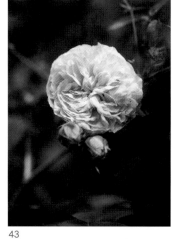

43

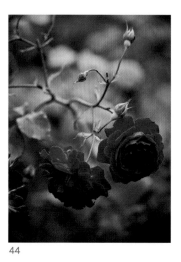

44

39

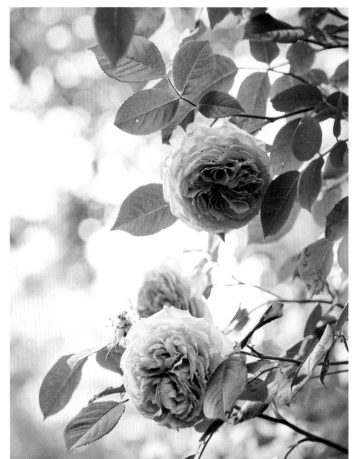

42

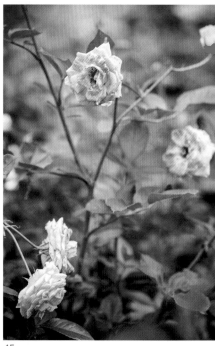

45

'Général Schablikine'
'Général Schablikine' is a tea rose introduced by Gilbert Nabonnand in 1878. In warmer climates, it is almost never without its sumptuous coppery-red blooms. Nabonnand was a horticulturist whose education included an apprenticeship with Jean-Baptiste Guillot (père), the breeder of hybrid perpetuals and bourbons. He set up his own nurseries in Sorgues and later Avignon, where he focused on roses exclusively. In 1855, Lord Henry Brougham hired Nabonnand to design and plant the garden at his property in Cannes, the Villa Éléonore-Louise, jumpstarting the nurseryman's career as a landscape designer. In 1864 Nabonnand moved his nursery to Golfe-Juan, where he also began breeding tea roses. In three decades until his death in 1903, Nabonnand introduced seventy varieties, of which 'Général Schablikine' is the most successful. Though its lineage is unknown, this copper-tinted beauty is thought to be a descendant of 'Safrano à fleurs rouges', a red tea rose with shades of yellow.

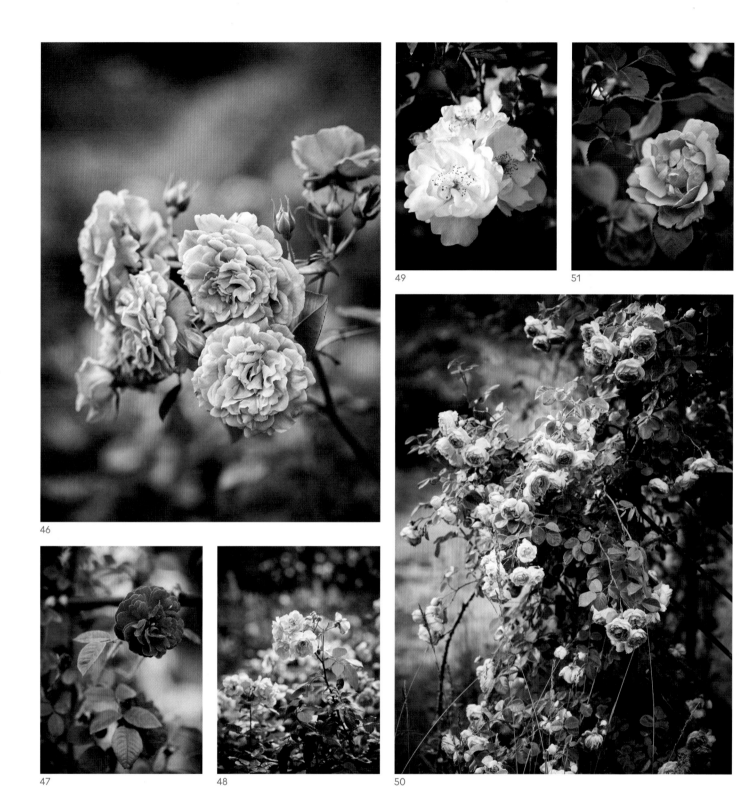

46 'Heilige Elizabeth'
 Sakura

 'Hector'
 Floret

47 'Henri Martin'
 Sakura

 'Heritage'
 Château de la Rongère
 Ninfa
 North Sea House

48 'Hina Matsuri'
 Sakura

 'Hippolyte'
 Roseraie de Berty, p.156

 'Hume's Blush
 Tea-Scented China'
 Château de la Rongère, p.116

 'Ispahan'
 Spilsbury Farm, pp.125, 128

49 'Jacqueline du Pré'
 Floret

 'Jacques Cartier'
 Hortus Conclusus
 Spilsbury Farm

 'James Galway'
 Floret, pp.86–87, 91

50 'Jasmina'
 Roseraie de Berty
 Ninfa

 'Jean Girin'
 Roseraie de Berty

51 'Jean Guichard'
 Roseraie de Berty
 Sakura

'Jacqueline du Pré'
'Jacqueline du Pré' is a modern shrub from the English rose nursery founded in 1879 by the brothers John and Robert Harkness. The flouncy white flowers with the striking red-tinged eye are a magnet for pollinators. The musk-scented blooms are short-lived, rarely lasting more than a day, but the soft apricot buds open in quick succession in large clusters. Introduced in 1988 and named for the virtuoso cellist, 'Jacqueline du Pré' is a rose as memorable as its namesake's music.

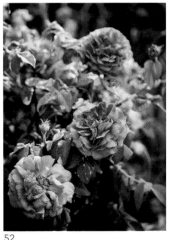

52

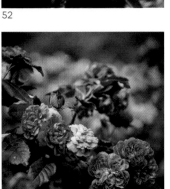

53

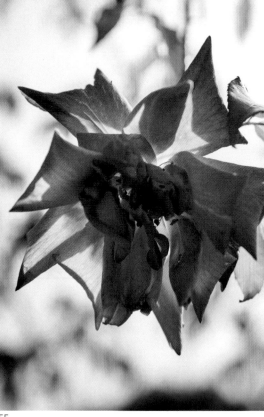

55

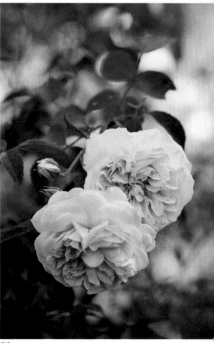

58

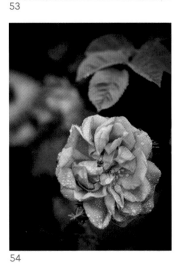

54

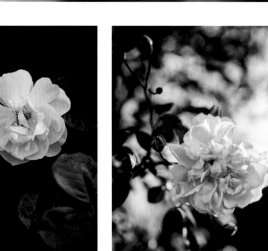

56

57

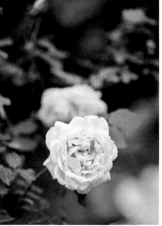

59

'Madame Alfred Carrière'
Along with 'Blush Noisette',
'Madame Alfred Carrière' is one
of the most enduring noisettes.
Introduced in 1879 by the
horticulturist Joseph Schwartz
of Lyon, who dedicated it "to the
wife of a great lover of roses from
our own province of Dauphiné" in
southeast France, 'Madame Alfred
Carrière' remains among the most
popular climbing roses in England.
Gertrude Jekyll considered it the
best white climber. At Sissinghurst,
Vita Sackville-West grew it to
bloom outside her bedroom
window. At Torrecchia Vecchia, a
magical garden hidden in the hills
of the Castelli Romani in Italy, Dan
Pearson planted 'Madame Alfred
Carrière' to throw its canes freely
over the walls of ruins, arching over
walking paths, scattering petals
along the way. The blush-tinted
white flowers are large, globular
and loosely formed, endowed with
a fruity fragrant. This vigorous rose
can climb up to eighteen feet with
long, graceful, and almost thornless
canes, blooming repeatedly from
summer to autumn.

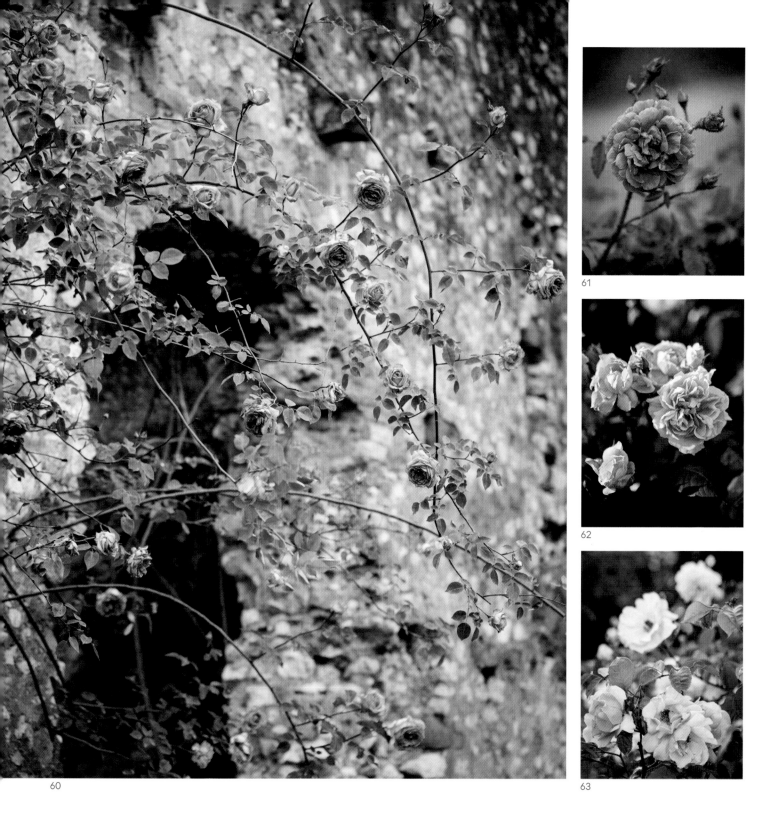

60

61

62

63

'Madame Caroline Testout'
At the start of the twentieth century, the civic leaders of Portland, Oregon, had a mission to beautify their city and brand it "Rose City" at the 1905 Exposition. Volunteers went door to door to give away cuttings and encourage residents to plant roses in their front yards. The rose of choice was 'Madame Caroline Testout', a hybrid tea bred by the French nurseryman Joseph Pernet-Duchet in 1890 and named after a Parisian dressmaker. Miles of rose hedges were eventually planted along the streets and at the fairground, including ten thousand 'Madame Caroline Testout' specimens. At the first Portland Rose festival in 1907, the city was awash in their large pink blooms, which also filled the leather mailbags of marching postal workers. The rose became an emblem of the "City of Roses," and in 1914 an Oregon-grown 'Madame Caroline Testout' was planted at the White House under the watchful eyes of President Woodrow Wilson.

60 'Madame Caroline Testout'
 Ninfa

 'Madame Grégoire Stachein'
 Ninfa

 'Madame Isaac Péreire'
 Rohuna, p.52
 Spilsbury Farm

 'Madame Labarte'
 Sakura

61 'Maréchal Davoust'
 Sakura, p.194

 'Marie de Blois'
 Roseraie de Berty

 'Marinette'
 Floret, p.99

62 'Mary Delany'
 North Sea House
 Hillside

63 'Meg'
 Château de la Rongère

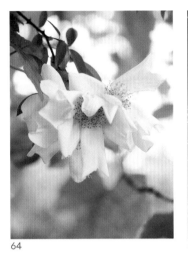
64

66

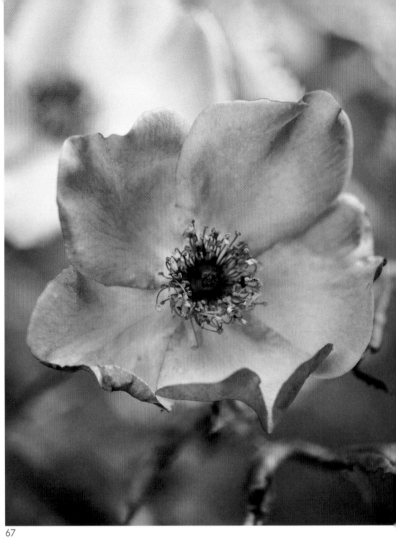
67

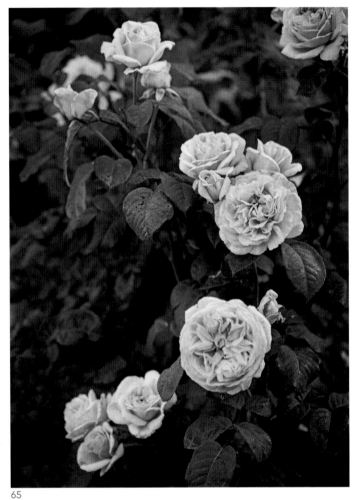
65

68

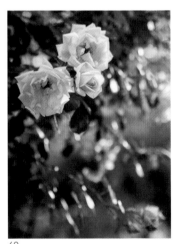
69

'New Dawn'
This hardy and vigorous rose has the distinction of being US Plant Patent Number 1. On August 18, 1931, the US Patent and Trademark Office granted the first plant patent to New Jersey resident Henry Rosenberg for 'New Dawn', described as "a climbing plant that bears champagne-colored roses." It is a sport of the climber 'Dr. W. Van Fleet', which is a cross of *R. wichurana*, the tea rose 'Safrano', and the hybrid tea 'Souvenir du Président Carnot'. Although the patent protection for 'New Dawn' has long expired, it remains popular in gardens everywhere.

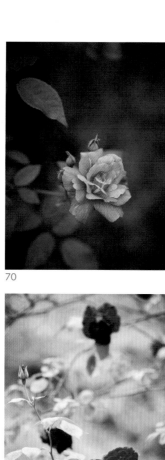

70

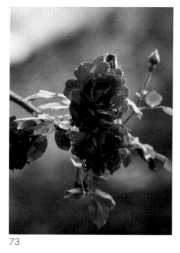

73

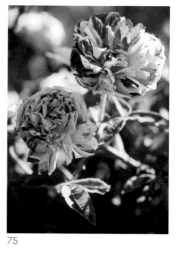

75

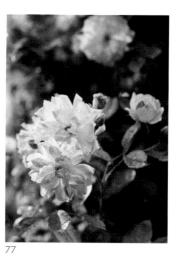

77

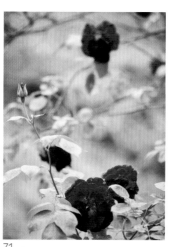

71

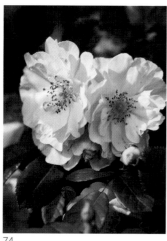

74

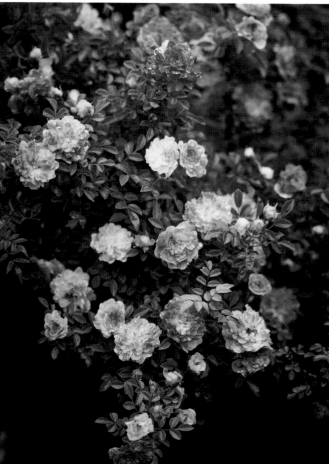

76

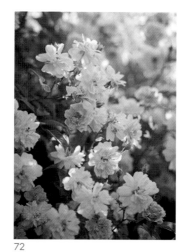

72

'Old Blush'
The introduction of 'Old Blush' to Europe in the late eighteenth century proved to be pivotal in the creation of modern roses. Thought to be the prettiest of the four stud Chinas that were used in the breeding of modern hybrids, 'Old Blush' was most likely collected by Sir George Staunton from China and sent back to Sir Joseph Banks, then director of Kew Gardens, in 1789. It was first seen blooming in the garden of John Parsons in 1793 and thus became known as 'Parsons' Pink China'. By the early nineteenth century, it was popular all over Europe and in the southern states of America. In literature, it is immortalized by the poet Thomas Moore in "The Last Rose of Summer." Among the many common names for this rose is the Old Pink Monthly rose. In China, 'Yue Yue Fen' (yue yue means "month after month," and fen is "pink") is the designation of a group of pink, repeat-flowering roses in cultivation for centuries, including 'Old Blush'.

70 'Old Blush' ('Yue Yue Fen')
 Ninfa
 Sakura, p.189

71 'Parkdirektor Riggers'
 Ninfa, p.39

72 'Paul's Himalayan
 Musk Rambler'
 Château de la Rongère, p.104
 Floret

73 'Paul's Scarlet'
 Ninfa, p.32

 'Peace'
 North Sea House, p.213

74 'Penelope'
 Hortus Conclusus
 Ninfa

 'Perfume Breeze'
 Floret

75 'Perle des Panachées'
 Floret

76 'Petite Pink Scotch'
 Sakura

77 'Phyllis Bide'
 Floret
 Hortus Conclusus

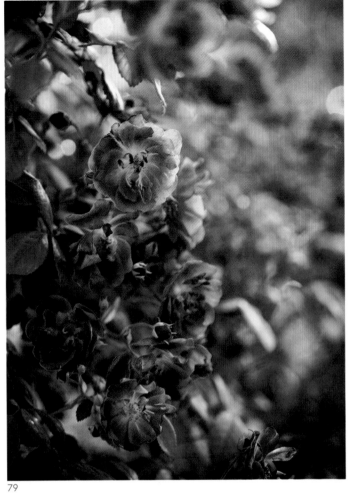

79

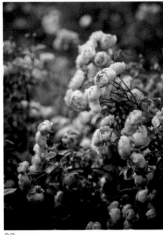

82

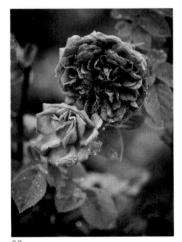

83

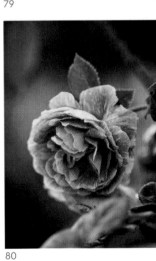

80

81

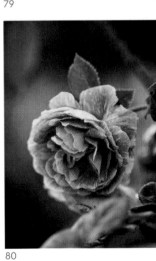

78

'Queen of Denmark'
A favorite in gardens for nearly two centuries, 'Queen of Denmark' is a seedling of 'Maiden's Blush'. First flowered in James Booth's nursery at Flottbek in 1816, it was named 'New Maiden's Blush' and distributed on a small scale. In 1826, it entered the nursery's catalogue as 'Königin von Dannemark' (Flottbek was then part of Denmark). In France it also went by the name 'Naissance de Vénus', a testament to its beauty. The once-blooming fragrant flowers are a deeper pink than most albas, with incurved petals forming an intricate rosette. This peerless rose was the subject of a dispute between Booth and Professor Lehmann, director of the Botanic Gardens at Hamburg, who claimed that the new alba rose was actually 'Belle Courtisanne', a cross of a centifolia with 'Maiden's Blush', a specimen of which was among the list of roses in his garden. The nursery published a widely distributed pamphlet to prove the professor wrong, quoting well-known growers as well as Pierre-Joseph Redouté, all of whom attested to never having heard of 'Belle Courtisanne'.

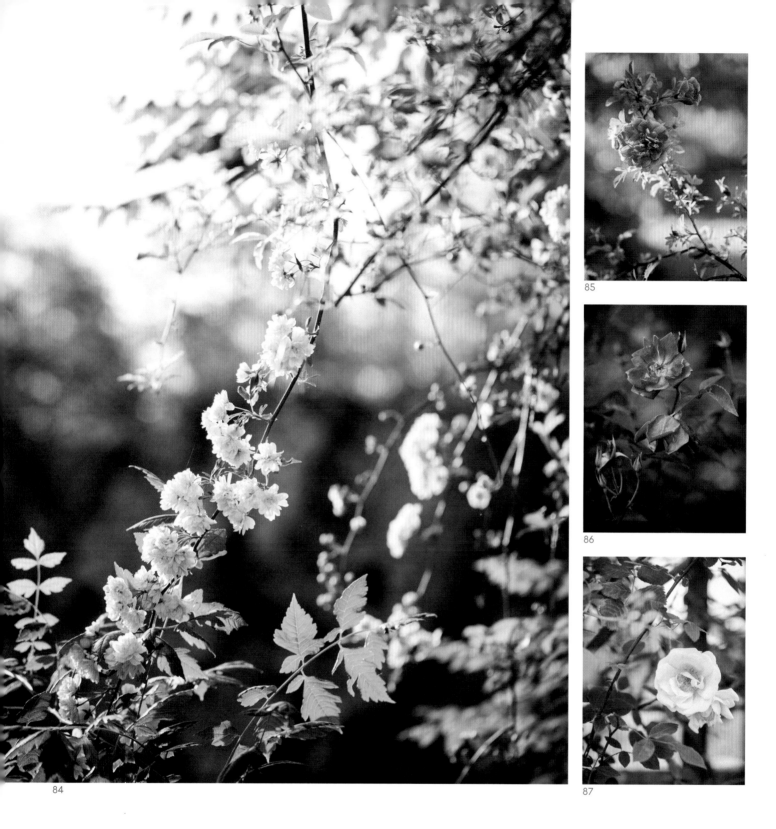

85

86

87

84

Rosa banksiae 'Lutea'

Rosa banksiae 'Lutea' is one of many varieties of what is commonly known in the West as the banksia roses and in China, where they originate, as Mu Xiang, which literally means "leaflet fragrance." In his book *Old Roses in China*, Dr. Guoliang Wang names more than twenty wild species and cultivated varieties that belong to this group. Their flowers can be white or yellow, single or double; some are thornless, others prickly. All are vigorous climbers, and the widely popular 'Lutea' is the most floriferous of the banksia roses. Citing examples in literature and paintings from the Tang and Song dynasties, Dr. Wang tells us that these roses had been used as a traditional vine flower in Chinese courtyard gardens for centuries before it was introduced to Europe in 1807. 'Lutea', a yellow double-flowered variety, flowered for the first time in England in 1824.

Rosa arkansana
Cat Rock, pp. 231, 240–241

Rosa banksiae var. *banksiae*
Ninfa

84 *Rosa banksiae* var. *lutea*
Ninfa, p. 20
Rohuna

85 *Rosa californica* 'Plena'
Floret
Spilsbury Farm, p. 137

Rosa canina
Hillside, pp. 172, 176
Spilsbury Farm

86 *Rosa chinensis*
Sakura

Rosa davurica var. *alpestris*
Sakura, p. 197

87 *Rosa dumalis*
Sakura

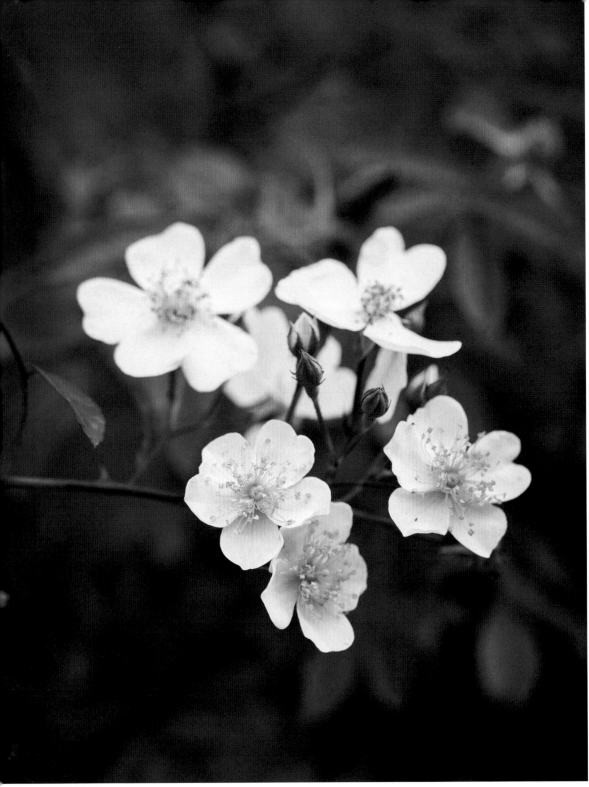

88

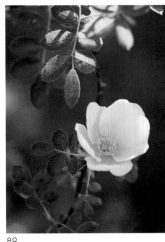

89

90

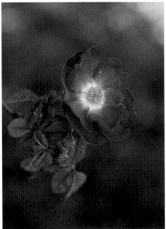

91

Rosa gallica 'Officinalis'
R. gallica 'Officinalis' is a distinguished old rose that has been in cultivation for centuries—possibly the first cultivated rose in the West. It was grown for its medicinal properties in medieval monastery gardens as well as Charlemagne's imperial garden. Early physicians discovered that the dusky red petals retained their perfume when dried. Exploiting this unique quality of the apothecary's rose, as it was known before 1600, a thriving industry in medicinal remedies and confections flourished in the town of Provins in France for over six hundred years. Among this venerable gallica's many names over the years are 'Rose de Provins' (not to be confused with the Provence roses from the southern provinces of France) and 'Red Rose of Lancaster', being the legendary badge of the Earl of Lancaster.

92

95

93

96

94

97

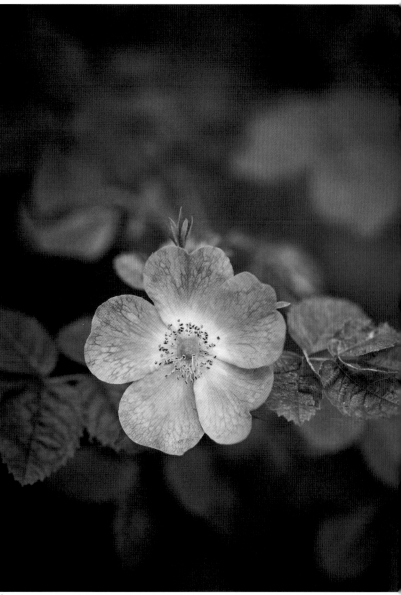

98

93	*Rosa helenae* Roseraie de Berty Sakura	96	*Rosa multiflora* var. *cathayensis* Sakura

93 *Rosa helenae*
Roseraie de Berty
Sakura

Rosa hirtula
Sakura, p.204

94 *Rosa moyesii* 'Geranium'
Hillside, p.177
Spilsbury Farm, p.142

Rosa mulliganii
Roseraie de Berty, p.157
Sakura

95 *Rosa multiflora* var.
adenochaeta
Sakura

96 *Rosa multiflora* var.
cathayensis
Sakura

Rosa pendulina
Hillside, p.173

97 *Rosa roxburghii* f. *normalis*
Sakura
Spilsbury Farm

Rosa roxburghii f. *plena*
Sakura, p.205
Spilsbury Farm

98 *Rosa rubiginosa*
Hillside
Spilsbury Farm, pp.134–135

Rosa rubiginosa
R. rubiginosa, commonly known as eglantine or sweet briar,
is a wild species native to Europe. Long thorny canes are covered
in summer with sprays of delicate pink flowers that ripen into
deep orange hips lasting through winter. The dark green foliage
carries an unusual scent redolent of apples—notably after the rain.
Used for centuries as hedging plants in England, the eglantine
rose has an importance place not only on the country's landscape,
but also in its history and literature. Queen Elizabeth I adopted it
as her personal emblem. In his play *A Midsummer Night's Dream*,
Shakespeare depicts Titania's bower as "quite over-canopied with
luscious woodbine, with sweet musk-roses and with eglantine,"
linking the Queen of the Fairies with the Virgin Queen. In
eighteenth-century France, Pierre-Joseph Redouté painted an
eglantine rose no longer in cultivation today, a floral portrait titled
Rosa Rubiginosa Zabeth / Eglantine de la Reine Elisabeth.

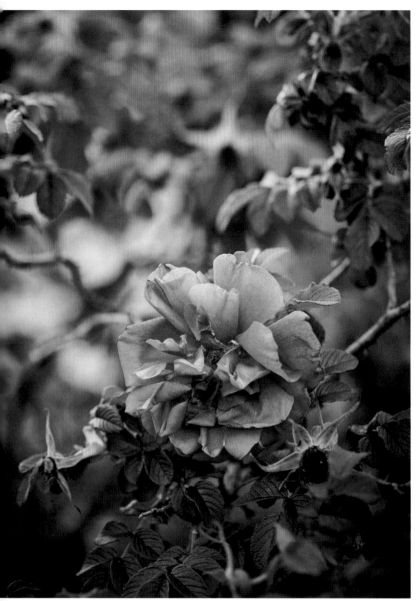

99

100

102

101

Rosa setigera
Commonly known as the prairie rose or climbing prairie rose, *R. setigera* is one of the most captivating North American native roses. First observed and described by the French botanist André Michaux, who found it blooming in South Carolina in 1810, the prairie rose thrives from the Atlantic to the Rocky Mountains, and as far north as Wisconsin. With canes that grow more than ten feet in a season, it can spread high and wide. The flowers, borne in clusters and varying in color from white and dark pink, are larger than other wild rose species and the last of these to bloom. The prairie rose has the distinction of being the only species in the genus *Rosa* to be dioecious, having male and female flowers on separate plants. The male plants have more flowers, but only the female plants bear the masses of bright scarlet hips that make the prairie rose such a striking plant in autumn. The flowers and hips are a magnet for wildlife throughout the year, attracting songbirds, bees, and butterflies.

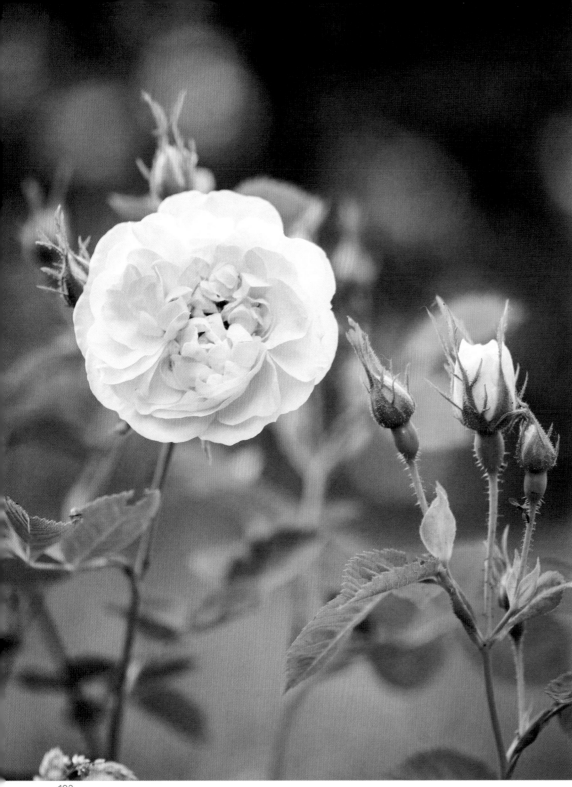

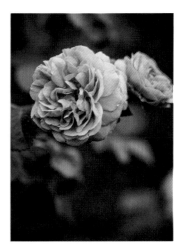

Rosa × alba 'Maxima'
One of the grandes dames of
old roses with a long cultural
history, 'Maxima' is thought to
have originated before 1320 as a
sport of the alba 'Semi-plena'. It is
most likely the Alba flore pleno of
medieval herbals. While 'Semi-
plena' was chosen by the Yorkists
in the Wars of the Roses in the
fifteen century, 'Maxima' became
the 'Jacobite Rose', a symbol of
the seventeenth- and eighteenth-
century political movement to
restore the reign of exiled Catholic
King James II and his descendants.
As the story goes, Bonnie Prince
Charlie plucked the white rose from
the roadside to wear on his hat on
his way south to start the Jacobite
Rebellion of 1745. 'Maxima' has
remained popular through the
centuries, its creamy white blooms
borne on long arching canes with
gray-green foliage still gracing
gardens everywhere. Gregg Lowery
noted that a late summer rebloom
can be expected in mature plants
in California.

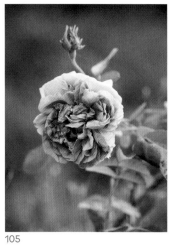

105

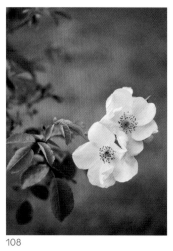

108

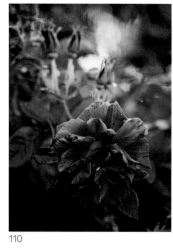

110

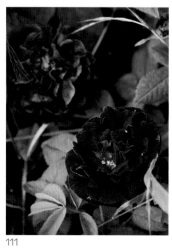

111

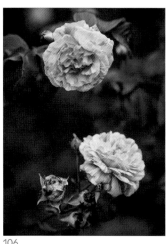

106

109

112

107

Rosa × odorata 'Mutabilis'
The origin of *Rosa × odorata* 'Mutabilis' is unknown, but it is widely cultivated for its delicate single flowers that change from apricot yellow to pink and then coppery crimson as they age. It was available commercially in northern Italy at the end of the nineteenth century as 'Tipo Ideale'. In 1895 Prince Gilberto Borromeo, who knew the rose as *Rosa turkestanica* and grew it his estate at Isola Bella, on the shores of Lago Maggiore, gave a plant to the Swiss botanist Henri Correvon, who renamed it 'Mutabilis'. Whatever its origin, it is a graceful rose that can grow to ten feet tall. In warmer climates, it blooms nearly all year long. It once bloomed on a mild December day on the High Line in New York. Alas, the following winter was not so kind, and the plant perished after one snowstorm too many.

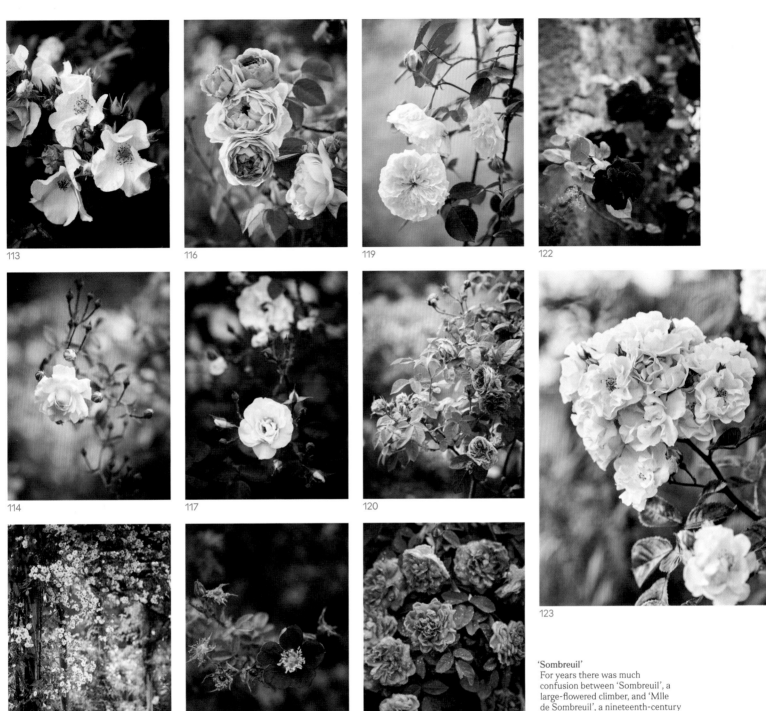

113

116

119

122

114

117

120

115

118

121

123

'Sombreuil'
For years there was much confusion between 'Sombreuil', a large-flowered climber, and 'Mlle de Sombreuil', a nineteenth-century tea rose, both bearing creamy white blooms. Many experts believed that the two were one and the same. In fact, the climbing 'Sombreuil', introduced in 1951, has full, sumptuous flowers in the old-fashioned rosette form and can grow to fifteen feet. On the other hand, 'Mlle de Sombreuil', named after a heroine who saved her aristocratic father from the guillotine during the French Revolution, is a tender rose (zone 7a to 10a) whose tea-scented petals are loosely arranged in cupped flowers on shrubs about six feet tall. To complicate matters, in 1959, an American grower introduced 'Sombreuil' under another name, 'Colonial White'. It was not until 2006 that the American Rose Society determined that all roses sold under 'Colonial White' should be shown as 'Sombreuil'.

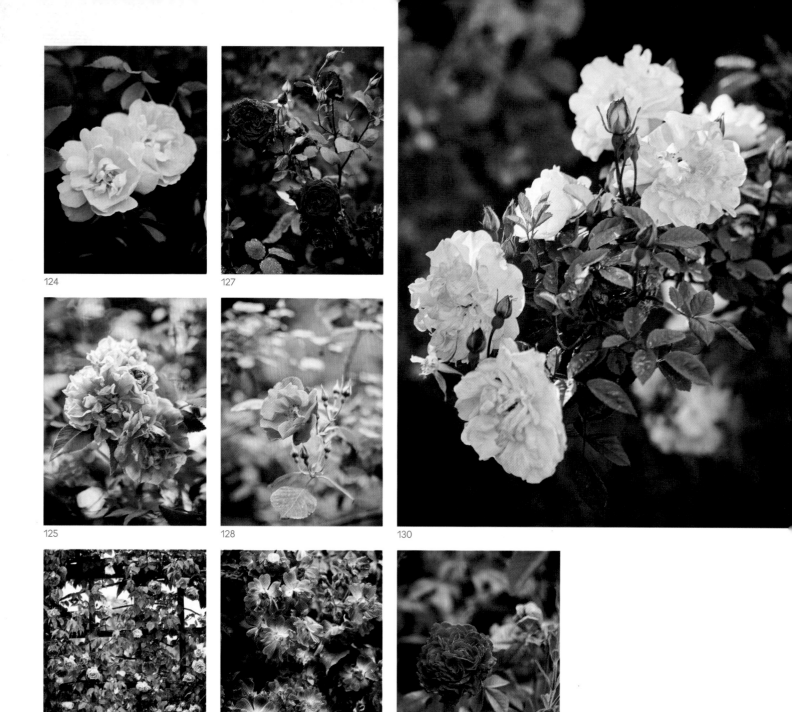

124

127

125

128

130

126

129

131

'Thérèse Bugnet'
Hybrid rugosas date back from
the nineteenth century but were
developed further in the 1940s
in Canada for their exceptional
cold hardiness. 'Thérèse Bugnet'
was bred in Canada in 1941 by
Georges Bugnet, an eminent French
writer of western Canada. Born in
France, Bugnet emigrated in 1904
to Canada, where he lived until the
age of 101. An interest in botany
led the writer to experiment with
plants that would thrive in the
northern Alberta climate. 'Thérèse
Bugnet' was named for his sister,
and like all hybrid rugosas, it is
extremely cold hardy and highly
fragrant. Its complex parentage
includes a species rose from
Russia, *Rosa amblyotis*; a species
rose from western North America,
R. macounii; a double-flowered
rugosa; and a mixture of pollens
from various species hybrids.

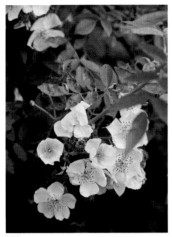

132

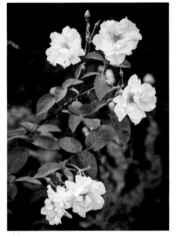

133

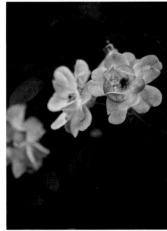

134

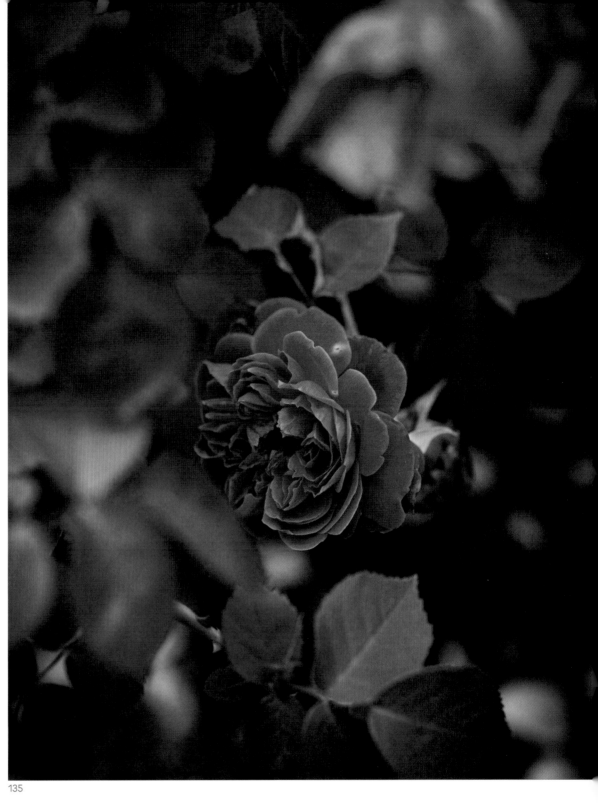

135

Further Reading

The literature on the rose is overwhelmingly rich, but for those interested, here is a small selection of books on the various aspects of the flower: its history, cultivation, social, cultural, and political impact.

Alvarez, Felicia. *Growing Wonder: A Flower Farmer's Guide to Roses.* Seattle, WA: Bloom Imprint, 2022

Brent, Eliot. *The Rose: The history of the world's favourite flower told through 40 extraordinary roses.* London: Wellbeck Publishing in association with the Royal Horticultural Society, 2020.

Caracciolo, Marella, and Giuppi Pietromarchi, with photographs by Marella Agnella. *The Garden of Ninfa.* Turin, Italy: Umberto Allemandi, 1999.

Catoire, Christian, Eléonore Cruse. *Les Roses Sauvages.* Esparon, France: Etudes et Communication, 2001.

Christopher, Thomas. *In Search of Lost Roses.* Chicago: University of Chicago Press, 2002.

Harkness, Peter. *Roses: From the Archives of the Royal Horticultural Society.* New York: Harry N. Abrams, 2005.

Morley, Simon. *By Any Other Name: A Cultural History of the Rose.* London: Oneworld Publications, 2021.

Phillips, Roger, and Martyn Rix. *The Quest for the Rose.* London: BBC Books, 1993.

Potter, Jennifer. *The Rose.* London: Callisto Books, 2010.

Solnit, Rebecca. *Orwell's Roses.* New York: Viking, 2021.

Thomas, Graham Stuart. *The Graham Stuart Thomas Rose Book.* Portland, OR: Sagapress Inc. / Timber Press, 1994.

Nurseries

Most garden centers tend to favor modern, new varieties so finding old or species roses sometimes requires a bit of detective work. In the US, the number of specialty nurseries offering these rare and historic beauties has dwindled over the last couple of decades. Following is a list of growers and nurseries that still offer hard-to-find varieties in the US, UK, and Europe.

BELGIUM
Lens Roses — lens-roses.com

FRANCE
André Eve — roses-andre-eve.com
Roseraie Ducher — roseraie-ducher.com

UK
David Austin Roses — davidaustinroses.co.uk
Garden Roses — garden-roses.co.uk
Harkness Roses — roses.co.uk
Peter Beales Roses — classicroses.co.uk
Trevor White Roses — trevorwhiteroses.co.uk

US
A Reverence for Roses — areverenceforroses.com
Angel Gardens — angelgardens.com
Antique Rose Emporium — antiqueroseemporium.com
Burlington Rose Nursery — burlingtonroses.com
David Austin Roses — davidaustinroses.com
Greenmantle Nursery — greenmantlenursery.com
Heirloom Roses — heirloomroses.com
High Country Roses — highcountryroses.com
Menagerie Farm & Flower — menagerieflower.com
Rogue Valley Roses — roguevalleyroses.com
Rose Petals Nursery — rosepetalsnursery.com

GLOBAL
Help Me Find — helpmefind.com

Lens Roses, based in Belgium, will ship to other European countries and the UK. An excellent source of information on all things related to roses, including nurseries around the world, is the website Help Me Find.

Thank You

This book lived in my head for over a decade, and I was only able to bring it into fruition with the help of a small army of people. I am grateful to Sarah Owens, who inducted me into the world of roses and allowed me to embark on the project of photographing them in 2008. Fifteen years later, she was also the first to read every chapter of the resulting book with thoughtful consideration and expert advice. Photographing roses in the solitude of my own home eventually led me to enchanting gardens near and far, to new and deepening friendships, to times long past. The book would not exist without the generosity and hospitality of all the owners, designers, and guardians of the gardens recorded here: Esme Howard and Antonella Ponsillo at Ninfa; Yannick Vu and Ben Jakober at the Hortus Conclusus; Perry Guillot at the North Sea House; Umberto Pasti at Rohuna; Tania and Jamie Compton at Spilsbury Farm; Dan Pearson and Huw Morgan at Hillside; Jack Bankowsky, Matthew Marks, Lindsey Taylor and Tony Bielaczyc at Cat Rock; Katsuhiko Maebara and Dr. Yuki Mikanagi at the City of Sakura Rose Garden; Eléonore Cruse at Roseraie de Berty; Bridget Elworthy and Henrietta Courtauld at Château de la Rongère; and Erin Benzakein, Jill Jorgensen, Becky Crowley, and the whole team at Floret. So many others also kindly shared their stories and expertise with roses: Felicia Alvarez from the picturesque Menagerie Farm & Flower, Page Dickey with her charming cutting garden bounded by native roses, Warrie Price with her species roses in the meadows, Melissa Goldstein with her rose-strewn Brooklyn garden. Gracielinda Poulson at Grace Rose Farm sent me her beautiful roses to photograph during the pandemic, an act of kindness I will never forget. Natasja Sadi gave me a master class in hospitality and the privilege of photographing her exquisite sugar roses for this book. Rebecca McMackin indulged me with long walks to talk about our shared love of roses. I am also indebted to the rose experts who generously gave their time to educate me on the subject of the rose: Clair G. Martin, Curator Emeritus Huntington Rose Garden, and Dr. Guoliang Wang, whose books on Chinese roses will hopefully find an English publisher in the near future. Patrick Li and Seth Zucker made the book of my dream into reality with their thoughtful and elegant design. They also encouraged me to put all of myself into these pages. I am grateful to Dung Ngo for his patience and diligence in shepherding the project from design through production. Elizabeth Smith was a dream copy editor with her thoroughness, enthusiasm, and timeliness. Sincere thanks to Charles Miers, who has supported my work through five books at Rizzoli. Lastly, my deepest gratitude to Julian Wass for his infinite patience, support, and love.

"2 [Here to me from Krete to this holy temple...]"
from *If Not, Winter: Fragments of Sappho*
by Sappho, translated by Anne Carson, copyright © 2002 by Anne Carson.
Used by permission of Alfred A. Knopf, an imprint of the Knopf Doubleday
Publishing Group, a division of Penguin Random House LLC. All rights reserved.
In the UK, reproduced with permission of Little Brown Book Group Limited
through PLSclear.

"Ninfa Revisited" from *The Collected Poems*
by Kathleen Raine, copyright © Kathleen Raine.
Used by permission of Faber & Faber Limited.

Gallic Rose (Rosa Gallica Versicolor)
by Pieter Withoos (1655–1692), Rijkmuseum, Amsterdam.

First published in the United States of America in 2025 by
Rizzoli International Publications, Inc.
49 West 27th Street, New York, NY 10001
www.rizzoliusa.com

Texts, photography, and drawings © 2025 Ngoc Minh Ngo

Publisher: Charles Miers
Editor: Dung Ngo
Copy Editor: Elizabeth Smith
Design: Li, Inc., Patrick Li and Seth Zucker
Production Manager: Maria Pia Gramaglia
Managing Editor: Lynn Scrabis

ISBN: 978-0-8478-4305-3
Library of Congress Control Number: 2024946660

Printed in Singapore
2025 2026 2027 2028 / 10 9 8 7 6 5 4 3 2 1

Visit us online:
Facebook.com/RizzoliNewYork
X: @Rizzoli_Books
Instagram.com/RizzoliBooks
Pinterest.com/RizzoliBooks

MIX
Paper | Supporting
responsible forestry
FSC
www.fsc.org
FSC® C167869